A HERITAGE OF
AMERICAN
PAINTINGS

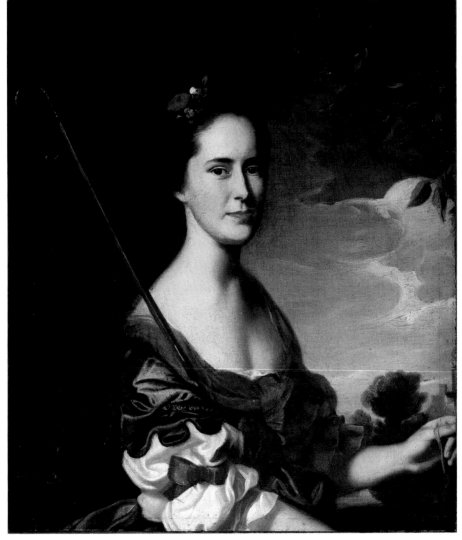

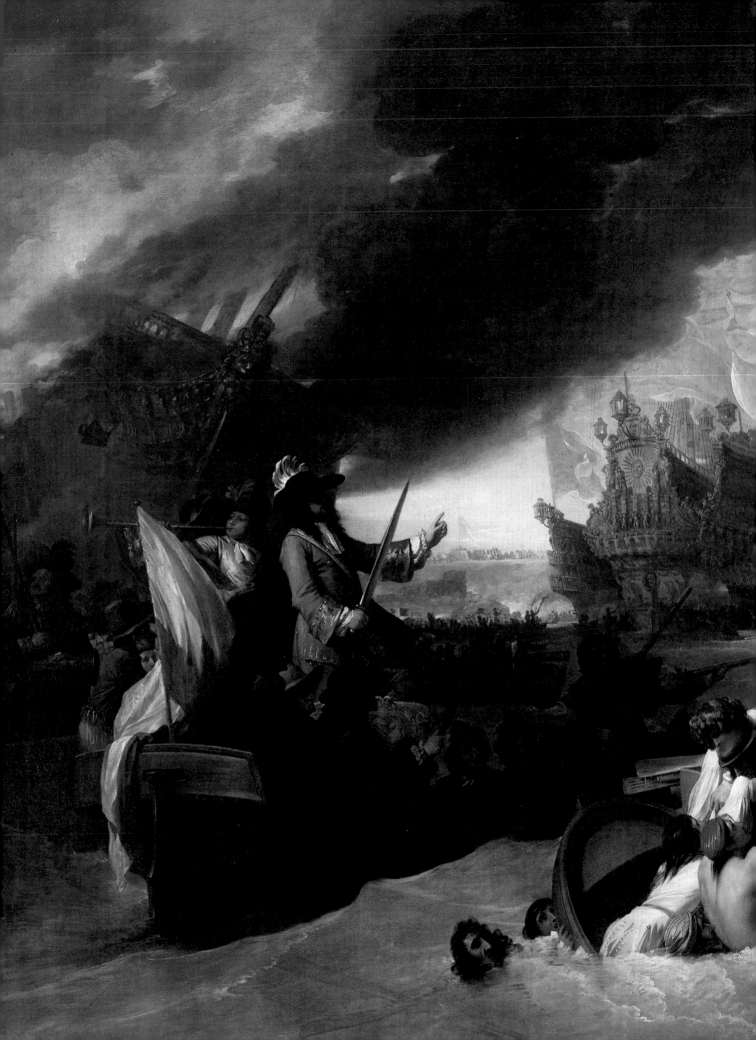

A HERITAGE OF AMERICAN PAINTINGS

From the National Gallery of Art

By William James Williams

A Rutledge Press Book

HAMMOND
INCORPORATED
MAPLEWOOD, NEW JERSEY 07040

To the memory of my parents

Edited by Deborah Weiss
Designed by Allan Mogel

Prepared by The Rutledge Press, A Division of W. H. Smith Publishers Inc.
112 Madison Avenue, New York, New York 10016

Published and distributed by Hammond Incorporated
515 Valley Street, Maplewood, New Jersey 07040

First printing 1981

ISBN 0-8437-1070-5 classics edition
ISBN 0-8437-1071-3 hardcover

Library of Congress Cataloging in Publication Data

Williams, William James, 1942–
 A heritage of American paintings from the
National Gallery of Art.

 Includes index.
 1. Painting, American—Catalogs. 2. Painting—
Washington (D.C.)—Catalogs. 3. National Gallery
of Art (U.S.)—Catalogs. I. Title.
ND205.W517 759.13'074'0153 81-5229
 AACR2

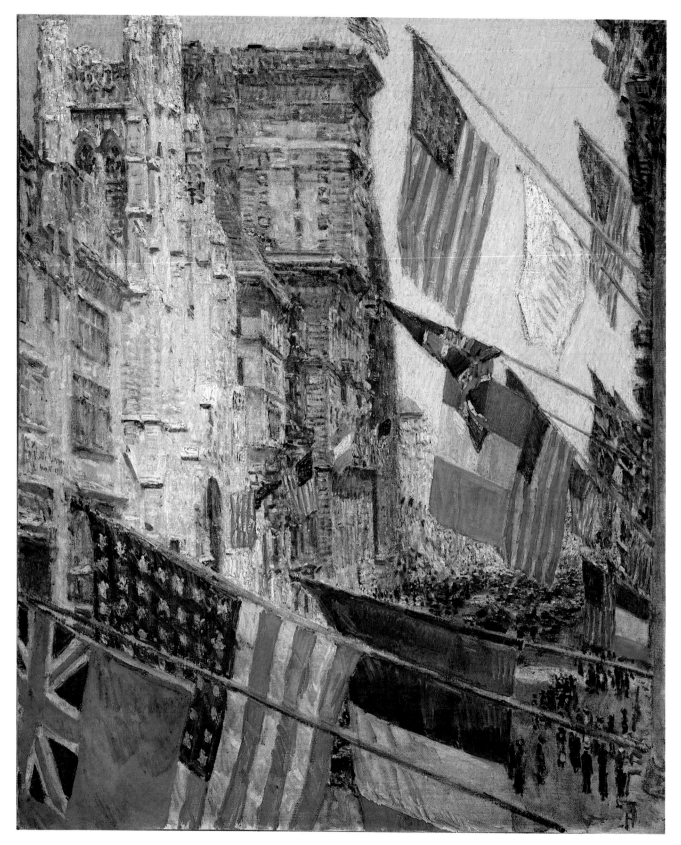

Childe Hassam *1859–1935*
Allies Day, May 1917 *1917*
Gift of Ethelyn McKinney in memory of her brother, Glenn Ford McKinney

CONTENTS

All photographs in this book reproduce works from the National Gallery of Art in Washington, D.C. Since the National Gallery periodically rehangs its collections, most of the original paintings illustrated here will not be on public view at all times.

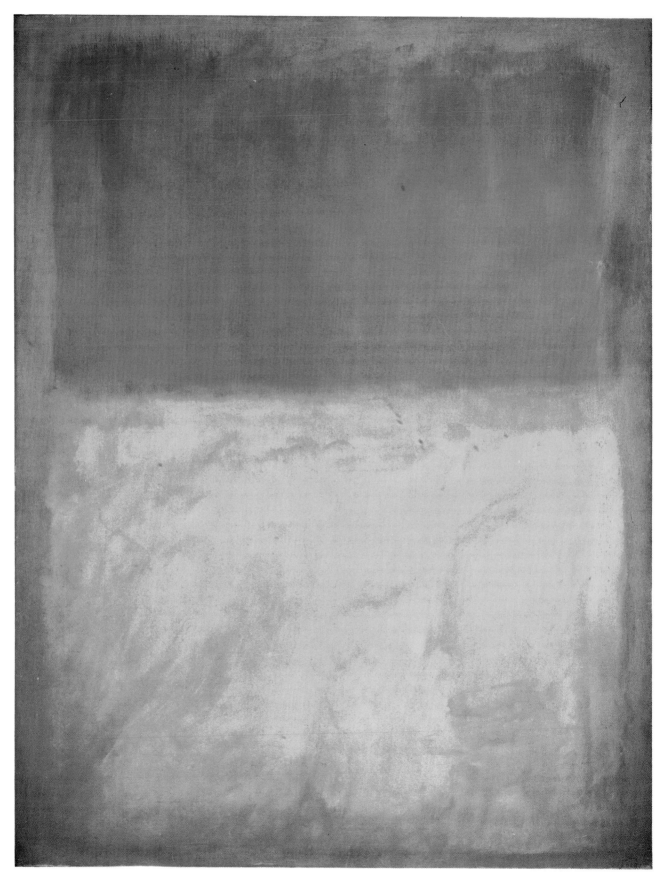

Mark Rothko *1903–1970*
Orange and Tan *1954*
Canvas, 81¼" x 63¼"
Gift of Enid A. Haupt

INTRODUCTION

A museum is not a book with a beginning and an end. Rather, its galleries invite browsing, stopping at paintings that catch your interest, or ignoring other works until a future visit. Museum fatigue defeats the gallery-goer, whether casual tourist or intent specialist. Trying to absorb too much too quickly, the brain wearies long before the feet begin to ache. The first advice a museum professional will offer is to relax and enjoy only what your current mood allows. In short, don't overdo it.

The chapters in this book are broken into brief essays, similar to related groupings of pictures on a wall or suites of interconnected galleries. The entries may be "walked through" in a forward, chronological sequence as well as backward, sideways, and back-and-forth. If a particular illustration catches your eye, refer to the entry on its individual painter. Compare and contrast types of works, such as group portraits or landscapes, throughout the chapters or galleries. Check the index to find out how closely related the painters in one chapter might be to those in adjacent sections. And, read the chapter introductions for a skeletal outline of American cultural history.

The color plates are arranged in four portfolios, excluding a survey of Americana in the introductory pages. This clustering indicates which artists are approximate contemporaries, even though they may be mentioned in separate chapters for thematic reasons. The four groups also demonstrate changing preferences for color and tonal schemes. In the 1700s, neutral tones often served as backgrounds for areas of clear colors; complexions had a powdery artificiality with rouged pink cheeks. The Romantic era of the early 1800s chose warm, golden light and hot red or yellow accents emerging from mysterious shadows. The late 1800s emphasized complex, scientific color harmonies or consciously unified schemes of an "art for art's sake" aestheticism. The hectic impersonality of the twentieth century expresses itself in somber or clashing tones and brash, strident colors.

This manuscript was commissioned to deal anecdotally with the fortunes and misfortunes of American painters represented in the National Gallery of Art. Being confined to the works curated by one institution, the text therefore cannot be considered a survey of all American art. And, by illustrating many pictures that do not hang on public view, neither is it a complete guide to the museum. Students of American painting might be amused to note how the author attempted to cover the gaps inevitable in any single collection and also to trim away those artists whose masterpieces are overpoweringly abundant at the Gallery. For ease of comprehension of the general reader, technical jargon, stylistic terms, and proper names have been kept to a minimum.

Art is the communication of an intellectual idea or the expression of an emotional mood. Taste is a sliding measure of social acceptability, upon which reward and fame constantly rise and fall. Never confuse art and taste: the most popular painter is not necessarily the best artist. And, each succeeding generation finds new values against which to judge past art. Unless the entries stress phenomenal success or dismal struggle, the reader may safely assume that most of these painters earned considerable esteem and more than a decent living. The quotations derive from the artists or their contemporaries—families, friends, competitors, patrons, and critics—never from subsequent historians. This follows the advice of many painters themselves, well summed up by Thomas Eakins: "When I read about artists and their works I am not as a rule interested in what is said about their works, but I am keen to know of the personality of the artists themselves. If I want to know about a picture I go to see it or get a reproduction."

THE NATIONAL GALLERY OF ART

Andrew W. Mellon, a perceptive art collector, was Secretary of the Treasury from 1921 until 1932. In attempting to insult him, a political critic delivered one of history's best back-handed compliments: "Three presidents served under Mellon." As Ambassador to the Court of St. James's in 1932–1933, Mellon conceived the idea for America's National Gallery of Art. Frequent visits to Britain's National Gallery in London inspired him to refine his own art collection to form the core for a similar institution in the United States' capital.

Just before Christmas 1936, Mellon surprised Franklin D. Roosevelt with an offer of a superb collection as well as the funds and plans for a building to be given to the American people. John Russell Pope, the leading architect of museums and monuments in the first half of the twentieth century, had designed the majestic, classical structure. An Act of Congress on March 24, 1937, established the future National Gallery of Art as an independent agency of the government. Regrettably, neither the patron nor the architect lived to see his dream realized.

Since the Gallery opened on March 17, 1941, more than 500 other patrons and benefactors have added their gifts—both works of art and acquisition funds—to the original collection and endowment. The holdings of European Old Master paintings, sculptures, prints, and drawings rank among those in a handful of the world's major museums. The generosity of donors surpassed anyone's wildest expectations. Within only thirty years, it became necessary to break ground for an annex to house the expanding collection and to facilitate scholarly research. Opened on June 1, 1978, the new East Building was provided by Paul Mellon and the late Ailsa Mellon Bruce, the children of the founder, and by The Andrew W. Mellon Foundation created by them. The architect Ieoh Ming Pei, paralleling Pope's earlier reputation, could be claimed as the principal designer of galleries in our time. Pei's concept, given a lopsided site, was brilliant. He erected a polygonal structure whose severe modern lines echo the pristine clarity of the original (now termed "West") building across a plaza and underground connecting concourse.

When the West Building opened, the Gallery owned only eleven American paintings. Forty years later, its American pictures number more than one thousand. Rather than secrete its excess holdings in storage vaults, the Gallery rotates its hangings and lends works to other accredited museums for the enjoyment of all. What is truly unique about this marvelous assemblage is that it was attained without spending one penny of taxpayers' money. Like both buildings, all the collections of the Gallery, by law, have been acquired from private sources.

*Aerial view of the **National Gallery of Art** looking eastward toward the Capitol*
West Building, designed by John Russell Pope, built 1937–1941
East Building and Plaza Concourse, designed by Ieoh Ming Pei,
built 1971–1978
Photograph by William J. Sumits

1

COLONIAL LIMNERS AND EUROPEAN ITINERANTS

Limner, from the same root as the word "illuminate," once had the perfectly respectable meaning of an artist who threw light on his subjects. During the eighteenth century, however, fine artists, in the sense of academically trained painters, began to use limner in a derogatory manner to snub self-taught or primitive craftsmen. Colonial America, in those terms, had only limners, no painters. Neither the size of the population nor the state of the economy could have supported a professional painter of landscapes, still lifes, daily-life scenes, historic events, altarpieces, or even those most saleable of pictures—portraits. Except for the native Indians, for instance, the whole population of the Thirteen Colonies was only about two and a half million people, and more than one million of them were black slaves or white indentured servants. The vast majority of the remainder were rural farmers. So only the middle and upper classes on the plantations or in the towns could afford art, and that segment of the citizenry was so very small that one painter could easily supply the patronage of an entire region. When John Singleton Copley worked in Boston in the 1760s, for example, he monopolized the market for a city of 17,000. The essential reason for the wanderings of colonial painters was to find a community whose leading citizens had not sat for their portraits by another artist a few months or years earlier.

A great deal used to be made of the Puritan ethic and the resulting plainness of colonial tastes. But increased scholarly research indicates that the early Americans were far less strict than we'd assumed. For one thing, many religious images did exist, even though our popular misconceptions have ignored their presence. The colonists wore brighter clothes, had more ornate furniture, and displayed more paintings than we've given them credit for. Rather than religious prohibitions against finery and imagery, hardship economics seems to have been the main reason for the relative lack of fine art in the Thirteen Colonies. As an anonymous seventeenth-century writer put it, "The plow-man that raiseth the grain is more serviceable to mankind, than the painter who draws only to please the eye."

Colonies are, by nature, dependents of a mother country.

Eighteenth-century Americans, therefore, looked to Europe to set their standards. Native-born painters learned by studying imported engravings after Old Master and contemporary art and by observing the working methods of itinerant artists from abroad. Since over seventy percent of the colonists were of English, Irish, Welsh, or Scottish descent, it was London that dominated tastes in America. Sir Joshua Reynolds, court painter to George III, can serve as an example of the ideals desired by the colonial painters and patrons. Reynolds' *Squire Musters* utilizes a low horizon line to make the figure command the landscape. The setting, which might detract from the carefully portrayed face, is rendered in a sketchy, suggestive manner so that it forms an atmospheric background, not a competition. The squire's air of nonchalance comes from his pose of leaning on a walking stick, but the authority in his gaze derives from the slight uplift of his chin. His body has been idealized, and the general posture was gained from a famous classical statue, lending subliminal dignity to the work. Moreover, the composition is a consummately integrated design. The overall triangular silhouette of the subject is repeated in smaller triangles everywhere, from the openings of the coat and vest to the air seen through the cocked elbow to the obvious shape of the tricorn hat. Reynolds' canvas is, in every way, a masterpiece.

But how were colonial artists to learn these concepts? Black-and-white engravings tell nothing about color mixtures or paint textures. The subtleties of anatomy, perspective, and composition cannot be learned from reading books. A great deal of experimentation was to take place among painters in America.

THE "AETATIS SUAE" LIMNER

Active c. 1715–c. 1725

About twenty-three colonial portraits bear the Latin inscrip-

John Singleton Copley *1738–1815*
Detail of Epes Sargent c. 1760
Gift of the Avalon Foundation

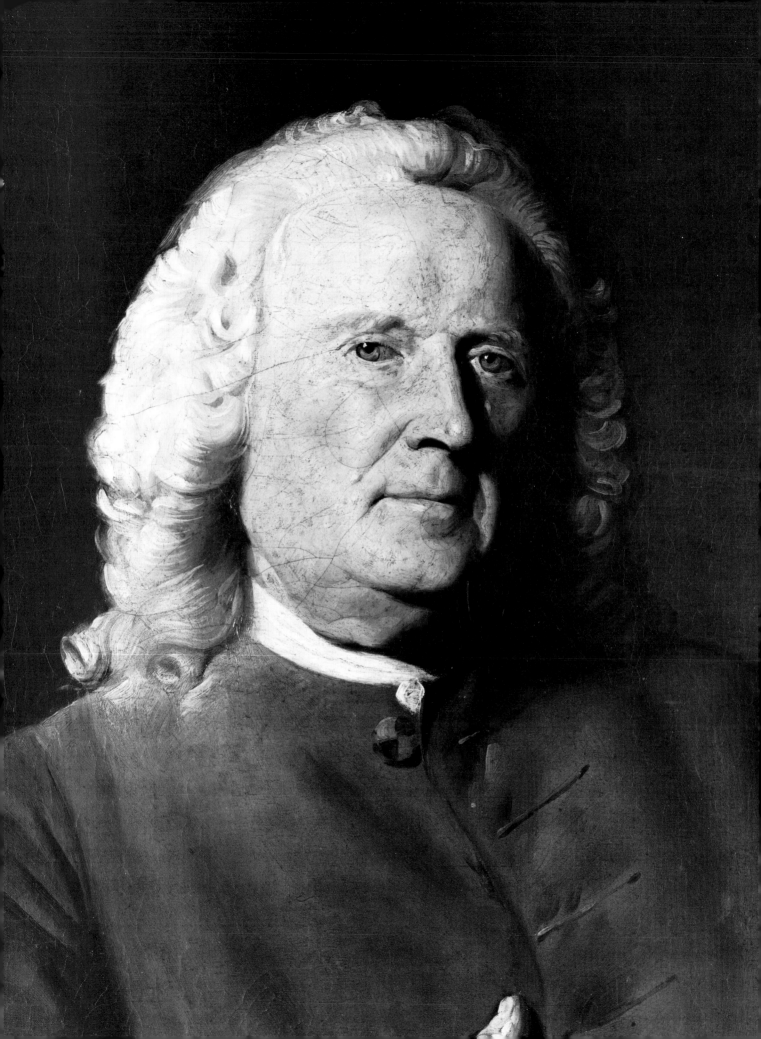

Sir Joshua Reynolds *(British) 1723–1792*
Squire Musters 1777/1780
Canvas, 93⅞" x 58"
Given in memory of Governor Alvan T. Fuller by the Fuller Foundation

tion *Aetatis Suae,* or an abbreviation of it, meaning "at the age of." The phrase is followed by the sitter's age and the date of the painting. The unknown limner, or delineator, of these pictures was studiously following a Northern European tradition for securely dating his works and his sitters. Back in Germany, the Netherlands, and Britain, though, such inscriptions were falling out of fashion. Typical of the stiff, heraldic images of the sixteenth and seventeenth centuries, these long passages of lettering looked awkward to sophisticated patrons of the eighteenth century. Since all the "Aetatis Suae" Limner's known portraits are dated from about 1715 to about 1725, he and his clients obviously didn't know or didn't care about the new standards in Europe.

Mr. Van Vechten, in its lower right corner, carries the legend: *Etas. Sue 43 / 1719.* Therefore, the sitter was forty-three years old in 1719. Van Vechten family history might identify the man with a certain Johannes Van Vechten, whose birthdate of 1676 is consistent with the painting's inscription. If it is Johannes, the subject of this portrait was the grandson of a Dutchman who arrived in the New Netherlands in 1638. The Dutch settled heavily in the Hudson River valley, and most of the "Aetatis Suae" Limner's works seem to come from the area between New York and Albany. It would be reasonable to suppose that the unknown painter, who specialized in prominent Dutch citizens, was of Netherlandish descent himself. Indeed, attempts have been made to identify him with specific artists documented as working in the Hudson area. Recently discovered documentary evidence suggests the painter may have been one Nehemiah Partridge from Portsmouth, New Hampshire. But scholars disagree on attributions, and they sometimes even advance the theory that the "Aetatis Suae" Limner was British. About sixty unsigned pictures are sometimes given to the same master on the basis of style, and they range in origin from Virginia to Rhode Island. Other experts insist those works must be by three different hands.

Whoever he was and wherever he came from, the "Aetatis Suae" Limner had received professional training in picture painting. He modeled well, with pale paint blended into dark paint in order to give an illusion of solid forms caught in the light and casting their own shadows. The sense of volume in Van Vechten's face, for example, could not have been achieved by a mere sign letterer or decorator of houses and coaches. And the roseate dawn, while being a standard emblem of a promising future, is most exceptional in its handling of pigment to suggest sunlight breaking through the clouds.

Turning to the portrait itself, the viewer can read a great deal about Mr. Van Vechten. His coat and cravat indicate he prospered at his business. The two ears of wheat he holds suggest his business was farming. His assured pose, hand elegantly on hip, conveys his pride about his station in life. The region around Albany was, in the early eighteenth century, on the threshold of the wilderness; Indians existed side-by-side with Dutch and English settlers. Van Vechten's pride in a successful farm in that area was thoroughly justified. However, the wilderness aspect makes one doubt the validity of the painting's background. The window gives a view of a formal garden with an alley of evergreens, and a dramatic swath of red drapery balances the landscape on the other side of his head.

These accouterments of the manorial life are highly suspect for the colonies. The accessories, then, like the posture, derive from accepted European conventions developed for court portraiture two centuries earlier.

ROBERT FEKE

1706–living 1751

Robert Feke was among the New World's first important artists who were native-born. He apparently grew up on Long Island, and the legend that he might have been a mariner explains why his earliest known pictures date from the artist's mid-thirties. Sea trade being common from Long Island to Newport or New York, either city could be the locale where Feke observed and culled ideas from the paintings of the Scottish émigré artist who influenced his work. Feke rambled quite a bit, setting up shop in Boston, Newport, Philadelphia, and Willingboro, New Jersey. His last recorded mention is in Rhode Island at a nephew's wedding in August 1751. Then, he simply disappeared from history until 1767, when his family received confirmation that he had been deceased for some time. The burial of a "Richard Feak" took place in 1752 in Barbados, where wealthy islanders would have been eager patrons for a portrait painter. Some authorities believe that "Richard Feak," given the lack of standardized spelling and the likelihood of error in handwritten documents, was Robert Feke.

Feke's style stressed ornamental patterning and geometric clarity. Sharp contours and equally harsh shadows break his compositions into crystalline shapes. *Captain Alexander Graydon*, painted in Philadelphia around 1746, shows a stiffly erect figure whose large scale threatens to burst beyond the canvas' edges. The extended fingers create a serrated form against the wall, just as the crisp shading around the nose, brows, and wig divides the face into distinct areas. Note, too, that the hand tucked in the waistcoat coincides precisely with the intersection of the window frame and hill's crest.

Alexander Graydon, an Irishman who came to this country in 1730, became a popular figure in Philadelphia coffeehouses due to his wit and education. A lawyer and merchant, he was taken aback by his first encounter with America: "Most of our trading people here are complaisant sharpers; and that maxim in trade, to think every man a knave, until the contrary evidently appears, would do well to be observed here if any where." A word might be said about Feke's depicting Graydon with his hand inside his vest, a gesture reminiscent of all those tall tales about Napoleon Bonaparte's itch. In that age of skin-tight breeches, a gentleman who wished to be nonchalant rested his hands in his waistcoat, just as modern men who are relaxing put their hands in their pockets. (Trousers with pockets weren't fashionable until the early nineteenth century.)

JEREMIAH THEUS

1719–1774

As a teenager, Jeremiah Theus accompanied his family from Switzerland to Charleston, South Carolina. His artistic background is unknown, but he advertised himself as a "limner" in a Charleston newspaper in 1740. "All Ladies and Gentlemen may have their Pictures drawn, likewise landskips of all sizes, Crests and Coats of Arms for Coaches or Chaises. Likewise for the Convenience of those who live in the Country he is willing to wait on them at their respective plantations." Everything about his career bears out these claims made when he was still in his early twenties. The young Swiss portrayed many eminent families of Georgia as well as South Carolina. The unidentified sitter for *Mrs. Cuthbert,* for instance, had relatives in both states. Beyond her window is a scene capable of being framed as a "landskip" by itself. And the precise lettering on the book she holds proves Theus' ability at crests and coats-of-arms. The words *GOSPEL/SONNET* are almost superfluous when one sees that kindly face and the quiet gesture of holding her hand to her cheek.

Theus must have learned the rudiments of painting in his native Switzerland. Several aspects of his work could be called Germanic, especially the attention to detail, seen here around the eyes. Indeed the entire treatment of facial muscles and skin tone

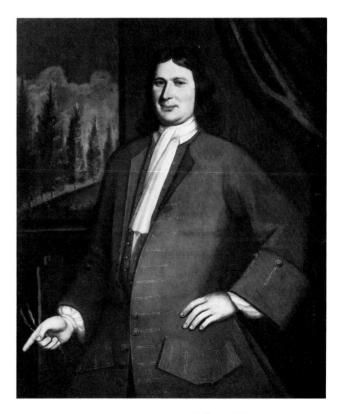

The "Aetatis Suae" Limner *active c. 1715–c. 1725*
Mr. Van Vechten *1719*
Canvas, 45⅝" x 38"
Andrew W. Mellon Collection

15

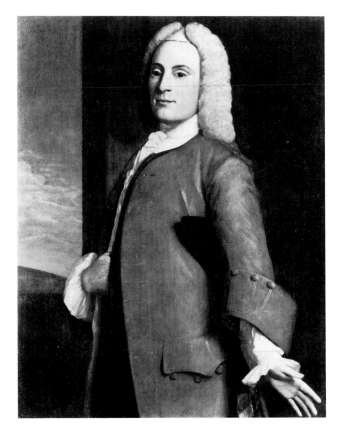

Robert Feke *1706–living 1751*
Captain Alexander Graydon *c. 1746*
Canvas, 39⅞" x 31⅞"
Gift of Edgar William and Bernice Chrysler Garbisch

projects a northern candor. The imitation of surface textures, whether it be the highlights on her pearl necklace or the zigzag creases in her satin sleeve, indicates a Northern European temperament, too. The marvelous translucency of her sheer white shawl, revealing the deep blue of the underlying bodice, is enough to rank Jeremiah Theus with the most accomplished painters of colonial days.

JOHN WOLLASTON

Active 1733–1767

An English officer stationed in New York City, Archibald Kennedy was a lieutenant in 1744, a commander in 1756, and a captain in 1757. He is best known in Great Britain as a member of the peerage, the 11th Earl of Cassilis. In the United States, his fame rests upon building an impressive residence at No. 1 Broadway, in which took place many historic events. The question mark in the title of *Lieutenant Archibald Kennedy (?)* (see page 41) indicates the National Gallery's cautious attitude. The portrait does not have a complete provenance, or history of owners, back to the time it was executed. Since it would be almost too good to be true that a painting this impressive would depict a person that important, the curators wait for solid documentary evidence.

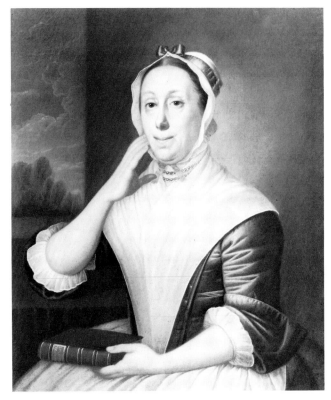

Jeremiah Theus *1719–1774*
Mrs. Cuthbert *c. 1765*
Canvas, 29¾" 24⅞"
Gift of Edgar William and Bernice Chrysler Garbisch

A comparison with an English portrait of Archibald Kennedy is inconclusive because that likeness of the Earl of Cassilis was painted some thirty years after the National Gallery's work. Even considering the altered age, though, the other portrait shows a similar rounded hairline, long nose, prominent cheek muscles, and dimple in the chin. Were the Gallery to assert that its painting definitely represents Kennedy, only later to discover proof that it is another British officer, the picture's reputation would be blemished. Works of art, like human beings, do have reputations. Gossip, rumor, and innuendo can permanently alter our perception of each other, no matter how unfounded or malicious. So, rather than make unwarranted claims which might backfire, the Gallery, as with any other reputable museum, makes a public declaration of being noncommital.

No matter which British officer it depicts, the canvas is a superb example of the genius of a British painter in America—John Wollaston. The son of a London portraitist of the early eighteenth century, Wollaston was active as an artist in England as early as 1734. Perhaps it was his acquaintance with British portrait practices that led him to create such huge pictures. A three-quarter-length portrait that is more than four feet high, this image is larger than life-sized. Its monumentality includes the seascape with two men-of-war and the commanding gesture of resting an officer's baton on a cannon muzzle.

Wollaston, who came to this country in 1749, was the first significant painter to live in New York City. While there, he developed the peculiar mannerisms of giving his sitters impish smiles and of portraying eyes in almond shapes that dip down toward the bridge of the nose. Wollaston's schooling under his father obviously included being a professional "drapery painter." His intensive work with textile surfaces is evident here in the starched cuffs, velvet coat, satin vest, and gold braid.

Wollaston left New York in 1752, worked in Maryland and Virginia until 1757, and then presumably went back to England via the West Indies. He arrived in Charleston, South Carolina, in 1767 before again returning to total obscurity in England. His date of death isn't known. Wollaston's output was astonishing; around three hundred American portraits by him are known to survive, and about one hundred of those were produced in his three or four years in New York. And, he greatly influenced native painters such as the young Benjamin West, who would become a court artist to George III.

times, the relationship seems pretty far-fetched. Whether Henry Benbridge laid claim to this impossibly distant connection for reasons of innocent familial affection or for the advancement of his own artistic reputation remains unknown.

Benbridge's introduction to painting came in 1758, when John Wollaston was in Philadelphia. On the evidence of Benbridge's earliest pictures, he somehow adopted Wollaston's stylized faces and crinkly satins. When Benbridge reached his majority at age twenty-one, he inherited a considerable property and almost immediately set sail for Rome. He worked under the most modern artists in Italy for five years, so by the time he arrived in London late in 1769, Benbridge was already an established professional. He was greeted warmly by the Wests and invited to submit works to the Royal Academy's exhibition. In 1770, at the second annual show held by that prestigious institution, Benbridge contributed two paintings, one a portrait of Dr. Benjamin Franklin. Benbridge returned home in the summer of 1770 with letters of introduction from West and Franklin, the most famous Americans living abroad.

Portrait of a Man, one of the two signed paintings by Benbridge, is dated 1771. Since he was then in Philadelphia and the sitter's black outfit would be unusual for residents of that fashionable city, it has been assumed that the subject is a clergyman. Regardless of the man's identity or occupation, however, the painting possesses a Naturalism unheard of in the Thirteen Colonies. The skin partakes of a soft fleshiness; the eyes sparkle with pinpoint highlights; the forms exist in a solid space of light-and-shadow modeling; and, most importantly, a melting, palpable atmosphere envelops the figure. Glazing, a complex technique of overlaying and merging different films of translucent oil paint, accounts for these subtle effects. Benbridge's accomplishment, though not equal to the best European painters, placed him far above any of the local American limners.

Benbridge is most often associated with portraying the southern gentry around Charleston, South Carolina. When Charleston fell to the British in 1780, Benbridge was arrested for refusing allegiance to the king. After more than two-and-a-half-years imprisonment, he was released. In failing health around 1799, Benbridge gave painting demonstrations to the young Thomas Sully, just as he had apparently learned by watching John Wollaston at work. It strikes a certain bizarre note that Henry Benbridge, the first artist in America to have exhibited at Britain's Royal Academy, spent the Revolutionary War aboard a British prison ship.

HENRY BENBRIDGE

1743–1812

Benjamin West left Philadelphia in 1760 and soon established himself as one of Europe's leading painters. Henry Benbridge loved to refer to Mrs. West as "my cousin"—Benbridge's mother's father was the brother of a woman whose son was the brother-in-law of Benjamin West's wife. Even given the extended families of colonial

JOHN GREENWOOD

1727–1792

Apprenticed to a sign painter and engraver in his native Boston during the early 1740s, John Greenwood found no competition as the city's chief portraitist for the brief period he worked at home. The Scottish artist who had earlier influenced Robert Feke had gone blind in 1748, and John Singleton Copley hadn't grown into

Henry Benbridge *1743–1812*
Portrait of a Man *1771*
Canvas, 30⅛" x 25¼"
Andrew W. Mellon Collection

his teens yet. Signed and dated 1749, *Mrs. Welshman* compensates in charm for what it lacks in anatomical Naturalism. Heavily rouged cheeks on an ashen complexion lend her oval face the solidity of a porcelain doll. Furthermore, her ungainly figure engages in a precarious acrobatic act; the head pulls far to the left as though to help the slender waist counterbalance that enormous bosom. But what seems humorous today was greeted with all due respect when it was painted, or her husband wouldn't have paid for it. This seriousness explains the arcadian landscape, the sumptuous shawl and gown, and the device of her hands toying with a strand of pearls.

A modern spectator can become quite saddened when contemplating the earnestness of this colonial woman's desire to be accepted as the equal of London society. The viewer can also become perplexed figuring out how a painter of such minimal training as Greenwood could have invented such a sophisticated pose and setting. The solution is simple: Greenwood derived the composition from a black-and-white print of an English oil painting, *Her Majesty the Princess Ann.* American artists, with no opportunity to study Old Master paintings in the original, or to watch academic artists at work, relied on second-hand information gleaned from engravings. Even the young Copley, four years later, would use the same design for one of his female portraits.

John Greenwood left Boston in 1752, after no more than five years as a practicing limner. He went first to Surinam (now the Netherlands Guiana), then to Holland, and in 1762 to England. Greenwood eventually acquired deftness at mezzotint engraving, a graceful paint handling, and a decent position as an art dealer. Yet, it seems a shame that he sacrificed his inherent raw-boned individuality in order to join the ranks of those hundreds of competent professionals in Europe.

JOSEPH BLACKBURN

Active 1752–1778

A drapery and accessory specialist from England, Joseph Blackburn introduced the light, spritely style of the later eighteenth century to America. *A Military Officer* contrasts remarkably with the earlier portraits of men in this chapter. Although the canvas per se is rectangular, a painted oval border softly enframes the sitter like a vignette. Blackburn mirrors this curve in the sweeping silhouettes of the sitter's lapels, shoulders, and poufed wig. Just as angular, dignified shapes have been supplanted by these graceful, beguiling forms, so too the colors are lighter and the tonal contrasts paler.

Blackburn, who'd spent two years working in Bermuda, arrived in New England in 1754 and filled the vacancy created when John Greenwood left for Surinam in 1752. Painting in Newport, Boston, and Portsmouth, New Hampshire, Blackburn monopolized the portrait market. His supple, fluid designs and easy, natural poses influenced a generation of New England's patrons and painters. *A Military Officer*, signed and dated 1756, when Blackburn was in Boston, is the type of work that inspired John Singleton

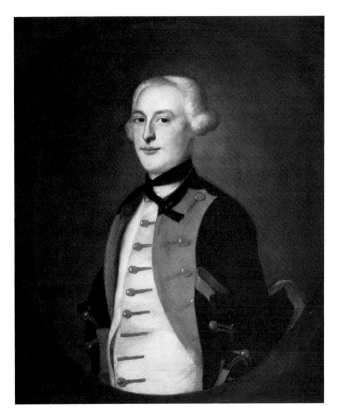

Joseph Blackburn *active 1752–1778*
A Military Officer 1756
Canvas, 30 ½" x 25 ⅛"
Andrew W. Mellon Collection

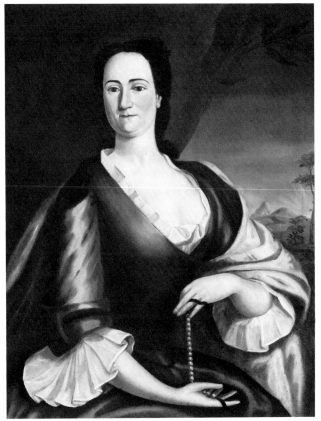

John Greenwood *1727–1792*
Mrs. Welshman *1749*
Canvas, 36" x 28"
Gift of Edgar William and Bernice Chrysler Garbisch

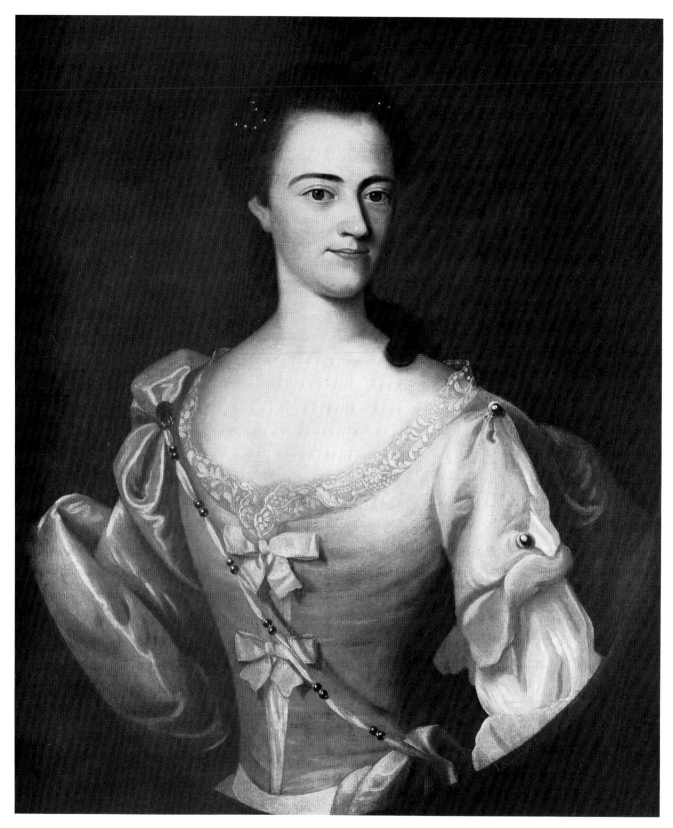

John Singleton Copley *1738–1815*
Jane Browne *1756*
Canvas, 30 ⅛ " x 25 ⅛ "
Andrew W. Mellon Collection

Copley. Regrettably for Blackburn, Copley learned the new idiom very quickly and soon rivaled him. Some authorities think that the twenty-five-year-old Copley's success is what drove Blackburn back to England in 1763.

JOHN SINGLETON COPLEY

1738–1815

Shortly after John Singleton Copley's birth, his father passed away. His mother, to support her only son, had to run a tobacco shop near Boston Harbor. One should say *in* Boston Harbor because the shop and the Copleys' home upstairs were on Long Wharf over the water. In 1748, his mother married a widower, though, and Copley moved away from the waterfront. A little more than twenty years later, Copley acquired a twenty-acre farm on Beacon Hill, next door to the mansion of John Hancock, one of the richest men in Massachusetts. The tobacconist's son had come that far solely on the basis of his own income—earned as the most important painter in colonial America.

Copley's stepfather, an English painter and engraver, raised the boy in an environment of prints and pictures. Possibly the young Copley received instruction in drawing and oil painting, too. But his artistic tutelage was cut short because, when Copley was only thirteen, his stepfather died. In later life, Copley insisted he was self-taught. He experimented with his late stepfather's studio equipment and observed the painting methods of other artists working in the colonies, notably John Greenwood, Robert Feke, and Joseph Blackburn. Soon, his innate ability to record details objectively and to suggest inner character launched the teenager on his successful career.

Copley's *Jane Browne*, dated 1756, when the artist was only eighteen, is indebted to contemporary European engravings and to Joseph Blackburn in its oval-vignetted format and its slender, graceful anatomy. In his attempt to idealize the sitter, Copley revealed his lack of training in anatomy. He couldn't handle the three-quarter view of the face which, meant to lend a lively action to the likeness, looks merely as though the unknown lady's nose is broken. Also, the fashionable sweep to her shoulders is overdone, creating the effect of a carved mannequin. Copley's genius shines forth in the textures. The sheen of satin and the crinkle of taffeta easily offset the primitive proportions.

Epes Sargent (see page 42), painted only about four years later, proves how rapidly Copley advanced. While the keen eyes and firm mouth suggest an astute mind, Sargent's pose is easy and relaxed. He comfortably rests one elbow on a pedestal and casually holds his other hand in a pocket. Approximately seventy years old when he posed for his portrait, Sargent had every reason to look pleased and relaxed; having dropped out of Harvard College to enter business, he worked his way into being one of Massachusetts' most prosperous merchants. His weighty mass in space, as rendered by Copley, suggests Sargent's pivotal role in the colonial economy.

John Singleton Copley *1738–1815*
Mrs. Metcalf Bowler *c. 1763*
Canvas, 50″ x 40¼″
Gift of Louise Alida Livingston

Copley's skill in expressing solidity is sometimes overlooked because his simulation of surface detail is so brilliant. The chapter frontispiece allows a closer examination of the material reality of the heavy wool coat, the soft muslin cuffs, and the stiff hair in the wig. Copley evidently gloried in depicting things as they were—a mole under Sargent's left eye or powder fallen from his wig onto his shoulder. The flesh, too, is superbly caught. As the painter Gilbert Stuart would say of this picture years later, "Prick that hand and blood will spurt forth."

The sharp, crisp quality of the details in *Mrs. Metcalf Bowler* betrays Copley's training as an engraver under his stepfather. The garland she holds is especially effective in reproducing the feel of various flowers (incidentally, her husband was one of the few men in the colonies to have a greenhouse). The painting of her plain, oval face epitomizes Copley's uncompromising fidelity to natural appearance. But the make-believe setting, resplendent with classical columns and a swag of red drapery, evokes the aspirations of colonists to a better life. Mrs. Bowler was probably aware that women of her social status in London would be wearing necklaces with real sapphires, not blue paste.

The ultimate in fantasy is brought out by *Mrs. Samuel Alleyne Otis (Elizabeth Gray)* (see page 1). The newly wed teenager stands in a pastoral wood enacting the role of an arcadian shepherdess. She holds a herder's crook, wears flowers in her hair, and stands before a mighty castle in the distance. One sometimes feels that Copley was not at ease with female sitters because he often resorted to formats and themes taken from chic European engravings when portraying them. Mrs. Otis' image is enchanting but seems more a social masquerade than a characterization.

When depicting men at the height of their political, military, and economic careers, Copley was at his best. The rich merchant, who also happened to be a leading High Tory power, cannot as a character be summed up any better than in *Harrison Gray*. The side lighting with penetrating shadows turns his face into a mask of granite, and his hand clutches his quill pen with the impatience of someone eager to get back to work. The determination in that face coincides with Copley's remark, "My pictures are almost always good in proportion to the time I give them provided I have a subject that is picturesk."

When the Massachusetts legislator sat for *Eleazer Tyng* in 1772, he was eighty-two years old. A Harvard classmate of Epes Sargent, after graduation Tyng devoted his life to public service. Copley shows him in a relaxed position, twisting slightly in his chair, with his legs crossed and his hands resting casually on the arm. A trace of amusement is apparent in his eyes and in the mobile set of his mouth. John Adams, acknowledging the immediacy of Copley's portraits, wrote in 1817, "You can scarcely help discoursing with them, asking questions and receiving answers."

In 1766, Copley had sent a picture to an exhibition in London. Benjamin West, who'd arrived in Europe in 1760, wrote to Copley in Boston complimenting the work. Even Joshua Reynolds, the dean of British painters, had admired the piece, stating that the "drawing is wonderfully correct, but that a something is wanting in your colouring." West practically begged Copley, "Nothing is want-

John Singleton Copley *1738–1815*
Harrison Gray *c. 1767*
Canvas, 30½" x 25½"
Gift of the Honorable and Mrs. Robert H. Thayer

ing to perfect you now but a sight of what has been done by the great masters, and if you could make a visit to Europe for this purpose for three or four years, you would find yourself then in possession of what will be highly valuable." Copley replied to West, acknowledging the paucity of fine art in the colonies. "I think myself peculiarly unlucky in living in a place into which there has not been one portrait brought that is worthy to be called a picture within my memory, which leaves me at a great loss to guess the style that you, Mr. Reynolds, and the other artists practice."

After Copley's marriage in 1769, he was faced with family responsibilities that prevented a trip abroad. Still dreaming of the marvels in Europe, he'd become the preeminent colonial painter, with a clientele ranging from revolutionary Whigs to reactionary Tories. At the outbreak of hostilities between England and America, Copley served as an arbitrator between the factions since most of Boston's society, rebel or loyal, had sat to him for portraits and trusted his impartiality. The strain of the precarious situation was too much. In June 1774, when he was already thirty-five years old, John Singleton Copley decided that he must go to Europe—now, or never.

John Singleton Copley *1738–1815*
Eleazer Tyng *1772*
Canvas, 49¾″ x 40⅛″
Gift of the Avalon Foundation

2

COURT PAINTERS TO THE BRITISH CROWN

It comes as a shock to Americans that European museums list our three greatest eighteenth- and early-nineteenth-century artists as "British." And so they were. Being born in the colonies, they automatically became English citizens; moreover, each spent an appreciable portion of his career abroad. Modern-day Europeans, however, receive an equal shock upon realizing how much impact three Americans had on Western culture at large.

Gilbert Stuart, who returned to the United States after the Revolutionary War, seriously rivaled Sir Joshua Reynolds and Thomas Gainsborough as the most fashionable portraitist in London. The two other leading American-born artists of the time never returned to their homeland after leaving for study in Europe; Benjamin West and John Singleton Copley dominated British art at a period when it, in turn, was the chief school of painting in the world. West, Copley, and Stuart all earned positions as royal painters to George III or George IV. Indeed, West presided over the prestigious Royal Academy for nearly twenty-eight years!

The Royal Academy's inauguration took place on January 2, 1769. The functions of such an art academy are manifold. They act as schools to train young painters, as guilds to govern the conduct and pricing of established masters, as exhibition halls to display recent work to potential clients, as lecture rooms to elevate public taste and connoisseurship, and as courts to judge on acceptable standards of culture. Sir Joshua Reynolds, first president of the Royal Academy, advocated an ideal beauty based upon quotations from classical antiquity and the Old Masters: "It is vain for painters or poets to endeavor to invent without materials on which the mind may work, and from which invention must originate. Nothing can come of nothing." The Americans followed these precepts for an idealized grandeur, but they were to invest European art with something new. Freshness of vision—a realistic depiction of things as they really are—was to be the American contribution.

JOHN SINGLETON COPLEY

1738–1815

John Singleton Copley, whose first thirty-five years are discussed in chapter one, left Boston as the acknowledged giant of American painting. When he sailed in June 1774, he planned on no more than an extended study trip abroad. But the events of the Revolution and the potential market in Europe combined to prevent him from ever returning. As he wrote to his family back in Boston, "Poor America. I hope for the best, but I fear the worst. Yet certain I am she will finally emerge from her present calamity and become a mighty empire. And it is a pleasing reflection that I shall stand amongst the first of the artists that shall have led the country to the knowledge and cultivation of the fine arts, happy in the pleasing reflection that they will one day shine with a luster not inferior to what they have done in Greece and Rome." He spent over a year working in Italy, France, Germany, and the Low Countries. His family, meanwhile, was in desperate straits, and he urged them to come quickly to London. Communications were so bad that he didn't learn his wife and children had left until long after they'd arrived in England.

The Copley Family (see pages 44-45) documents a happy reunion in safety and demonstrates the artist's newfound skills. From observing the Old Masters' compositions, Copley had acquired the ability to integrate a large number of figures into a coherent design. The setting is pure Grand Manner; the arcadian landscape with waterfall implies natural simplicity, while the carpet, drapery, column, and camel-back sofa refer to civilized sophistication. Copley himself appears at the top of the group, holding a sheaf of drawing

24

Benjamin West *1738–1820*
Detail of The Battle of La Hogue *1778*
Andrew W. Mellon Fund

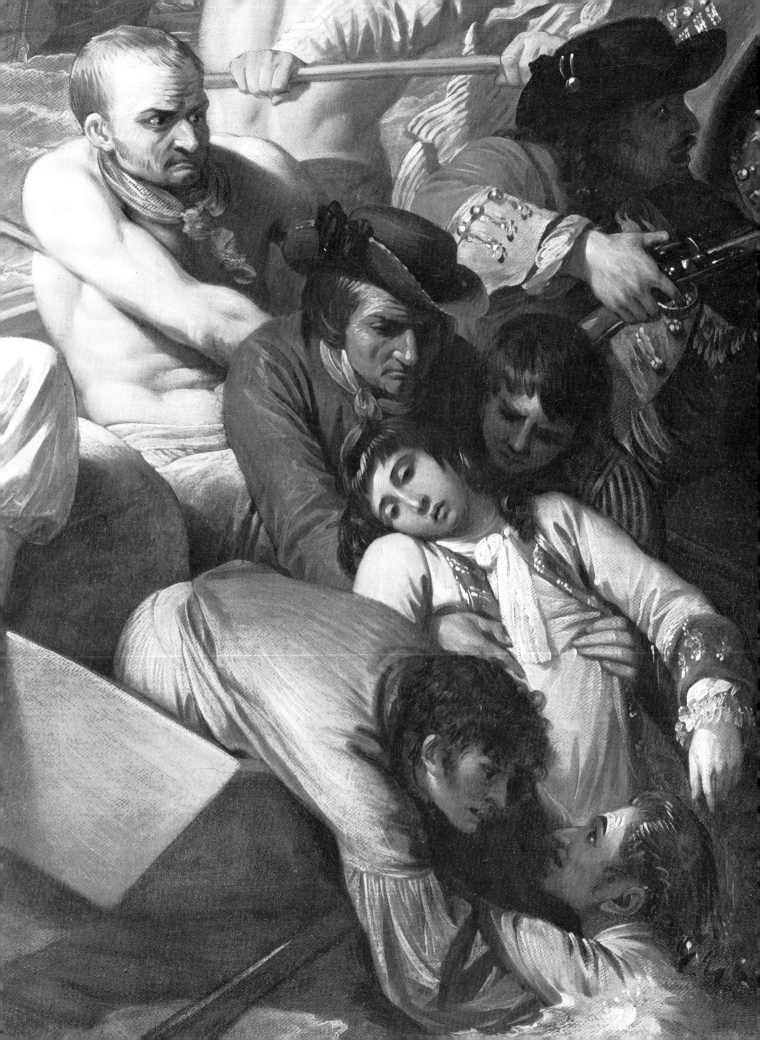

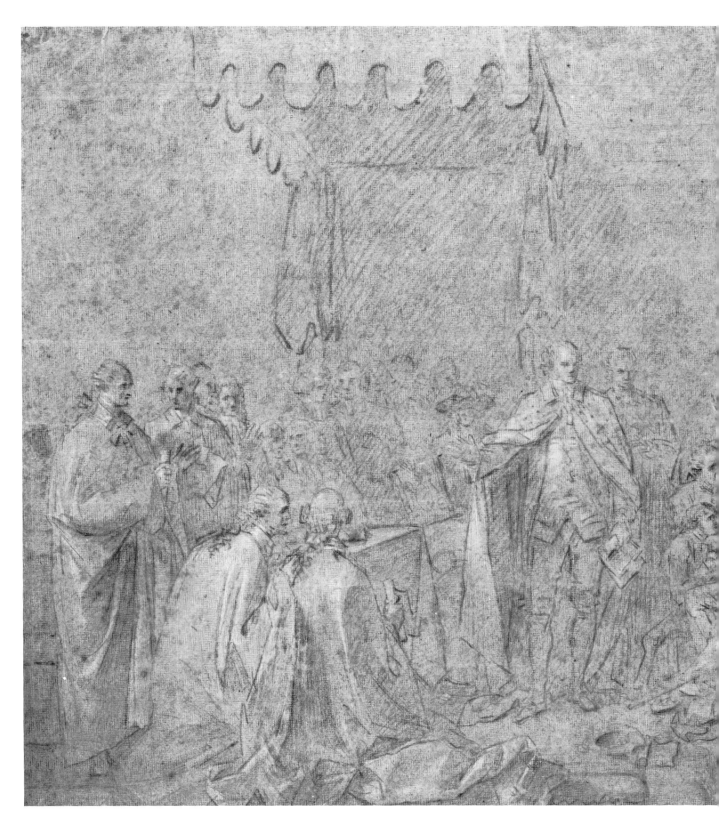

26

John Singleton Copley *1738–1815*
Study for The Death of the Earl of Chatham *1779*
Pencil and white chalk on paper, 12 3/16 " x 19 9/16 "
Andrew W. Mellon Purchase Fund and Avalon Fund

27

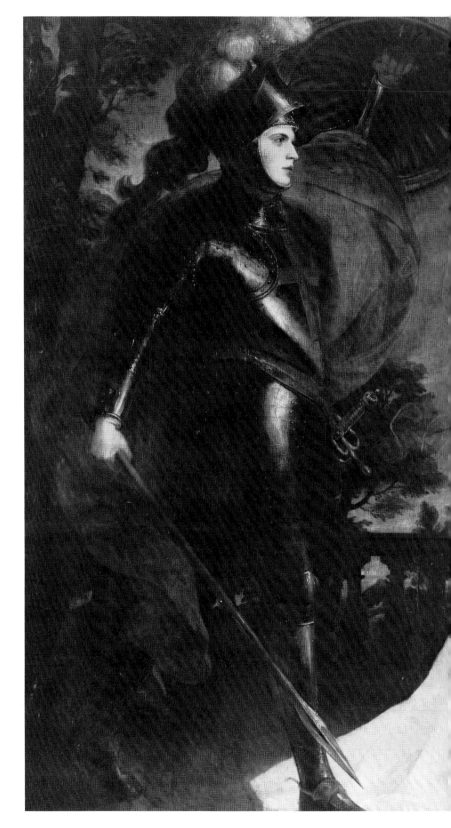

28

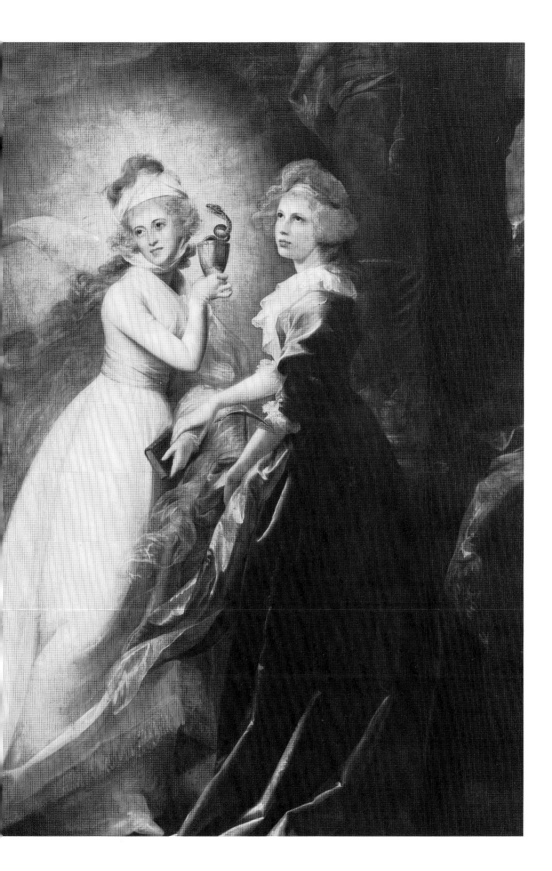

papers. Below him is his father-in-law, Richard Clarke, a prominent Tory merchant whose fortune was destroyed when his investment in tea went overboard during the famous Boston Tea Party of 1773. Clarke holds his youngest grandchild, Susanna, in his lap. Copley may have deliberately placed the baby in the arms of the family's senior member as an allegory of the ages of life; yet in spite of any intended symbolism, there is a marvelously human contrast between Richard Clarke's thoughtful expression and little Susanna trying to attract his attention with her rattle. Elizabeth, at six the eldest of Copley's children, stands in the center of the group. Her brother, John Junior, looks lovingly up into his mother's eyes. (That is a boy; in eighteenth-century custom, toddlers wore long dresses regardless of their sex.) Copley's wife, Susanna, hugs her son, while daughter Mary hugs her arm. Mary looks teasingly at the viewer from her comfortable position atop the sofa, while stern Elizabeth not only counters her sister's coyness but also acts as the fulcrum for the design. A great V or check-mark triangle relates the heads of the figures on either side of Elizabeth. One line ascends through her grandfather to stop on Copley; the other angle ties into her mother by passing through John Junior's face. And, by positioning the babies high up in a lap and on a sofa, Copley raised their tiny heads to a level with their older, standing siblings and leaning mother.

For all of its complex relationships between figures, *The Copley Family* shows that the artist had lost none of his gift for texture. Note particularly the translucency of Elizabeth's sheer overskirt, revealing the pink chemise below. And Copley delighted in reiterating this tour de force of fabrics with Elizabeth's identically dressed doll, lying in the corner. Virtually the scale of life, the picture could not help but attract newspaper notice when sent to the Royal Academy exhibition of 1777: "Mr. Copley, from the size of his family piece, is likely to be as much the subject of observation in the rooms as any artist who has exhibited." The painting hung in the Copleys' drawing room for two generations. John Junior, who grew up to become Lord Chancellor of England, akin to the Chief Justice of our Supreme Court, treasured it all his life.

The talent at composing such a "conversation piece" group portrait was to stand Copley in good stead with his first major history painting in England, *Watson and the Shark* (see page 46). The unfortunate soul in the water, Brook Watson, had been orphaned at six and sent by relatives to Boston (where he may or may not have known the young John Singleton Copley). Eventually he entered the British merchant marine. In 1749, when fourteen years old, Watson decided to go for a swim in the harbor at Havana, Cuba, where his ship was docked. A shark grazed his leg, raising blood, which spurred the ravenous fish on to a second attack. That encounter left Watson with no right leg below his knee, as one might guess from the blood staining the water. Just as the monster approached a third time to finish his meal, Watson's shipmates arrived to rescue him. This is the climactic moment Copley chose to depict.

The artist staged the scene carefully to keep the viewer in suspense: will Watson be saved or not? A West Indian has thrown a life line, but Watson has missed the rope. An old tar holds the shirts of young sailors who reach to pull the victim from the water, but it is

obvious they won't be in time. Everything depends upon the man standing in the prow of the craft, ready to harpoon the shark with a boat hook. That he will succeed is indicated by a complex Christian allegory hidden underneath this scene from daily life. The harpooner takes the exact stance of the Archangel Michael driving Lucifer from heaven in a religious painting by Raphael, the Italian Renaissance genius. The men reaching over the side of the boat are borrowed from another of Raphael's designs, showing the miraculous draft of fishes. And Brook Watson himself derives from still a third composition by Raphael. Turned flat on his back in the water, Watson has the pose of the helpless child, foaming at the mouth, who stands in Raphael's last great altarpiece as Christ drives the unclean spirit from his body. Copley so cleverly concealed these quotations from Raphael that scholars have failed to notice them all. Yet they interact to reinforce the contemporary drama: casting out demons, hauling in the Lord's bounty, and healing the sick or injured.

Copley's design, a dynamic, lopsided triangle encasing the rescuers and peaking at the boat hook, conveys the thrill of the moment, as does the placement of the shark and its victim in the immediate foreground, right in front of the viewer's eyes. The artist also presented the spectator with a variety of figures with whom to empathize; the men in the boat register every conceivable reaction to the scene, from heroism to pity to horror to cowardice. Needless to say, *Watson and the Shark* generated a sensation at the Royal Academy in 1778. A London critic wrote, "We heartily congratulate our Countrymen on a Genius, who bids fair to rival the great Masters of the Ancient Italian Schools."

Copley made a handsome profit on sales of engravings after the picture, and he painted replicas of it, too. The question mark that rears up is why Brook Watson, who kept this original, would have wanted such a grisly reminder of the incident that had got him a peg leg. Watson survived to become a prosperous London businessman, and since he and Copley moved in the same social circles, no one is sure who first suggested the idea of this painting. The gory tale was certainly a risky undertaking for a court artist, and depictions of unusual events in the lives of ordinary individuals had not been attempted before—especially on a gigantic scale. But, Brook Watson may have had two motives in mind. First, the painting's original frame bears a dedicatory plaque stating that it was bequeathed by Watson to a London orphanage in 1807. The inscription mentions his high offices, including those of Lord Mayor and Baronet, and ends with this moral:

> Thus shewing that a high sense of integrity and rectitude with a firm reliance on an over ruling Providence united to activity and exertion are the sources of public and private virtue and the road to honours and respect.

Therefore, the painting's theme is that through hard work anyone can become rich and famous. What more appropriate a message to leave orphans? Especially when Watson had been an orphan himself, and a handicapped one at that.

The second explanation for this bizarre picture lies in a careful reading of that dedication. Watson's various elected and appointed offices came long *after* Copley painted this scene. Could it be that

the wealthy merchant, anxious to enter politics, decided to make everyone in England aware that there was a peg-legged candidate around? If so, Watson's scheme worked. All Britain soon knew the name of the young American artist and the physical disability of the aspiring politician. To Copley, the painting through its brilliance assured his reputation; to Watson, the picture's fame amounted to free campaign publicity.

The planning of a composition as complex as this scene is almost beyond the belief of anyone who hasn't attempted to design a picture. Copley, who'd never been to Havana, used maps and viewed paintings of Cuba to construct a realistic background. But that's simple compared to the integration of figures, the repetition of shapes, and the harmonization of colors. Soon after arriving in London from Boston, Copley had written his family, "The Students had a naked model from which they were Drawing." If life classes weren't enough of a discovery for the colonial painter, he soon got an even bigger shock: preliminary drawings were standard practice for blocking out a design. The naïve colonial noted, "The sketches are made from life, and not only from figures singly, but often by groups." How he'd distributed the seven members of his family in the "conversation piece" and constructed the elaborate pictorial scaffolding for the rescue scene may better be understood by looking at his progress on another complicated work, *The Death of the Earl of Chatham.*

On April 7, 1778, the Earl of Chatham, William Pitt, rose to speak in the House of Lords. In the midst of advocating a stern policy toward the American rebels, Pitt fell senseless. Although he didn't die for another month, it was just the same as having been mortally stricken in the House of Lords. Benjamin West began to record the scene, as noted by a contemporary patron: "It has none but the principal person's present; Copley's almost the whole peerage, of whom seldom so many are there at once. . . . West would not finish it not to interfere with his friend Copley." Copley's pencil and chalk study for *The Death of the Earl of Chatham* positions the Duke of Richmond, Pitt's archrival and an advocate for American freedom, squarely in the middle of the design. Pitt's own slumped body, accompanied by a crutch and gouty stockings, virtually disappears in the crowd. Copley reworked the grouping in the National Gallery's preliminary study in oils on canvas (see page 47). Now, the view of the room and dais differs, and the assembled lords stand back to open up a central funnel of space that leads toward the stricken William Pitt. Yet this is still far from the final painting. It is a sketch in *grisaille,* or "grays," made to determine the best angle of light and shadow before considering any color scheme. So lively is Copley's brushwork—his highlights in pure white against the gray and tan tonality, and his outlining accents in jet black—that one doesn't miss the colors. Look carefully and you'll see a gridwork of vertical and horizontal lines drawn over the *grisaille.* These squares form a proportional network for transferring and enlarging the design onto another canvas. The scheme was "squared" onto a huge canvas, which now belongs to the Tate Gallery in London. That final picture in sparkling color marked the beginning of the end for Copley's relationship with Benjamin West and the other members of the Royal Academy. Knowing the interest generated by Pitt's stroke, Copley did not submit the completed picture to the Royal

Academy exhibition in 1781. Instead, he showed it in a competing exhibition of his own. Admission was charged, and brochures identifying all the noblemen were distributed. Within six weeks, twenty-thousand visitors had paid to see it. And the Royal Academy lost money, being nearly deserted because of Copley's rivalry. Although he remained a member, Copley wasn't ever trusted again, after having staged his own "raree-show."

Copley was also adept at "fancy pictures," or costume pieces from literature and history. *The Red Cross Knight,* for instance, derives from Edmund Spenser's *Faerie Queene,* a sixteenth-century poem celebrating the Christian virtues. Wearing "on his brest a bloudie Crosse," the hero, an allegory of the soul, meets Faith and Hope. Gowned in purest white, Faith holds a chalice with a vicious serpent which she need not fear. Hope, garbed in heavenly blue, carries a small anchor, recalling the passage in Hebrews which names hope "as an anchor of the soul." The glint of the knight's armor, the fabrics of the women's robes, and the glorious sunlight in the landscape are appropriately airy for the fanciful theme. The models, incidentally, are three of Copley's grown children. Having inherited their mother's good looks, they often posed for their father. The Red Cross Knight is John Junior; Faith is Elizabeth; and Hope, Mary. It's fun to compare them to their younger selves in *The Copley Family.*

Colonel Fitch and His Sisters was probably commissioned by the sitters' uncle back in Boston. The Fitches were close friends of the Copleys in London, having come from a similar background; their father was a Loyalist merchant who'd been forced to flee the colonies at the outbreak of the Revolution. A large, colorful "conversation piece," the work almost goes beyond Grand Manner portraiture in its classical urn, wild grove, and fiery sunset. But it begins to betray a lessening of Copley's powers. As he grew older, Copley fretted more and more on each picture. This one took at last six years of piecemeal attention between other jobs. Copley hasn't lost any of his ability as a colorist or in imitating textures; they're superb. The anatomy, however, is weak, especially in the outstretched—and elongated—arm of the sister in white. Also, the proportions are off. The horse, needed to balance the white and black dresses of the women, has been enlarged in scale, as any astute painter would do. But Copley overdid it. Although a magnificent steed, the horse is so large it belongs in a different space-time continuum from the people.

When dealing with less complicated subjects, the aged Copley proved his remarkable powers of observation. *Baron Graham,* depicting a British judge, is absolutely breathtaking in its simulation of the soft fur lining of the judicial robes. Indeed, the straightforward candor in rendering Sir Robert Graham's fleshy cheeks and double chin seem to revert to the integrity of Copley's early portraits in colonial Boston. Copley included this among his entries to the Royal Academy show of 1804, and a critic observed, "Mr. Copley's contribution to the general display reflects honour on his industry and talents." Not everyone was as kind. Copley's late history paintings were ridiculed, and he lost his standing at court. When Samuel Morse, a West student who was later to invent the telegraph, visited Copley in 1811, he wrote a dismal report. "His powers of mind have almost entirely left him; his late paintings are

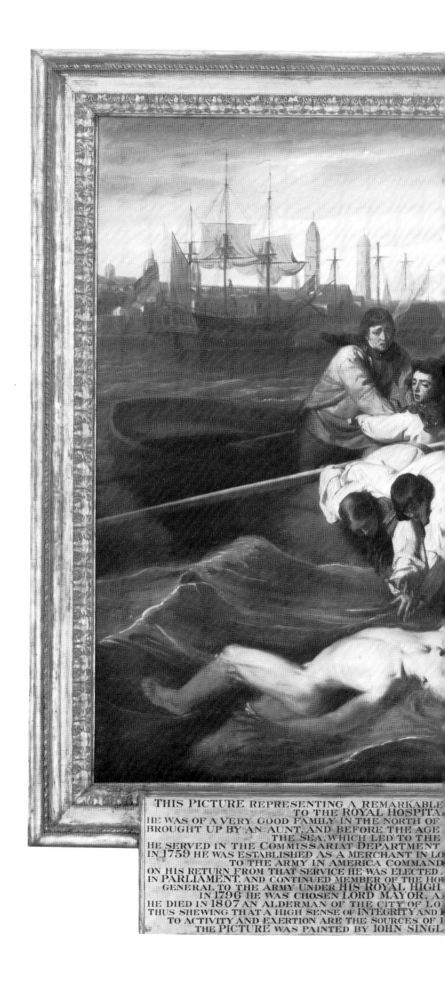

THIS PICTURE REPRESENTING A REMARKABLE
TO THE ROYAL HOSPITA
HE WAS OF A VERY GOOD FAMILY IN THE NORTH OF
BROUGHT UP BY AN AUNT, AND BEFORE THE AGE
THE SEA, WHICH LED TO THE
HE SERVED IN THE COMMISSARIAT DEPARTMENT
IN 1759 HE WAS ESTABLISHED AS A MERCHANT IN LO
TO THE ARMY IN AMERICA COMMAND
ON HIS RETURN FROM THAT SERVICE HE WAS ELECTED
IN PARLIAMENT, AND CONTINUED MEMBER OF THE HOU
GENERAL TO THE ARMY UNDER HIS ROYAL HIGH
IN 1796 HE WAS CHOSEN LORD MAYOR, A
HE DIED IN 1807 AN ALDERMAN OF THE CITY OF LO
THUS SHEWING THAT A HIGH SENSE OF INTEGRITY AND
TO ACTIVITY AND EXERTION ARE THE SOURCES OF
THE PICTURE WAS PAINTED BY IOHN SINGL

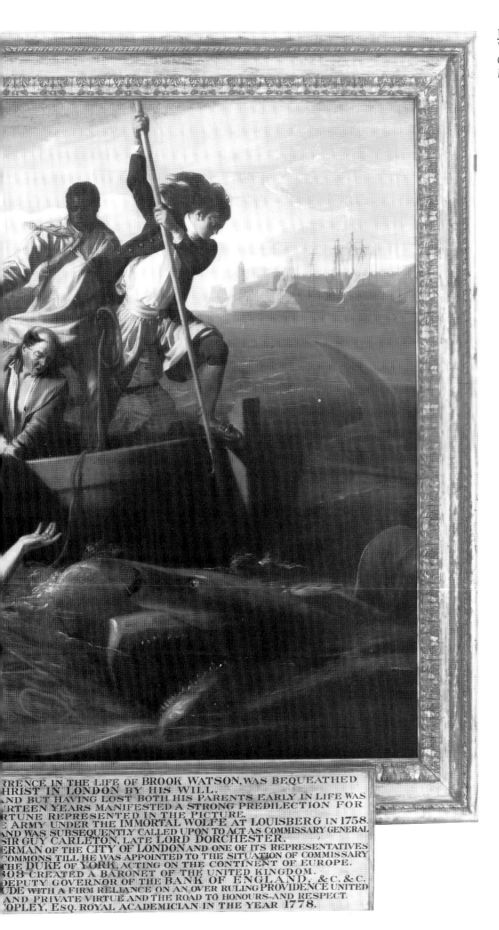

John Singleton Copley *1738–1815*
Watson and the Shark *1778*
Canvas, 71 ¾ " x 90 ½ "
Ferdinand Lammot Belin Fund

RRENCE IN THE LIFE OF BROOK WATSON, WAS BEQUEATHED
HRIST IN LONDON BY HIS WILL.
ND BUT HAVING LOST BOTH HIS PARENTS EARLY IN LIFE WAS
RTEEN YEARS MANIFESTED A STRONG PREDILECTION FOR
RTUNE REPRESENTED IN THE PICTURE.
E ARMY UNDER THE IMMORTAL WOLFE AT LOUISBERG IN 1758.
ND WAS SUBSEQUENTLY CALLED UPON TO ACT AS COMMISSARY GENERAL
IR GUY CARLETON, LATE LORD DORCHESTER.
ERMAN OF THE CITY OF LONDON AND ONE OF ITS REPRESENTATIVES
OMMONS TILL HE WAS APPOINTED TO THE SITUATION OF COMMISSARY
HE DUKE OF YORK, ACTING ON THE CONTINENT OF EUROPE.
08 CREATED A BARONET OF THE UNITED KINGDOM.
EPUTY GOVERNOR OF THE BANK OF ENGLAND, &C. &C.
DE WITH A FIRM RELIANCE ON AN OVER RULING PROVIDENCE UNITED
AND PRIVATE VIRTUE AND THE ROAD TO HONOURS AND RESPECT.
OPLEY, ESQ. ROYAL ACADEMICIAN IN THE YEAR 1778.

John Singleton Copley *1738–1815*
Colonel Fitch and His Sisters *1800–1801*
Canvas, 101 ½ " x 134"
Gift of Eleanor Lothrop, Gordon Abbott, and Katharine A. Batchelder

34

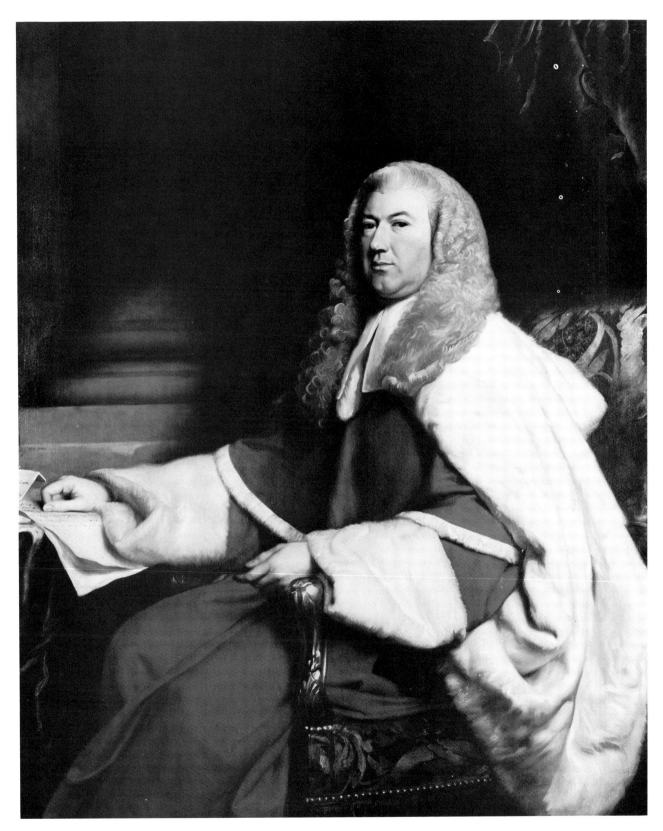

John Singleton Copley *1738–1815*
Baron Graham *1804*
Canvas, 57¼″ x 46⅞″
Gift of Mrs. Gordon Dexter

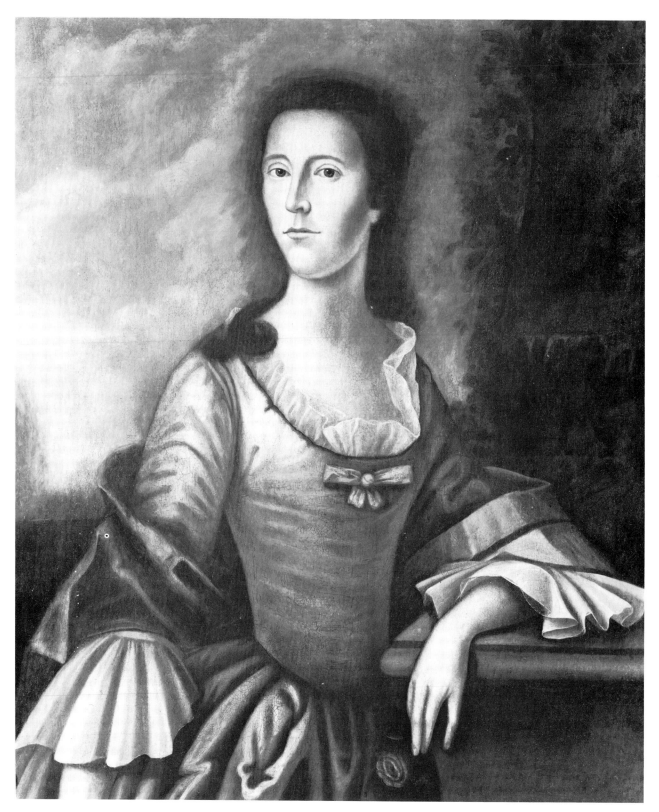

Benjamin West *1738–1820*
Mrs. Samuel Boude *1755/1756*
Canvas, 35 ⅝ " x 30 ⅛ "
Gift of Edgar William and Bernice Chrysler Garbisch

miserable. It is really a lamentable thing that a man should outlive his faculties." It has become fashionable to regret that Copley left the colonies and tempered his sincerity with European sophistication. This appraisal is neither fair nor accurate. The contribution Copley made to world art doesn't depend upon the scrupulous attention to detail and factual accuracy in the single figures of his colonial likenesses. Rather, Copley revealed to Europe how such realism and emotional truth could generate an excitement and immediacy in profound historic and literary scenes.

BENJAMIN WEST

1738–1820

Being born within three months of each other in 1738, Benjamin West and John Singleton Copley were exact contemporaries, and both were eventually to dominate the field of history painting as court artists in London. But there the similarity ends. West's genius lay in the distribution of weighty forms in space, whereas Copley's strength was in textural simulations. West maintained his gentlemanly composure throughout vicious attacks on his presidency of the Royal Academy. Copley, however, who never achieved top official status, grew jealous and cranky with age. West, the son of a country tavern keeper, did not even see an illustrated Bible until long after he'd completed his first portrait; Copley, as stepson to a European artist, had early advantages which are made quite clear by the excellence of his colonial portraits. In summary, West continued to mature artistically through his long career, but Copley went downhill after his initial success in Europe.

Over the last two centuries, several children's books have been published about West's own childhood—partly because he earned fame while remaining modest (qualities appealing to parents who wish to moralize) and partly because of the fairytale aspect of his youth (qualities attractive to schoolchildren who wish to play hooky). The various tales about his early life center on his father's stagecoach inn outside Philadelphia. While babysitting for a niece, West drew her portrait in two colors—the red and black inks of his father's business ledgers; "at this period he had never seen an engraving or a picture, and was only in the seventh year of his age." Indians "taught him to prepare the red and yellow colours with which they painted their ornaments. To these his mother added blue, by giving him a piece of indigo, so that he was thus in possession of the three primary colours." When neighbors told him of camel's-hair paintbrushes, he was temporarily at a loss. There being "no camels in America, he could not think of any substitute, till he happened to cast his eyes on a black cat, the favourite of his father. . . . his depredations upon which were so frequently repeated, that his father observed the altered appearance of his favourite, and lamented it as the effect of disease. The artist, with suitable marks of contrition, informed him of the true cause." Substantiated by reliable sources, this story of confessing misuse of the family cat for paintbrushes recalls the totally fictitious tale of Washington owning up to chopping down the cherry tree.

When nine years of age, Benjamin West met his first true painter and saw his first real oil on canvas. William Williams, an itinerant English artist settled in nearby Philadelphia, upon being introduced to the child, showed him his own pictures, lent him theoretical books on art, and encouraged his family to promote his painting. West, who'd never read a book other than the Bible, was enthralled by the biographies of great artists and the hints of appropriate design: "Learn then from Greece, ye youths, Proportion's law; Informed by her, each just position draw." In speaking of Williams, West stated, "Had it not been for him I never should have become a painter."

By his mid-teens, Benjamin West was earning an income from likenesses. In 1755–1756, he worked in Lancaster, Pennsylvania, where he painted a distant relative, the wife of a doctor. *Mrs. Samuel Boude*, the pose and accessories of which were undoubtedly borrowed from a European print, reveals West's instinctive concern for volume. The face is carefully modeled as a solid ovoid, and the shading of the gown conveys a believable, if metallic, three-dimensionality. West was only seventeen or eighteen at this time, and his understanding of form and pattern are very evident in the crisp, angular folds of the fabric being played off against the smoothly rendered head and hands. It is instructive to compare this to a similarly early portrait by Copley, *Jane Browne* (see page 20). Copley displays a far better ability with textures and surfaces than West; yet West's composition is more ambitious than Copley's.

Mrs. Samuel Boude portrays the somewhat elongated, slanted eyes that John Wollaston, another English itinerant, introduced to Philadelphia. In local magazines, comparisons were beginning to be made between the young native son and the older Wollaston:

> *Nor let the muse forget thy name, Oh West.*
> *Loved youth with virtue as by nature blest!*
> *If such the radiance of thy early morn,*
> *What bright effulgence must the noon adorn?*
> *Hail sacred genius! may'st thou ever tread*
> *The pleasing paths your Wollaston had led.*

Philadelphia merchants, anxious to sponsor America's first hope for a professionally trained artist, raised a subscription fund to send West abroad to study art. His patrons' hopes were not in vain. West never returned to America, but, as the most influential teacher in the English-speaking world, he served his homeland well.

Almost immediately upon reaching Rome in July 1760, West caused a commotion. Cardinals of the church and aristocratic art collectors flocked to see this phenomenon—a painter-savage from the wilderness. A great throng accompanied him to the Vatican to witness his initial reaction to the papal museum's fabulous collection of Old Master paintings and classical antiquities. Upon seeing the highly revered ancient statue of the sun god, the *Apollo Belvedere*, West exclaimed, "My God! How like it is to a young Mohawk warrior!" Startled by this seemingly derogatory remark, they demanded an explanation. West compared the idealized physique of the marble statue to the real muscles of stalwart native Americans: "I have seen them often standing in that very attitude, and pursu-

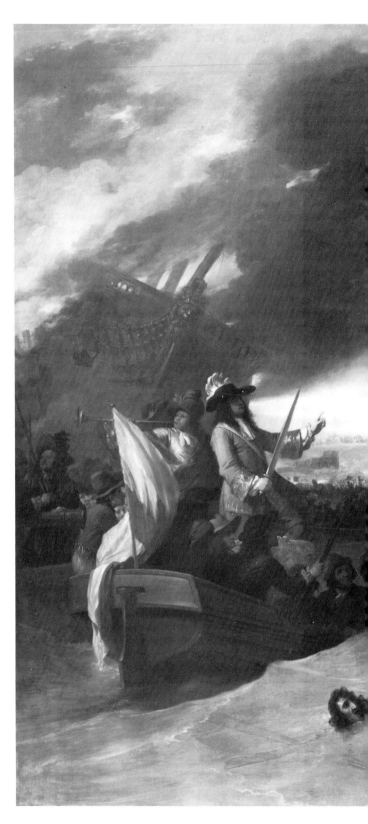

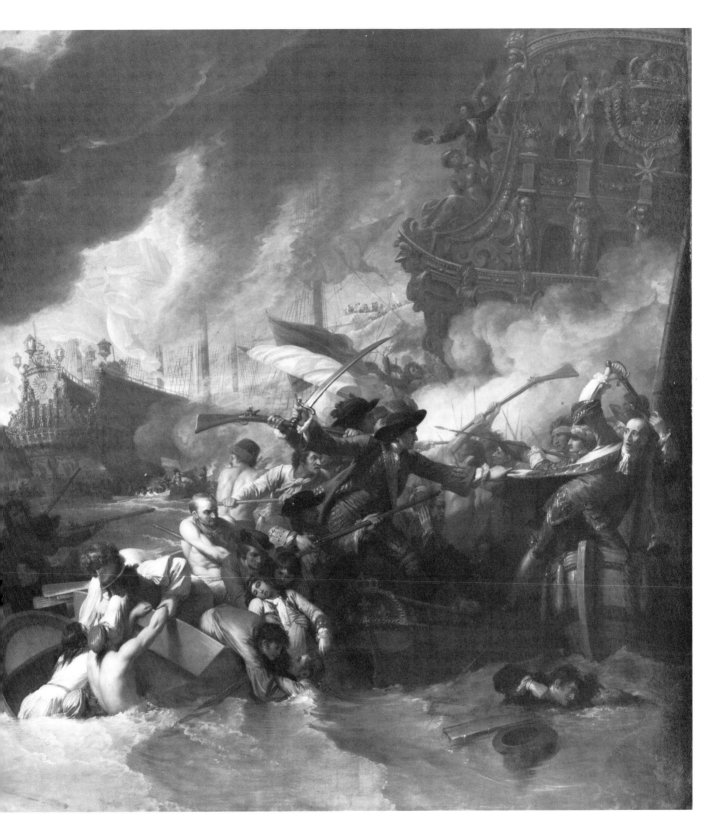

ing, with an intense eye, the arrow which they had just discharged from the bow." The astute observation of the similarity between a "noble savage" and the "glory that was Greece" won great admiration. West spent three years in Italy, studing the techniques of contemporary artists and copying the compositions of Old Masters. When he arrived in London in 1763, after traveling through France on the way, he had already achieved international fame.

The assurance with which Benjamin West confronts us from his *Self-Portrait* (see page 43) is not conceit but richly deserved satisfaction. When he depicted himself at his drawing board in London, West was only in his early thirties, yet this youth from a rural village in colonial Pennsylvania had become one of Great Britain's most admired painters. In 1768, he had been appointed a founding member of the Royal Academy and had achieved distinction with recreations of contemporary history. The humane and fresh pose—an artist pausing to glance at a visitor—conveys an initial impression of candor which masks the controlled design and conscious artifice. West deliberately treated the shapes of his body almost abstractly, causing natural anatomy to conform to geometric volumes. The arm, for instance, is contrived of two cylinders, and the facial structure has been smoothed into full, rounded surfaces. All the silhouettes and edges, like the flattened oval of the furred hat, consist of gentle arcs. To still the movement of these continuously flowing lines, West occasionally countered them, as in the queue and the shirt cuff that interrupt the long S-curve winding from the hat brim across the collar and into the coat sleeve. The serenity engendered by these swelling contours is augmented by the pervading violet tonality. All the hues—crimson upholstery, ashblue jacket, powdered hair, and rosy complexion—are dignified by a touch of cool, pale lavender.

Colonel Guy Johnson (see page 48) applies the narrative precepts of history painting to portraiture. The sitter, an Irish officer who served as British Superintendent of Indian Affairs in the American colonies, wears a complex mixture of clothing to communicate the dual nature of his position as ambassador to the Iroquoian Confederacy. Although he wears his military uniform—the traditional red coat—he has a wampum belt across his vest and an Indian blanket thrown over his shoulder, and he holds a beaded Mohawk cap and dons moccasins instead of boots. An Indian stands beside him, carrying and pointing to a peace pipe, while the colonel himself grasps a musket; the combination of peace pipe and musket conveys that harmony will be maintained at all costs, by force if necessary. Even the distant view expresses the theme of cooperation between Mohawk and British peoples: an Indian family gathers around a campfire, but their home is not a teepee—it's a regulation English military tent. The Indian has been identified as a Mohawk chief, Thayendanega, who changed his name to Joseph Brant after accompanying Johnson to England to serve as his aide and secretary. However, the facial features do not resemble known portraits of Thayendanega. West may have incorporated this figure as a symbol of all native Americans. In any case, the lighting clearly makes this a portrait of Colonel Johnson; his face glows with sunlight penetrating below the rocky cliff, while the standing Indian is buried in shadow. These hot reds and earth browns also magnificently capture the martial spirit of this work.

That West would accept a portrait commission from a Red Coat in London in 1776, the very year of the Revolution's start, would imply that he was a Tory. Nothing could be further from the truth. A notably civil man, West repeatedly urged American independence to George III and acted as the monarch's advisor on the rebels' outlook; all this while he served as a court painter! Both the king's and the artist's attitudes may be summed up by an incident that occurred at the palace, when a snobbish lord told West:

"His Majesty's troops in South Carolina have gained a splendid victory over the rebels, your countrymen. This, I suppose, cannot be very pleasant news to you, Mr. West."

"No, sir, that is not pleasant news to me, for I never can rejoice at the misfortunes of my countrymen."

The king, who'd overheard, said to West, "Sir, that answer does you honor," but snapped at the aristocrat, "Sir, let me tell *you* that, in my opinion, any man who is capable of rejoicing in the calamities of his country, can never make a good subject of any government."

West actually poked fun at his equivocal position with the English painters in the Royal Academy. He composed, and sang at Academy meetings, a comic variation on *Yankee Doodle*:

> From Philadelphia's broad-brimmed race
> Who vanity have undone,
> I took my easel on my back
> And crossed the seas to London!
>
> Yankee doodle, doodle do,
> Yankee double dandy,
> A perpendicular line is straight
> But beauty's line is bandy.

The reason for West's high situation at court lies not only with his tact but also with his innovations in painting. *The Battle of La Hogue* (see pages 2-3) masterfully presents a complex pictorial problem resolved into an easily comprehensible solution. Hundreds of individual figures occupy a canvas over seven feet long; yet the climax of this famous engagement clearly emerges, thanks to West's control of the design's focus. The massive forms of the principal protagonists fill the lower foreground; their distinct, brightly colored forms are silhouetted before a distant, hazy background. By merely eliminating any action in the middle depth, West threw the main elements into sharp relief against a landscape subdued by the pale color of the atmosphere.

The scene required not only a great deal of work on composition, but also research into history, because the Battle of La Hogue took place eighty-six years before West painted the canvas in 1778. The events that led up to the encounter were the exile of James II of England when he converted to Roman Catholicism, the French attempt to restore him to the British throne, and the Protestant Dutch joining the British forces against the Catholic French fleet. In 1692, the French invasion force took refuge from the British and Dutch ships near the Catholic fort at La Hogue, on France's Normandy coast. The combined Protestant fleets destroyed the French ships, gaining an imperative victory in England's history. West

An Eighteenth-Century Color Portfolio

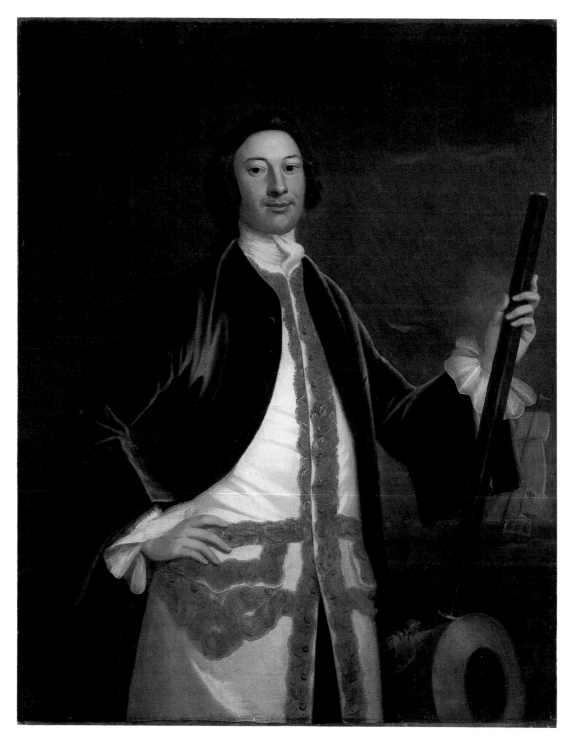

John Wollaston *active 1733–1767*
Lieutenant Archibald Kennedy (?) *c. 1750*
Canvas, 50⅛" x 40⅛"
Andrew W. Mellon Collection

John Singleton Copley *1738–1815*
Epes Sargent *c. 1760*
Canvas, 49⅞" x 40"
Gift of the Avalon Foundation

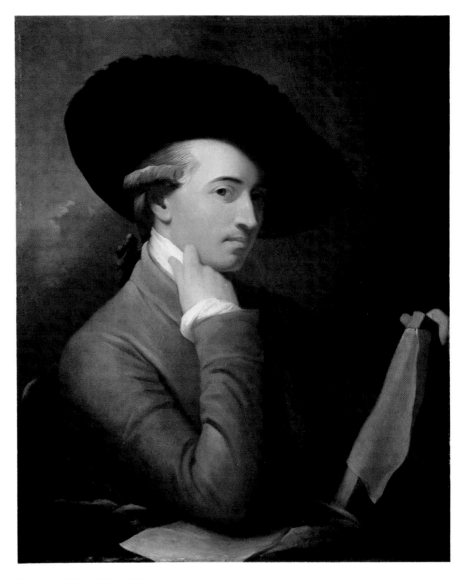

Benjamin West *1738–1820*
Self-Portrait c. 1770
Canvas, 30 ¼ " x 25 ⅜ "
Andrew W. Mellon Collection

John Singleton Copley *1738–1815*
The Copley Family *1776–1777*
Canvas, 72 ½ " x 90 ⅜ "
Andrew W. Mellon Fund

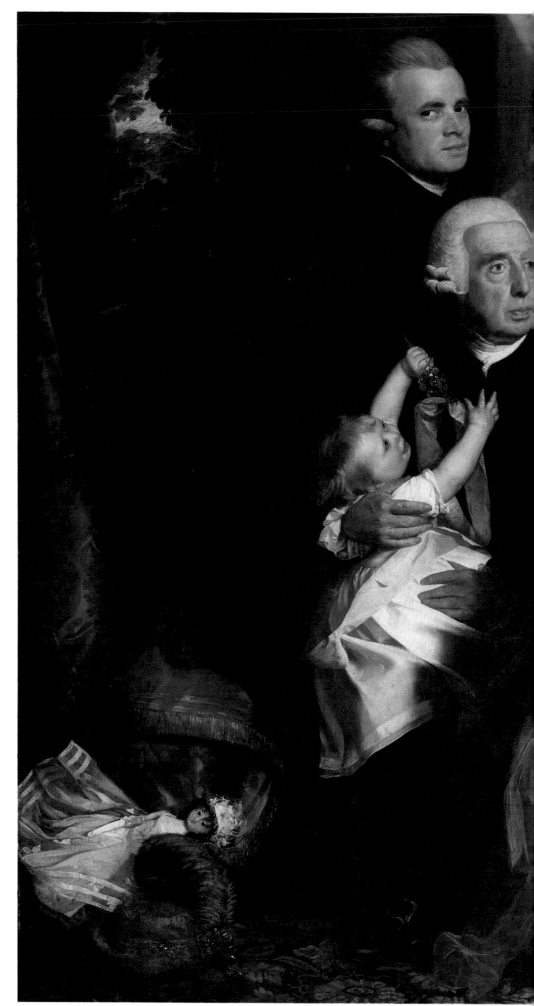

44

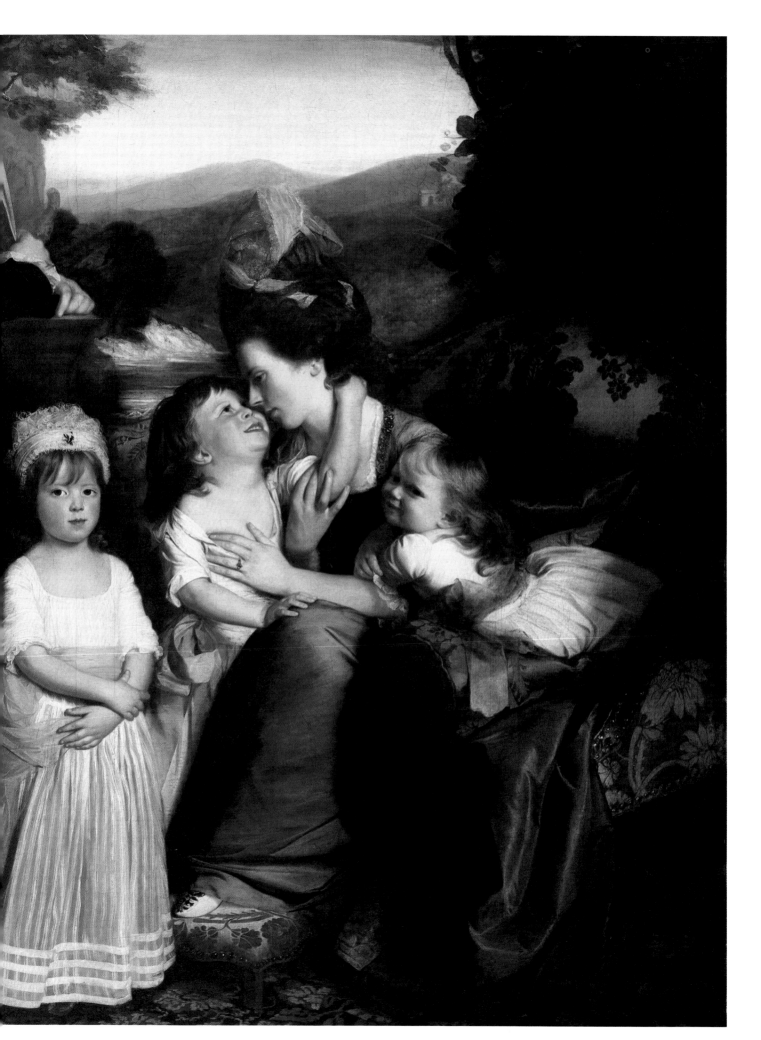

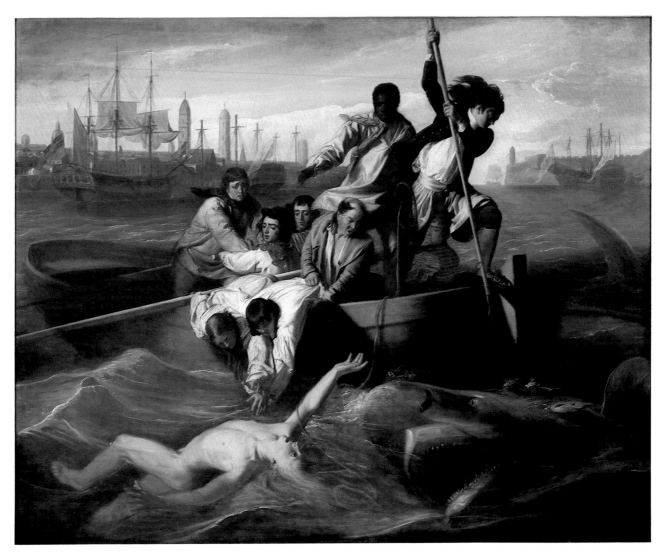

John Singleton Copley *1738–1815*
Watson and the Shark *1778*
Canvas, 71 ¾ " x 90 ½ "
Ferdinand Lammot Belin Fund

John Singleton Copley *1738–1815*
The Death of the Earl of Chatham *1779*
Canvas, 20¾" x 25⅜"
Gift of Mrs. Gordon Dexter

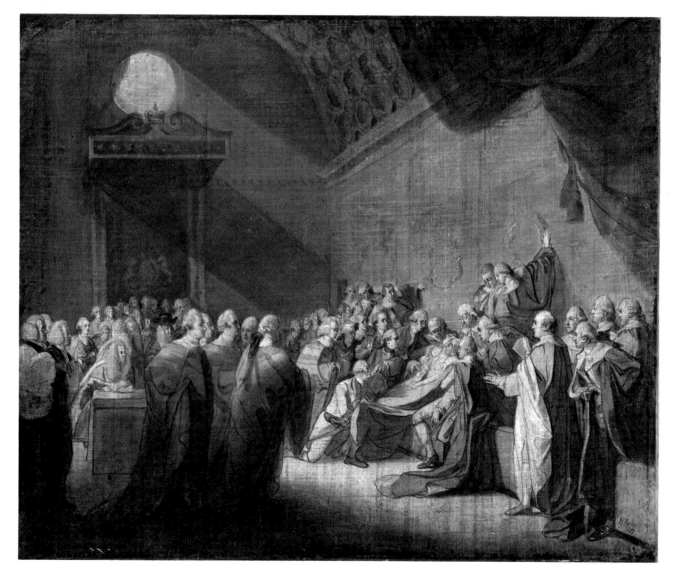

47

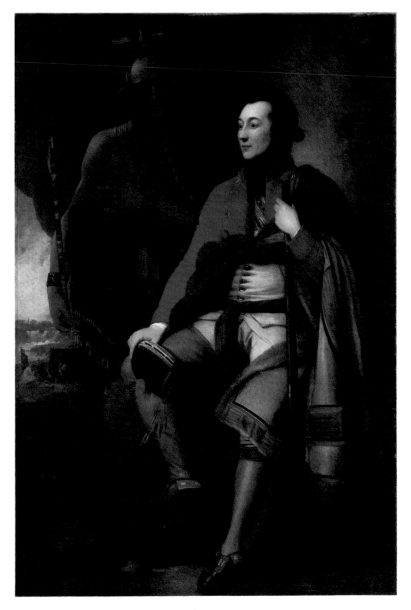

Benjamin West *1738–1820*
Colonel Guy Johnson *1776*
Canvas, 79¾" x 54½"
Andrew W. Mellon Collection

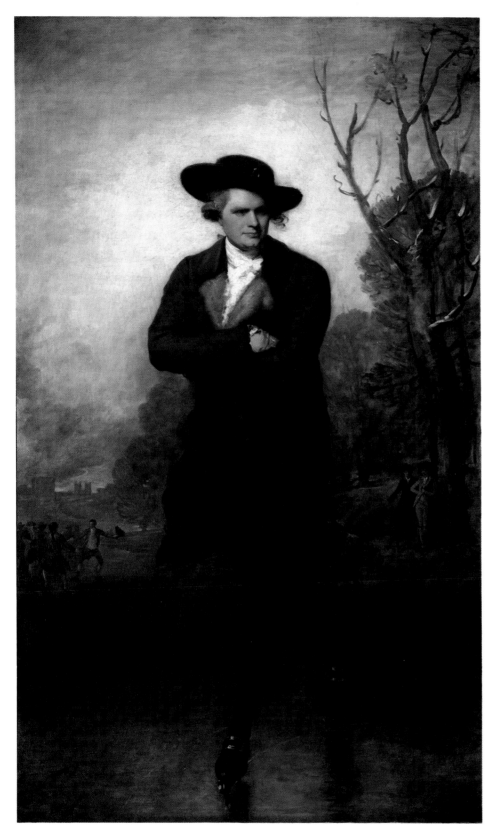

49

Gilbert Stuart *1755–1828*
The Skater (Portrait of William Grant) *1782*
Canvas, 96 ⅝ " x 58 ⅛ "
Andrew W. Mellon Collection

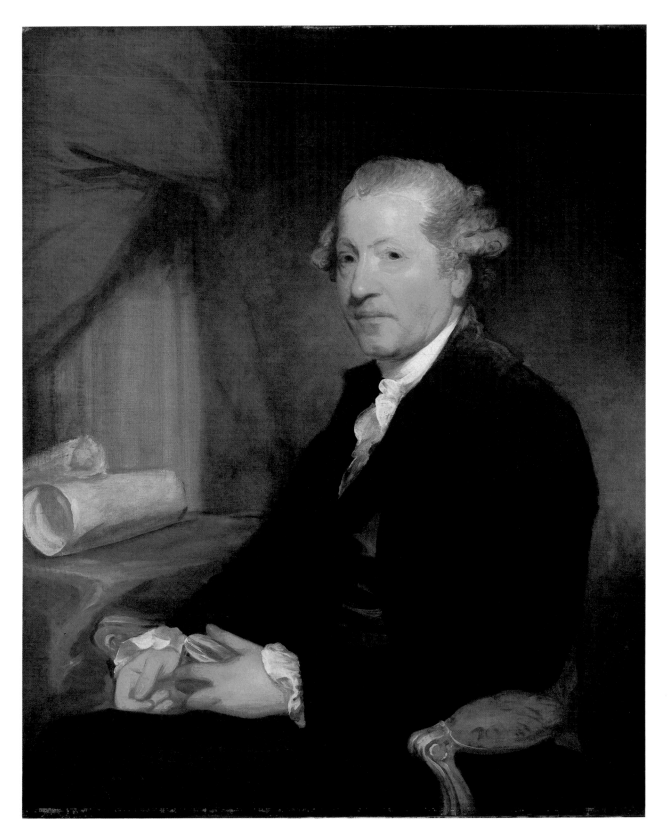

Gilbert Stuart *1755–1828*
Sir Joshua Reynolds *1784*
Canvas, 36″ x 30″
Andrew W. Mellon Collection

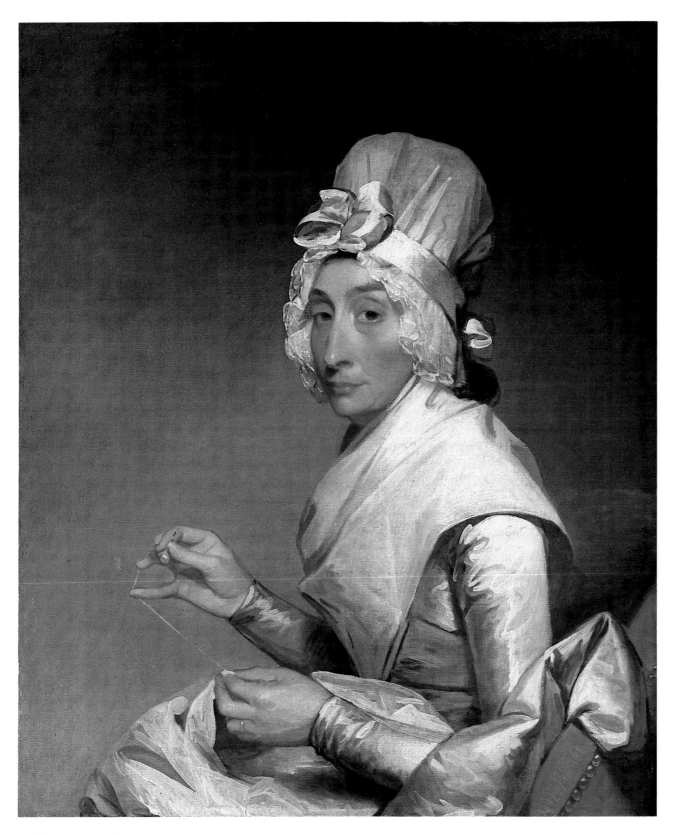

Gilbert Stuart *1755–1828*
Mrs. Richard Yates *1793/1794*
Canvas, 30¼″ x 25″
Andrew W. Mellon Collection

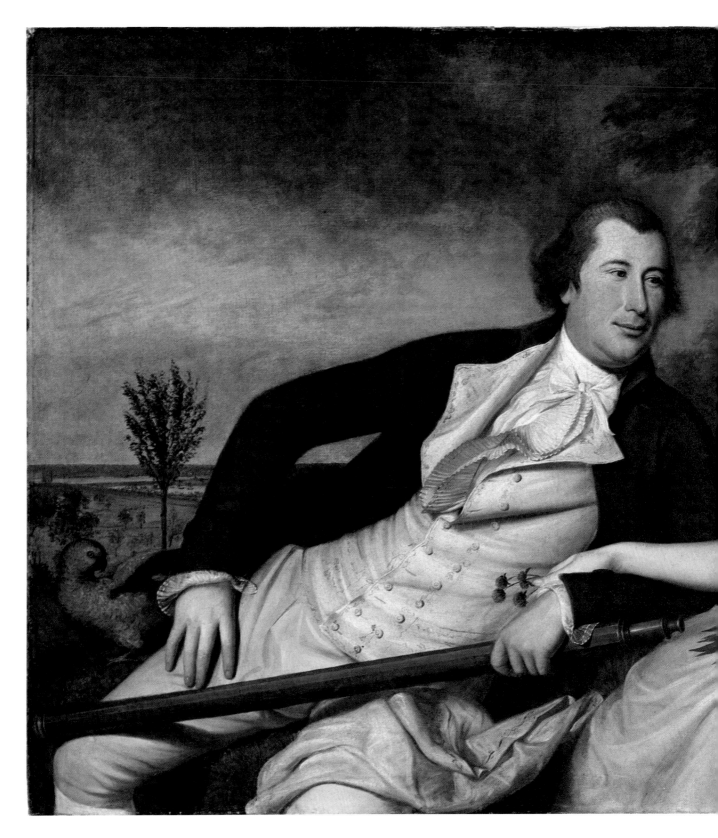

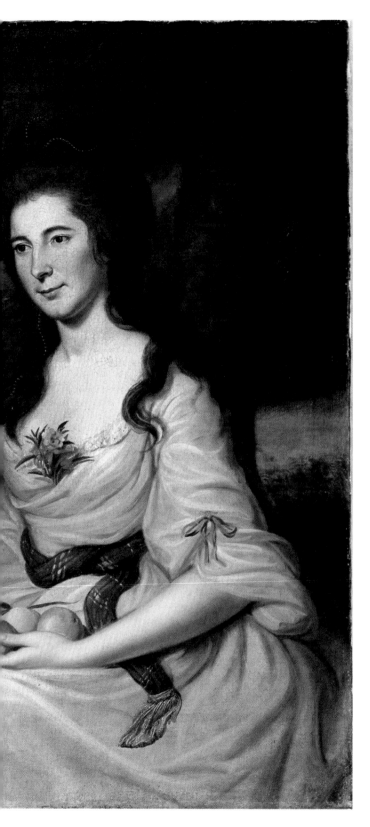

Charles Willson Peale *1741–1827*
Benjamin and Eleanor Ridgely Laming *1788*
Canvas, 42" x 60¼"
Gift of Morris Schapiro

53

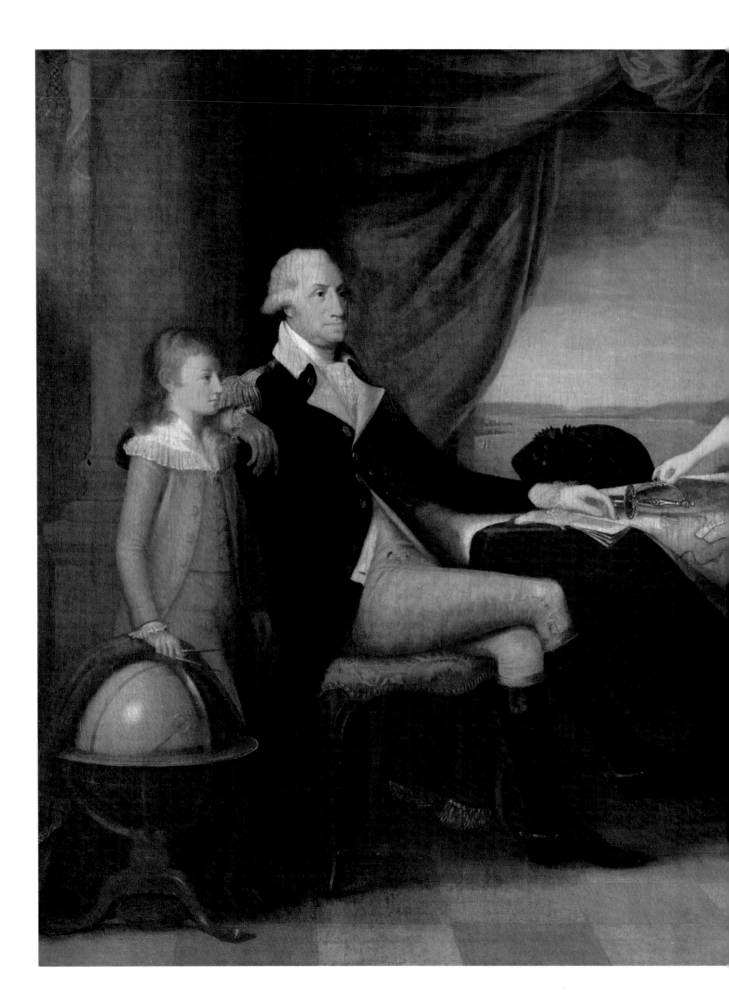

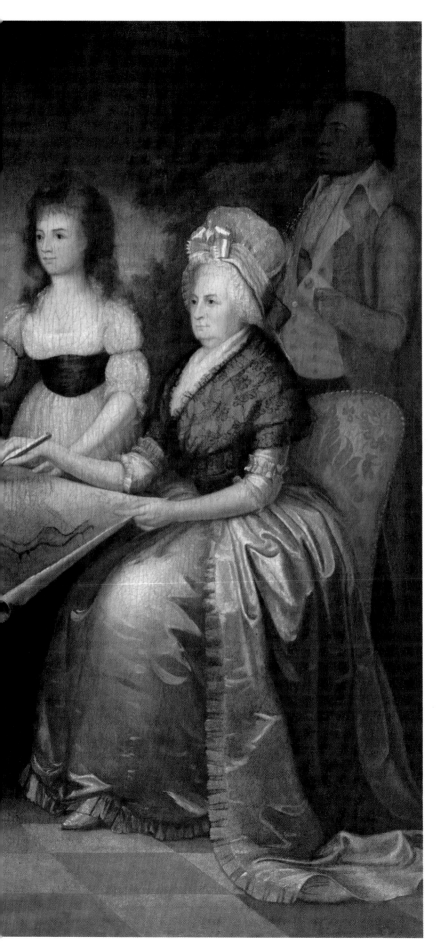

Gilbert Stuart *1755–1828*
George Washington [Vaughan Portrait] *1795*
Canvas, 29" x 23¾"
Andrew W. Mellon Collection

Edward Savage *1761–1817*
The Washington Family *1796*
Canvas, 84⅜" x 111⅞"
Andrew W. Mellon Collection

John Trumbull *1756–1843*
Patrick Tracy *1784–1786*
Canvas, 91½" x 52⅝"
Gift of Patrick T. Jackson

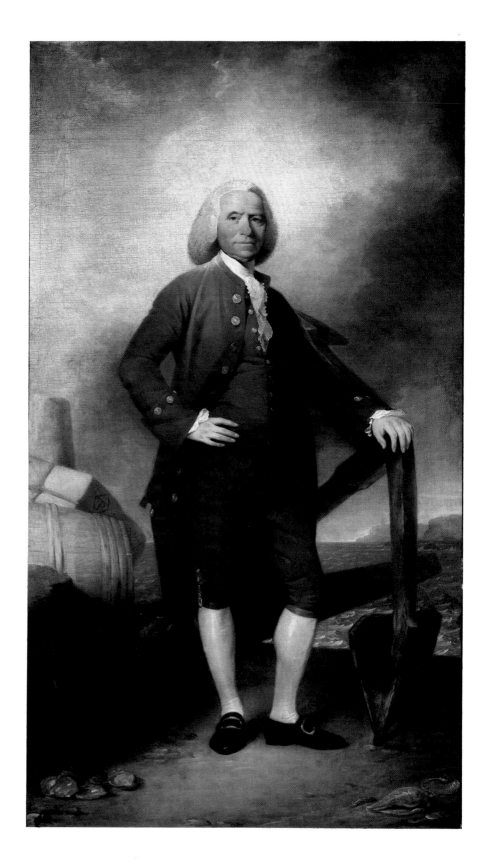

studied the costumes, weapons, and ships of that time by reading books and inspecting the trophies in British museums. But he'd never witnessed a naval battle. To guarantee the accuracy of this scene, he was privileged to watch while the English fleet went on maneuvers just for him. Firing blank shots and burning tar barrels aboard decks, the Royal Navy outdid itself. Sketching these faked effects of war, West was able to incorporate into the final picture such realistic details as the smoke rings belching from the cannon.

But the rest of the painting is pure propaganda, as is true with most military art. At the left, sword drawn, stands Vice-Admiral George Rooke, exhorting his men to victory. It is highly unlikely that such a key strategist would be in the thick of battle. Instead of showing Rooke's supervisory capacity with a tiny figure overseeing the fleet from a distance, West placed the admiral in the forefront as a symbol of heroism. Beached against the cliffs in the central background, the flagship of the French navy bears the radiant sun's face of Louis XIV on its stern. This is another piece of artistic license. The *Royal Sun* had sunk in an engagement a few days before the battle; West "refloated" it only to set it afire as a convenient method to prove that the French were losing. At the far right, a good Dutch sailor raises his sword to threaten a cowardly French officer, who cringes against a mast and becomes an object of ridicule, having lost his wig. The central group, seen in the detail at the chapter's beginning, demonstrates the charity of the English and Dutch, who rescue their enemy. A note of pathos is introduced by the French cabin boy, identifiable by his blue-and-white uniform, who has drowned. The bare-chested older oarsman was posed for by West's first teacher, William Williams. Having returned to England and fallen on hard times, Williams was befriended by his protégé, who employed him at odd tasks to keep him from poverty. In all, *The Battle of La Hogue* magnificently integrates reality and fiction to create an energetic, impassioned image of war.

This portrayal of British victory was well received at the Royal Academy's exhibition in 1780. Later, John Trumbull learned the rudiments of history painting by making a copy of this composition for West. What is most unusual, indeed almost unprecedented, is the depiction of events in contemporary guise. Academicians such as Sir Joshua Reynolds always aggrandized important occasions, regardless of where and when they occurred, by dressing them in the honored garb of ancient Greece and Rome! In answering Reynolds' admonitions about trying such a daring idea as to convey history plainly rather than allegorically, West had earlier stated, "The same truth that guides the pen of the historian should govern the pencil of the artist. . . . I want to mark the date, the place, and the parties engaged in the event; and if I am not able to dispose of the circumstances in a picturesque manner, no academical distribution of Greek or Roman costume will enable to do justice to the subject."

After the death of Sir Joshua Reynolds, Benjamin West was elected second president of the Royal Academy. From March 24, 1792, until his death on March 11, 1820, West directed the most prestigious taste-setting body in the English-speaking world. Once, for a single term, internal squabbles ousted West, but the Academy nearly collapsed without his guiding hand. So, year after year, the contrite academicians kept electing the quiet, unassuming Quaker from Pennsylvania as their leader. West's purity of reputation and

his diplomacy in dealing with others are indicated by his friendship with William Beckford, one of the richest men in England but a social outcast. Disowned by his family for his relationships with stable boys, Beckford was shunned by everyone. Only West, secure in his own happy marriage, would even bother to acknowledge the eccentric's existence. Beckford used his money to build a retreat, a fabulous recreation of a medieval castle termed Fonthill Abbey, and West had a hand in the decorations. *Mrs. William Beckford*, representing the patron's mother, formed part of West's contribution to this sham castle. Since Maria Beckford died in 1798 in her mid-seventies, West probably worked up this youthful image from earlier portraits of her. To match the grandiosity of the Fonthill Abbey setting, West piled ornament upon ornament. She sits before the ancestral home where her son had grown up, surrounded by lavish bouquets, swaths of brocade, and a guitar, and she holds an elaborately tooled book.

When West died at age eighty-one, Sir Thomas Lawrence, then England's leading young society portraitist and West's successor as president of the Royal Academy, mourned the loss of "the most profound judge of art and one of its ablest professors that Europe has had for centuries, and a humane kind-hearted man." West's remains were interred with royal honors in St. Paul's Cathedral. His paintings lived after him, and so did his influence as the proverbial "Father of American Art." Among the colonial painters who studied and lived in his Covent Garden and Windsor Castle residences had been Gilbert Stuart, Mather Brown, Matthew Pratt, Ralph Earl, John Trumbull, and Charles Willson Peale. Pupils of the next generation included Peale's son Rembrandt, Thomas Sully, and the painters-turned-inventors Samuel F. B. Morse and Robert Fulton. In addition to teaching, West often assisted young Americans who were not strictly his protégés, such as John Singleton Copley. To advise students whose inclinations were so diverse and so often at odds with his own theories, Benjamin West exercised his considerable perception as well as his noteworthy charm and civility.

MATTHEW PRATT

1734–1805

The earliest pupil of Benjamin West, Matthew Pratt arrived in London from Philadelphia in July 1764. The ostensible reason for his journey was to accompany his cousin, who was West's fiancée. "In a few weeks after our arrival, I had the pleasure of officiating, as father in the marriage ceremony." Pratt, following the wedding, remained in London. Although four years West's senior, Pratt knew that his own artistry could be expanded by studying under the younger man, whose growing fame had already reached the New World. Pratt moved into the Wests' home, which he described as "a very elegant house, completely fitted up, to accommodate a very large family." And, West "rendered me every good and kind office he could bestow on me, as if I was his father, friend and brother."

One of Pratt's student tasks was to copy an Old Master composition from West's own replica made previously in Italy. The *Madonna of Saint Jerome* depicts Mary Magdalene caressing Jesus' leg while Jerome, attended by the lion that befriended him in the wilderness, looks on. Correggio, a leading genius of the Italian Renaissance, painted the original in Parma in 1523. Because of its complex poses, intricate composition, and lyric colors, Correggio's design had been much admired. Note, for instance, how all the heads line up on a diagonal axis from Jerome through the angel to Mary, Jesus, the Magdalene, and a small cherub. The rigorous examination necessary to imitate each and every one of Correggio's brush strokes had allowed West to discover some of the tricks of the trade. Now, West hoped that Pratt would similarly learn by copying his copy. Pratt spent two and a half years in West's household and then set himself up as a portraitist in Bristol for another year and a half. He had become such a competent studio assistant that British artists often had difficulty telling his work from West's.

Pratt returned to America in 1768, working in New York and his native Philadelphia. On March 4, 1773, *The Virginia Gazette* advertised an art show in the King's Arms Tavern at Williamsburg. "Mr. Pratt, Portrait Painter, Lately from England and Ireland ...Has brought with him to Williamsburg a small but very neat Collection of Paintings... among which are, first, a very good Copy of Correggio's St. Jerome, esteemed to be one of the best Pictures in Italy." This undoubtedly refers to the National Gallery's copy after West's version. Pratt supported his family well enough, but as Peale, Trumbull, and Stuart returned to the United States, his style began to appear more and more old-fashioned. Charles Willson Peale may have summed up Pratt's business problems when he called him "a mild and friendly man." The competition for clients in early federal America was cutthroat, and Pratt may have been too nice for his own good.

MATHER BROWN

1761–1831

The teenaged Gilbert Stuart gave Mather Brown his first lessons in art in Boston. In 1781, Brown arrived in London "with a View of perfecting himself in the Art of Miniature painting." He studied "gratis" under Benjamin West, whose "Miracles of Historic Art" soon persuaded Brown to attempt more grandiose themes, too. The going was rough, particularly after Stuart returned to London; a rivalry for the portrait market developed between the two New Englanders. In spite of Brown's idolization of West's character, it was Stuart's mature style that most influenced him. *William Vans Murray*, portraying a Maryland lawyer who trained for the bar in England, is even livelier in its colors and looser in its brushwork than is typical of Stuart. Brown outlined the eyelids in bright red, and he pirouetted his brush through the hair and cravat.

When Gilbert Stuart left for Ireland in 1787, Brown found it easier to reach his market. British painters, exasperated by the parade of Americans coming through to steal their clients, gnashed their teeth at both the New World artists and the Old World patrons. "Mr. West paints for the Court and Mr. Copley for the City. Thus the artists of America are fostered in England, and to complete the wonder, a third American, Mr. Brown of the humblest pretences, is chosen portrait painter to the Duke of York. So much for the Thirteen Stripes—so much for the Duke of York's taste." They needn't have been quite so sarcastic, because the American monopoly of English art was drawing to a close. Brown, who died in London, spent the latter part of his career painting likenesses in provincial centers like Manchester and Liverpool.

GILBERT STUART

1755–1828

Growing up in Newport, Rhode Island, Gilbert Stuart demonstrated his powers of visual observation quite precociously and in a somewhat macabre manner. The public executioner, to protect his anonymity, always wore a hood. When the hangman's identity stumped the adult townspeople, the little boy piped up, "Oh, I know who it was... I knew him by his shoes." At the age of fourteen, Stuart met a Scottish artist who took the youth under his care. They sailed from Newport to the Southern colonies and then to Edinburgh, where his tutor saw to Stuart's social, academic, painterly, and musical education. Suddenly, the generous benefactor died in 1772, leaving his seventeen-year-old ward without guidance. Stuart, penniless, worked his way home as a sailor; whatever experiences occurred were so mortifying that he never once mentioned this episode in his life.

In Newport, Stuart built an appreciable following as the town's resident portraitist. But when the library requested a full-length likeness of its founder, "he declined it in sullen silence." Stuart knew himself to be a face painter, without proper background or inclination to take on a whole figure. While every artist of his time strove to execute Grand Manner formal portraits and heroic history scenes, Stuart swam against the tide. His impish comment—"No man ever painted history if he could obtain employment in portraits"—would have seemed nonsense to West, Copley, Peale, or Trumbull.

The rumblings of war in 1775 dried up the funds of any and all potential clients. Stuart fled to England in search of a better market. London, however, was awash with distinguished society portraitists, and he almost literally starved. He got a pittance for playing church organ, but by Easter 1777, he was flat broke. Swallowing his pride, Stuart wrote his own letter of introduction to Benjamin West. "The benevolence of your disposition encourageth me.... Pity me good sir. I've just arrived at the age of 21... and

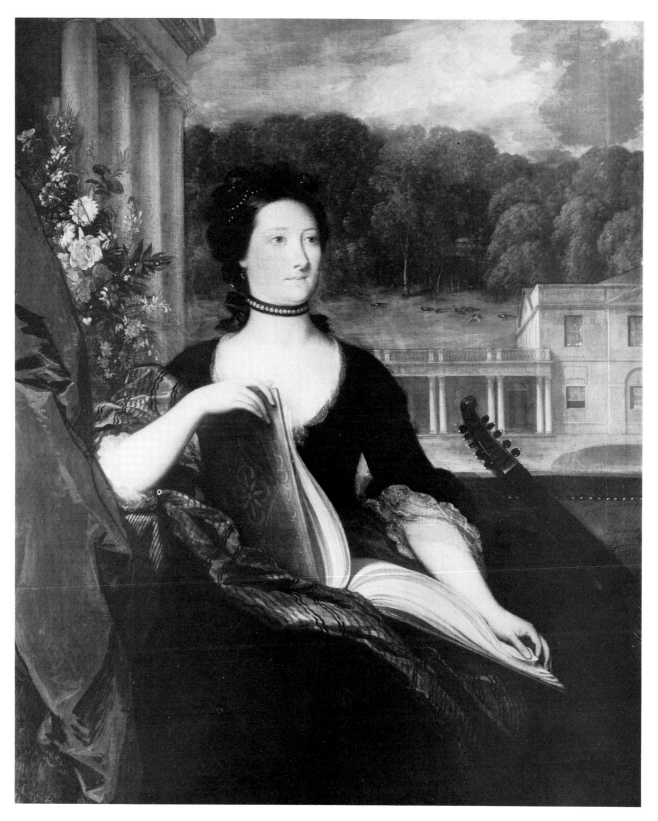

Benjamin West *1738–1820*
Mrs. William Beckford *c. 1799*
Canvas, 57½ " x 45¼ "
Andrew W. Mellon Collection

59

Matthew Pratt *1734–1805*
Madonna of Saint Jerome *1764/1766*
Canvas, 30⅝" x 23⅝"
Gift of Clarence Van Dyke Tiers

Mather Brown *1761–1831*
William Vans Murray *1787*
Canvas, 30⅛ " x 25"
Andrew W. Mellon Collection

find myself ignorant, without business or friends, without the necessities of life . . . pitching headlong into misery I have only this hope. . . . to live and learn without being a burden." Typical of Stuart's high-strung personality, the letter ricocheted between inflated platitudes and neurotic self-pity. But it worked. West invited Stuart to lodge and study in his home. For the next five years, the witty Stuart acted as brother to West's grown sons, companion to his wife, *raconteur* to their guests, and eventual partner to the master himself.

West, to free his time for history painting, turned over the portrait work to Stuart, who rapidly honed his talents. Critics noted that Stuart confined himself to bust-length portraits, saying he "made a tolerable likeness of the face, but as to the figure he could not get below the fifth button." Galled by such comments, Stuart finally undertook a full-length commission from a Scottish gentleman, William Grant of Congalton near Edinburgh. "On entering the artist's room, he regretted the appointment, on account of the excessive coldness of the weather, and observed to Stuart, that the day was better suited for skating than sitting for one's portrait. To this the painter assented, and they both sallied out to their morning's amusement. Stuart said that early practice had made him very expert in skating. His celerity and activity accordingly attracted crowds on the Serpentine River—which was the scene of their sport." That morning changed Gilbert Stuart's life, for it inspired one of the most unusual and celebrated likenesses ever painted, *The Skater (Portrait of William Grant)* (see page 49).

The depiction of vigorous activity was without precedent in Grand Manner society portraiture. A portrait on ice skates would have gotten Stuart declared insane or incompetent; such things simply weren't done. So Stuart knew that he'd need a time-honored structure for the idea forming in his mind. In the corner of West's studio was a plaster cast of the *Apollo Belvedere*, the famous Roman statue that West had compared to a Mohawk warrior. The eternal sun god held a pose of strength and virility, feet planted far apart. All Stuart needed to do was fold the arms over the chest to suggest a chilly day. And this he did. None of the newspaper critics, all of whom raved about the novelty, challenged Stuart, but if they had, he was prepared to prove the validity of his reinterpretation of classical art. Stuart's concept aspired to those heights called true genius. If he had failed, the result would have been ludicrous: the head of a middle-aged Scot atop the body of a youthful Roman god, the whole plunked on ice skates in the middle of a city park.

Lending credence to the work, the background is readily identifiable as the frozen Serpentine in Hyde Park; the twin towers of Westminster Abbey appear over the hill. A crowd in the distance admires two men putting on a virtuoso skating demonstration, possibly inspired by the artist's and sitter's own performance. A discrete gleam from the shoe buckles and skate blades ensures that the spectator will instantly comprehend what Mr. Grant is doing. This anecdotal setting could have presented a major dilemma, detracting from the face, which, after all, is the main point of a portrait.

But Stuart cleverly adopted the feathery brush strokes of Thomas Gainsborough to render that landscape. Since the scenery is indistinct and vaporous, the viewer's attention rivets upon Grant's head, which is meticulously detailed. Where there is more to focus on, the eye will naturally tend to linger. The tones are also arranged to emphasize the face. The canvas is essentially a series of variations on gray, but a jet-black hat and pure white cravat encompass and thereby emphasize the head. The hat brim and the shoulders' angle make an emphatic "X," also centered on the face. And the sky lightens right behind the upper body to silhouette it. Grant's ruddy complexion finishes this orchestration; the largest area of a warm color in the picture, it stands out by reason of its difference from the cool blue-grays. Paint textures, tones, colors, and shapes combine to form an image of breath-taking freshness.

The Skater was the sensation of the Royal Academy exhibition in the spring of 1782. Grant and Stuart avoided the gallery lest they be mobbed by well-wishers and curiosity seekers. As Stuart said of this renowned work, his first full-length, he was "suddenly lifted into fame by a single picture." A member of the Royal Academy advised him, "You are strong enough to stand alone," urging, "Take rooms; those who would be unwilling to sit to Mr. West's pupil will be glad to sit to Mr. Stuart." Stuart took the advice and was soon commanding prices above those of anyone in London save the court portraitists Thomas Gainsborough and Joshua Reynolds. In 1784, Reynolds himself deigned to sit for Stuart. Of the finished work, *Sir Joshua Reynolds* (see page 50), the sitter commented, "If that was like him, he did not know his own appearance." The paint is loose and free, unlike Reynolds' smooth manner. But the technique wasn't what bothered the president of the Royal Academy: the likeness was too honest for his idealizing tastes. Years later, an art critic recalled that Reynolds was "depicted with a wig that was as tight and close as a hackney coachman's caxon, and in the act of taking a pinch of snuff." When Reynolds painted self-portraits, it was in the role of a philosopher with papers or an artist with brushes. Stuart, overly candid, portrayed a somewhat stuffy old man with an unpleasant, flushed complexion. Moreover, the snuffbox is undignified, and Stuart did not disguise Reynolds' harelip. Did Stuart intend this unflattering image as a way of getting even with Reynolds for his politicizing against West in the Academy?

As Stuart's fame grew, so did his ambition. Carriages and liveried servants were beyond his means, but he hired them anyway. To escape his creditors, he snuck out of London in 1787 and moved to Dublin. With no rivals to speak of, Stuart monopolized Irish society portraiture in a way impossible in artist-filled England. *Luke White* portrays a future county sheriff and member of the Irish parliament. Interestingly, his arms cross over his chest in a manner not unlike *The Skater*. Stuart knew a good thing when he saw it and often painted by formula. By 1792, Gilbert Stuart had run up debts in Dublin as bad or worse than those in London. He resolved to make his fortune by returning home to paint the international hero of the day, George Washington.

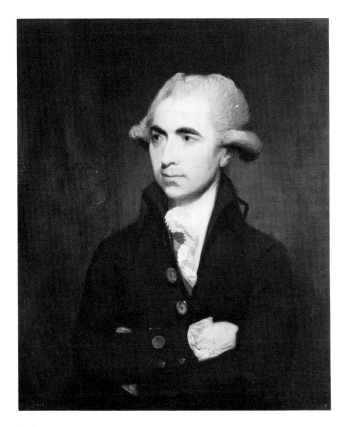

Gilbert Stuart *1755–1828*
Luke White *c. 1790*
Canvas, 30" x 25"
Andrew W. Mellon Collection

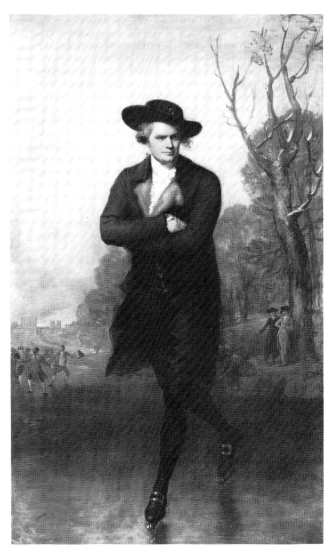

Gilbert Stuart *1755–1828*
The Skater (Portrait of William Grant) *1782*
Canvas, 96 ⅝" x 58 ⅛"
Andrew W. Mellon Collection

3

PATRIOT ARTISTS TO THE YOUNG REPUBLIC

The Revolutionary War disrupted American culture more than any other event, natural or manmade, in our history. Leading artists were either engaged in combat, like John Trumbull and Charles Willson Peale, or they had taken refuge abroad, like Gilbert Stuart. With the ratification of peace on September 3, 1783, the former Thirteen Colonies instantly became a world symbol of rebirth. Immigrants poured toward the new freedoms, and painters and architects joined in the collective effort to build a distinctive environment for the novel republican ideals. Some were skeptical that it would work. When Trumbull explained to his father, the governor of Connecticut, that he wished to be honored for artistry in the fashion of the ancient Greek republics, the reply was terse: "My son, you have made an excellent argument, but . . . you have omitted one point . . . Connecticut is not Athens."

Trumbull proved his father wrong; he opened a public museum dedicated to the great events that formed our nation. Peale, Edward Savage, and Robert Pine, an English émigré, also founded galleries that emphasized patriotic history paintings. The hopes of the young republic were perhaps best summed up by one of the Founding Fathers, John Adams. "I must study Politicks and War that my sons may have liberty to study Mathematicks and Philosophy—my Sons ought to study Mathematicks and Philosophy, Geography, natural History, Naval Architecture, navigation, Commerce and Agriculture, in order to give their Children a right to study Painting, Poetry, Musick, Architecture, Statuary, Tapestry and Porcelaine."

GILBERT STUART

1755–1828

Following his phenomenal success in London and Dublin, discussed in chapter two, Gilbert Stuart found himself in a quandary.

If he stayed abroad, he might either gain more fame or end up in debtor's prison. As he explained to an Irish friend, "So silly am I, and so careless of keeping out of debt, it has cost me more to bailiffs for my liberty than would pay the debt for which they would arrest me. . . . When I can nett a sum sufficient to take me to America, I shall be off to my native soil. There I expect to make a fortune by Washington alone. I calculate upon making a plurality of his portraits." Little did he realize that nearly one-tenth of his life's work would be devoted to that plurality of Washingtons. Moreover, he wasn't exaggerating the gravity of his financial situation; his daughter recalled, "It gave my mother pain to remember anything associated with reckless extravagance, or what she called his folly."

On May 6, 1793, the ship carrying the Stuart family docked in New York. The artist who'd been next in line to be appointed Principal Painter to George III found himself in a homeland that was foreign to him. After a slow start, Stuart recovered his patronage through a combination of his fame, his athletic good looks, and his affable nature. *John Bill Ricketts*, being unfinished, reveals the sophisticated technique Stuart had developed in Europe. Maintaining that drawing should be done with a brush directly on the canvas, Stuart broke with the precedent of making preliminary sketches. The spontaneity is apparent in the hand petting the horse's nose. After finishing the face, Stuart could complete the body and background without troubling the sitter—or so he thought. A procrastinator extraordinaire, Stuart plagued his clients with incomplete works and stalled projects. Many of his pictures, like this one, remained undone. His humor, though, assuaged most wounds. The casual observer might miss an excellent example of Stuart's wit in this picture. Ricketts, an English equestrian who ran popular circuses in Philadelphia, New York, and Boston, is shown with his favorite horse, Cornplanter. As Stuart blocked out the area around Ricketts's head, he amused himself by converting the background into a silhouette of Cornplanter.

Ricketts' smoothly rendered features typify the flattering style Stuart usually adopted in Britain. Now, faced with Yankee mer-

64

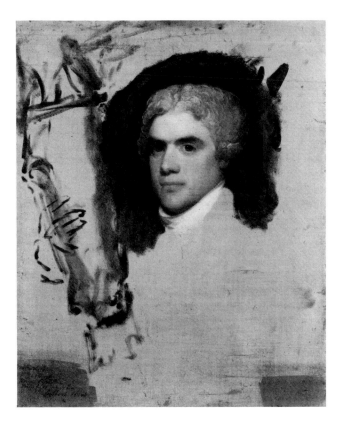

Gilbert Stuart *1755–1828*
John Bill Ricketts *1793/1799*
Canvas, 29⅝" x 24¼"
Gift of Mrs. Robert B. Noyes in memory of Elisha Riggs

chants' families, the artist found that he must reverse his attitude. Factuality was demanded. *Mrs. Richard Yates* (see page 51), depicting the wife of a New York importer, is almost brutal. The only flattery is concealed; Stuart positioned Catherine Yates at an angle that minimized her droopy right eyelid. Complaining about the literalness required of him in America, Stuart quipped, "In England my efforts were compared with those of Van Dyck, Titian, and other great painters—here they are compared with the works of the Almighty!" The Almighty had given Mrs. Yates a bony face and an appraising character, and that is what Stuart had to portray. Oddly, this spartan image has a sensual appeal. Stuart's brilliant paint manipulation generates a verve few others could match. Every passage contains some technical tour de force: the translucency of her cap, the softness of the muslin in her lap, the glint from the brass upholstery tacks, the reflections of the red velvet chair onto her silvery satins, and the lightning-streak highlights of her rustling sleeve. The frontispiece of this chapter is a detail of her industriously sewing hands. Examine the variety of thick and thin, clear and opaque paint employed for the fabrics, thread, needle, thimble, wedding band, skin, and fingernails. It is little wonder that *Mrs. Richard Yates* has become one of America's most famous paintings, both as a

masterpiece of craft and as a symbol of the rectitude of the early republic.

After two years in New York City, Stuart finally received a letter of introduction to the president from their mutual friend Chief Justice John Jay. Arriving in Philadelphia, then the capital, the painter was surprised at the simple modesty of the brick house that served as the presidential mansion and which would temporarily become his studio. For the convenience of the chief executive, sittings were held right after breakfast in a downstairs parlor. A charming conversationalist, Stuart chatted while painting, thereby keeping his sitters entertained and maintaining the freshness of their expressions during the long hours of posing. To the serious and taciturn Washington, however, Stuart's glib wit and showy erudition seemed merely supercilious. The artist claimed, "An apathy seemed to seize him, and a vacuity spread over his countenance, most appalling to paint." Nevertheless, this image has spontaneity because of its relatively quick, sketchy technique. The warm tan underpainting, for instance, shows through the thinly brushed hair, while virtuoso slashes of pigment model the black queue ribbon and form the shimmering highlights on collar and cravat. To impart the sixty-three-year-old sitter's imposing physical presence, Stuart placed the head high in the design, as though the president's six-foot-two-inch frame towered above the viewer. Finally, he added the crimson glow that complements Washington's ruddy complexion and surrounds his head like a superhuman aureole.

The portrait's progress was the talk of Philadelphia. Eventually curiosities were satisfied at an exhibition in City Hall, where the completed work drew mobs of gawking visitors. Stuart was besieged with orders for copies, and he astutely doubled his asking price to one-hundred dollars per likeness. Wags soon joked about Stuart's Washington portraits as the painter's "Hundred-Dollar Bills." On April 20, 1795, he compiled a list of thirty-three patrons who had requested a total of thirty-nine replicas. But to the gregarious and intuitive artist, the routine duplication of one of his own pictures became an unbearable task. The frustrated painter never completed half of the commissioned copies.

Distinguishing among the seventeen surviving versions is problematic, but the National Gallery's *George Washington [Vaughan Portrait]* (see page 55) has a freedom of paint application that implies it was not repetitive copy work. The monotonous quality of the slickly finished replicas suggests that Stuart grew weary of the president's face. Moreover, many of those renditions flatter the sitter, whereas the candor of the sullen features in the National Gallery canvas coincides with Washington's known impatience at having to pose for Stuart. If, as most authorities agree, this is the original study done from life, it is the very first portrait ever painted of the "Father of Our Country" by an internationally acclaimed American artist.

The subtitle, *Vaughan Portrait*, requires explanation. Stuart's 104 known likenesses of the first president are divided into categories named after the owners of Stuart's original portraits from which he made his own replicas: *Vaughan* of March 1795, facing to his left; *Athenaeum* of April 1796, unfinished and facing to his right; and

the full-length *Lansdowne,* finished in the autumn of 1796. The National Gallery's *George Washington [Vaughan Portrait]* was purchased by Samuel Vaughan, a London merchant who was the president's close friend.

For all practical purposes, Stuart had now become the "court portraitist" to the federal government. *Mrs. Robert Liston,* a portrait of the wife of the British ambassador to Philadelphia, typifies the status of his sitters and the range of his poses. The lady's simple gesture of pulling on her glove tells much about her character. And the champagne hues of her outfit enhance her lovely complexion. Stuart was expert at capturing various skin tones. "Good flesh color partook of all colors, not mixed so as to combine one tint, but shining through each other, like blood through natural skin." This flattering portrayal of the sitter took as long as usual, Mrs. Liston explaining, "Mr. Liston and I, busy as we are at this moment, have consented to everybody's advice, and are sitting for our pictures to Mr. Stewart, an artist of great fame, but remarkable for being dilatory. I am endeavoring to persuade him to finish them soon."

In 1803, three years after the government moved to Washington, Stuart followed. The pair of portraits of the Thorntons evidence the new level of high society in the United States. *William Thornton,* depicting the Irish physician, inventor, and businessman who designed the Capitol Building, alludes to the sitter's scholarly nature by showing him marking a passage in a book with his finger. His wife, one of Washington's leading hostesses, was an accomplished musician; so Stuart placed a pipe organ in the background of *Mrs. William Thornton.* As a pair of portraits, the pictures match in their hot red draperies. And, if hung facing each other, the paintings' scooped chairs would cradle Mr. and Mrs. Thornton together.

Washington's adopted granddaughter forms the subject of *Mrs. Lawrence Lewis.* Edward Savage had depicted her as a child years before in his *The Washington Family;* a comparison of these two works reveals not only the different attitudes of the artists but also the fact that Nellie Custis always possessed a languid beauty. Stuart renders her lost in thought and enveloped in a haze. "In the commencement of all portraits the first idea is an indistinct mass of light and shadows, or the character of the person as seen in the heel of the evening, in the grey of the morning, or at a distance too great to distinguish features with exactness."

Occasionally, portraitists are presented with faces or figures so individualistic that no amount of artistic manipulation can make the sitter conform to social expectations. Such is the case with *John Randolph.* Anyone looking at the portrait would assume he or she were seeing the likeness of a well-mannered schoolboy. Actually, he was a fiery orator and a congressman from Virginia. What is most amazing is that Randolph was thirty-two years old in 1805 when he sat for Stuart! Proud of his youthful appearance, Randolph used his apparent innocence to throw political enemies off guard. Stuart went along with the gag by making him seem even more vulnerable, nestling in a chair.

In 1805, Stuart settled in Boston. There, he had the most impact on American art, teaching many young followers. He never allowed them to paint the commissioned copies of his original por-

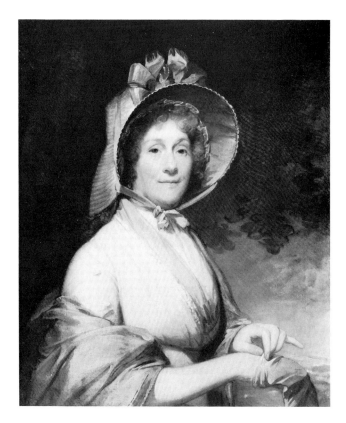

Gilbert Stuart *1755–1828*
Mrs. Robert Liston *1800*
Canvas, 29 ⅛ " x 24 ⅛ "
Gift of Chester Dale

traits, however. Unlike his British contemporaries who often used studio assistants, as he himself had been used by Benjamin West, Stuart usually worked alone. This self-reliance was necessary to maintain the proper personal rapport with his sitters. He was unusually perceptive about the second First Lady, for instance, remarking, "I wish I could have taken Abigail Adams' likeness when she was young. I would have had a perfect Venus." His only completed portrait of her, *Mrs. John Adams* captures the patrician beauty of her straight nose and arched brows. It also suggests the forthright nature of this fifty-four-year-old daughter of a Massachusetts minister; Mrs. Adams felt that "if we mean to have heroes, statesmen and philosophers, we should have learned women." The companion portrait, *John Adams,* was also done directly from life, as indicated in the hair and lace, where soft brush strokes merely suggest rustling movement and indistinct contours.

Comparison with Stuart's other *John Adams,* painted about ten years later, shows the difference between the sketchy vivacity of an original and the greater detail and slicker finish, but lesser immediacy, of a copy. This second Adams belongs to the National

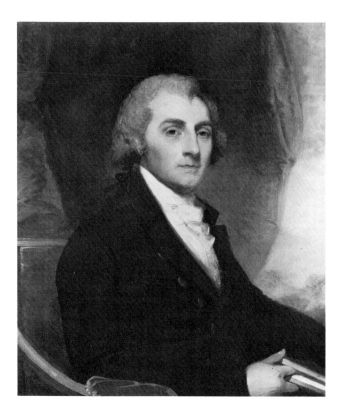

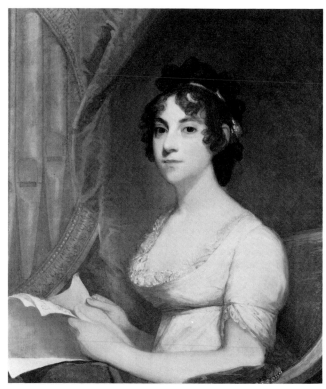

Above left: **Gilbert Stuart** *1755–1828*
William Thornton *1804*
Canvas, 29" x 24 ⅛"
Andrew W. Mellon Collection

Above right: **Gilbert Stuart** *1755–1828*
Mrs. William Thornton *1804*
Canvas, 28 ¾" x 24"
Andrew W. Mellon Collection

Gilbert Stuart *1755–1828*
Mrs. Lawrence Lewis *(Nelly Parke Custis) c. 1805*
Canvas, 29" x 24 ¼"
Gift of H. H. Walker Lewis in memory of his
parents, Mr. and Mrs. Edwin A. S. Lewis

Gallery's suite of the first five presidents. Stuart painted two sets, but since the other was partially destroyed in an 1851 fire in the Capitol, this grouping takes on added historical importance. Many of these late Boston pictures remained in Stuart's studio at his death. As John Quincy Adams politely stated about the artist's procrastination, "Mr. Stuart thinks it the prerogative of genius to disdain the performance of his engagements."

Regardless of his dilatory habits, Stuart possessed a talent that set him far above the more prosaic artists in America. His sophisticated use of translucent oil glazes and his deftly executed brushwork in opaque highlights capture the energy of his sitters, whom he preferred to pose in simple bust-length formats against neutral backgrounds in order to emphasize their features. And, he was exclusively a portraitist; in his prolific, five-decade career, he produced well over 1,100 pictures, fewer than ten of which were not likenesses. And, of the portraits, nearly one-tenth were images of George Washington. The National Gallery is extremely fortunate to possess forty-two Gilbert Stuart oils, ranging from his early work in London under Benjamin West to his late canvases when, living in Boston, he was the paramount painter in the New World.

Gilbert Stuart *1755–1828*
John Randolph *1805*
Canvas, 29⅛" x 24⅛"
Andrew W. Mellon Collection

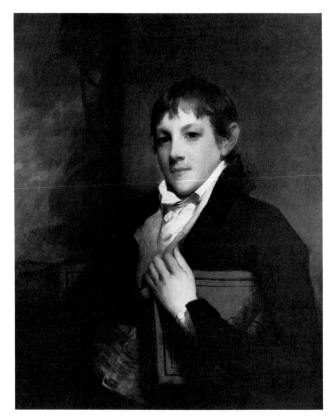

ROBERT EDGE PINE

1730–1788

The London-born and -trained Robert Edge Pine gave the first one-man art show in the New World, published the first exhibition catalog in the colonies, and opened the first museum in America. His relative lack of fame owes to a fire in 1803 that destroyed a significant portion of his life's work.

Pine, whose painter-father was a close friend of William Hogarth, the leading artist in mid-eighteenth-century England, had an estimable education in the arts. Pine clearly rivaled Sir Joshua Reynolds, the first president of Britain's Royal Academy. In fact, some experts theorize that Reynolds' professional jealousy is the main reason Pine wasn't included among the founding members of the prestigious Royal Academy in 1769. Another reason may be found in Pine's American sympathies; an English artist noted that his antimonarchical "turn of mind" was "sufficiently demonstrated, by observing that he painted several portraits of the popular Patriots of his day." Pine was also argumentative, for an American biographer described him as "a very small man—morbidly irritable. His wife and daughters were also very diminutive; they indeed were a family of pigmies." Unwilling or unable to join the artistic and political establishment in Britain, Pine sailed for Philadelphia in the summer of 1784.

Hoping to establish himself as a history painter, Pine exhibited his English works in a Philadelphia boarding house that proved much too small. "Whereupon the Supreme Executive Council allowed him the use of one of the large apartments in the State House," from October 27, 1784, "until he could otherwise accommodate himself." Thus, America's earliest one-man show and exhibition catalog appeared at Independence Hall, the old State House. More than two years later, Pine built a home with a spacious studio and exhibition hall, thus constituting America's first museum. In Independence Hall and his house-gallery, Pine worked on a number of scenes concerning Revolutionary history, all now lost. Pine's recreation of the signing of the Declaration of Independence, known through a painted copy and an engraving (both made by Edward Savage), achieved remarkable accuracy, having been done on the spot. However, the public image of that crucial event is based on John Trumbull's much aggrandized and rhetorical version. It seems that Pine had no better luck in America than he had had in Britain.

In spite of Pine's desire to perpetuate historical occasions, it was to portraiture that he, like every other early American artist, turned for a livelihood. Traveling to the southern states, he developed a novel technique for saving time, which was described by Rembrandt Peale, the son of Pine's chief artistic competitor, Charles Willson Peale. "His custom was, on small, thin pieces of canvas, to paint the heads of his sitters, making on paper pencil sketches of their figures, so that on his return home . . . he and his two daughters could rapidly finish them. It happened in more than one instance that he made mistakes with his pencil sketches and

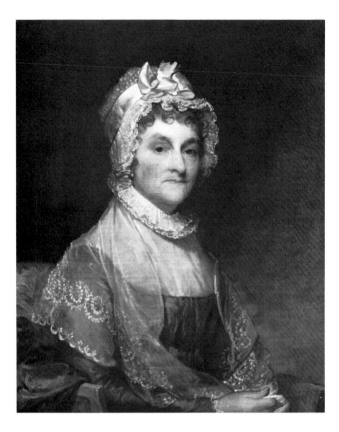

Above left: **Gilbert Stuart** *1755–1828*
Mrs. John Adams *1815*
Canvas, 29" x 23¾"
Gift of Mrs. Robert Homans

Above right: **Gilbert Stuart** *1755–1828*
John Adams *1815*
Canvas, 29" x 24"
Gift of Mrs. Robert Homans

Gilbert Stuart *1755–1828*
John Adams *c. 1825*
Wood, 26" x 21⅜"
Ailsa Mellon Bruce Fund

gave his subjects bodies that belonged to other persons." In the case of *General William Smallwood*, X-rays prove that the face is on a separate section that was carefully stitched into a hole cut in the overall canvas. And Pine did make errors in the body, or at least failed to satisfy the sitter, who refused to pay until the uniform's details and epaulettes were corrected. Since the artist was back in Philadelphia and the retired major-general of the Continental Army was now governor of Maryland and living in Annapolis, Pine asked Charles Willson Peale to make the necessary alterations. Besides changing the uniform, Peale had to add the medal for the Order of the Cincinnati and do some cosmetic work on the aging hairline. Peale's diary for June 1788 contains his comments about the governor: "I find him very difficult to please. The picture I consider among the best of Mr. Pine's works. He has labored to please and has given the mouth and cheeks an affected smile that has done injury to the portrait. I am obliged to make the figure as beautiful formed as possible, and now scarcely have satisfied him." Regardless of the governor's vanity, the subtle atmospheric effects demonstrate that Pine was the most sophisticated painter working in America during the Revolutionary years. Pine, had he lived longer, might have eclipsed Gilbert Stuart upon his return to America in 1792. But Robert Edge Pine died of apoplexy in 1788, after little more than four years in the New World.

CHARLES WILLSON PEALE

1741–1827

Charles Willson Peale, probably more than any other American artist of the colonial and federal periods, managed to strike a balance between native simplicity and cosmopolitan sophistication. He possessed a thorough knowledge of anatomy which he employed for natural, never affectedly artificial, gestures. He wielded his brush to describe surface textures accurately, not merely to show off a virtuoso command of pigment. *John Philip de Haas* demonstrates these qualities perfectly. The jauntily crossed knees and cocked head express the sitter's liveliness, while his placement next to a window allows sunlight to rake across his head, subtly revealing the facial muscles. The Dutch-born de Haas came to Pennsylvania as a child, entered the army, and rose to the rank of brigadier general during the Revolutionary War. Thirty-seven when this portrait was painted in 1772, de Haas wears civilian attire and rests his elbow on a table strewn with scholarly tomes. Peale included hints of the major's military occupation as well as his private interests by showing him holding a sword and silhouetted against a framed picture of a battle from the French and Indian wars.

Peale's inventiveness of pose is especially evident in *Benjamin and Eleanor Ridgely Laming* (see pages 52–53), where he devised a leaning posture for the husband so that his bulk would not overshadow his petite wife. This unusual, reclining attitude also binds the couple closer together, telling of their love. Peale had earlier

painted a miniature of Mr. Laming, and on the artist's appearance in Baltimore in 1788, the couple asked him to do this double portrait. Peale's diary records his activity on the work from September 18, when he "sketched out the design" after dinner, to October 5, when he added the final touches to Mr. Laming's figure. As was customary for itinerant painters, Peale stayed at the family's estate outside Baltimore. When the Lamings were too busy to sit, or during odd hours in the evenings, the artist-scientist occupied his time with natural history: "Walking into the meadows after butterflies and grasshoppers. . . . finish the dressing of two woodpeckers. . . . making the model of a new-constructed windmill. . . . A canary bird dying I dress it for the Museum by candlelight. . . . I spent the afternoon in catching bullfrogs, one of which I dress for the Museum. I found frogs in its stomach."

These entries prove beyond a doubt that Charles Willson Peale must have been an indefatigable worker. In the midst of those eighteen days, he progressed from the Lamings' faces to their figures and costumes, accessories and background, always returning to the features for refinements. The landscape, "view of part of Baltimore Town," is appropriate for the wealthy Maryland merchant. The spyglass might indicate Laming's interest in shippage by sea, and the green parrot behind his leg recalls his birth in the West Indies. Mrs. Laming's fruit and flowers, traditional emblems of innocence and fertility, could also be special indications of her hobbies. In any case, the attention paid to the bird, plants, scenery, and optical device is characteristic of Charles Willson Peale's encyclopedic knowledge. And, with the one eloquent gesture of Eleanor laying her hand trustingly over Benjamin's arm, Peale spoke volumes about the Lamings' relationship.

Born in Maryland, Charles Willson Peale was the archetypal jack-of-all-trades. A professional saddler in Annapolis, he heard of a successful painter living nearby and offered "one of his best saddles with its complete furniture, for permission to see him paint a picture." Peale, with this experience, soon added sign painting to his leather business and was to become an accomplished clock repairman, silversmith, upholsterer, and radical politician. On a trip to Boston, Peale called upon John Singleton Copley, who lent the youth an oil portrait to copy for practice. By 1766, a group of Maryland businessmen subscribed funds to send their precocious native son abroad for art study.

Peale spent twenty-five months in London, working with extraordinary dedication in Benjamin West's studio. West, at twenty-nine only three years older than his pupil, called him "the ingenious Mr. Peale." Peale repaired West's favorite palette which, being broken, the master had thrown away. The student, as West explained to visitors surprised by sudden hammering, "when he is not painting, amuses himself by repairing my locks and bells." But Peale wasn't happy in London. His republican sentiments prohibited him from doffing his hat to the king; he didn't have enough money to tip the servants to see private collections; and he dearly missed his wife.

Charles Willson Peale returned home in 1769 to become one of early America's most remarkable entrepreneurs in art and science. On July 21, 1788, a Philadelphia newspaper announced the public opening of "Mr. Peale's Museum, Containing the Portraits

of Illustrious Personages, distinguished in the late Revolution of America, and other paintings—Also, a Collection of preserved Beasts, Birds, Fish, Reptiles, Insects, Fossils, Minerals, Petrifactions, and other curious objects, natural and artificial." With all his endeavors, Peale found it difficult to make ends meet. "I now find it necessary to travel to get business sufficient in the portrait line to maintain my family, which is not small," he wrote to Benjamin West in 1788, the year he portrayed the Lamings. His considerable progeny, numbering seventeen, were often named after prominent painters and scientists. Though many of these children died in infancy, several, such as Rembrandt Peale, became major artists in their own right. Charles Willson Peale, usually remembered as fathering a dynasty of American painters, holds a significant position in the history of our early politics, science, inventing, museums, and, above all, sheer artistry.

EDWARD SAVAGE

1761–1817

From a small town in Massachusetts, Edward Savage taught himself portraiture by copying John Singleton Copley's works. His reputation grew rapidly, for by 1789 President Washington was induced to sit for Savage. Early the next year, on commission from John Adams, Savage executed another portrait of George and a companion piece of Martha. Martha Custis had been a widow when George married her, so after her son died of camp fever during the siege of Yorktown, she and George adopted her two younger grandchildren. New York City, being the capital at the time, was the residence of the Washington family, and Savage presumably also painted portraits of Nelly Parke Custis and George Washington Parke Custis in 1789–1790. These dates, all before Edward Savage's three-year study in England, are crucial to understanding the development of a unique painting completed after that European sojourn: *The Washington Family* (see pages 54–55), the only group portrait of the first "First Family" to be executed from life.

Savage spent the years 1791 to 1794 abroad, though it is unrecorded with whom he apprenticed. By February 20, 1796, he advertised in a Philadelphia gazette that he was adding to his private museum, the Columbian Gallery, "the President and Family, the full size of Life. Price of admission to the Gallery, one quarter of a dollar." The huge canvas, over nine feet long, must be one of the most ambitious projects ever undertaken by a painter in the federal period. Moreover, the formal composition bespeaks the dignified balance characteristic of the best European Grand Manner portraits. A central vacuum of space separates a seated adult and standing child to either side. Vertical elements, a classical column to the left and a tall servant to the right, bracket this foreground group. The viewer would assume that such an effective design on such a colossal scale must have been worked up by Savage, using his individual facial studies done seven years earlier, after his return from Europe. Amazingly, the artist's own letter to George Washington

proves that he'd conceived the design before being exposed first-hand to Old Master art!

Writing to Washington in 1798 about his recently completed engraving of the 1790 composition, Savage said, "The likenesses of the young people are not much like what they are at present. The Copper-plate was begun and half finished from the likenesses which I painted in New York in the year 1789. I could not make the alterations in the copper to make it like the painting which I finished in Philadelphia in the year 1796. The portraits of yourself and Mrs. Washington are generally thought to be likenesses." A careful reading shows that the entire concept existed as an unfinished print before Savage left for England. Since George and Martha were adults, the seven-year lapse did not effect their countenances, but Savage was forced to let the grandchildren look much younger than they really were when he finished the oil painting in 1796. In that year, Nelly was seventeen and George Custis fifteen, while in 1789, she had been ten and he eight—believable ages for the children in the final canvas.

The catalog from Savage's Columbian Gallery further complicates the matter. Martha, expensively gowned in gray satin, is "pointing with her fan to the grand avenue," now known as Pennsylvania Avenue. However, the District of Columbia wasn't surveyed until 1791, after Savage had begun work on the engraved design, so that map on the table is either imaginary or a later addition. Savage also claimed that the panorama was "a view of thirty miles down the Potowmac River, from Mount Vernon." Mount Vernon's veranda consists of simple square piers, not the cylindrical marble columns that appear in the painting; furthermore, the scenery doesn't match the bends in the Potomac.

The Washington Family, one of the best documented and most popular of early American paintings, reminds experts and casual museum-goers alike not to make snap judgments. What appears to be a life portrait is, in fact, an ideal composite of images. In some ways, the achievement was beyond Edward Savage's essentially self-taught artistry; the layout is unimaginatively symmetrical, and the anatomy alternates between wooden and rubbery. But Savage made a tidy fortune from selling engravings of his ceremonial treatment of the First Family and from exhibiting the canvas for a fee in Philadelphia, New York, and Boston.

RALPH EARL

1751–1801

Ralph Earl, a self-taught New England portraitist, produced what may well be the earliest history paintings done in America. Hearing of the battles of Lexington and Concord in 1775, he and an engraver friend visited the sites to create paintings and prints of the campaigns. Strangely, Earl was a Loyalist who eventually fled from the rebelling colonies. When young Ralph refused to accept a commission in his father's regiment of American soldiers, the captain disinherited his son. Given the choice of leaving the colony of

Connecticut or being imprisoned, Earl "hid in a remote part of the Province" and supplied information to the Redcoats. He would have been executed for treason by the Connecticut rebels except for "the respect which they paid his Father as an Officer of High Rank in their Army." In 1778, he escaped to England disguised as the servant to a British officer.

Earl's quixotic nature, his spendthrift ways and his indulgence in high spirits, must have tried the patience of Benjamin West, with whom he worked intermittently over the next seven years. The chief influence upon Earl's development in London, however, seems to have been Sir Joshua Reynolds' pictures. When the expatriate returned to the new United States in 1785, he brought back the solid massings and smoothed surfaces typical of Reynolds' style. *Daniel Boardman,* painted in New Milford, Connecticut, in 1789, mixes the charming naïvete of a self-taught colonist with the sophistication of an academically trained artist. In true Grand Manner fashion, the canvas is the size of life, and the sitter displays a pose of nonchalant aplomb. Boardman, a prosperous dry-goods merchant, stands proudly to the side so that the viewer may glimpse a landscape of his home town beyond the Housatonic River. The quickly sketched suggestion of foliage and the diaphanous clouds, like the elegant posture, recall Earl's British training. But the meticulous detailing of the distant buildings betrays his American literalness. The large house seen beyond Boardman's hand, possibly the family home, is too minutely rendered; details such as the number of rails in the white fence would not actually be visible from this great distance. The artist also precisely delineated the church spire without any feeling for atmospheric depth (however, since Boardman's grandfather had been the first minister of the Congregational Church in New Milford, the steeple assumes a symbolic function). Earl hadn't learned the basic precept of portraiture: to suppress accessories and background in order to emphasize the likeness. Even the anatomy, on second look, has the awkward handling of a primitive or folk painter; the arms are too short for the legs, and the hands are boneless.

How Earl, who wasn't a very diligent worker while in London, managed to effect such an obviously complicated and elegant posture seems mysterious. The mystery may be solved by turning back to the first illustration in chapter one, Sir Joshua Reynolds' *Squire Musters.* With the single exception of the turn of the head, Earl's figure derives exclusively from Reynolds' canvas. The cocked elbow, the limp arm holding a tricorn hat, the crossed legs, and the attitude of leaning on a walking stick are identical. Earl, who was West's pupil but not a student of Reynolds, must have visited Reynolds' studio when *Squire Musters* was in progress in 1777–1780, because the finished British portrait apparently never received a public exhibition. Earl didn't copy Reynolds' work; he reinterpreted it, imbuing his American provincialism with an international élan. And, after all, Reynolds took the posture of his subject from an ancient Roman statue!

How many more of these European inspirations for American art remain to be discovered is anyone's guess. A systematic exami-

Robert Edge Pine *1730–1788*
General William Smallwood *1788*
Canvas, 29⅛″ x 24″
Andrew W. Mellon Collection

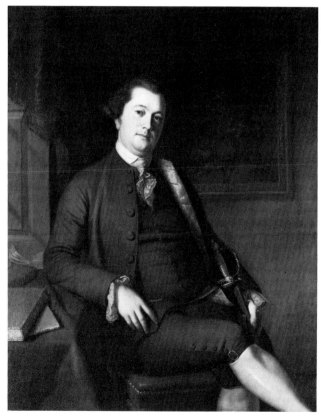

Charles Willson Peale *1741–1827*
John Philip de Haas *1772*
Canvas, 50″ x 40″
Andrew W. Mellon Collection

nation of Earl's own paintings might turn up several other examples because he was quite prolific, doing eighteen other portraits of the Boardman family and relatives alone. In the last few years of his life, Ralph Earl declined rapidly in his art and in his habits; a pastor listed his cause of death as "intemperance."

JOHN TRUMBULL

1756–1843

A Harvard graduate at seventeen and heir to an influential Connecticut family, John Trumbull waivered before committing himself to a career in the arts, which he felt beneath his dignity. But, after serving two years as a colonel in the Continental Army, he finally determined to study painting in Europe. On November 19, 1780, a few months after his arrival in London, Trumbull was arrested as a rebel. Benjamin West, fearing for the safety of all his American students, made a personal appeal to George III. The king assured him, "Go to Mr. Trumbull immediately, and pledge to him my royal promise that, in the worst possible event of the law, his life shall be safe." West needn't have worried about his other pupils because Trumbull, as son of the governor of Connecticut, had been singled out in retaliation for the American hanging of Major André as a spy. Trumbull's money made his seven months in prison relatively easy; he was even allowed to hire models to pose in his cell. Gilbert Stuart came by to paint his portrait, and Trumbull borrowed West's *Madonna of Saint Jerome,* which Matthew Pratt had previously copied, to study. Trumbull's life, it may be said, was one of moving easily through English, French, and American high society.

A London portrait by Trumbull, *Patrick Tracy* (see page 56), demonstrates an American colonial rapidly absorbing the British Grand Manner. The subject, a prosperous Massachusetts warehouse owner, appropriately lays his hand on an anchor, symbolic of his maritime trade, and stands on a shell-strewn beach before crates and barrels. His wizened visage reveals his seventy-some years, but his delicate fingers and slender calves seem to belong to a younger, or at least idealized, figure. In the colonies, John Singleton Copley had been among the first to encourage Trumbull in painting, and the sharp Realism of the face is an homage to Copley's American frankness. The body, however, belongs to Sir Joshua Reynolds' flattering canons for harmonized proportions. Trumbull's account book for 1784 resolves the dilemma: "Whole length of Mr. P. Tracy (father of Nat) leaning on an anchor—head copied." While in London, Nat Tracy, the sitter's son, apparently commissioned the portrait; since Patrick was still in America, Trumbull must have copied the face from another likeness which Nat loaned him. Tracy family records indicate that the work wasn't finished and paid for until 1786; the ensuing two years allowed Trumbull to adopt Reynolds' manner for the body. Since Reynolds had earlier criticized Trumbull's Copley-like style as "bent tin," it's understandable that the youth would want to emulate the president of the Royal Academy.

Ralph Earl *1751–1801*
Daniel Boardman *1789*
Canvas, 81⅝" x 55¼"
Gift of Mrs. W. Murray Crane

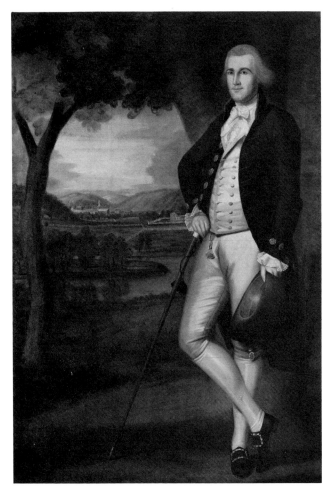

74

While working on Patrick Tracy's life-size portrait, Trumbull received an unprecedented honor from Benjamin West. West, who'd hoped to do a vast series on events from the War of Independence, decided he was too busy and passed the idea on to Trumbull. The results form a world-famous group of history paintings that occupied the artist for the rest of his career. Trumbull's famed rendition of the signing of the Declaration of Independence appears even on the back of the two-dollar bill. Several contemporaries, however, noted that while Trumbull's work on a small scale was excellent, surpassing the best efforts of leading European painters, his large murals appeared spatially ambiguous. On observing an early work by Trumbull, Stuart unknowingly blurted out, "This looks as if it was drawn by a man with but one eye." Deeply stung, Trumbull retorted, "I presume, sir, that you know I have lost the sight of one eye, and any allusion to it in this manner is illiberal." With vision in only one eye, Trumbull lacked binocular depth perception. So, although he had no problems working at close range, Trumbull did experience difficulty with distant space.

In 1792, when Alexander Hamilton was at the peak of his influence, John Jay, first Chief Justice of the Supreme Court, commissioned a portrait of the first Secretary of the Treasury from John Trumbull, by then the leading artist in America. It is assumed that the *Alexander Hamilton* in the National Gallery is the likeness done from life for John Jay, but this cannot be proven, as Trumbull painted six replicas of this composition and, furthermore, did eleven other paintings of Hamilton in a different pose. However, the freshness of paint application and the vivacity of the image make this particular picture the best of all eighteen Hamilton portraits that Trumbull eventually executed.

As leader of the Federalist Party, Alexander Hamilton was second only to the president during the early years of American independence. The Federalists advocated strong centralized government and, in principle, wished to abolish the individual states altogether. Trumbull, who was a Federalist himself, lent Hamilton an impressive, even imposing, air in this portrait. Using a low viewpoint, the artist forces the spectator to look up toward the statesman. The sitter's perceptive sensitivity is heightened by Trumbull's exaggeration of the delicacy of the facial features, and Hamilton's commanding presence is communicated by his uplifted chin and his gaze into the distance. The somber color scheme of browns, grays, and tans adds further dignity to the work.

In his later years, Trumbull became reactionary and hidebound, grumbling constantly about any little slight to his self-importance. He devoted more and more energy to the formation of his Trumbull Gallery, the earliest American art museum affiliated with an educational institution. In 1832, Yale University opened the Trumbull Gallery, housing the artist's own collection in a building designed by the master himself. Trumbull recalled in his *Reminiscences* that, as early as 1785, he had begun "to meditate seriously the subjects of national history, of events of the Revolution, which have since been the great object of my professional life." From his vast murals in the Capitol rotunda to his portrait miniatures of generals and legislators, it is Trumbull's works that allow us, as the "Patriot Artist" hoped, to imagine the events and leaders of our nation's birth.

John Trumbull *1756–1843*
Alexander Hamilton *c. 1792*
Canvas, 30¼" x 24⅛"
Gift of the Avalon Foundation

4

CHRONICLERS OF THE FRONTIER AND FOLKLORE

With independence, the citizens of the prior Thirteen Colonies took greater notice of their newly won resources and heritages. Artists and authors began to chronicle the flora, fauna, and native inhabitants, as well as to explore the rich legends that had developed in the New World. The primary concern of colonial times had been settling America, not studying it. Among the rare exceptions was Benjamin Franklin's foundation of the American Philosophical Society in 1743; housed next to Independence Hall in Philadelphia, this private organization contributed as much to pure science as did many of its royally sponsored European counterparts. And Thomas Jefferson's *Notes on the State of Virginia,* published in Paris in 1785, constituted an encyclopedia of topography, climate, natural resources, and the livelihoods and customs of the Indians and whites.

When President Jefferson negotiated the Louisiana Purchase from Napoleon in 1803, the United States' territory doubled overnight. With that immense area freed from foreign interference, interest in Western settlement grew apace. Thus, in addition to scientific curiosity, there was an economic necessity to understand the new lands. The Lewis and Clark expedition of 1804–1806 was but one of many surveys and explorations, including the private ventures of John James Audubon to study animal life and of George Catlin to preserve the Indian heritage.

The United States' pride in its wondrous natural history paralleled an increasing fascination with its unique cultural history. Colonial authors had normally aped European themes and styles, but by the early 1800s, our poets and novelists focused on the peculiarly New World folklore. Henry Wadsworth Longfellow, James Fenimore Cooper, and Washington Irving—all of whom lived and wrote abroad for extended periods—intrigued readers in Europe as much as at home. Like these best-selling authors, painters dealt with colorful, homegrown tales and traditions.

JOHN JAMES AUDUBON

1785–1851

Born in Haiti and raised in France, the young John James Audubon pursued nature studies with the aid of doctors and teachers who were family friends. Audubon, who was schooled for a French naval career, was essentially self-taught in zoology and art. First coming to the United States in 1803 to manage his father's holdings near Philadelphia, Audubon's indifference to business was soon matched by his fascination with American flora and fauna.

To finance his expeditions to study animal life, he worked as an itinerant portraitist, a taxidermist, and a tutor of drawing, French, dancing, and fencing. Audubon's wanderings in that age of flatboats and stagecoaches were as remarkable as his scientific accomplishments. He traveled throughout the Ohio, Mississippi, and Missouri river valleys as well as the Atlantic seaboard from Florida to Labrador. Moreover, he lived in the British Isles periodically from 1826 to 1839 in order to enlist subscribers for *The Birds of America,* to supervise its publication, and to conduct seminars. The Philadelphia society portraitist Thomas Sully had been one of the few Americans to encourage Audubon's endeavors. But, while in England, the young scientist-artist wrote to his wife, "It is Mr. Audubon here and Mr. Audubon there until I am afraid poor Mr. Audubon is in danger of having his head turned."

A perceptive naturalist and prolific author in several fields, Audubon is best remembered today for the engraved illustrations in his "large work," as he called *The Birds of America.* In the 435 copperplate engravings, the birds are usually shown life-size, accurately

George Catlin *1796–1872*
Detail of Catlin Painting the Portrait of
Mah-to-toh-pa—Mandan *1857/1869*
Paul Mellon Collection

transcribed from Audubon's original watercolor drawings. The folio sheets were engraved primarily in London by the printing firm of Robert Havell and Son from 1827 until 1838. The Print of the *Golden-eye Duck*, like most engravings in the "large work," combines scientific precision with vivid design. The male duck plummets downward at an exact right angle to the female's ascent. The line along his back continues through her farther wing, and her breastline parallels the male's lower wing. These poses do not merely create a bold geometric composition across the paper; they also display the birds to best advantage. The difference between the male's extended and closed wings is revealed; the upper and lower surfaces of the female's wings are apparent; yet, both ducks' heads are in pure profile to show that the female lacks the male's white facial spot.

The success of this ornithological encyclopedia inspired Audubon, at age fifty-four, to begin another venture: *The Viviparous Quadrupeds of North America.* Since his sight was beginning to fail, he relied heavily on his two sons to create 150 lithographs of four-footed mammals. *Arctic Hare* (see page 89), done in a typical mixture of media, is one of John James Audubon's few original and totally autograph paintings for this last work. An almost musical counterpoint plays between the alignments of the legs and ears, as well as between the hares' silhouettes and the Labrador hills behind

John James Audubon *1785–1851*
Print of Golden-eye Duck, Fuligula Clangula *1836*
Engraving, mezzotint, and hand coloring on paper, 21³⁄₁₆ " x 30³⁄₈ "
Mrs. Walter B. James

them. Audubon's genius for texture differentiates several qualities of fur on only two animals, contrasted in their camouflage coloring of gray-brown for summer foliage and white for winter snow. His uncanny ability to unite artifice in design with naturalism in subject elevated Audubon to the status of cult figure during his own life.

GEORGE CATLIN

1796–1872

Fortunately, in view of George Catlin's own wishes, his surviving works are not scattered throughout numerous collections. About four-fifths of Catlin's Indian paintings reside in neighboring museums in Washington, D.C.; the Smithsonian Institution houses 445 Catlins, and the National Gallery of Art cares for another 351. Catlin devoted himself to perpetuating the vanishing cultures of North and South American Indians, and his pictures were intended to be seen as coherent, educational groups. Nevertheless only a handful of the Gallery's Catlins are on public view at any one time as the oils were given by Paul Mellon, the son of the Gallery's founder, with the request that they be lent as widely as possible.

Born in Pennsylvania and trained as a lawyer, Catlin found that "after having covered nearly every inch of the lawyer's table (and even encroached upon the judge's bench) with penknife, pen and ink, and pencil sketches of judges, jurors, and culprits, I very deliberately resolved to convert my law library into paint pots and brushes." With virtually no formal instruction in art, he set up as a painter of portrait miniatures and was elected to the Pennsylvania Academy of the Fine Arts by 1824. Seeing a delegation of Indians pass through Philadelphia on its way to Washington, D.C., Catlin resolved, "The history and customs of such a people, preserved by pictorial illustrations are themes worthy the life-time of one man, and nothing short of the loss of my life, shall prevent me from visiting their country, and of becoming their historian." The spring of 1830 saw him in St. Louis, Missouri, beginning a series of Far West treks that would occupy the next seven years.

Assinboin Chief before and after Civilization documents why Catlin was so concerned about perpetuating, at least in pictures, the Indians' culture. To the left, Wi-jun-jon stands proudly in his buckskins and eagle-feather bonnet, holding a peace pipe, as he surveys the United States' Capitol. (Incidentally, that is the original appearance of the Capitol before it was enlarged and the huge dome was added in the mid-nineteenth century.) The same man appears again at the right, returning to his village, stripped of all dignity by the perversion of white society. He wears a ridiculously ill-fitting military uniform while awkwardly straddling a sword he can't manage. A beaver top hat crowns his head as he smokes a cigarette, and whiskey bottles protrude from his hip pockets. His fan and umbrella, now necessary with his impractical European clothes, would not be needed with naturally ventilated, naturally waterproof buckskins. Catlin had accompanied Wi-jun-jon home to North Dakota in 1832, where his own tribe killed the chief for having become a preposterous braggart. Indians will not tolerate falsehood.

The self-portrait included in *Catlin Painting the Portrait of Mah-to-toh-pah—Mandan* shows the semi-European, semi-Indian

George Catlin *1796–1872*
Assiniboin Chief before and after Civilization 1857/1869
Cardboard, 15⅜" x 21¾" oval
Paul Mellon Collection

79

outfit that the artist adopted. The tribe looks on in anger, fright, and wonder as Catlin works his "white man's magic" on their chief. But Catlin's realism, which so amazed the Mandan, is not that convincing to viewers accustomed to the ideals of academic painting. In the detail that begins this chapter, one can see the naïve outlining which Catlin employed, almost like that of a cartoonist. His anatomy is faulty, and his perspective unconvincing. Catlin was aware of his own shortcomings as a fine artist and made a droll comment on them here. Just behind and to the right of Catlin a man covers his mouth to hide a snicker while pointing at the painter's easel. No Mandan would ever giggle at this fixing of his chief's soul onto canvas; Catlin plays a joke on himself by converting that Indian into a Philadelphia art critic.

Although Catlin hadn't been trained in anatomy, perspective, or composition, he had worked for years as a portraitist. When painting heads alone, his true ability emerges. *See-non-ty-a, an Iowa Medicine Man* (see page 91), is a superb rendition of the bone and muscle structure of a human face. Even more remarkable is that Catlin manages to convey the three-dimensional effect of light and shade underneath the sitter's war paint, which was intentionally designed to distort form! Catlin also convincingly captures the varying textures of the dyed deer's-tail headdress, conch-shell earrings, and porcupine-quill wampum necklaces.

Below the Indian's shell gorget, or throat protector, hangs a round medallion suspended on a red, white, and blue ribbon. Queen Victoria had presented this medal in London in 1844 to See-non-ty-a, a member of Catlin's Indian entourage. Catlin has often been accused of being too emotional, too sentimental. Quite the reverse is true. Almost all other artists who portrayed the Indians did so with preconceived notions and, therefore, distorted them into blood-thirsty savages or noble innocents. Catlin painted what the Indians understood of themselves. This medicine man had been honored by the white man's queen; Catlin showed him exactly as he wished to be seen—wearing his British medallion.

John James Audubon, Catlin's fellow scientist-artist, tried to discredit him with a snide comment which ironically turned out to be a compliment: "When and where Mr. Catlin saw these Indians as he represented them, dressed in magnificent attire, with all sorts

of extravagant accoutrements is more than I can divine." Of course the Indians never honored Audubon with their finest regalia; why should they? He ignored them when they weren't selling him bird specimens, dead or alive. Catlin, however, cared about the Indians, learning their languages before he arrived at their villages, and they treated him accordingly.

Beginning in Pittsburgh in 1833, Catlin exhibited his Indian Gallery to an eager nation; by 1839, he packed up hundreds of pictures and tons of actual Indian artifacts and set sail for Europe. He wouldn't return home for thirty-one years. In London, Brussels, and Paris, his collection created a sensation. The slim, wiry explorer and his troup of Indian performers entertained and educated school children and royalty alike. King Louis Philippe even commissioned him to do a series on the voyages of La Salle, the seventeenth-century French explorer of the Great Lakes and the Mississippi River. "I told him that I had visited every tribe of Indians that La Salle saw, and that I could show him landscape views of every place that La Salle had visited," Catlin declared. Completing the set of twenty-seven historical episodes only three days before the 1848 Revolution in France stopped all royal patronage, Catlin was never paid.

La Salle's Party Feasted in the Illinois Village (see page 90) recreates an event that took place in January 1680; Catlin visited the same area a century and a half later and, realizing that the Illinois' customs had probably changed, elected to portray accurately what he experienced there firsthand. Thus, he depicts a mixture of permanent bark wigwams and nomadic skin teepees which had not existed in La Salle's time. Also, he gives some of these Eastern Woodlands Indians the tall eagle-feather bonnets which, although appropriate for the open Plains, would have caught in forest branches. Regardless of Catlin's errors in attempting to recreate past Indian life, he magnificently captures the spirit of the council ring with its weapons piled peacefully in full view of all. And, Catlin's quick, feathery method of painting exquisitely conveys the effect of snow tingeing the trees and houses. La Salle, for ease of

recognition, always sports a gold-edged scarlet cape which lends thematic unity to the suite of pictures.

La Salle's spiritual advisor, Father Hennepin, is another figure who unifies the sequence because, wearing his brown Franciscan habit, he inevitably raises his cross to bless each new discovery. *Father Hennepin at the Falls of St. Anthony* shows what an incredible visual memory Catlin had. Working in Paris in 1847, the artist had last visited this site eleven long years before. Even so, any resident of modern Minneapolis can recognize the island in the Mississippi's midst. As usual, Catlin employed free brushwork for the majestic spaciousness of the landscape but used a tight linearity to accent the foreground action.

Having documented the North American Indians wasn't enough for Catlin. From 1853 to 1858, he took three trips to South America to depict the natives there. He also sailed up the Pacific Coast of North America to Siberia to compare the Asian versus the Alaskan Eskimos. An Argentine adventure of 1856 inspired *Ostrich Chase, Buenos Aires—Auca.* In one of his numerous journals, Catlin wrote, "I have joined in the buffalo chase in all its forms, but never before took part in a chase so difficult as this. After the brood was separated, they ran in all directions, darting in zig-zag and curved lines before and around us." Catlin exaggerated the awkward postures of the horses and rheas, or American ostriches, to convey the disorder of this hunt under a blazing sunset.

In spite of his engaging personality and public popularity, Catlin had not been able to find investors in his grand scheme for a "Museum of Mankind." Objects of intense curiosity before the Civil War, Indians became undesirable when the Far West opened to settlement by farmers, ranchers, and miners. The driving of the Golden Spike at Promontory Point, Utah, in 1869, linking the East and West Coasts by railroad, signaled the systematic removal of the Indians. Catlin sold very little, and his dying concern was, "What will become of my Gallery?" Ironically, its financial failure ensured that the pictures would stay together in large groups as they passed through bankruptcy sales or to the artist's heirs.

George Catlin *1796–1872*
Catlin Painting the Portrait of Mah-to-toh-pa—
Mandan *1857/1869*
Cardboard, 15⅜″ x 21⅞″
oval
Paul Mellon Collection

FRANCIS WILLIAM EDMONDS

1806–1863

His contemporaries called Francis William Edmonds "probably the most prominent amateur painter which the country has produced." A New York City banker of Quaker upbringing, Francis William Edmonds first exhibited under the pseudonym E. F. Williams, to protect his financial and religious reputations. He attended night classes at the National Academy of Design and got up at the crack of dawn to paint before the bank opened. Edmonds, a regular contributor to Academy exhibitions after 1837, was an amateur only in the sense that he had another full-time occupation in his banking. His refined depictions of daily life, literature, and folklore won him hearty acceptance in the top ranks of American art. Edmonds' interior scenes derived both their humorous mood and their structured compositions from seventeenth-century Dutch genre paintings.

After his first wife died unexpectedly, Edmonds spent eight months studying art in Europe. Upon his return in 1841, he remarried. *The Bashful Cousin,* painted around the time of Edmonds' second marriage, may be partially autobiographical since it depicts a demure young lady entreating a shy bachelor to stay for tea. Meanwhile, the girl's mother harangues her husband to stop reading and to help entrap this eligible suitor. The father's disinterested absorption in his newspaper and saucer of tea is matched on the far left by a dog slinking out the door with his tail between his legs. The symbolic placement of the hound just beside the bachelor, who is equally anxious to go, has theatrical overtones. In fact, the whole design is theatrical. Edmonds organized the space into a series of retreating rectangles much like stage scenery, and careful spotlighting illuminates the actors. The young couple stands in the light from the door; a beam from the window picks out the mother and father; and a sunset through the kitchen window backlights the black servant.

Several of the anecdotal details here seem inspired by *The Dutchman's Fireside,* a novel published in 1831 by James Kirke Paulding. Paulding's popular tale tells of a shy and scholarly youth who, when introduced to a distant female relative, "stood twirling his hat, immersed in a chaos of conflicting feelings." But Edmonds conceived of his pictures first as refined artistic designs and only secondarily as narrative anecdotes. The landscape painter Charles Lanman recalled being invited to dinner by Edmonds: "He took me

George Catlin *1796–1872*
Father Hennepin at The Falls of Saint Anthony *1847/1848*
Canvas, 14⅞" x 22⅛"
Paul Mellon Collection

into his studio and exhibited to me his picture of *The Bashful Cousin*, which was all finished excepting the head of the leading figure; and then telling me that he knew all about my innate bashfulness, asked me to help him in his work. I accordingly stepped out upon the floor to the proper distance, looked as sheepish and frightened as possible, and in a very short time the deed was done." Lanman's comment is proof that Edmonds constructed his settings, posed his characters, and carefully lit the action before worrying about minor elements such as comedic expressions.

JOHN QUIDOR

1801–1881

Washington Irving published *The Sketch Book* serially in London and New York in 1819 and 1820. Its charming folktales immediately captivated readers on both sides of the Atlantic. John

Quidor, born in Tappan, New York, near Irving's country, portrayed the homespun humor of these stories better than any other artist. Indeed the painter's renditions have become inseparable in the popular mind from the original tales. Quidor, however, exaggerated the sly humor of Irving's characters into robust caricatures. In Quidor's *The Return of Rip Van Winkle* (see page 100), for example, the dwarflike children who mock the old man recall the strange antics of Henry Hudson's enchanted crew who had drugged Rip to sleep twenty years earlier.

Quidor accurately interpreted the colonial town in the Catskills as brick houses with stepped, or Dutch-gabled, rooflines. But for Rip, who had slept through the Revolutionary War, everything else in his hometown had changed. A fluttering flag bore "a singular assemblage of stars and stripes," while the familiar face of King George on the tavern's swinging sign had been altered to that of an unknown General Washington. On an election day, handbills filled pockets and littered the street. Their messages—"rights of citizens, Bunker's Hill, Seventy-six"—bewildered Rip. Finally, he pleaded, "Does nobody here know Rip Van Winkle?" Someone cried out that he was the lazy, ragged youth "leaning against the

George Catlin *1796–1872*
Ostrich Chase, Buenos Aires—Auca *1856*
Canvas, 18⅝″ x 25¾″
Paul Mellon Collection

tree." Compounding the confusion, a young mother, seen at the far right, soothed her crying child by saying, "Hush, Rip, . . . the old man won't hurt you." This riddle of identities was due to the fact that the young man was Rip's son and the baby his grandchild. Hobbling up on her crutch, an old woman peered at the stranger and exclaimed, "Sure enough! It is Rip Van Winkle . . . where have you been these twenty long years?"

Quidor, a highly inventive artist, lent extraordinary animation to his scenes. Thick strokes of pure white pigment gleam as highlights against the tawny, golden colors. The free, loose brushwork generates a vibrating surface texture perfectly matched to the undulating, almost curlicue, contours. The painter's strong, vigorous character pervades the entire canvas. Quidor's obsession with depicting Rip Van Winkle, who stubbornly defies the narrowminded townspeople in his search for his identity, has been inter-

preted as representative of the artist's own search for acceptance.

Quidor's personality must have clashed with that of his teacher, the New York portraitist John Wesley Jarvis, because their four-year relationship ended with a bitter lawsuit in 1822. Although he occasionally exhibited pictures of literary themes at the National Academy of Design, Quidor earned his living by producing signs, banners, and decorative panels for fire engines. From about 1837 to 1850, he seems to have resided in Illinois, where he farmed and dabbled in land speculation, as well as painted. Ultimately, he gave up his art.

Now recognized as one of America's most original painters, Quidor had little impact on his contemporaries. In the late nineteenth century, however, the mystic Albert Pinkham Ryder seems to have been somehow influenced by Quidor's rich textures, unified colors, curving forms, and romantic moods.

Francis William Edmonds *1806–1863*
The Bashful Cousin *c. 1842*
Canvas, 25" x 30"
Gift of Frederick Sturges, Jr.

5

PORTRAITISTS OF THE MATURE REPUBLIC

In the derivation of their techniques and formats from artists of colonial and federal times, the portraitists of the mature republic represent the first generation of American painters who could achieve sophistication at home. The efforts of earlier artists such as Pine, Peale, Savage, and Trumbull to establish academic curricula or exhibition halls had taken root. In 1802, the American Academy of Fine Arts had been formed by New York businessmen interested in collecting art. The National Academy of Design, begun by artists in 1825, dedicated itself to exhibiting contemporary works to its New York audience. Philadelphia's urbane Pennsylvania Academy of the Fine Arts, opened in 1805, enjoyed a more serene continuity than its Manhattan counterparts. Throughout the land, patrons and painters returning from Europe realized the value of regular exhibitions in elevating public tastes and the importance of training schools to teach students. Cincinnati, Ohio, had an Academy of Painting and Drawing by 1812—seven years before it incorporated as a city!

As the economy leapt upward from the days of colonial taxation, more and more potential clients acquired the hard cash to have their likenesses made by society portraitists. Thomas Sully, in particular, became *the* artist to be "done by." But, just as this cultural bubble inflated, it burst, as mechanical reproduction began to intrude on the place held by painting. A Philadelphia magazine published the first American lithograph in 1819, exactly two decades after this printing technique had been patented in Germany. While other methods for mass reproduction, whether carved into wood or etched into metal, have limited printing spans before constant crushing in the presses erodes the printable image, lithography, based on chemical principles, is easily executed and almost inexhaustible. By the mid-1800s, scores of lithographic firms like Currier and Ives were churning out reasonably priced illustrations and portraits.

Another technical innovation also superseded painted likenesses. European experimenters had tried to obtain an image by fixing rays of light permanently onto a surface. The method that worked best was devised by Louis Daguerre of France. Announced in the spring of 1839, the daguerreotype process soon reached the United States via publications. By that fall, Samuel Morse, the American artist-inventor who had witnessed Daguerre's demonstrations in Paris, returned to this country to promote the new photography. The cry immediately arose, "From this day forward, painting is dead." Photography didn't kill painting, however; it simply took over the mundane task of recording ordinary appearances.

By the mid-nineteenth century, the function of the oil portrait as a social document had vanished. Friends and families could afford photographs of each other at only a fraction of the cost of a painting. And the famous had their features available cheaply in lithographic prints, newspapers, and magazines. Freed from having to communicate factual data, later painted likenesses, such as those by James McNeill Whistler, John Singer Sargent, or Thomas Eakins, tell more about the artists' personalities than they do about the sitters' faces.

JOHN WESLEY JARVIS

1781–1840

Born in England, John Wesley Jarvis arrived in Philadelphia while still a child. He studied under the engraver and painter Edward Savage from 1796 to 1801. When barely out of his own apprenticeship, Jarvis taught Thomas Sully briefly and later fought violently with another pupil, the genre artist John Quidor. Jarvis drank heavily, dressed peculiarly, and lived in unkempt clutter.

One of Jarvis' first important works is *Thomas Paine*. The English pamphleteer whose *Common Sense* helped spark the American Revolution had returned to the United States in disgrace in 1802. Now branded an atheist and a radical, the infirm seventy-year-old patriot roomed with Jarvis in 1806–1807 in New York. As neither was precisely neat in habit, artist and sitter got along well. "I have had Tom Paine living with me for these five months," wrote Jarvis,

84

adding, "he is one of the most pleasant companions I have met with for an old man." Attesting to the scrupulous realism common to early American taste, the portrait reveals piercing eyes, thinning hair, and an enlarged red nose.

Since his brutal honesty was much more suited to men than to women, it was from military portraits that Jarvis earned and squandered a fortune. A rival artist called his life "a chaos hastening to destruction." Eventually, Jarvis' intemperance led to a paralytic stroke; he died destitute.

THOMAS SULLY

1783–1872

For the half century from the War of 1812 until the Civil War, portraitists in the United States measured themselves against the standard set by Thomas Sully. One of those gifted with the ability to make the difficult look easy, Sully dashed off portraits or whipped up patriotic tableaux with equal facility. Born in England to a theatrical family, Thomas Sully came to Charleston, South Carolina, in 1792 when his father and mother moved their thespian company to America. The nine-year-old grew up in a world of melodramatic postures and eloquent language; theatrical flash and verve characterize his painting, but they did not influence his quiet, well-disciplined life. Possibly because as a child he apprenticed to an insurance firm, Sully maintained the most astonishingly complete business records of any American painter prior to the twentieth century, with its typewriters and photocopiers. Sully's *Register* lists names, places, fees, sizes, and precise starting and ending days for each picture. By his own reckoning, Sully produced 2,631 paintings, of which 2,017 were portraits, during his eighty-nine-year life.

His early artistic training was spotty; he took lessons from Henry Benbridge in Norfolk, Virginia, worked with Jarvis in New York City, and observed the methods of the aged master Gilbert Stuart in Boston in 1807. By 1809, he'd saved enough from his portrait commissions to spend nine months in England. Sully showed a picture to Benjamin West, the American-born dean of British art. "He looked at it dubiously, and asked me whether I understood anatomy or osteology, and upon my confession that I did not, he set me to work studying these." The kindly West also advised the twenty-six-year-old to "go about and see whose portraits you like best." He liked those of Sir Thomas Lawrence, England's most fashionable painter. Sully cleverly adopted Lawrence's liquid oils and langorous poses to his own penchant for theatrical effects.

Joseph Dugan, painted in 1810, the year of Sully's return to Philadelphia, demonstrates the artist's new-found flair for conveying personality. The wealthy shipping magnate and patron of Catholic charities positively slouches in his chair. One arm hooks over the chair's back, while the other hand toys foppishly with a

86

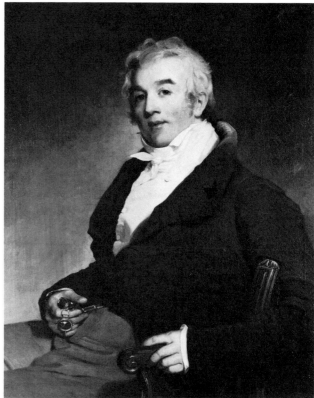

Top: **John Wesley Jarvis** *1781–1840*
Thomas Paine *c. 1806/1807*
Canvas, 25¾" x 20½"
Gift of Marian B. Maurice

Above: **Thomas Sully** *1783–1872*
Joseph Dugan *1810*
Canvas, 36⅛" x 29"
Gift of Herbert L. Pratt

jeweled watch key and fob. Dugan turns inquisitively toward the viewer as though to greet someone who has just arrived at a social gathering. Such engaging intimacy would have left Copley, Stuart, and West aghast; theirs was an earlier, more staid time. After the Revolution, however, an almost cocky self-assurance entered the American atmosphere. Sully was just the right man to render this air of nonchalance.

In *Captain Charles Stewart* (see page 101), a smoldering color scheme of fiery ambers complements the golden epaulettes, braid, and sword decorations, and heightens the auburn hair. The blue of the naval uniform has been darkened to black so as not to fight the warm hues elsewhere. Sully masterfully manipulated the dashing outfit into contrasting patterns of light and dark throughout the composition. The bright white stockings and breeches stand out against the shaded room, but a shaft of sunlight on the wall accentuates the cocked elbow. This vigorous stance betrays Stewart's years of active duty; the thirty-two-year-old captain braces his feet apart as though standing on a rolling deck. The assertive posture, most unexpected in a Grand Manner formal portrait, expresses his commanding presence, as does his thumb, aggressively pressing down on a chart.

In the summer of 1813, the year after this portrait was finished, Captain Stewart took command of the *Constitution*. That frigate had already acquired her nickname of "Old Ironsides" when a British cannonball had bounced off her sturdy oak hull. Since neither man nor ship ever lost a battle, the soubriquet "Old Ironsides" identifies both. Having won several early victories over French privateers, Stewart commissioned this painting as a gift for his widowed mother. Half a century later, Sully recalled the occasion: "The most patient sailor I ever painted was 'Old Ironsides,' then Captain Stewart. This was my first full-length portrait. He called to arrange the time for a sitting, and was just going away when I said to him, 'But, Captain, you have not told me the size.' 'Oh,' he replied, 'the old woman wants me, and she shall have me altogether.'" Stewart's cavalier manner had evidently so impressed Sully that the artist's memory became faulty: *Captain Charles Stewart* was actually the painter's second full-length, life-size likeness.

The modishly dressed girl in *Lady with a Harp: Eliza Ridgely* appears dreamily lost in reverie. She rests a hand, holding a tuning key, on her imported English harp while treading absentmindedly on a pedal. Her shimmering white satin gown is a tour de force of oil painting; Sully slathered on his pigments as though they were cake frosting. This artifice of texture was ideally suited to this romantic era, as was the elongation of her limbs. Eliza becomes, in Sully's hands, the epitome of feminine grace, her body seeming to waft in the breeze. Yet, if one actually saw a woman with fingers that slender, arms that long, and thighs that endless, one would pity her. That Sully deceived the viewer into accepting these deliberate anatomical distortions is a triumph of poetic or artistic license.

Sully's distinctive use of poses calls to mind his instruction, "When the person calls on you to make arrangements for the intended portrait, observe the general manner, etc., so that you may determine the attitude you had best adopt." One can imagine "Old Ironsides" swaggering into Sully's studio or the demure Eliza pluck-

ing idly at her parlor harp while her parents negotiated with the artist. In a single instant, Sully perceived and captured their true characters.

Fifteen years old when Sully made her the personification of gentle innocence, Eliza Eichelberger married ten years later into the family which Charles Willson Peale had depicted in *Benjamin and Eleanor Ridgely Laming* (see pages 52–53). Eliza's marriage made her mistress of Hampton, an impressive estate outside Baltimore, and daughter-in-law of a former Maryland governor. Sully's *Governor Charles Ridgely of Maryland* depicts Eliza's father-in-law at age sixty. As he leans an elbow on the table, the governor appears to swerve and rise up, asserting his strength. Here again, Sully followed his own advice: "The color of the background should be either darker or lighter than the head or drapery." The tone of the wall, for instance, grows darker behind the head to silhouette the pure white hair.

Sully worked with efficient rapidity. His *Register* proves that even a canvas involving three likenesses and a genre scene, *The Sicard-David Children* (see page 95), was completed in the less than three weeks from April 26 to May 16, 1826. Very few artists ever work that quickly, and one must not assume that even Sully was always this fast. But Sully was accused in his own time of being superficial on occasion, of staying within the limits of a formula he understood well. In the detail of *The Sicard-David Children* at the beginning of this chapter the viewer may sense Sully acting by rote to depict this Philadelphia family of a French émigré. Baby Stephen has toes so fat they belong on a cupid; toddler Ferdinand displays perfect pudginess in his infant hands; and sister Julia holds her tapering fingers in an affected gesture much too mature for her age. It was often the incidental elements that challenged Sully; the staircase group in the distance here is a masterpiece compared to the idealized generality of the children. With deft strokes of his brush, Sully communicated the young ladies' whispered conversation on the steps and conveyed the intricate lighting effects flooding in from a lower parlor and filtering down from above.

The older he got, the more Sully fell into repeating his elegant simplifications. "From long experience I know that resemblance in a portrait is essential; but no fault will be found with the artist, (at least by the sitter,) if he improve the appearance." *The Coleman Sisters* sums up the benefits and problems of Sully's flattery. With their oval countenances, swan necks, pagoda shoulders, and boneless wrists and fingers, the eligible maidens are transformed into fashion plates. Isabel, standing to the left in pale blue, flirts with the viewer; in butter yellow at center, Sarah acts the mother to her sisters; Margaret, seated and wearing lavender, appears the stern, thoughtful one. Yet, somehow, one feels that these personalities are social masquerades, that the women's true depths of character have been sacrificed for a pleasing arrangement of pastel tints and curling arabesques in limbs, shawls, and hair ringlets. It was the small glass vase with five kinds of flowers that intrigued Sully. Brilliantly painted, that still-life accessory has more life than the humans do.

Aware that his innate talents often led to facile, shallow repetition, Sully chose sitters with whom he could empathize. His unfinished, 1845 version of Andrew Jackson represents a consummate

An itinerant, untutored artist, he learned so rapidly that he purportedly stole eighty sitters from Gilbert Stuart in six months. Staying in England from 1823 to 1826, Harding fell under the glossy influence of Sir Thomas Lawrence, as Sully had done two decades previously.

One of New England's most prolific portraitists, Harding created *Charles Carroll of Carrollton* while on a trip to Baltimore in 1828. Soothing, warm light sets off the frail face, bracketed by the glaringly white hair and collar. Even the marking of a place in the book draws attention to the gnarled, bony hands. The prominent Maryland sitter wrote a relative, "A Mr. Harding has lately drawn my portrait, a most striking likeness of me in the ninety-first year of my life, the countenance with little meaning, the eyes dim and dull." As the last surviving signer of the Declaration of Independence, Carroll wasn't criticizing Harding's portrayal but only his own advanced years.

Harding's unflinching, backwoods honesty even marks *Amos Lawrence* (see page 94), one of his rare Grand Manner portraits. Though the floral carpet, damask curtain, and classical column are traditional, a convalescent chair equipped with castors and a sliding footrest falls decidedly outside the formal heritage. Lawrence, however, was an invalid. So, Harding depicted him in the paisley robe, velvet cap, and flower-embroidered slippers he usually wore at home instead of the dignified attire he could have donned. The geometry of the room and furnishings creates a foil for the limp curves of Lawrence's resting body. And the hot scarlets in the fabrics overpower him, causing the figure to become even more recessive. Illness had forced Lawrence, a textile manufacturer, to retire from business in 1831. He devoted the rest of his life to philanthropy, being exceptionally munificent to Williams College in Williamstown, Massachusetts. Harding wrote, "My full-length of Amos Lawrence I consider the best thing I have ever done in my whole artistic career." Fault can be found with the work. Harding didn't have enough academic training to deal correctly with the whole figure; there is some awkwardness, for example, in the crossing of the legs and the position of the feet. But regardless of minor flaws in anatomical accuracy, this painting exudes the straightforward candor which caused London and Boston society alike to lionize Chester Harding.

blend of fact and flattery. Though the lion's mane of blond hair and the classical nose are certainly idealized, they did exist. It may not be an exact record of the seventh president just before his death at seventy-eight, but *Andrew Jackson* shows what the American public, then as now, had grown to believe "Old Hickory" looked like. Such generosity, in his art and in his manners, won Sully an affectionate clientele and devoted students right up to the time of his death.

CHESTER HARDING

1792–1866

A true frontiersman, Chester Harding labored as a farmer, sign painter, chairmaker, saloonkeeper, woodsman, and peddlar from New Hampshire to Kentucky. This tall, muscular man wryly admitted his homemade spirit by titling his memoirs *My Egotistiography.*

Thomas Sully *1783–1872*
Lady with a Harp: Eliza Ridgely *1818*
Canvas, 84⅜" x 56⅛"
Gift of Maude Monell Vetlesen

SAMUEL FINLEY BREESE MORSE

1791–1872

A Yale graduate with conflicting interests in art and science, Samuel Finley Breese Morse stated, "I cannot be happy unless I am pursuing the intellectual branch of art. Portraits have none of it; landscape has some of it; but history has it wholly." Regardless of his grandiose aspirations, the American public didn't have the least interest in his renditions of historic episodes, so Morse reluctantly turned to portraiture, which, though lucrative, he disdained. *Portrait of a Lady* demonstrates Morse's meticulous training under

An Early-Nineteenth-Century Color Portfolio

John James Audubon *1785–1851*
Arctic Hare *c. 1841*
Pencil, watercolor, ink, and oil on paper, 24½ ″ x 34¼ ″
Gift of E. J. L. Hallstrom

George Catlin *1796–1872*
La Salle's Party Feasted in the Illinois Village *1847/1848*
Canvas, 14⅞" x 22⅛"
Paul Mellon Collection

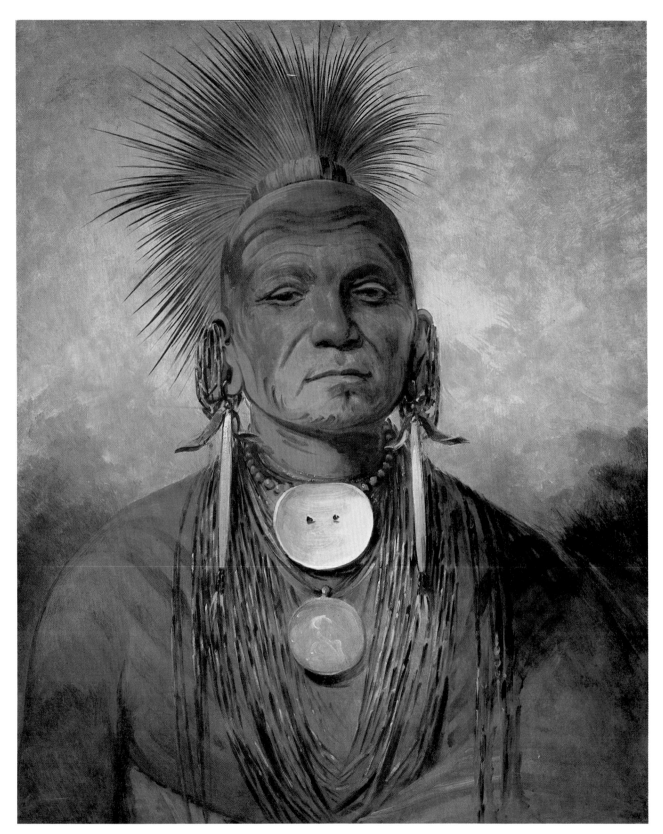

George Catlin *1796–1872*
See-non-ty-a, an Iowa Medicine Man *c. 1845*
Canvas, 28" x 22⅞"
Paul Mellon Collection

91

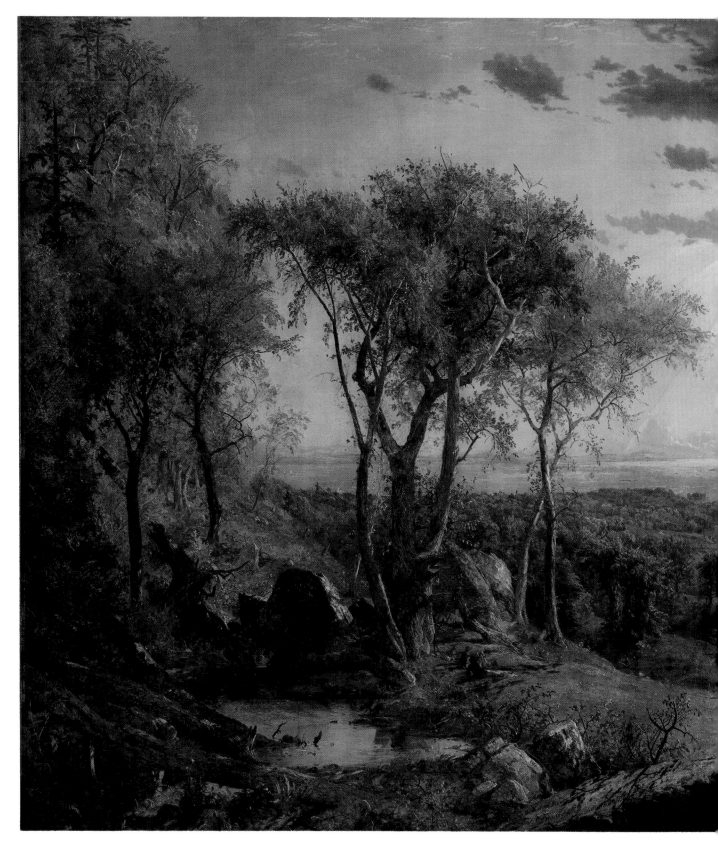

Jasper Francis Cropsey *1823–1900*
Autumn—On the Hudson River *1860*
Canvas, 60″ x 108″
Gift of the Avalon Foundation

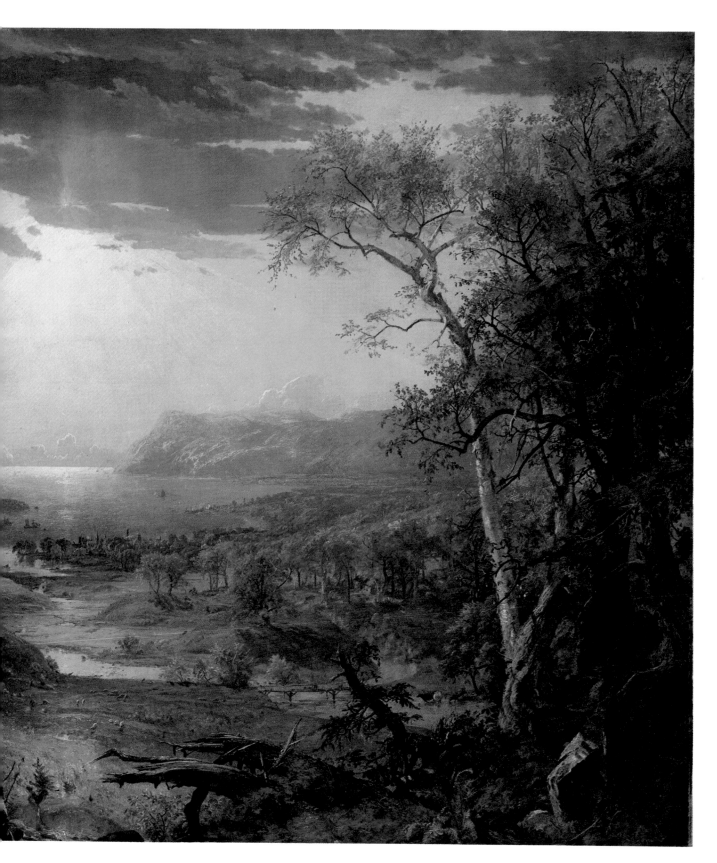

Chester Harding *1792–1866*
Amos Lawrence *c. 1845*
Canvas, 84 5/8 " x 54"
Given in memory of the Rt. Rev.
William Lawrence by his children

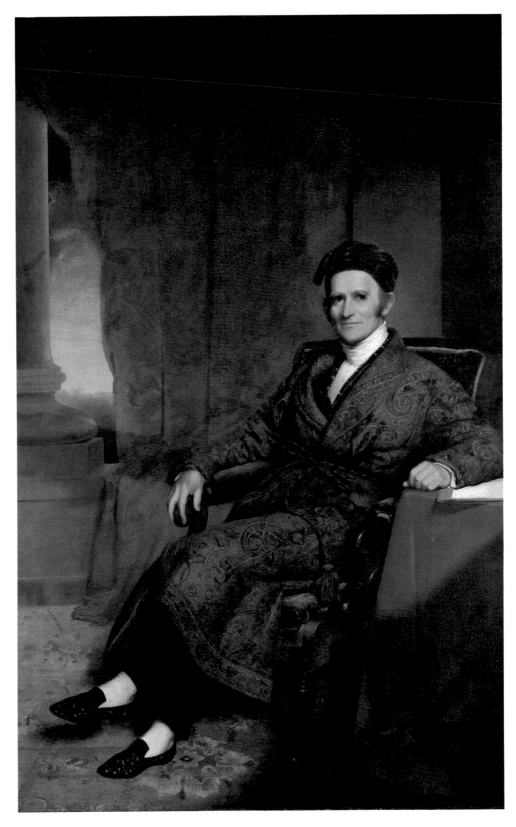

94

Thomas Sully *1783–1872*
The Sicard-David Children *1826*
Canvas, 34¼" x 44¼"
Gift of Chester Dale

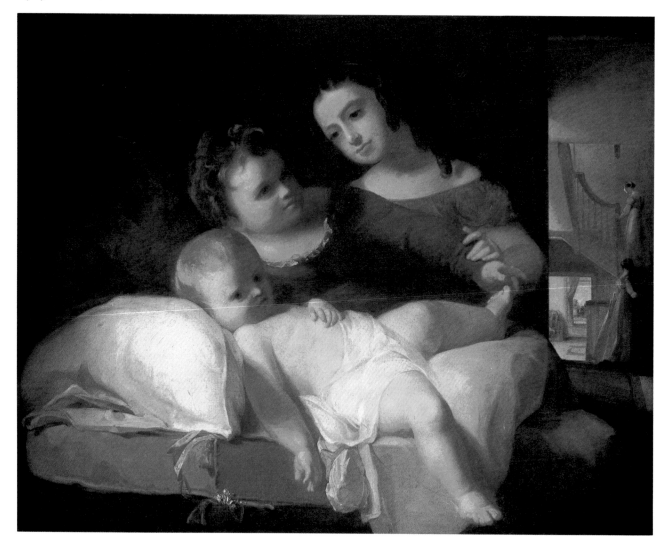

96

Top: **Thomas Cole** *1801–1848*
The Voyage of Life: Childhood *1842*
Canvas, 52 7/8 " x 76 7/8 "
Ailsa Mellon Bruce Fund

Above: **Thomas Cole** *1801–1848*
The Voyage of Life: Youth *1842*
Canvas, 52 7/8 " x 76 3/4 "
Ailsa Mellon Bruce Fund

Top: **Thomas Cole** *1801–1848*
The Voyage of Life: Manhood *1842*
Canvas, 52 ⅞ " x 79 ¾ "
Ailsa Mellon Bruce Fund

Above: **Thomas Cole** *1801–1848*
The Voyage of Life: Old Age *1842*
Canvas, 52 ½ " x 77 ¼ "
Ailsa Mellon Bruce Fund

Fitz Hugh Lane *1804–1865*
Lumber Schooners at Evening on Penobscot Bay *1860*
Canvas, 24⅝" x 38⅛"
Andrew W. Mellon Fund and Gift of Mr. and Mrs. Francis W. Hatch, Sr.

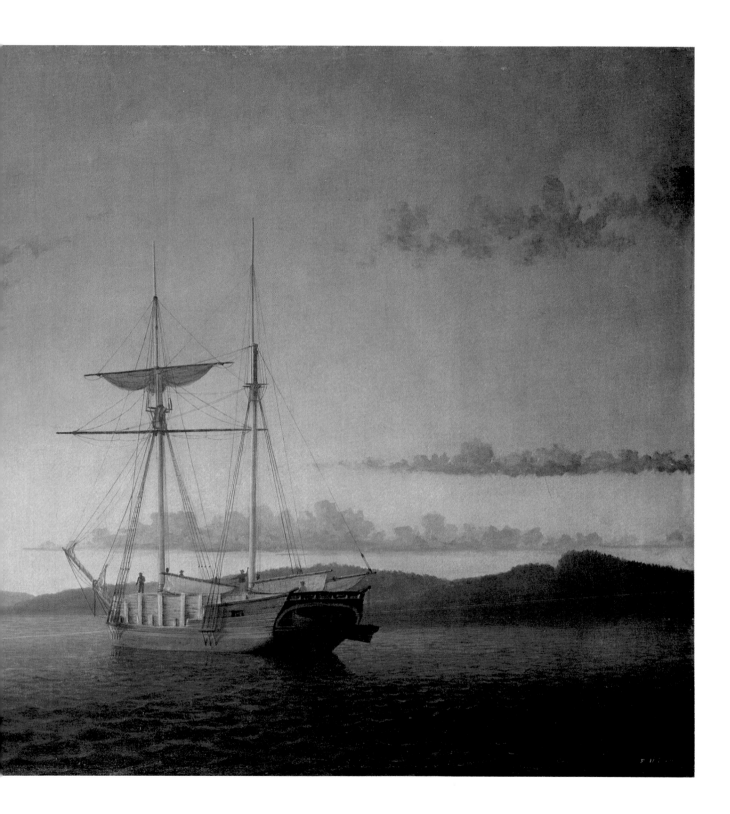

John Quidor *1801–1881*
The Return of Rip Van Winkle *c. 1849*
Canvas, 39 ¾ " x 49 ¾ "
Andrew W. Mellon Collection

Thomas Sully *1783–1872*
Captain Charles Stewart *1811–1812*
Canvas, 93¼ " x 58¾ "
Gift of Maude Monell Vetlesen

Frederic Edwin Church *1826–1900*
Morning in the Tropics *1877*
Canvas, 54 ⅜ " x 84 ⅛ "
Gift of the Avalon Foundation

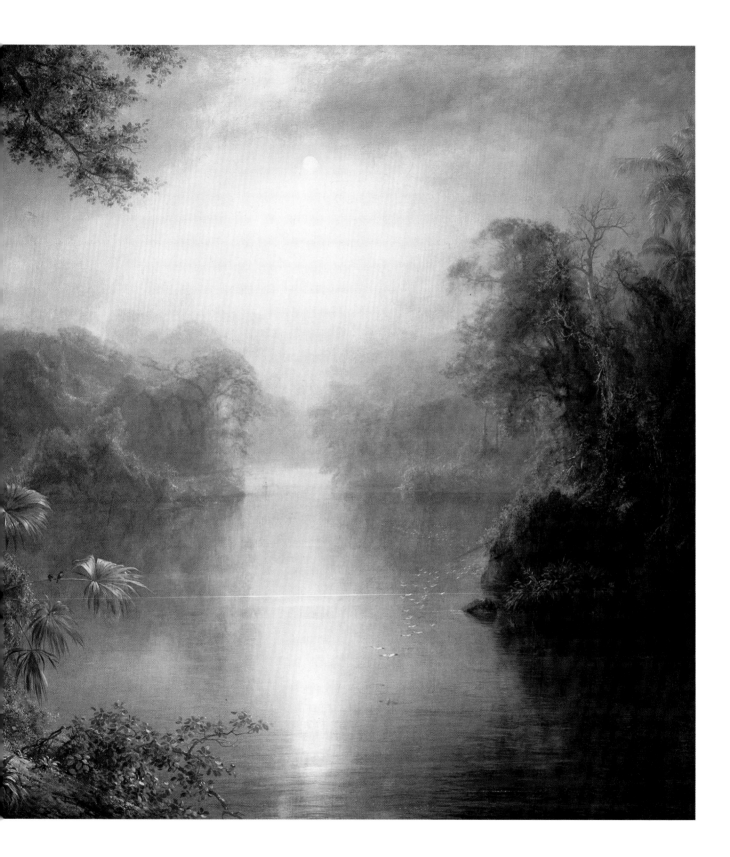

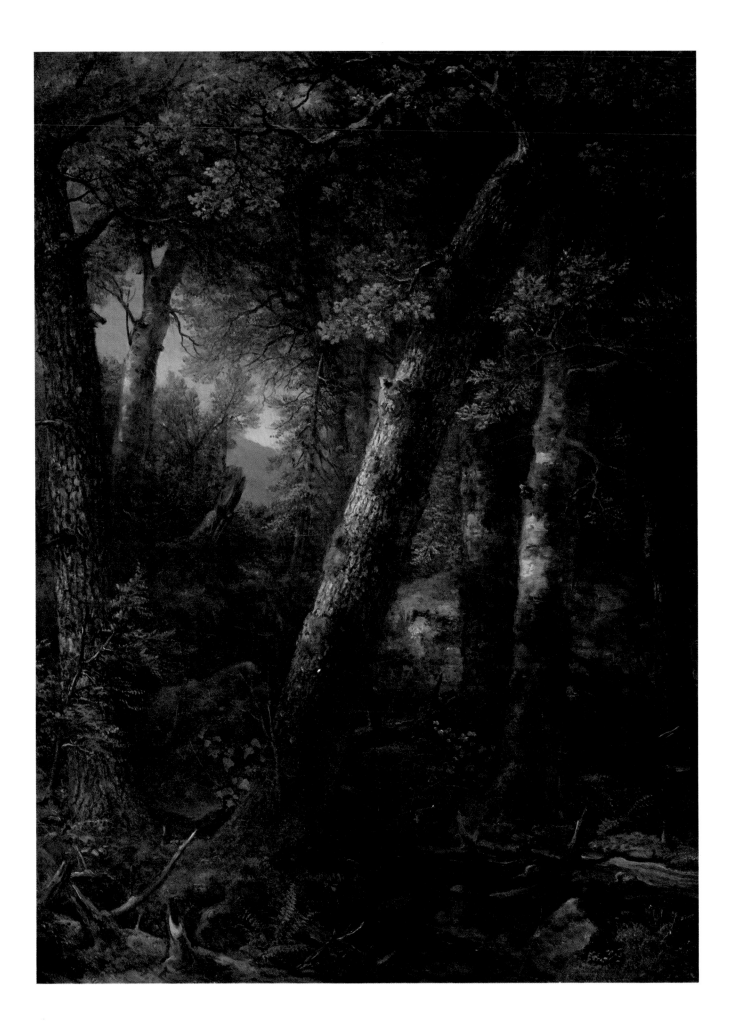

Benjamin West in London from 1811 to 1815. The drawing is lucid in detail, the anatomy almost surgically correct, and the gesture of touching her cheek not only expresses the sitter's thoughtful personality but also plays up her wedding band. The fluffy, ribboned bonnet, perhaps too girlish for such a pleasantly mature face, suggests the unknown woman's bubbliness.

Few people remember that Samuel F. B. Morse was once one of America's leading painters, but everyone has heard of the Morse Code. His invention of the telegraph in 1844 has even overshadowed his importance as the principal introducer of photography to America in 1839. Although the financial success of his scientific endeavors would have allowed him to paint anything he wished, the frustrated artist-scientist simply abandoned painting altogether. He wrote his friend, the novelist James Fenimore Cooper, "Painting has been a smiling mistress to many, but she has been a cruel jilt to me. Will you believe it? When last in Paris, in 1845, I did not go into the Louvre, nor did I visit a single picture gallery."

JOHN NEAGLE

1796–1865

John Neagle married Thomas Sully's stepdaughter, and this family connection virtually explains Neagle's artistic style. Rich paint textures and careful positioning of tonal areas, derived from his father-in-law, characterize Neagle's *Colonel Augustus James Pleasonton*. The light in the smoke-filled sky creates a foil to the flowing sideburns and hair, just as the gleaming epaulettes and braid contrast to the dark dress uniform. A retired artillery officer who had become a lawyer, the thirty-five-year-old colonel shows no concern as he leans on a cannon muzzle. Military experience and common sense to the contrary, this dangerous pose was customary for incorporating emblems of warfare into portraits. Just as the painter was the son-in-law of Thomas Sully, so the sitter was the husband of Clementine Dugan, who had been reared by her bachelor uncle, the wealthy merchant Joseph Dugan, portrayed by Sully thirty-five years earlier. Close family ties, rather than mere coincidence, probably explain the connections between two artists and two subjects.

REMBRANDT PEALE

1778–1860

Charles Willson Peale named many of his children after famous Old Masters, such as the seventeenth-century Dutch genius Rembrandt. His father's favorite pupil, Rembrandt Peale painted so well that Napoleon Bonaparte once offered him a position as court artist. A devoted son, Rembrandt managed the Peale family

Thomas Sully *1783–1872*
Governor Charles Ridgely of Maryland *1820*
Canvas, 50" x 40"
Gift of Mr. and Mrs. John Ridgely

museum and dedicated himself to carrying on his father's memory by turning out thirty-nine copies of George Washington's portraits by Charles Willson Peale. Rembrandt also did sixteen of his own portraits of Washington, painted from life in 1795. Not satisfied, he tried again: "I determined in 1832 to make a *last effort*; and in an excitement even beyond the 'poetic frenzy,' which controlled me during three months to the exclusion of every other thought, . . . I succeeded." The result—known as the "Port Hole Washington"—was judged the best likeness ever done of the Father of His Country. Rembrandt stated that he filled orders for seventy-nine copies of the original, now in the White House. The National Gallery's late version is today considered among the best.

The popular term "port hole" is a misnomer. Washington is shown enshrined in history's oval niche, which preserves so many figures for posterity. The treatment is thoroughly French in its sculpturesque solidity and its attention to clean, geometric precision. The forehead, nose, and collar look for all the world as though they are arcs drawn with a compass. A far cry from the piercing

Asher Brown Durand *1796–1886*
Forest in the Morning Light *c. 1855*
Canvas, 24¼" x 18¼"
Gift of Frederick Sturges, Jr.

Thomas Sully *1783–1872*
The Coleman Sisters *1844*
Canvas, 44¼" x 34½"
Gift of William C. Freeman

Chester Harding *1792–1866*
Charles Carroll of Carrollton *c. 1828*
Canvas, 35⅞" x 27⅞"
Gift of Mr. and Mrs. Alexander Dallas Thayer

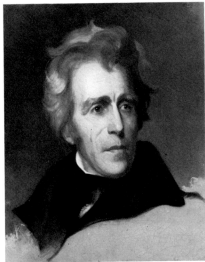

Thomas Sully *1783–1872*
Andrew Jackson *1845*
Canvas, 20⅜" x 17¼"
Andrew W. Mellon Collection

John Neagle *1796–1865*
Colonel Augustus James Pleasonton *1846*
Canvas, 36¼" x 29⅛"
Gift of Eugene S. Pleasonton

Samuel Finley Breese Morse *1791–1872*
Portrait of a Lady *c. 1825*
Canvas, 30" x 25¼"
Gift of Chester Dale

106

analysis of Stuart or the straightforward recording of Savage from a half century before, Rembrandt Peale's idealized *George Washington* proves that the country had deified its founders.

GEORGE PETER ALEXANDER HEALY

1813–1894

George Peter Alexander Healy's story is that American dream of going from rags to riches through sheer pluck. The son of an impoverished sea captain, Healy, with Thomas Sully's early encouragement, became the paramount international society portraitist of the mid-1800s. His only respite from a heavy work load portraying the crowned heads of Europe and the magnates of American industry was aboard ships. With thirty-four Atlantic crossings to his credit, Healy had time to relax. When meeting European royalty, Healy said, "It was agreed that, in my character of an American republican, I might dispense with all ceremony."

Cleverly, he turned that around for Americans and greeted them with the continental sophistication they craved.

Roxanna Atwater Wentworth portrays an Illinois beauty, the daughter of a newspaper publisher who owned more real estate in Chicago than any other man. Miss Wentworth, however, posed in Paris in 1876. Before a gray-green background, her brown hair, black dress, and alabaster complexion recall the subtle harmonies of an old daguerreotype grown life-sized. Healy's whole style was breathtakingly original: he applied the selective, flattering eye of the artist to the candid accuracy of a camera lens. It was this meticulous detailing, which carefully omits any undesirable quality, that made Healy rich and famous.

Healy stands at the end of a long line of professional portraitists. The artists in this chapter, whether rustic backwoodsmen or collegiate sophisticates, represent but a fraction of America's nineteenth-century portrait painters. Their battle against the cost-effective improvements in the camera was doomed. Significantly, it was Healy who, in 1870 in Rome, advised the young John Singer Sargent to take up painting. Sargent and his contemporaries would later turn the painted portrait into a vehicle of pure self-expression.

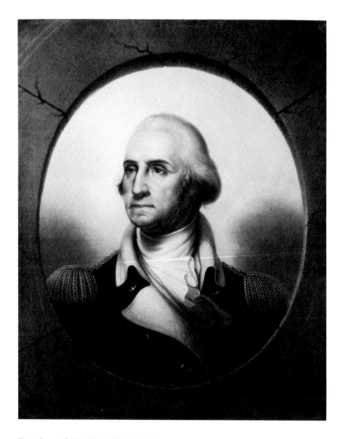

Rembrandt Peale *1778–1860*
George Washington *c. 1850*
Canvas, 35⅞" x 28⅞"
Gift of Mr. and Mrs. George W. Davison

George P. A. Healy *1813–1894*
Roxanna Atwater Wentworth *1876*
Canvas, 30¼" x 25"
Gift of Lady Vereker

6

LANDSCAPISTS OF THE NATIONAL PRIDE

Landscape replaced portraiture as the dominant subject matter of American painting by the mid-1800s. And scenery played an important role in all other aspects of nineteenth-century American art, from the songs of Stephen Foster to the city parks landscaped by Frederick Law Olmstead. Visualizing the locales of our early literary classics is an easy and enjoyable pastime: the settings of *Hiawatha, The Scarlet Letter, Moby Dick,* and *The Pathfinder* are as important as their characters. The philosophies of Emerson and Thoreau, moreover, amount to a spiritual communion with nature.

What generated this national obsession with forests and prairies, mountains and seas? In general, it was part of an international artistic movement and adoration of nature termed Romanticism. More specifically, landscape was the symbolic focus that a new country needed for its own self-identity.

Romanticism, beginning in the late eighteenth century, held that the contemplation and appreciation of nature, in all her aspects, could soothe and uplift the soul. An emotional response to the arts became mandatory: music tended to be lyric or explosive; poetry, sentimental or bombastic; novels, tearful or bloody. Landscape painting gave vent to similar feelings. Exotic, foreign, ancient, and imaginary views proliferated throughout the Western world.

European attitudes toward nature had polarized around two differing artistic personalities of the seventeenth century: the peaceable Claude Lorrain and the tempestuous Salvator Rosa. For more than two hundred years, the impact of Claude versus Rosa caused artists to depict the world as either a fruitful, man-dominated utopia or as a threatening, intimidating wilderness. The nineteenth-century Romantics deliberately overlapped these diametrically opposed ideas, thereby creating an emotional conflict in scenes which were simultaneously enticing and frightening. In England, varying attitudes toward this emotionalism are evident in the pastoral farms painted by John Constable, the wind-swept heaths depicted by William Turner, and the apocalyptic panoramas invented by John Martin. American painters and patrons were well aware of these trends abroad. By reading, by studying engravings, and most importantly by traveling on the inevitable Grand Tour of Europe, Americans fell under the spell of Roman ruins and Germanic castles, of the landscape paintings of their English contemporaries, and of the continental Old Masters.

In the United States, however, as nowhere in Western Europe, landscape assumed paramount artistic significance. The new nation, without a significant past, looked to the future, and the future meant exploitation of its great, untapped wilderness. In short, what America lacked in classical ruins it made up for in fresh grasslands; what it desired in fine traditions of music and literature, it possessed in timber and wildlife. The land became, to nineteenth-century Americans, a symbol of freedom and unlimited possibilities. Europe may have had its hoary culture, but Americans could easily assuage their inferiority complex by reveling in their unique resources.

This patriotic chauvinism grew in proportion to the country's expansion. In 1790, only a twentieth of our four million people lived away from the East Coast; by 1815, the population had exploded to eight and a half million, and one-fifth of them resided beyond the Appalachians! In 1825, the Erie Canal opened, linking the Eastern manufacturing centers to the raw materials and new markets of the Great Lakes and the Midwest. Pennsylvania and South Carolina constructed railroads in 1829; exactly thirty years later, iron rails reached across the Mississippi to tie the Missouri River into the country's trade routes. An 1845 editorial about the annexation of Texas maintained that it was "the fulfillment of our manifest destiny to overspread the continent." The time was ripe for the exaltation of landscape.

America's leading depictors of natural scenery demanded, and received, astronomical sums for their work. Many became gentlemen of leisure, inhabiting mansions furnished with objets d'art and antiques acquired on numerous international travels. Since the Hudson River and the New England mountains formed the wilderness most accessible from the larger cities, these regions became

Thomas Cole *1801–1848*
Detail of The Notch of the White Mountains (Crawford Notch) *1839*
Andrew W. Mellon Fund

metaphors for the taming of nature. Thomas Cole, America's pre-eminent early landscapist, said of the Hudson, "Its shores are not besprinkled with venerated ruins, or the palaces of princes; but there are flourishing towns, neat villas, and the hand of taste has already been at work." A malicious critic dubbed Cole and his followers the "Hudson River school," an inadequate term because it implies that they depicted solely that region. Yet these so-called Hudson River landscapists searched the world over and delved into their imaginations to portray a nature grander than any that ever existed. Their compositional formats retained the European tradition of bracketing a distant vista with flanking, large-scale foreground elements. But only painters who had experienced the nationalistic pride and the geographic vastness of the new United States could ever have created such vivid color schemes, such panoramic spaces, and such rich textures.

THOMAS DOUGHTY

1793–1856

Thomas Doughty was the first pure landscapist in the United States. He painted and sold vistas, exclusive of other subjects, at least five years before Cole or the other Hudson River artists. A native Philadelphian, Doughty apprenticed as a tanner. Dissatisfied with that career, he studied art for three months at a night school and sought the advice of the portraitist Thomas Sully. Doughty's entry into the art world as a landscape specialist must have been difficult. Between 1814 and 1820, his listings in the Philadelphia city directories seesaw back and forth from leather currier to painter.

By 1826, Doughty had earned enough to sail for Europe. He remained for three years and later traveled abroad twice more. In museums there, he saw the pictures whose influence is clearly apparent in his *Fanciful Landscape*. Painting it in Boston in 1834, Doughty probably refreshed his memory with engravings after the seventeenth-century masters' landscapes. The misty sunset and babbling cascade derive from Claude's placid serenity, while the ruined castles and ominous crags belong to Rosa's awesome majesty.

Repeating curves in the boulders and treetops converge tranquilly toward a lake at the middle of the canvas. Thus, a central course of empty space above the river lures the eye into depth. The sense of colossal scale is cleverly introduced by the miniscule travelers who trudge through this melancholy panorama. The nostalgic poignance of summer's end tinges the browning leaves and yellowing grass; high in the bleak mountains, icy blues and mauve grays warn of winter's approach.

The picture now called *Fanciful Landscape* may have been the one shown at a Boston exhibition in May 1834. In that show's catalog, a painting by Doughty entitled *Source of the Rhine* was accompanied by this descriptive poem, possibly written by the artist himself:

Above, the blue old Alps in grandeur rose,
Their glaciers bright with sunbeams . . .
Gray, crumbling Castles here and there were seen,
Relics of olden days and warlike pride . . .
Beneath, the golden waters of the Rhine
Began their course—fed by a thousand brooks

THOMAS COLE

1801–1848

Considered America's foremost early landscapist, Thomas Cole was actually born in England and did not immigrate to the United States until he was seventeen. As a youth, he apprenticed as a designer of calico textiles in the British manufacturing district of Lancashire. He occupied his spare time by reading the romantic poems of Byron and Wordsworth while wandering the English countryside. When his family moved from Philadelphia to Steubenville, Ohio, he remained behind to work as a woodblock engraver's assistant. A visit to the tropical West Indies in 1819 reinforced Cole's appreciation for nature's sublimity. Joining his family in Ohio, he taught art at a young ladies' seminary run by his sisters, designed wallpaper for his father's intended factory, and painted stage scenery for a drama society. These last two jobs apparently influenced his preference for rich, bold textures. As can be seen in the detail that fronts this chapter, Cole applied oil paint to his mature landscapes in a manner entirely consistent with his early training in fabric and wallpaper patterns, heavy woodblock printing, and emphatic theater sets.

Back in Philadelphia, at the Pennsylvania Academy of the Fine Arts, Cole's curiosity was piqued by the landscapes of Thomas Doughty. He moved to New York and continued his boyhood hobby of hiking, taking sketching trips up the Hudson River to the Catskill Mountains and painting the scenery. The making of a legend was in progress. A New York picture-frame dealer displayed three of Cole's Hudson River views in his window. Soon, an impressive committee of fashionable artists gathered outside the shop while Cole stood by like a bashful schoolboy. Cole's three oils were purchased, one apiece, by the three deans of American art: John Trumbull, the aged painter of Revolutionary War history; William Dunlap, a painter who was the biographer of early American artists; and Asher Durand, the country's paramount engraver. In a single afternoon, the unknown young Englishman was elevated to become America's major landscapist; the following year, 1826, he was elected a founding member of the National Academy of Design.

Such was Cole's fame that when he departed for a three-year trip to Europe in 1829, his friend William Cullen Bryant admonished him with this poem:

Fair scenes shall greet thee where thou goest
Gaze on them, till the tears shall dim thy sight,
But keep that earlier, wilder image bright.

Cole, hesitant himself lest European sophistication should spoil his art, answered Bryant with another rhyme:

> *Let not the ostentatious gaud of art*
> *That tempts the eye but touches not the heart*
> *Lure me from nature's purer love divine.*

In point of fact, however, Cole seldom depicted pure nature, for he believed, "A scene is rather an index to feelings and associations."

One of his greatest successes, *The Notch of the White Mountains (Crawford Notch)*, appears at first sight a gloriously accurate view of scarlet and gold foliage menaced by an approaching storm in New Hampshire. The empty clearing, stripped for future plantings, generates a vacuum propelling the viewer toward Mount Webster. Two ranges of bluffs converge upon the central location of Crawford Notch's narrow gap, which is further accentuated by the pale, silhouetting mist floating beyond it. A lone horseman approaches the way station at Crawford House while a barely perceptible stage-coach, having just left the inn, enters the gap. The majesty of nature defies these intrusions by puny mortals.

Comparison of the final oil painting with the actual site, as well as Cole's preparatory sketch in pencil and his reminiscences of an earlier visit, reveal interesting discrepancies between the painting and the place. The rift in Crawford Notch is not really as narrow as Cole painted it, nor does Mount Webster rear itself so high. Cole reduced the size of the buildings to make the cliffs loom larger, and he shifted the barn from its true location beside the inn in order to create a symmetrical framing of structures on either side of the chasm. Moreover, although the preliminary drawing was made on the spot in early summer of 1839, the painting displays flaming autumn trees. Cole's conception was based on his first trip to the area, eleven years before accepting the commission for this canvas from a New York businessman. Having then heard the local story of a family crushed beneath a rocky avalanche, Cole wrote, "The wind blew violently down the pass as we approached, and the gray, heavy clouds were rushing round the overhanging crags, as if contending which should sit upon the mountain throne." On another

111

occasion, Cole mentioned to Asher Durand, "I must wait for time to draw a veil over the common details, the unessential parts, which shall leave the great features, whether the beautiful or the sublime, dominant in the mind." In this case, an eleven-year distillation process turned a pleasant summer's sketch into a thrilling reminiscence of an autumn adventure.

The ubiquitous ax-cut stumps and skeletons of trees killed by cutting bands through their bark are a hallmark of the Hudson River school. Cole did not need to exaggerate the anthropomorphic image of dying trees as anguished hands clutching a death grip in the air. Their barren forms appalled the novelist Charles Dickens and other European visitors to the new United States. On the most obvious symbolic level, the stumps recall the transience of all life. To men like Dickens, however, they represented the worst form of progress in their slash-and-burn method for claiming the wilderness. Ultimately, and in a way difficult for modern Americans to understand, these pathetic trees stood for optimism, growth, and our manifest destiny. For Cole's contemporaries leaving to settle in the hinterlands, these lifeless trees conveyed man's ability to conquer the brutal forces of nature. Cole's picture, then, was both a hymn to God's awesome bounty and a prayer for protection from that awful wilderness.

When exhibited at the National Academy of Design in 1840, *The Notch of the White Mountains* received rave reviews: "This is truly an American picture. The boldness of the scenery itself, the autumnal tints which are spread over the forest, and the wild appearance of the heavens, gives it a character and stamp that we never see in foreign schools; and we pronounce the artist a master, without rival among his own countrymen."

Although his fame and fortune were based upon such transformations of natural wonders, Cole rebelled against being considered a "mere leaf painter." A Christian millenarian, he combined a profound pessimism about man's sinful self with a cheerful optimism about salvation after death. Cole therefore decided to elevate his audience with religious themes presented in natural guise. Among his several series of morally instructive landscapes was *The Voyage of Life* (see pages 96–97), four canvases portraying the vicissitudes of a Christian Everyman on his journey from birth to demise.

Cole had painted an earlier sequence on this theme in 1839–1840, but the owners placed such restrictions upon its public exhibition that the artist decided to create another set of his own. So, on a second European sojourn, rather than studying the antiquities of Rome, he produced the National Gallery's pronounced variation on the original work. Using his preliminary sketches and prior experience in executing the basic compositions, he painted the four canvases, each over six feet long, in the record time of five months, from December 1841 to April 1842.

The quartet, comprising *Childhood, Youth, Manhood,* and *Old Age,* is tantalizingly detailed. The voyager's age, the time of day, the season of year, the weather conditions, and the course of the stream are all depicted, and all relate to varying stages of development. Lest anyone miss the point, Cole's ship of life bears carved heads of the Hours, whose expressions change from merry singing, to smiling, to wailing, to—in *Old Age*—being battered beyond recognition. And the winged figurehead holds an hourglass of relentlessly flowing sands. In the last picture, both figurehead and hourglass are broken away: time has run out. Like individuals and nations, the land itself ages throughout the four pictures. Only the eternal guardian angel remains fixed in time, and even his actions differ from one canvas to the next.

In *Childhood,* the guardian steers the helm of the ship of life while our voyager is an innocent, laughing baby, wonderstruck at

the bright flowers of spring and the pink glow of sunrise. The blue sky of midday soon spreads over the afternoon of life and the verdant meadows of summer; in *Youth*, the angel stands on the bank as the now-adventurous voyager assumes control of his own vessel. The evening sun sets in *Manhood*, and lightning-blasted autumn trees greet the bearded man who, having lost control of his youthful dreams, prays for deliverance. In *Old Age*, a bald and white-bearded sage sits quietly in a rocking boat next to the lifeless shores of winter under the black dome of midnight. His guardian angel, who has watched unseen over his tribulations, finally appears to comfort him by directing his gaze to a burst of divine light.

More important for a landscape painter than these allegorical emblems is the choice of direction for the river. In *Childhood*, it pours straight out of the picture toward an unknown destination. Its waters lead back toward the distant horizon in *Youth*. In his enthusiasm to reach the dream castle, the young voyager fails to note that the river turns a sharp bend and heads for a chasm at the far right. Frightful rapids surge left to right across *Manhood*, while the placid sea of eternity characterizes *Old Age*. Cole's own lengthy catalog notes reveal his intentions. In *Childhood*, "the dark cavern is emblematic of our earthly origin, and the mysterious past." For the second canvas, "the gorgeous cloud-built palace, whose most glorious domes seem yet but half revealed to the eye, growing more and more lofty as we gaze, is emblematic of the day-dreams of youth, its aspirations after glory and fame." In *Manhood*, "the helm of the boat is gone," and ghostly shapes in the clouds are "Suicide, Intemperance, and Murder, which are the temptations that beset men in their direst trouble." But in the final picture angels descend "as if to welcome him to the Haven of Immortal Life."

Returning from Rome with the completed suite, Cole exhibited it in Boston, New York, and Philadelphia in 1843–1844. The shows' gate receipts and catalog sales were disappointing. The painter had overestimated his American audience. In attempting to educate and uplift viewers with his complex, moralizing pictures, Cole ran afoul of the same prejudices that earlier had embittered Trumbull, Morse, and the Peales. The frustrated artist declared, "I am not the painter I would have been had taste been higher." Critics and poets praised his efforts at allegory; the public didn't care. But, so long as he continued to produce views of the American wilderness, Cole prospered. His death at forty-seven, after a lifetime of frail health, was mourned as a national tragedy, and it left the way open for several other landscapists to share in the profits that Cole had monopolized.

ASHER BROWN DURAND

1796–1886

Asher Brown Durand, a close friend of the nature poet William Cullen Bryant, was Cole's undisputed successor as leader of the Hudson River school. But whereas the temperamental Cole preferred to work alone, Durand was an amiable and sociable teacher. While Cole sought the tempestuous wonder of mountains and gorges, Durand found solace in sheltering woodland glens. And though Cole was practically self-taught in oil techniques, Durand had the most rigorous formal training.

From a New Jersey family of watchmakers and mechanical inventors, Durand apprenticed in 1812 to a leading engraver. His careful surface finishes, so unlike Cole's rugged paint textures, are due to his training as an engraver of copperplates. He advanced so rapidly that he was soon the country's foremost master at printing reproductions of famous paintings. His unerring eye and scrupulous attention to detail helped make him a leading society portraitist in oils, as well. As such, he was one of the discoverers of Cole's landscapes in the New York shop window in 1825. Cole's shyness in Durand's presence was understandable, even though the fashionable artist was only six years his senior.

Durand's *Forest in the Morning Light* (see page 104) is the supreme example of his contemplative, even melancholy views. Neither robin nor raccoon disturbs the quiet of the enclosed grove. A smooth-flowing spring gleams in the half-light of sunshine filtering through the leaves. Instead of a dramatic vista into depth, a visual path obstructed by brambles and branches ends at the relief of a verdant hillside and balmy sky outside the wood. Durand's precise description of every leaf, twig, and crinkle of bark allows botanists to identify the exact species of each tree and bush. With his engraver's background, Durand directed, "Form is the first subject to engage your attention. Take pencil and paper, not the palette and brushes, and draw with scrupulous fidelity the outline or contour of such objects as you shall select, and, so far as your judgment goes, choose the most beautiful or characteristic of its kind." This instruction was for beginning students. Durand himself, having already perfected his draftsmanship, often painted out-of-doors with pigments specially packed in bladders. This explains why so many of his canvases are relatively small; barely two feet tall, *Forest in the Morning Light* would have been portable on a hike. That it was done on the spot is suggested by its fidelity to natural color, unlike the imaginary hues of studio-concocted landscapes. "Stop muddling the fresh green of summer with brown," Durand stated. Here, the variety of greens demonstrates his careful observation of sunshine and shadow. The few touches of thick, pure white paint for highlights recall the technique of John Constable, a recently deceased English landscapist whose works Durand admired while in Europe in 1840–1841.

On the European study trip, Durand tutored some younger American engravers, including John Casilear and John Kensett, who were to become major landscape painters. They were influenced by the seventeenth-century French landscapist Claude Lorrain. Claude's browsing cattle and watery reflections, inspired by the bucolic verses of the ancient Roman author Virgil, can be sensed as a direct inspiration for Durand's *A Pastoral Scene*. But Durand's rough pasturage and forested foothills evoke the farming hinterlands of the New World. And a strong, clear light speaks accurately of the sharper air of the United States rather than the perfumed mists of a French neverland. Durand, able to derive ideas from others while maintaining his individual vision, wrote, "The

Thomas Cole *1801–1848*
The Notch of the White Mountains (Crawford Notch) *1839*
Canvas, 40″ x 61½″
Andrew W. Mellon Fund

'lone and tranquil' lakes embosomed in ancient forests, that abound in our wild districts, the unshorn mountains surrounding them with their richly-textured covering, the ocean prairies of the West, and many other forms of Nature yet spared from the pollution of civilization, afford a guarantee for a reputation of originality that you may elsewhere long seek and find not." Durand need not have worried about anyone doubting his originality, for his fellow artists and leading patrons elected him to several terms as president of New York's prestigious National Academy of Design from 1846 to 1861.

JASPER FRANCIS CROPSEY

1823–1900

Jasper Francis Cropsey worked for five years as a draftsman for a New York architect, and his precision of detail can be explained by his intense study of mechanical drafting. Indeed, he never abandoned architecture; in his last years, he designed houses and the "Olde Englishe" kiosks for New York City's new elevated railway. Being a full generation younger than Doughty, Cole, or Durand,

Cropsey had the advantage of becoming a landscape painter in the early 1840s, long after Americans had eagerly taken this novel subject matter to heart.

While enjoying a two-year honeymoon in Europe, Cropsey rented the Roman studio that had previously been Thomas Cole's Italian headquarters. Upon returning to New York in 1849, Cropsey found that few artists were attempting to create the grand allegories that had obsessed the late Cole. Cropsey thereupon tried one himself. *The Spirit of War,* shown at the National Academy of Design in 1851, elicted glowing reviews, especially because Cropsey politely refused to depict the gore of martial horror. "As war, in its immediate contemplation and results, presents painful and unpleasant features for delineation, the Artist has chosen to express, rather, those incidents that are suggestive of it, than its actual representation. The feudal times, at once picturesque and expressive, yield the material. . . . the burning Hamlet;—the Unhappy Mother;—the Goatherd's frightened flock;—and the Baron's vassals, fully armed, hastily riding to battle; their revelry suddenly suspended by the alarm from the blazing beacon fires."

But these and other anecdotal incidents pale in significance next to Cropsey's startlingly clashing lights and darks. The eye seldom has a chance to explore the rocky, shadowed regions of the picture before it is violently jerked to some lurid pocket of bloody red light such as the gleam from the castle windows or the stupen-

Asher Brown Durand *1796–1886*
A Pastoral Scene *1858*
Canvas, 21⅞" x 32⅜"
Gift of Frederick Sturges, Jr.

dous sunset of crimsons, scarlets, and lightning yellows. If the symbolism of day's end weren't enough, the very earth seems in its death throes, shifting treacherously in alignment. One is left to wonder whether an earthquake is presently extruding or leveling those geologically impossible mountains.

These histrionics work because Cropsey chose a faraway time and place that existed more in the imaginations of nineteenth-century readers than it ever did in actual history. Indeed, the artist admitted that the fanciful poetry of Sir Walter Scott suggested some of the images. The power of the scene and its vigorous brushstrokes simply out-Cole Thomas Cole. Cropsey must have realized that his high melodrama was almost too artificial, because he never again tried anything so theatrical.

In addition to Cropsey's first literary painting and his most extravagant piece, the National Gallery also displays the largest picture he ever painted. From 1856 to 1863, Cropsey lived in London, gaining an impressive reputation for his English scenes. Sometime before October 8, 1858, when a friend inquired "how the large landscape is getting on," he had begun his magnum opus, *Autumn—On the Hudson River* (see pages 92–93). Working from sketches and memory, it took him over a year to finish the nine-foot-long canvas. The attention it attracted while in progress foreshadowed its position as the "great adornment" of the American section of the 1862 International Exposition in London. John

Ruskin, the great English art critic and scholar, "at first could scarcely believe the brilliant combinations in this artist's autumnal sketches were other than exaggerations of 'Young America'; but having proved Cropsey's rare fidelity by watching his English landscapes, he now believes fully in the radiant truth of his trans-Atlantic studies." Europeans, whose fall foilage is relatively drab, could scracely credit the splendor of Cropsey's depiction of red oak, hemlock, sugar maple, and beech. A London newspaper reassured them by reporting that beside the painting, "to show that this is a faithful representation of American trees, some real leaves, pasted on cardboard, are shown."

Even though the pressed leaves proved that Cropsey's coloring was true, the painter did take liberties with geography. With Cropsey's rearrangement of nature, American audiences could not decide which town the church steeples and factory chimneys marked. Is it any wonder that, working three thousand miles away from his subject, Cropsey refined and simplified the compositional format? What is clear is that the view is downriver, to the south-southeast, and that Storm King Mountain, heightened in its bulk, just blocks the sight of West Point Military Academy.

London critics noted approvingly, "The details of the picture have been elaborated with great care, and add immensely to its value. The rugged bark of the trees, the felled trunks, and the gnarled roots are presented with a marvelous degree of minute-

Jasper Francis Cropsey *1823–1900*
The Spirit of War *1851*
Canvas, 43⅝" x 67⅝"
Avalon Fund

ness." Cropsey employed the microscopic detailing to enliven what otherwise might have been a boringly empty vastness. The viewer may wander down paths and through thickets, discovering hunters and their dogs relaxing, sheep grazing in a meadow, a log cabin, cattle drinking from a pond, children playing on a rustic bridge, and, out on the Hudson, both quiet sailing ships and smoke-belching paddle wheelers. Overall, the sun lends compositional and thematic unity. The mid-morning light glistens off the dew on the grass, radiates from the foreground brooks and distant river, and flashes its rays across the sky. The strong vertical line of sunlight thus binds earth, water, and air together as a unified design. Moreover, the presence of the glowing orb is patently religious. The celestial body which gives warmth and light to mankind is inevitably equated with God.

The phenomenal success of *Autumn—On the Hudson River* gained Cropsey an audience with Queen Victoria and ensured his lasting fortune. When he returned to the United States, he specialized in serene woodlands depicted in a meticulous technique. Never again did he approach the vital brushwork and grand symbolism of the National Gallery's two unusual, early works.

JOHN WILLIAM CASILEAR

1811–1893

A successful engraver of ornate bank notes and certificates, John William Casilear descended from Spanish colonists. Asher Durand prompted him to make illustrative prints after paintings. In 1840, Casilear accompanied Durand and John Kensett on their three-year trip to Europe, drawing from nature and observing works in museums. Casilear, financially secure by 1854, retired from his engraving business to become a full-time landscape painter.

Casilear left for another two years abroad in the summer of 1857. Since his *View on Lake George* bears that date, it is presently not known whether it was painted on the site, as usually advised by Durand, or done in Europe from sketches. This upstate New York lake was a favorite retreat of painters, authors, and travelers in the mid-nineteenth century. Casilear depicted it so often that he became identified with it. The artist with portfolio seated on the left shore, for instance, is assumed to be a self-portrait. "One of his most congenial and successful American subjects is Lake George," a contemporary biographer noted. In writing of Casilear's style, the same author praised the painter, noting that, "The habit of dealing strictly with form gives a curious correctness to the details of his work: there is nothing dashing, daring, or off-hand; all is correct, delicate, and indicative of a sincere feeling for truth, both executive and moral."

Casilear enjoyed a long career creating such evocative, misty views. Although they partake of the romantic grandeur of the Hudson River school, Casilear's gentle landscapes possess a more tranquil mood and a more open space than was typical of the early painters of American scenery. Here, for example, the customary

dark masses framing either side of the foreground are de-emphasized; the tree sheltering the artist grows far back in the middle distance on the left, and only a low cluster of foliage exists on the right. The optimism expressed by the symmetrical neatness of Hudson River compositions is replaced by a quiet spaciousness of infinite light. Casilear's *View on Lake George* does not express the certainty of an eager generation. Rather, with its delicate forms and restful openness, it looks forward to the need for reassurance against the national unrest during the War between the States.

John William Casilear *1811–1893*
View on Lake George *1857*
Canvas, 19⅞″ x 30″
Gift of Frederick Sturges, Jr.

7

LUMINIST AND TONAL LANDSCAPISTS

The intensity of America's early Hudson River landscapes mellowed by the mid-nineteenth century. The second generation of view painters often chose smaller, more intimate canvases of an unusually long, low shape. In this horizontal expanse they sacrificed solid earth in order to examine the spaciousness of a wide, open horizon. By deemphasizing human activity, artists focused minutely on nature's infinite details. And covert suggestions of life's transience—dawn mists or twilight calms—replaced overt religious and patriotic symbols. As more of the United States was settled and the public grew satiated with now-familiar motifs, painters searched farther afield for virgin and exotic scenes.

Due to their interest in nuances of light, John Kensett, Fitz Hugh Lane, Martin Heade, and Frederic Church are currently being termed "Luminists." Although these friends didn't apply the word to themselves as a group, "Luminism" has validity in describing their reticent, contemplative art. Particularly around the Civil War of 1861–1865, their delicate renderings of quiet atmosphere took on a melancholy poignance. The American art world, disillusioned by the war, could no longer accept view paintings as affirmations of any national optimism or natural benevolence. The market for landscapes would collapse in the 1870s. Later nineteenth-century landscapists, such as George Inness, devised visual tone poems as escapes from life's realities.

JOHN FREDERICK KENSETT

1816–1872

John Frederick Kensett, from a family of professional engravers, studied printing and draftsmanship under his father and uncle. Another young engraver, John William Casilear, encouraged Kensett to take up oil painting. Together, Casilear and Kensett joined the established portraitist and landscapist Asher Durand on an 1840 trip to Europe. Kensett, however, stayed abroad after the others returned to the United States. He copied Old Masters' pictures in the museums, refined his printmaking craft, and

painted landscapes in Germany, Switzerland, Italy, France, and England. Britain intrigued him most, and he spent as much time of his seven years abroad there as possible. Long after returning to America in 1847, Kensett acknowledged, "My real life commenced there, in the stately woods of Windsor, and the famous beeches of Burnham, and the lovely and fascinating landscape that surrounds them."

Landing at Sabbath Day Point, Lake George, though painted in the early 1850s in upstate New York, recalls the English Lake Country in its open space hemmed in by low mountains. The format is basically that of the Hudson River school, as is the popular site. A dark, purplish embankment intrudes on a blond distance. Amidst the olive-green foreground foliage, crimson leaves or berries such as sumac cling to the rock. This dense area contrasts to the beige mountain and dove-gray lake. The conical mountain and flat sheet of water possess a geometric severity equal to balancing the ruggedly textured right-hand rock. Also, the left side has the visual interest created by the human activity on the dock.

In his mature works, Kensett strove for palpable atmosphere by contrasting solids against voids. Beacon Rock, Newport Harbor, dated 1857, and Beach at Newport, done more than a decade later, both partake of this opposition of dense, secure earth to transient, insubstantial water and air. Moreover, both canvases are painted very thinly, unlike the thickly painted earlier view of Lake George. Like many Luminists, Kensett employed oil glazes so transparent that they suggested the immaterial nature of atmosphere itself. His contrast between matter and vapor is masterfully brought out by the crystalline contours of the sharp-edged rocks and foliage, a legacy of his precise training as an engraver.

Many of the Luminists summered in Newport or Narragansett so that they could portray the coves of Rhode Island's coastline. Kensett became particularly attached to the area, and he did a number of views of the same scene at slightly different tides or times. Often, it requires quite a bit of work for the viewer to differentiate between such serial images, so subtle are the changes. Although these two paintings are obviously not depictions of the same spot, they are enough alike for you to imagine that you are trying to identify almost imperceptible changes of weather, season, or hour of the day. In Beacon Rock, for instance, the tide is high, covering

John Frederick Kensett *1816–1872*
Landing at Sabbath Day Point, Lake George *c. 1850/1853*
Canvas, 10" x 15¾"
Gift of Mrs. Sigourney Thayer

John Frederick Kensett *1816–1872*
Beacon Rock, Newport Harbor *1857*
Canvas, 22½" x 36"
Gift of Frederick Sturges, Jr.

John Frederick Kensett *1816–1872*
Beach at Newport *c. 1869/1872*
Canvas, 22" x 34"
Gift of Frederick Sturges, Jr.

the shore of the massive promontory. A slight breeze chops the waves as they pass the fisherman by the cliff and splash ashore. *Beach at Newport,* however, shows becalmed weather; the bay barely ripples. And the tide is low, exposing a mossy line on the rocks and allowing a boy with a basket to go clam digging. Kensett had a concern for the particular, for the momentary. By clarifying and ordering these natural cycles and perpetuating them on his canvases, he provided objects of meditation on the continuing promise of life.

FITZ HUGH LANE

1804–1865

Fitz Hugh Lane lived all his life in his native Gloucester, Massachusetts. Despite the relative isolation of this whaling and mer-

cantile port north of Boston, Lane achieved a reputation as one of America's finest marine painters, exhibiting in major cities as well as making lithographs of harbor views and open seascapes. The son of a Gloucester sailmaker, Lane lost the use of his lower limbs when eighteen months old. An old local historian wrote, "Although he was grew to the ordinary stature of a man, his legs were useless and he always obliged to walk with two crutches." This crippling malady was attributed to the infant having been left unattended in his father's garden, eating the seeds or leaves of an Apple of Peru. Since that fruit is merely a tomato, experts guess polio was the actual cause. His confinement to crutches may partially explain why he did not become a Hudson River painter, taking long treks in the mountains. It is true that most of his motifs could be reached by working one's way along Gloucester's docks, rowing oneself out to coves in a small boat, or sitting on the decks of a chartered ship. However, Lane's infirmity did not prevent him from tending the elaborately terraced garden of his home or from taking an active role in Gloucester's civic affairs, even though his house was on a rise of land some distance from town. No, Fitz Hugh Lane didn't paint the New England coast because it was expedient; he painted the waterways because he'd grown up in a family tradition of loving the sea.

A shoemaker and amateur draftsman, Lane came to the attention of a local printmaker, who introduced him to a major lithographic company in Boston. His only professional training in art, therefore, occupied but five years in Boston after the age of twenty-eight. By 1850, he'd saved enough to build his substantial granite home; inspired by Nathaniel Hawthorne's *House of Seven Gables* (except for the glass-roofed studio). It was there that Lane painted *Lumber Schooners at Evening on Penobscot Bay* (see pages 98–99) in 1860. He had visited Maine first in 1848, and returned there almost every summer until he died. A friend commented, "I was with him on several trips to the Maine coast where he did much sketching, and sometimes was his chooser of spots and bearer of materials when he sketched in the home neighborhoodFor his physical infirmity prevented his becoming an outdoor colorist."

Regardless of having been painted from sketches, miles away

from the site, *Lumber Schooners* evokes the crystalline clarity of sunset over sheltered waters. Typically, large ships would be heading toward Boston loaded with wood or granite. By removing any foreground objects, Lane opened up the expanse of the bay, increasing the picture's spaciousness. The tiny scale of the sailors aboard the closer schooner virtually eliminates any interest in man's activity, so that the viewer focuses on the tranquil beauty of nature at twilight—symbolic of fleeting time. The translucent blue-grays of the sea, islands, and sky are suffused by the pinks of the setting sun.

The intensity of this hot light striking the clouds, rigging, and masts resulted from the introduction of new pigments, based on chemical dye processes. By the early 1850s, at least, Lane was among the first to experiment with these synthetic reds, yellows, and oranges, becoming a pacesetter in their use for other landscapists desirous of spectacular atmospheric effects. In his numerous excursions to Maine, for instance, Lane may have introduced these startlingly bright new colors to Frederic Edwin Church.

MARTIN JOHNSON HEADE

1819–1904

Keeping track of Martin Johnson Heade's wanderings is akin to watching the hummingbirds he so loved to paint in his late nature studies. A native of rural Pennsylvania, he received his first instruction from a naïve, or folk artist. Then he went off to France, Italy, and England in 1838 for a few years. He lived variously in New York, Trenton, Boston, St. Louis, Chicago, and Washington, D.C., made a return trip to Rome in 1848, and took three extended sojourns to Latin America during the 1860s. Even when he married at sixty-four and settled down in St. Augustine, Florida, Heade kept leaving for short excursions. The diversity of his subject matter matches his endless changes of address. Heade produced floral still lifes, seascapes, portraits, landscapes of tidal marshes, and exquisite pictures of tropical birds. Since the height of his restlessness corresponded with the Civil War and Reconstruction, some modern authorities have concluded that Heade was fleeing the chaos in the United States and pursuing a virgin paradise elsewhere.

Rio de Janeiro Bay was painted in Brazil during Heade's first South American stay of 1863–1864. The extreme horizontality of the format stretches the vista beyond what was customary even for the Luminist painters. A pink flush in the air blends into strange yellow-green. Multihued sheens of red-violet and blue-green reflect from the still waters of the bay. What first appears a tranquil scene of boats sailing under a peaceful tropical sky becomes almost ominous on continued examination. The viewer is alone on a desolate beach, unable in the still atmosphere to call to the ships. A few sea birds wheel quietly over isolated shells on the sand.

What is wrong with this quiet landscape is that it is too quiet. Heade painted a vacuum. Far-distant objects can be seen as clearly as though there were no natural atmosphere to diffuse the light. Against the flat expanse of sea and sky, a serrated line of waves breaks on the beach. The jagged, jarring surf is about to encroach on the spectator's feet. And the troughs consistently diminish from left to right until the peaks merge into a solid wall of water. Though fragile in its pristine clarity, *Rio de Janeiro Bay* expresses an unsettling moodiness characteristic of much American art around the time of the Civil War.

FREDERIC EDWIN CHURCH

1826–1900

Frederic Edwin Church has the distinction of being the only pupil ever accepted by Thomas Cole, America's leading early landscapist. The son of a wealthy Connecticut insurance executive, Church rejected his socially assigned role as a gentleman of the leisure class. Instead, he lodged in Catskill, New York, from 1844 to 1846 to study with Cole. Church soon abandoned Cole's religious imagery and painterly handling for a microscopic description of natural form. In this exactitude, Church came closer than any other painter to Henry David Thoreau's transcendental identification with nature: "Talk of mysteries!—Think of our life in nature,—daily to be shown matter, to come in contact with it,—rocks, trees, wind on our cheeks! the *solid* earth! the *actual* world! the *common sense*! *Contact*! *Contact*!"

Frederic Edwin Church had an innate talent for causing his hand to portray precisely what his eyes observed. Combined with his piercing intellectuality, his magical craftsmanship soon made him the leading painter in the United States. The public waited in line for hours to catch a glimpse of his vast panoramas of Central American volcanoes, Arctic glaciers, Niagara Falls, famous Greek ruins, or the Holy City of Jerusalem. Spectators used opera glasses to examine his gigantic canvases inch-by-inch, as though they were standing on a look-out platform at the actual site. When one of Church's landscapes sold for ten thousand dollars in 1859, it established the highest price yet paid for the work of any living American painter.

Morning in the Tropics (see pages 102–103), one of his last major canvases, has so much physical conviction that it seems larger than its seven-foot width. The stillness of the jungle dawn hushes the two scarlet birds on the palm frond, the wings of the flying water fowl, and the paddle strokes of a distant native canoer. The verdant foliage slowly fades from emerald green through olive to pale jade as the trees and underbrush become absorbed in the heavy, equatorial atmosphere. The rising sun, cutting its way through the haze over the river, converts the water droplets in the mist into myriad prisms, breaking the light down into the component parts of the visible spectrum. The tangible moisture in the air forms an opalescent dream of pink, gold, azure, violet, turquoise, and coral. This chapter's frontispiece detail shows the wizardry of Church's paint manipulation. The fungus on the rotten log was stippled or sponged for a coarse texture; the sharp palm leaves were carefully edged with highlights of a thickened, waxy pigment; and

121

had a lot farther to topple from his exalted position than did his lesser contemporaries. Sadly, this fall in reputation coincided with an onslaught of rheumatism that curtailed his painting capacity. Church retired to his fabulous estate overlooking the Hudson River, intermittently creating pictures as his medical condition allowed. When he died just before his seventy-fourth birthday, obituaries noted, "The fact that he was still alive has been almost forgotten by present-day artists."

WILLIAM STANLEY HASELTINE

1835–1900

Even though William Stanley Haseltine often produced the open panoramas of distant horizons typical of mid-century landscapists, he stands apart from the majority in his devotion to rocks. An appreciable proportion of his work consists of close-up views of craggy shorelines being kissed by gentle waves or dashed by breakers. Inland, too, Haseltine depicted cliffs and bluffs rather than whole mountain ranges. *Marina Piccola, Capri* characterizes his obsession with boulders and geological accuracy. Instead of the promontories and headlands of his later New England scenes, here is a sheltered inlet on the isle of Capri. The strong Italian sunlight rakes across the sturdy rocks, which Haseltine's capacity for geometric simplification turned into even more massive forms. The small sea arch is all that is left of one of Capri's famous underwater grottoes, long since collapsed. The quaint fishing village, the peasant woman tending the drying racks, and the distant sailboats to

the reflections over the water were made with thinned oils blended together in translucent glazes.

Church favored the topographic and climatic variety of South America as his subject matter. He'd journeyed there twice, in 1853 and 1857, making oil sketches and pencil drawings of Ecuador, Colombia, and Peru. Painted a full two decades after his last trip, *Morning in the Tropics* distills his equatorial experiences into an evocation of the dawn of time. That this composite scene appears so convincing is tribute to Church's scientific study of meteorology, botany, geology, and optics. Critics compared his views of unsullied paradises or violent apocalypses to revelations of the divine forces that created the universe. They even went so far as to call Church himself, "Moses who looked on God unveiled."

When the public reaction against dramatic landscapes began after the Civil War, Church was at the pinnacle of his career. He

Top: **Martin Johnson Heade** *1819–1904*
Rio de Janeiro Bay *1864*
Canvas, 17⅞" x 35⅞"
Gift of the Avalon Foundation

Above: **William Stanley Haseltine** *1835–1900*
Marina Piccola, Capri *1856*
Paper on canvas, 12" x 18½"
Gift of Mrs. Roger H. Plowden

Alexander H. Wyant *1836–1892*
Peaceful Valley *c.1860*
Canvas, 7" x 12¼"
Gift of James C. Stotlar

the south complete the picturesque quality of the scenery. This small sketch, with its pristine accuracy in capturing tone, shows Haseltine's rigorous training in Philadelphia under a German emigré teacher whom he accompanied back to Düsseldorf in 1854. There, he increased his ability to convey solid form, but Haseltine's knowledge of geology was entirely of his own making.

sign painter from Ohio, had seen an exhibition of George Inness' landscapes in Cincinnati in 1857. Journeying to New York expressly to meet the master, Wyant received such encouragement that his stylistic development paralleled that of Inness. Wyant's *Peaceful Valley* stands at the same point of breaking away from Hudson River formats that Inness' work did at the same time.

ALEXANDER HELWIG WYANT

1836–1892

Alexander Helwig Wyant earned his reputation as a tonalist landscape painter following a European sojourn in 1865–1866. While abroad, he studied the low-keyed colors and free brushwork in the pictures of the English Romantics John Constable and William Turner and of the French Realists. *Peaceful Valley*, however, painted around 1860, is a youthful work with bright hues and precise detailing. Even though it is no larger than a sheet of legal typing paper, this small, carefully finished pastoral stands up well to examination under a magnifying glass. Each grove of trees is clearly distinguished in tone from the nearer and farther foliage. Except for some clearings on the opposite bank of the river, no sign of human activity has disturbed this idyllic wilderness. Wyant proceeds from umber and deep green underbrush across woods of jade, ochre, and tan to a violet mountain and pastel-blue sky with butter-yellow clouds. The sequential arrangement of colors, beginning with a dark foreground and terminating with a pale vista, recalls the works of the Hudson River artists who had influenced Wyant, particularly those of Asher Durand. But the lack of prominent foreground bracketing forms, the horizontal expanse of the canvas, and the unassuming serenity of the soft tones do not belong to the earlier Hudson River tradition of strong emotion. These quieter elements look forward to Wyant's tonal views after the Civil War. Wyant, a

GEORGE INNESS

1825–1894

Because of his frail health, George Inness never graduated from high school, much less attended any art institute. His indulgent father, a wealthy New York grocer, paid for the few months of study the teenaged Inness did have under two minor landscapists. The youth also apprenticed for two years to a map engraver. That drudging experience in linear tightness so gauled the artist, who was to become a leading exponent of softly glowing color, that he seldom mentioned it in adult life. Inness' lack of technical training in oils partially accounts for his eccentric painting methods. For, while the taste of the times dictated carefully finished details, he painted as much with rags and palette knives as he did with brushes.

Inness achieved early recognition, being elected to the National Academy of Design in 1853 when only twenty-three. *The Lackawanna Valley*, an early work of 1855, demonstrates his similarity to both Hudson River and Luminist landscapists. A dark brown tree rises vertically across the canvas, uniting the horizontal layers of freshly cleared fields, city-dominated valley, far range of hills, and distant sky. In this solid, well-ordered composition, the picture partakes of Hudson River gravity. But, the wide sweep of space and carefully blended tones show an awareness of Luminist lighting effects. A superb orchestration of color blends the foreground greens across the middle-distance tans to the mauve hills and pink sky.

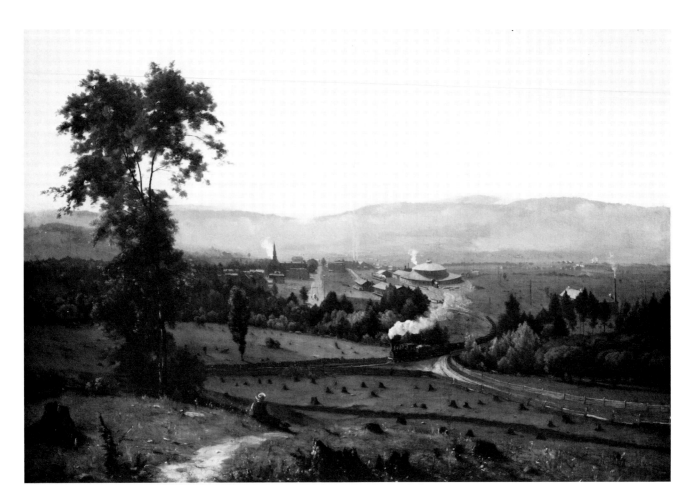

George Inness *1825–1894*
The Lackawanna Valley *1855*
Canvas, 33⅞″ x 50¼″
Gift of Mrs. Huttleston Rogers

The painting has become famous not only as a work of art but also because of its appealing subject. The stumps of cleared trees on the outskirts of Scranton, Pennsylvania, disclose, to historians, the nineteenth century's relative assessments of woodlands versus iron mills. And, the boy in the bright red vest who looks longingly at the train while dreaming of adventure inevitably recalls Tom Sawyer watching riverboats.

Because of a biography of George Inness written by his son, whom he trained as a studio assistant, a great deal is known about Inness' working methods in general and about the execution of this picture specifically. In 1855, the first president of the Delaware, Lackawanna, and Western Railroad commissioned Inness to paint an advertisement promotional for the new line. From Brooklyn, where he was then living, Inness traveled by stagecoach to Scranton to make the preliminary sketches, but he returned to his studio to execute the canvas. In fact, as credible as Inness' views always are, they were rarely painted on the site in front of the motif but

from memory. In this case, Inness was scrupulously accurate in depicting the view, but his honesty roused one of those age-old conflicts between artist and patron.

The railroad's roundhouse, for instance, apparently was not completed in 1855. So, the artist was forced to construct it from the architect's blueprints. Also, "There was in reality only one track at the time running into the roundhouse, but the president of the road insisted on having four or five painted in, easing his conscience by explaining that the road would eventually have them. Pop protested, but the president was adamant, and there was a family to support, so the tracks were painted in." Years later, Inness said to his wife, "Do you remember, Lizzie, how mad I was because they made me paint the name on the engine?" With his artist's conscientiousness, though, Inness achieved a remarkably successful compromise between the railroad's demands and his picture's design. Only the initials "D.L.& W.R.R." appear on the tender behind the wood-burning locomotive, so no obvious lettering intrudes on the view.

And the extra trains puffing away in the far-distant railyard are so tiny as to be nearly invisible, which in reality they were.

The domesticated, bucolic mood of Inness' art was produced by a working frenzy which seems totally at odds with the placid results. "When he painted he painted at white heat. Passionate, dynamic in his force, I have seen him sometimes like a madman, stripped to the waist, perspiration rolling like a mill-race from his face, with some tremendous idea struggling for expression." Sometimes, Inness' son would find him unconscious in the morning, lying on his studio floor beneath a work that he'd completed in a night's burst of creativity. The exhaustion was due to the same "fearful nervous disease" which had prevented Inness from completing his education; given nineteenth-century prejudices, the son never once mentioned the word "epilepsy" in his long biography. Yet, it may be significant that Inness seldom painted the wilderness customary to his generation of artists. Without modern drugs to prevent seizures, he preferred the peaceful farmyards and rolling orchards he could easily reach from his homes in the suburbs of Boston and New York. When working in Europe, he chose similarly familiar motifs that differ from his American scenes only in the picturesqueness of their architecture.

Inness had visited Europe twice in the early 1850s, but from 1870 to 1875 he and his family lived there on the advice of art dealers. American collectors, Inness' agents knew, would snap up all the romantic, foreign views he could paint. *Lake Albano, Sunset* demonstrates how daring Inness had become during his years in Italy. Against a black-green pasturage with goats, the sun bursts across the deep lake. The strength of the light visually erodes the far bluffs and nearly obliterates the domes of Castel Gondolfo, the summer residence of the popes. The brutal collisions of paint texture conjure up exactly what occurs when one looks right at the setting sun. Inness once remarked, "I'd paint with mud if it would give me the effect I wanted."

View of the Tiber River Near Perugia (see pages 4–5) eliminates foreground elements. The artist had observed that when his eyes were trained on the horizon, nearby objects would be out of focus, so to speak, falling away beneath his feet. Thus, only a few dry grasses and barren rocks punctuate the heights here. Uninterrupted, our vision sweeps into the middle distance and across the broad valley. The spaciousness becomes infinity as the far mountains fade into an iridescent haze. Behind the viewer of this panorama, the Tiber River has entered a wide plain, hemmed in by the rolling foothills of the Apennine Mountains. A peasant couple with a donkey, having left the medieval town of Perugia just outside the picture to the right, crosses a pasture. Down in the valley, the bridge and village of Ponte San Giovanni glisten in the sunset. Where else but in the Umbrian highlands of central Italy could such a breathtaking, yet restful, vista be imagined? And that is exactly what it was—imagined.

Although the landmarks are recognizable, from no actual vantage point would the nearby slopes, distant ranges, and meandering river align precisely as they do on this canvas. When asked where one scene had been painted, Inness snapped, "Nowhere in particular. Do you think I illustrate guide books? That's a picture." He argued that picayune details destroy natural appearance and that

George Inness *1825–1894*
Lake Albano, Sunset *1872 / 1874*
Canvas, 30⅛ " x 45"
Gift of Alice Dodge in memory of her father, Henry Percival Dodge

George Inness *1825–1894*
View of the Tiber River Near Perugia *1874*
Canvas, 38⅝ " x 63¾ "
Ailsa Mellon Bruce Fund

suggestion rather than literal depiction of form was more true to life. Mere daubs of cream-colored pigment here indicate stuccoed buildings in the plain, while flurries of dry, opaque paint capture the golden fields and emerald foliage ablaze with the autumn twilight. The glowing pastel tints of the clouds may very well have been wiped together with his customary rags. Regardless of their odd techniques, such canvases sing a lyric worship of nature. In the mid-1860s, Inness had adopted the philosophic principles of Swedenborgianism, maintaining that God evidences his spiritual self through material form. As a religious mystic, George Inness permeated his compositions with an elegiac mood.

8

AESTHETIC EXPATRIATES

The majority of America's professional artists in the latter half of the nineteenth century did go abroad, either for short acquaintances with Old World culture or for extended study. For a small number of Americans, though, Europe was to remain their home throughout their careers. To sculptors, this expatriation was based on technical necessity; assistance from the expert bronze founders of France and Germany or from the gifted marble carvers of Italy simply could not be found in the United States. Excellent academies of painting, however, flourished in several American cities. And the private galleries run earlier by men such as Charles Willson Peale, Edward Savage, and John Trumbull were being replaced with public museums. Major institutions opened in both Boston and New York in 1870; while small by the contemporary standards in Europe, the Museum of Fine Arts and the Metropolitan Museum of Art did offer a sampling of Old Masters' works to educate young American painters. Residency in the capitals of Europe, thus, was no longer the prerequisite it had been in the days of Benjamin West, John Copley, and Gilbert Stuart.

Many of the later American expatriates preferred just to depict European scenery or customs. But for the most part these artists became mere imitators and have faded with the minor native European painters. The cleverer Americans decided upon a European life for snob appeal. American patrons of the arts, disillusioned by the Civil War and its aftermath, desired European pictures as escapes from national problems or as signals of social prominence. A foreign address thereby assured greater sales potential back home. But this group too is largely forgotten today, since it pandered to the lowest common denominator of taste.

Only a handful of late-nineteenth-century Americans chose to abandon their homeland permanently for a genuine artistic challenge. Disregarding financial expediency, many of these painters participated in the avant-garde cultural experiments that formed the basis of modern, abstract art. They knew each other personally, but seldom got along well. Their styles and subjects differed as much as their personalities. Although each tried his hand at the

shimmering brushwork and light palette of French Impressionism, none could be called an Impressionist. All of them reveled in the bold silhouettes and decorative flair of Oriental art, which became a pervasive influence on Occidental culture partly as a result of their efforts, yet not one of them was an Orientalist. Because of their radical innovations, they had to struggle to gain acceptance. In the end, they all won international acclaim. Painters in Europe and America for the next two generations found it impossible to avoid their creative impact; succeeding artists either meekly accepted their precedents or violently rejected them. While this band of New World reformers calls to mind a Bohemian army of wild-eyed zealots, nothing could be farther from the truth. These aesthetic expatriates numbered only three, and each came from genteel, not to say staid, society.

James McNeill Whistler, Mary Cassatt, and John Singer Sargent grew up abroad as the children of American parents whose occupations allowed lucrative, foreign employment or free time for leisurely travel. Similar to the disenfranchised children of today's diplomatic corps or petroleum corporation executives, they were reared in an artificial environment. The result was that these artists, like their contemporary counterparts, remained isolated, rootless wanderers. They were not comfortable with Americans, being semi-foreign in their upbringing; nor were they completely at home abroad, because they didn't associate with the natives on an equal footing or, if they did, they failed to stay in any one country long enough completely to absorb its folkways and mores.

Whistler, born in Massachusetts, spent his boyhood in England and in czarist Russia; Cassatt, from Pennsylvania, enrolled in private schools in France and Germany; Sargent, whose American parents had retired to Italy, was born in Florence. Coming from wealthy and itinerant childhoods, each reacted differently as an adult to the problems of being a citizen of the world. Though they worked in the same generation, it would be folly to claim they had anything in common other than being members of a cosmopolitan, international elite. Whereas Sargent was an infant prodigy and

126

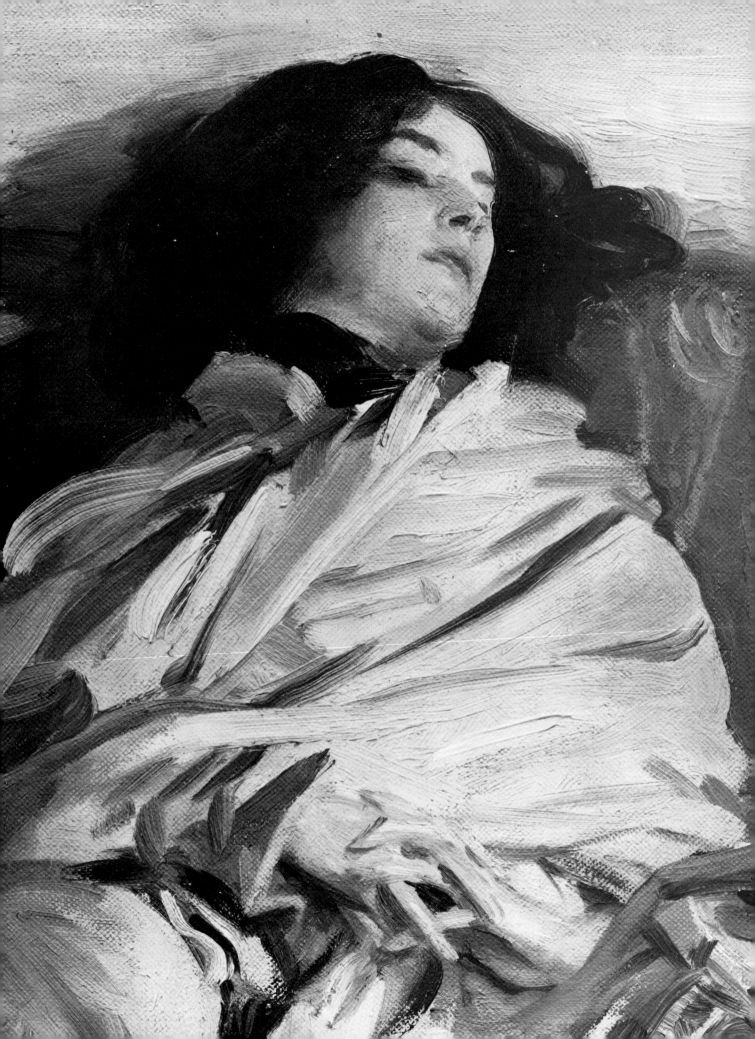

Whistler a slow-starter, Cassatt was methodical to a fault. Their styles of life and art, in fact, differ from each other's probably more than those of any other painters who are normally mentioned together.

Despite their diversified environments, however, each is noted for a single consistency in his or her art. Cassatt, who evolved through a wide variety of styles and techniques, has become virtually synonymous with the depiction of children, young women, and mothers with babies. Whistler, intrigued by an endless array of subject matter, approached every theme as though it were an exercise in calm, geometric arrangement and restrained, muted tonality. Sargent, who had neither Cassatt's thematic consistency nor Whistler's compositional unity, always wielded his brush the way a premier ballet dancer extends his body—to create dazzling, bravura movement. Is it conceivable that these single-minded artists, virtually homeless, were searching for one stable aspect in their lives?

JAMES McNEILL WHISTLER

1834–1903

James Whistler so enjoyed growing up in St. Petersburg (modern Leningrad) he later perjured himself in court by testifying to be Russian by birth. Ignoring the prosaic truth of his birth in Lowell, Massachusetts, Whistler spent his life reliving a fantasy childhood. His father, the American engineer who directed the building of Russia's first railroad line from St. Petersburg to Moscow, received such czarist privilege that the family lived near the Hermitage Palace in a neighborhood reserved for foreign dignitaries. Although discipline was severe under his private tutors, all in all Whistler had an easy and somewhat idyllic youth. His first drawing lessons, for example, came from the Imperial Academy of Fine Art, an impressive neoclassic edifice directly across the Neva River from his house.

Certain aspects of Whistler's character might be attributed to his pampered boyhood. Capricious and impractical, he relied on the women in his life to supervise his finances. And he always expected to be the center of attention. In the hard times of his Bohemian student years in Paris or in his periods of public rejection in London, Whistler lived on loans which he construed as tributes to his genius, never to be repaid. Moreover, the monumental grandeur of St. Petersburg itself must have played a role in his adult insistence on viewing the world in terms of cerebral color harmonies and simple geometrics. Whistler's painting, with its architectural forms and restrained tones, recalls the city's broad blocks and fairytale colors, especially under the glow of the Russian summer's White Nights.

The formality of Russian neoclassic architecture was but one influence on his art. A brilliant eclectic, Whistler absorbed ideas

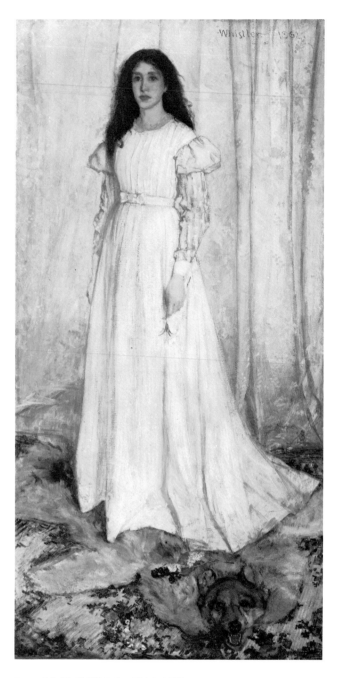

James McNeill Whistler *1834–1903*
The White Girl (Symphony in White, No. 1) *1862*
Canvas, 84½" x 42½"
Harris Whittemore Collection

from a bewildering variety of sources, assimilating them to his own ends. The crisp patterning and flattened space in Japanese prints and Chinese porcelain contributed to the sparse clarity of his designs. From the seventeenth-century Old Masters Rembrandt and Velázquez, he took his ability to manipulate shimmering highlights atop shadowed masses. In conjunction with French cohorts such as Edgar Degas, Whistler developed an appreciation for the purely visual effects of compositions, disregarding any narrative interpretations.

When Whistler's father died in 1849, the family, in suddenly straitened but not impoverished circumstances, returned to America. Whistler enrolled at West Point just before his seventeenth birthday. His family was convinced he should follow in his father's footsteps as a military engineer; he did not share their conviction. In three years, he ran up an appalling number of disciplinary demerits, failed chemistry, and was discharged. He later quipped, "Had silicone been a gas, I would have been a Major-General." His impish personality more than his poor grades was responsible for the dismissal. When a history professor, for instance, asked what he would do if a dinner companion wanted to know the date of an important battle, Whistler sneered, "Do? Why, I should refuse to associate with people who could talk of such things at dinner."

Whistler was, far and away, the best cadet in the drawing class, the only course he liked. (West Point's graphics professor, coincidentally, was the father of Julian Alden Weir, who in turn became one of the American painters most indebted to Whistler's style.) With this drafting ability to his credit, Whistler got a job with the Coast and Geodetic Survey in Washington, D.C. The expert cartographers there taught him the precision of engraving maps, even though he was habitually tardy or absent. In three months, he had acquired enough command of etching into copper plates to earn as much respect for his prints as for his oils.

In 1855, he left to study art in Europe, never to return to the United States. In Paris and London, which remained his changeable addresses, Whistler soon abandoned academic study to immerse himself in the artistic and literary maelstroms of the mid-nineteenth century. His mainstay from 1860 to 1867 took the charming form of Joanna Hiffernan, an Irish artist's model whose coppery hair fascinated him. Jo styled herself "Mrs. Abbott," in reference to one of Whistler's family names. The artist and model complemented each other perfectly; while he sharpened his incorrigible glibness, she was practical and punctual. And it was Jo who inspired Whistler's first masterpiece.

During the winter of 1861–1862, while managing his business expenses as usual, Joanna found herself with the additional task of sewing an elaborate white dress to match Whistler's specifications. He, meanwhile, rented a studio on Montmartre to have space for his first large canvas. He hung the room with white draperies and, to filter the light, covered the skylights with white gauze. Whether or not he knew it, Whistler was beginning the vanguard work in the Aesthetic Movement, which embodied the late-nineteenth-century concept of "art for art's sake." *The White Girl*, even though it contains a private symbolism, is essentially what its title implies:

an exercise in the varieties of one tone.

Whistler shipped the completed canvas to the 1862 Royal Academy Exhibition in London; it was turned down. The owner of a new sales gallery agreed to show it, but he gave it his own title, *The Woman in White*. Unfortunately, this name was also the title of a current best-seller by Wilkie Collins, the English novelist credited with inventing detective stories. Joanna's blank stare was seen to characterize the mystery's heroine, an heiress confined to an insane asylum by greedy villains. But nothing else fitted Collins' novel, and the London public and critics became so confused that Whistler was forced to publish the first of countless letters to the editor: "I had no intention whatever of illustrating Mr. Wilkie Collins' novel; it so happens, indeed, that I have never read it. My painting simply represents a girl dressed in white, standing in front of a white curtain." In 1863, Whistler took the picture back to Paris to enter it in the Salon, but the official French exhibition rejected it just as the British Academy had. The conservative jury for the 1863 Salon refused so many pictures that Emperor Napoleon III, pressured by the rejected artists and their supporters, intervened, decreeing that the offended artists might display their work at a special *Salon des Refusés*. Whistler's *The White Girl* caused a tremendous stir. One French critic wrote that she was "rarely without her group of grinning admirers digging each other in the ribs and going off into fits of helpless mirth."

It is now difficult to appreciate why this portrayal of a serious young woman once seemed so bewildering and hilarious. Nineteenth-century audiences, however, expected paintings to be narrative or symbolic, and the incidental details here just cannot be resolved into a comprehensible story line. The meaning that is present is so personal that only the artist and sitter understood its implications. Jo's white dress recalls a wedding gown, and the lily she holds is a traditional emblem of purity. In contrast, the bearskin rug connotes bestiality. The earliest flowers of springtime, purple and white lilacs, lie wilting on the floor to imply lost innocence. The scheme, therefore, hints that the marriage of Mr. and Mrs. "Abbott-Whistler" was without benefit of church or state.

The very idea that a life-sized depiction of a person was not intended to be a portrait did not occur to contemporary viewers. Whistler deliberately suppressed any personality in Jo's expression, and he minimalized the modeling of her head; there are few shadows and no highlights on her face. The flattening of her features corresponds to the compressed space; an Oriental, or bird's-eye, perspective forces an overhead view down onto the floor. With so little anecdotal interest or spatial depth, the artist focused attention on his subtle color scheme. The stark white of the freshly starched dress stands out from the darker whites of the diaphanous sleeves and the glowing whites of the brocade curtain. Much whiter than those tones are the waxy cuffs and the lily. Even the rug laid over the Chinese carpet is a polar bear's skin, adding yet another white to the design. "Art," Whistler wrote later, "should stand alone, and appeal to the artistic sense of eye or ear, without confounding this with emotions entirely foreign to it, as devotion, pity, love, patriotism, and the like."

Among the perceptive few, one French critic dubbed the

painting a *Symphonie du Blanc*, and Whistler soon adopted this compliment as *Symphony in White, No. 1*. It was the first of his musical titles, emphasizing the abstract nature of his work; words like harmony, arrangement, variation, symphony, and nocturne imply that the art of painting is analogous to musical composition. Various colors relate to a dominant hue, just as various notes relate to a dominant key. Even that world-famous icon of filial devotion commonly called *Whistler's Mother*, now in the Louvre Museum in Paris, bore the artist's original, dispassionate title, *Arrangement in Grey and Black, No. 1*.

Whistler advanced rapidly in his pursuit of refined composition. He took a house in London's Chelsea region, fashionable among painters and actors. His home on Lindsey Row was carefully chosen to overlook the River Thames. *Chelsea Wharf: Grey and Silver* (see page 153), executed around 1875, reflects his fascination with nature's ever-changing moods. Although the canvas captures the view from his studio window, it probably was not painted while looking at the motif. Whistler preferred to absorb effects quietly and work from memory in order to distill only the essential features of his landscapes. When twilight descended, he would row out upon the river to commune with the vague, evocative shapes created by the obscuring mists. His impressions of the night's romantic suggestions would be produced the next day in the studio, sometimes with the aid of quick sketches made on the spot. The magic transformations he created by using this method are evident in *Grey and Silver*. Barely visible through the fog, the distant Battersea shoreline appears formed of majestic palaces and cathedral spires. The actual view to the south was of commonplace tenements and factory smokestacks.

Oriental influence, based on his growing collection of porcelain, fans, and woodblock prints, is apparent in the delicate placement of only the barest masses. The horizontals of docks and shore balance the verticals of masts, chimneys, and some passersby. A few diagonals in the form of ships' spars enliven the stark gridwork. With Whistler's sensitivity to tone, it cannot be accidental that the pale blue fog allows only one other hue to show itself; the dull orange of the tied sails. Blue and orange are complementary colors, precisely contrasted because they oppose each other on the spectrum. "The same color ought to appear in the picture continually here and there, in the same way that a thread appears in an embroidery," he wrote, "in this way, the whole will form a harmony."

Shortly after completing this twilight scene, Whistler exhibited a similar view of the Thames at night which roused the ire of John Ruskin, the paramount English art critic. Ruskin stated in a newspaper review that he "never expected to hear a coxcomb ask two hundred guineas for flinging a pot of paint in the public's face." Whistler promptly sued Ruskin for libel, and the court case of November 1878 has earned a place of distinction in the annals of law. Answering the prosecutor's question about his musical titles, Whistler explained:

> If it were called a view, it would certainly bring about nothing but disappointment on the part of the beholders. It is an artistic arrangement.

Prosecutor: How soon did you knock it off?

Whistler: I beg your pardon . . . Let us say, then how long did I take to 'knock off'—I think that's it—to knock off that Nocturne. Well, as well as I remember, about a day. I may have put a few more touches to it the next day if the painting were not dry. I had better say, then, that I was two days at work on it.

Prosecutor: The labour of two days, then, is that for which you ask two hundred guineas?

Whistler: No. I ask it for the knowledge of a lifetime.

Although the whole trial, including the courtroom display of Whistler's pictures turned upside-down, had been greeted by peels of laughter, the sincerity of his final answer was warmly applauded. "I ask it for the knowledge of a lifetime" has subsequently become a motto in the pricing and reviewing of works of art. In fact, the verdict in Whistler's favor helps explain why modern critics have retreated all too often into bland, cautious phrases. Although Whistler won the token damages of one farthing, the costs of the trial bankrupted him. It was a slow financial recovery.

Females captivated and reassured Whistler constantly, but portraying young girls formed a major preoccupation in the years following the trial. The haunting beauty who posed for *Head of a*

James McNeill Whistler *1834–1903*
Head of a Girl *c. 1883*
Canvas, 20⅜" x 15"
Gift of Curt H. Reisinger

Girl has too much presence to be a model hired for a character study. The aristocratic demeanor of this British adolescent suggests that the work is a commissioned portrait. Whistler's elegance had begun to appeal to upper-class clients. The three dark spots to the left of this girl's face are Whistler's personal device. In the mid-1860s he had abandoned conventional, written signatures because the lettering was obtrusive in his designs. Instead, he formed a calligraphic flourish of his initials, producing a butterfly encased in an oval shape. The three dots here are the empty space surrounding the ethereal insect, which has vanished. With his very name thus abstracted, Whistler's signature became a prominent part of his compositions.

In *L'Andalouse, Mother-of-Pearl and Silver* (see page 154), for example, the butterfly device apparently floating before the right-hand wall creates a visual anchor for the slender figure wafting away to the left. The exotic center of Moorish civilization in Spain, Andalusia was also the birthplace of Velázquez, one of the Old Masters whom Whistler most admired (or envied). When a lady once declared that there had been only two great artists, Velázquez and Whistler, he joked, "Why drag in Velázquez?"

L'Andalouse evokes all the proud reticence associated with Spain; yet, in fact, her hairdo and gown would not have been the least bit strange in any high-fashion center of the mid-1890s. Compare her chignonned coiffure and layered fabrics to those of the New York women conversing in *A Friendly Call* (see page 162) by William Merritt Chase, one of Whistler's protégés.

If her outfit is so in tune with international style, what makes the Andalusian appear so Spanish? It is Whistler's generation of mood through pose and tone. Walking away from the spectator, the woman turns sharply back in the opposite direction. The hieratic, impersonal profile of her face lends the distance reminiscent of Spanish reserve. Furthermore, Hispanic sobriety has for centuries been associated with a dark, moody aura. Against the chocolate and charcoal setting here, only a few gleams of pale gray emerge from beneath the black net sleeves and overskirt. The subtitle, *Mother-of-Pearl and Silver*, directs attention to Whistler's nuances of dim half-lights in the barren room. Thus the Andalusian hauteur is all effect, but it is marvelous effect indeed.

The model for *L'Andalouse* was no more Spanish then her costume. She was Whistler's sister-in-law, Ethel Birnie Philip; he had married her sister, the widow of an English architect, in 1888. Ethel herself, in 1895, wed the author Charles Whibley. After Whistler's wife died in 1896, Ethel and his other female in-laws mothered him and tended to his business interests, much as his mistresses had done earlier. The style of this picture dates it in close proximity to both Whistler's wife's death and Ethel's marriage. Either their mutual bereavement or the joy of her wedding could have occasioned the familial companionship required by the long sessions of Ethel's posing. The painting, however, is not to be considered a portrait. As an "art for art's sake" exercise, its pale tints rival counterpart darks. Like fireworks rising from the earth only to sink back as glowing embers, her tall figure shoots upward to burst into the delicate tones of sash, sleeves, arm, and face.

Shortly after finishing the composition for which his sister-in-

James McNeill Whistler *1834–1903*
George W. Vanderbilt *1897–1898*
Canvas, 82⅛" x 35⅞"
Gift of Edith Stuyvesant Gerry

131

law posed, Whistler met the American multimillionaire George Vanderbilt and was entertained aboard his private yacht. Whistler liked to call Vanderbilt "the modern Philip of Spain," a flattering reference to the seventeenth-century monarch who was one of history's greatest art patrons and whose court painter was none other than Velázquez. Much about *George W. Vanderbilt* strikes a responsive chord in anyone who has seen Velázquez' portrait of his royal master. The air of studied nonchalance, feet braced apart to steady a sway of the hips, generates exactly the right movement for the hands, which toy with a riding crop. There is marked facial resemblance between the famous art collectors, too, which Whistler undoubtedly emphasized. The American industrialist's face becomes almost inseparable from the Spanish king's; they share the same mustache, long neck, sharp nose, narrow cheeks, and high forehead.

The exaggeration of this image goes far beyond anything that Velázquez could have attempted, however. Vanderbilt's limbs and torso are unbelievably elongated. The plummeting space with its steeply raked floor is derived from Japanese woodblock prints. Yet surely no Japanese home (nor any Victorian interior) was ever this devoid of furniture. The lighting, reminiscent of Rembrandt, creates a bold abstraction of six lit areas blindly glaring from a dark background: head, collar, two hands, riding whip, and decorative wall panel alone emerge from the penumbral shades. The portrait, indeed, occupies only the central third of the upper half of the canvas. The right and left thirds of the top half, and the whole bottom half, function as a vacuum, separating the viewer from the aloof sitter. Whistler caught, by these dramatically effective means, the personality of the shy and scholarly Vanderbilt, who erected his mansion, Biltmore, in the woods of North Carolina as a retreat from the annoyance of New York, Boston, and Newport high society.

Vanderbilt's portrait, which hung in Biltmore for many years, was commented on by a close friend of the artist: "Probably not one

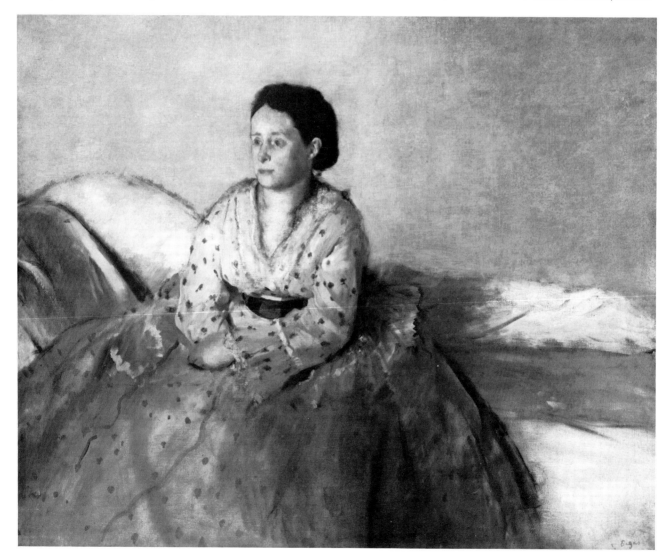

James McNeill Whistler *1834–1903*
Brown and Gold: Self-Portrait *c. 1900*
Canvas, 24½″ x 18¼″
Gift of Edith Stuyvesant Gerry

Edgar Degas *(French) 1834–1917*
Madame René de Gas *1872 / 1873*
Canvas, 28¾″ x 36¼″
Chester Dale Collection

133

Mary Cassatt *1845–1926*
Miss Mary Ellison *c. 1880*
Canvas, 33½ " x 25¾ "
Chester Dale Collection

of his portraits of men interested Whistler so much; certainly not one was finer than the picture when we saw it in the London studio. But it was a wreck in the Paris Memorial Exhibition of 1905. Like some of the other portraits of this period, it had been worked over too often." It is true that in his later years, Whistler achieved new peaks, or depths, of exacerbation in trying to perfect his craft. Impetuously, he destroyed many works, and others suffered greatly from continual scraping down and building up.

But *George W. Vanderbilt,* although reworked, is not one of these wrecks. The sitter himself was very fond of it, for one thing, and his significance as an art patron suggests that his perceptions should not be taken lightly. The deep tones so characteristic of Whistler's last pieces are not muddy or indistinct here. The charcoal-gray highlights on the black patent shoes, for instance, are just enough accent to communicate the shiny texture sparkling in the blackness. Unusually dark, even for Whistler's late career, this portrait generates more power than many of the painter's earlier, lighter canvases. It's almost as if the aging artist envisioned Vanderbilt as a wraith, materializing briefly before returning to the seclusion of the other world.

Vanderbilt had written Whistler on May 18, 1897, asking him to consider painting his portrait; by that New Year's Eve, the patron sent his check for half payment, since he considered the work done. Whistler kept stalling on delivery and, now financially independent, considered returning Vanderbilt's payment as a gentlemanly way out of his obligation. Although extensive correspondence sur-

vives between artist and sitter, the letters do not mention railroads, a common bond between the two men. Even so, it's impossible to believe that during the repeated posing sessions in Paris and London, Whistler didn't amuse Vanderbilt with stories about his father having built the first railway in Russia. The admiration between the railroad engineer's son and the railroad magnate's son was mutual. Some authorities maintain that Vanderbilt let Whistler keep the portrait as a bond of their friendship. On Whistler's death in 1903, Vanderbilt not only took possession of his portrait but also purchased a memento from the artist's estate, *Brown and Gold: Self-Portrait.*

The only spot of intense color in *Brown and Gold* is a red rosette glowing in Whistler's lapel. One of his proudest possessions, it is the mark of a Knight of the Legion of Honor, the highest accolade France can bestow upon a foreigner. Whistler had been knighted in 1889. The eloquent gesture of his left hand and his dapper monocle complete the picture of this aging gadfly. The only bizarre note is the tuft of pure white hair, which he acquired in 1886. In that year, Whistler had abruptly left London, claiming that he was going to aid the Chileans in their insurrection against the Spanish. The brief trip to Valparaiso may have been prompted by an aesthetic desire to experience Latin America, or he may have gone as a personal vindication of his valor, since his foreign residency had prohibited him from fighting for his beloved Confederacy, with which he had family connections, during the Civil War. Whatever motivated this strange interlude, he returned with one lock of his jet

Mary Cassatt *1845–1926*
Study for The Loge *c. 1882*
Pencil on paper, 11⅛" x 8⅝"
Gift of Chester Dale

Mary Cassatt *1845–1926*
The Loge *1882*
Canvas, 31½" x 25⅛"
Chester Dale Collection

135

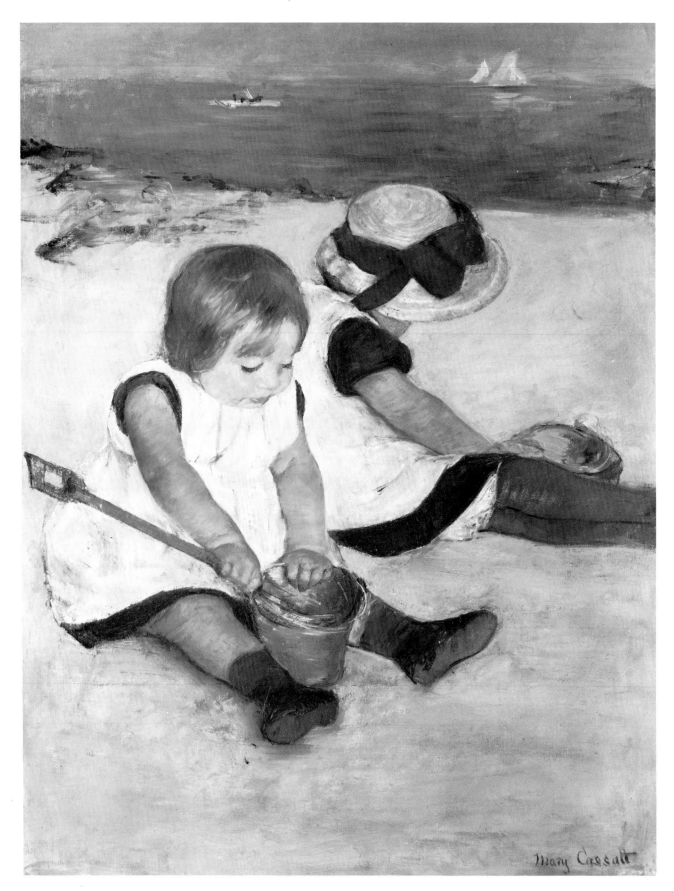

Mary Cassatt 1845–1926
Children Playing on the Beach 1884
Canvas, 38⅜″ x 29¼″
Ailsa Mellon Bruce Collection

black hair turned into a frizzed, ashen curl. This eccentric touch was an appropriate addition to Whistler's already affected grooming of yellow gloves and outsized hats. Once, observing him prance into a restaurant, his dour French rival and friend, Edgar Degas, called out, "Whistler, you've forgotten your muff!"

At the time of this self-portrait, Whistler was the dean of London's artists and the lion of international society. Cashing in on his notoriety to attract an audience, in 1885 Whistler had delivered a lecture called "The Ten O'Clock"—its unfashionably late hour allowing the guests time to digest dinner before having to digest Whistler's comments. He incorporated portions of the lecture into his book, *The Gentle Art of Making Enemies*, a collection of his verbal witticisms which grew wittier with each written editing. True art, he maintained, was a goddess seeking only beauty, "purposing in no way to better others." Misguided viewers had acquired the "habit of looking, as who should say, not *at* a picture, but *through* it, at some human fact." By ignoring morals and messages, Whistler created an art of shapes and colors to be appreciated for their own sakes and for the mood they could generate. Other painters championed this "art for art's sake," but few of them could produce designs of his quality or arguments of his persuasion. Upon Whistler, then, must rest a large portion of the credit or blame for Abstract art.

It rained the day of Whistler's funeral, casting a gray pallor over Chelsea such as he had painted many times. His sister-in-law Mrs. Whibley, who had posed for *L'Andalouse*, had nursed the frail artist through his last illness. George Vanderbilt, whose portrait still hung in Whistler's studio, acted as an honorary pallbearer. Some of the mourners swore that a mysteriously veiled, elderly woman who greeted no one during the funeral was Joanna Hiffernan. If it were she after a separation of thirty-six years, "Mrs. Abbott" now appeared as a dirge in black instead of a symphony in white.

EDGAR DEGAS

1834–1917

A foremost French artist may seem an odd inclusion in a book about American painters, but Edgar Degas did spend half a year in the United States. And, in all fairness, one should remember that one-quarter of the so-called American works illustrated in this survey of the National Gallery's collection were executed on foreign soil. Degas, in fact, bore more in common with James Whistler, Mary Cassatt, and John Singer Sargent than he did with many of his French avant-garde associates. Like the American expatriates, Degas was an independent artist rather than an Impressionist per se. The Impressionists sought to record the subtle nuances of transient sunlight on canvas; Degas and these three Americans seldom painted landscapes, preferring to concentrate on human emotion. Moreover, all four belonged to the wealthy upper classes. Schooled as a lawyer, Degas always brought his sharply analytic mind to the problems of creating a picture. Before coming to New Orleans in the winter of 1872–1873, he had won favorable criticism from establishment artists for the early works he'd shown in several official Salons in Paris.

Upon his return to France, Degas became instrumental in organizing a group exhibition in defiance of the Salon's stultifying standards of conventional propriety. The young radicals of *The Anonymous Society of Artistic Painters, Sculptors, Engravers, Etc.* eventually held eight shows, irregularly, from 1874 to 1886. At their first appearance, hostile critics dubbed them the "Impressionists" by way of ridiculing the title of one of Claude Monet's landscapes, *Impression, Sunrise*. Degas was furious about the casual, slipshod implication of the term, but it stuck. He preferred to characterize himself simply as an "independent." Nevertheless, undaunted by public misconceptions, he participated in seven of the "Impressionist" shows. Of the fifty-five artists who submitted work to these exhibitions only one, Camille Pissarro, proved to be more tenacious than Degas by joining all eight shows. Degas devoted his talents to conveying mood through movement and gesture, rendered with precise draftsmanship. These qualities made him the painter *par excellence* of ballerinas, washerwomen, and race horses—all of which move with rehearsed economy—as well as one of the finest psychological portraitists of the nineteenth century.

Degas' mother had been born in Louisiana, and his two brothers and an uncle left France to establish themselves as cotton brokers in New Orleans. In the autumn of 1872, his brother René, while on a business trip to Paris, convinced Edgar to accompany him back to America. Overwhelmed by New York and New Orleans, Edgar wrote, "I am hoarding projects which would require ten lives to put into execution. I shall abandon them in six weeks, without regret, to return to and to leave no more *my home."* The realization dawned on him that "one likes and one makes art only of that to which one is accustomed. The new captivates and bores in turn." Thus, the results of his American sojourn deal with those subjects that had always captivated him; he painted the postures of businessmen in the New Orleans Cotton Exchange, and he portrayed the personalities of his American relatives.

Edgar's sister-in-law Estelle posed for *Madame René de Gas*, one of his most brilliant portraits. With unassuming simplicity, the composition places her alone on a couch in a room stripped of cluttering accessories. Her dress and the chaise are of one color, a soft dove gray, while her complexion and the wall contribute the only other hue, a pale pink blush. Amidst this light and airy space, a black sash and her raven hair encircle her face, drawing attention to her plain features. Estelle's polka-dot skirt and sleeves are carefully controlled, too, to focus upon her face. In a pattern totally illogical for a dressmaker but entirely consistent with Degas' ingenuity, the dots merge into closer and closer placement as well as darker and darker tonality as they approach Madame René de Gas's sincere expression and placidly folded arms.

In writing of his brother René, Edgar said, "He is married and his wife, our cousin, is blind, poor thing, almost without hope. She has borne him two children, she is going to give him a third whose godfather I shall be, and as the widow of a young American killed in

the War of Secession she already had a little girl of her own who is nine years old." What better way to communicate Estelle's blindness and maternity than with such daring, yet sympathetic, candor? Sightless and lost in reverie, she is unaware of her brother-in-law's gaze as she turns her face away from the center of the design. Her asymmetrical placement to the left of the canvas conveys her isolation, and the recessive color scheme is appropriately understated, complementing her pregnancy.

In the spring of 1873, Degas went home to Paris. Later that year, a young American art student in France persuaded an American heiress to purchase one of Degas' pastel drawings. The student, Mary Cassatt, had not yet met the master and did not realize how important Degas was to become to her.

MARY CASSATT

1845–1926

Mary Cassatt has become a *cause célèbre* among amateur psychologists. Rich, intelligent, and sociable, she chose to remain a spinster in the best nineteenth-century connotation of that word. Yet, her most quoted remark was, "After all, woman's vocation in life is to bear children." The only children she ever bore came from her brush, pencil, or etching needle; perhaps she meant her comment to be taken ironically. Well over three-quarters of her paintings and prints depict aspects of infancy, adolescence, or maternity. Yet, the cloying sentiment one might associate with such subjects is absent. Taking a clear-headed approach to her models, she transformed them into carefully wrought patterns across her canvases. "I am American," she once stated, "clearly and frankly American." Perhaps it is her no-nonsense attitude toward potentially saccharine themes that most reveals her American straightforwardness.

Although born in Allegheny City, now a part of Pittsburgh, Mary Cassatt spent the years between ages seven and fourteen in Europe with her family. Her study at private schools in Paris, as well as in Heidelberg and Darmstadt, in the Rhine River valley, made her fluent in French and German. Her father, a banker and businessman with a love of French culture, earned enough money for the family to live well. But as an adult artist, Cassatt was expected to pay for her own studio, materials, and models through the sale of her works. She did. Her rather strong-willed mother may have been the instrument of her decision to become a painter. In an age when respectable women could be employed only as volunteers doing "good works," Mary's desire to enter the professions was unusual, to say the least. That she chose painting as a career was unbelievable. Her father is reported to have declared, "I would almost rather see you dead."

Persuading her father to relent, she enrolled in the Pennsylvania Academy of the Fine Arts in Philadelphia, where the family had moved. Completing a four-year course there, she left for Europe in 1866, twenty-one years old and therefore chaperoned by her mother. She traveled extensively in the next eight years, copying Old Masters' composition in museums in Spain, Italy, and the Netherlands. On three occasions, the conservative juries of the official French Salons accepted her entries; Edgar Degas noted her work in the Salon of 1874, remarking coolly, "There is someone who feels as I do." He was apparently unaware that she had been promoting the sale of his works to American collectors. Having been intrigued by his pictures displayed in a dealer's window, she wrote to a friend, "I used to go and flatten my nose against that window and absorb all I could of his art. It changed my life." Although Cassatt's disciplined draftsmanship is indebted to Degas' example, she must not be slighted by being considered merely his pupil. By the time of their first meeting in 1877, Cassatt had devoted over fifteen years to a conscientious program of artistic development and, during most of that period, had been self-taught and self-directed.

She settled permanently in Paris in 1874; three years later her family joined her. At their urging, Cassatt enrolled in the studio of a third-rate academic artist. Rebelling against his petty ideas, she struck out on her own. Soon, Degas appeared to properly introduce himself and to request her to join forces with the Impressionist group. Mary accepted immediately. "At last I could work with absolute independence, without considering the opinion of a jury," she exalted. "I hated conventional art—I began to live." The only American ever invited to join the Impressionists, she participated in four of their eight shows: 1879, 1880, 1881, and 1886. And regardless of her contact with the Impressionists, or independents, Cassatt continued to send pictures to exhibitions in Philadelphia and New York. She maintained Philadelphia as her legal address and kept up a steady correspondence with her American society friends. Even if Mary Cassatt had never painted a single picture, she would rank high in the annals of modern art as an advisor, critic, and purchasing agent for American collectors. It was largely through her encouragement that French Impressionist pictures entered American private galleries to form, eventually, the impressive holdings in our public museums.

Miss Mary Ellison, a portrait of a Pennsylvania socialite to whom Miss Cassatt had been introduced by mutual friends in Paris in 1879, shows how quickly the painter had absorbed avant-garde principles. The space is compressed, creating a display of surface pattern across the canvas; the accessories of fan and porcelain vase pay homage to the current fashion for Oriental exoticism; and, although this is a portrait in an interior, rather than an outdoor landscape, the picture shows an Impressionist's interest in the subtleties of light. The scintillating effects of shimmering illumination are here captured by the broken brushstrokes that form vague, dabbed planes of paint. Cassatt challenges her ability to convey varying types of light by including the mirror; its blurred, dulled reflection of the back of Miss Ellison's head is a foil to the sharper, thicker paint modeling her face.

Mary Ellison and Mary Cassatt became close friends, and the former agreed to sit again for a thematic picture, *The Loge* (see page

155). The painting of 1882 and its pencil study demonstrate Cassatt's similarity to and difference from the pure Impressionists. The very fact that there is a pencil study proves that the oil was a calculated design, not simply a spontaneous recording of transient light effects. The position of Miss Ellison's arms has been adjusted twice in Mary Cassatt's preparatory sketch. The perspective of her fan, receding back into depth, was altered in the final oil to form a perfect crescent shape, parallel to the surface of the canvas itself.

Her companion model in *The Loge* was the daughter of the French Symbolist poet Stephane Mallarmé; Mademoiselle Mallarmé undergoes more subdued but more significant changes between the sketch and the finished oil. In the pencil drawing, her arms rest comfortably in her lap while she leans slightly against her chair. The painting, however, shows her bolt upright, her bouquet pulled into the precise lower center of the composition and her upper arm exactly parallel to the canvas' vertical edge. The effect Miss Cassatt sought is best evident in a comparison of Mademoiselle Mallarmé's shoulder line, before and after. What natural observation recorded as complex anatomy, art has forged into geometric regularity; her shoulders form arcs that reiterate the curves of the fan, bouquet, chair-back, chandelier, and distant balconies.

Yet in some ways Mary Cassatt *was* an Impressionist. The austerity of the artfully structured curves, far removed from Impressionist objectivity, is tempered by the fleeting light within the

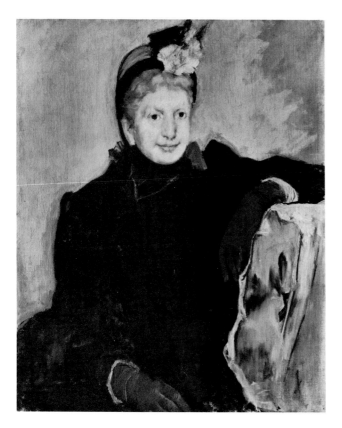

Mary Cassatt *1845–1926*
Portrait of an Elderly Lady *c. 1887*
Canvas, *28⅝ " x 23¾ "*
Chester Dale Collection

canvas. The sitters' complexions, on close examination, read as myriad flecks of multicolored pigment. In deliberately keeping her colors separate, Cassatt worked as an Impressionist who believed that the varied daubs, by blending in the viewer's eye, would simulate a brighter, lighter illumination than conventionally mixed paint would yield. These spots of pink, amber, turquoise, and jade, which read as flesh and fabric, are indebted to Impressionism. In another Impressionistic play on light, the reflection of Miss Ellison's shoulder at the far right indicates that the entire background is an image of the opera house seen in a plate-glass mirror behind the ladies' box.

Cassatt's simultaneous acceptance and rejection of Impressionist specificity is apparent in *Children Playing on the Beach*. The sandy beach, which an Impressionist would have rendered in a full range of spectral color, appears as an undifferentiated yellow background for the little girls' bold silhouettes. A suppression of detail in the sea and sky, too, plays up the contrasted positions of the girls. One presents us with an almost full view of her pudgy face, while the other turns away, her head hidden behind a ribboned straw hat. Both wear similar clothes, and the repetition of their dark frocks and stockings against their white pinafores makes the opposed alignments all the more unexpected. Cassatt's amazing ability to record the natural attitudes of children is marvelously apparent in the awkward way the foreground toddler grasps the rim of her bucket and attempts to control the long handle of her shovel. This engaging scene was probably painted in Spain, where Mary Cassatt had taken her ailing mother for a climatic change in January 1884.

In the mid-1880s, while viewing an exhibition with Degas, Cassatt commented upon the work of an acquaintance, noting, "He has no style." Her misanthropic mentor shrugged his shoulders as if to dismiss her opinion as feminine chatter. Cassatt resolved to prove that a woman could understand matters of artistic consequence. So to refute Degas she produced *Girl Arranging Her Hair* (see page 154). All trace of Impressionist brushwork is gone. The paint is applied thickly in long, sure strokes. And the color scheme is totally unnatural; instead of shimmering spots of the full color wheel, the hues are all related to a narrow segment of the spectrum. Violet dominates and unifies the composition. Blue-violets form the shadows on the chemise and the tone of the marble washstand. The pinks of the girl's complexion are red-violet, and purplish reds shade the wallpaper. The browns of the bamboo chair and her hair are but darkened variations on purple, too.

The coloring here is a triumph of Post-Impressionist stylistic consistency. The term "Post-Impressionism" was coined in 1910 by a critic frustrated in his attempt to describe the work of those artists who had abandoned Impressionist naturalism to strive for an integrity of pure design. (In a sense, Whistler's "art for art's sake" was an early form of the Post-Impressionism seen here.) Cassatt dictated this harmony of red-violet and blue-violet to instill an order onto natural happenstance. And, much as she had imposed order on the complex curves of *The Loge*, here she arranged the shapes to counterbalance sharp angles against soft curves. The model's bony elbows, her crinkled nightgown, and the spindly bamboo rungs weave a pattern of triangles. These straight lines play off the cylindrical arms, columnar neck, and weak, rounded chin. This linear

artifice helps integrate the girl with her setting: the S-curve of the back of her neck precisely parallels the silhouette of the water carafe behind her and the sweeping splashboard of the washstand.

Cassatt's assiduous copying in the museums aided her in the conception of this design. The gesture of the girl's turned head and uplifted arm derive from Michelangelo's *Dying Slave* in the Louvre. Instead of a Renaissance statue of a muscular hero, however, Cassatt renders a girl in the most awkward and ungainly act of her daily toilette. *Girl Arranging Her Hair* was exhibited in 1886, at the eighth and last Impressionist exhibition. Degas was thunderstruck when he realized what a compellingly beautiful design Cassatt had conjured from a homely adolescent braiding her hair. He purchased the picture immediately and treasured it all his life. He also wrote Cassatt a note exclaiming, "What design, what style!" It is unknown whether or not Cassatt ever reminded Degas that he'd once implied women couldn't understand style, much less create it.

When asked how she could tolerate Degas' moods, Cassatt answered mildly, "I am independent! I can live alone and I love to work. Sometimes it made him furious that he could not find a chink in my armor, and there would be months when we just could not see each other, and then something I painted would bring us together again." She also noted in admiration, "However dreadful he was, he always lived up to his ideals." An ideal they shared was that of the expressive potential of black, a tone banished from the bright palette of the Impressionists. Cassatt's *Portrait of an Elderly Lady* employs a heavy black outfit to play up the delicacy of the friendly face, the fragile pink flower, and the silver hair. The rippling, sometimes jagged contours of the black silhouette also convey a feeling of the tremulous frailty of age. The success of jet black in this portrait of an unknown sitter demonstrates that rules are meant to be broken, even the rules of the Impressionists.

In 1890, a huge exhibition of Japanese woodblock prints was held in Paris; Degas and Cassatt, attending it together, became even more enamored of Oriental clarity than they had been in the past. Cassatt's *Boating Party* employs an Oriental, bird's-eye view to flatten space. With the perspective tilted upward until the shoreline nearly touches the top of the canvas, the ocean forms a neutral backdrop for a counterpoint of curves. The hired oarsman's sash

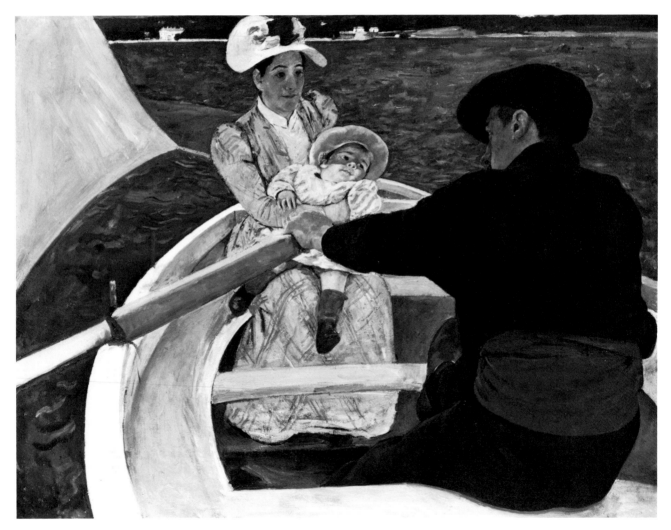

Mary Cassatt *1845–1926*
The Boating Party *1893/1894*
Canvas, 35½″ x 46⅛″
Chester Dale Collection

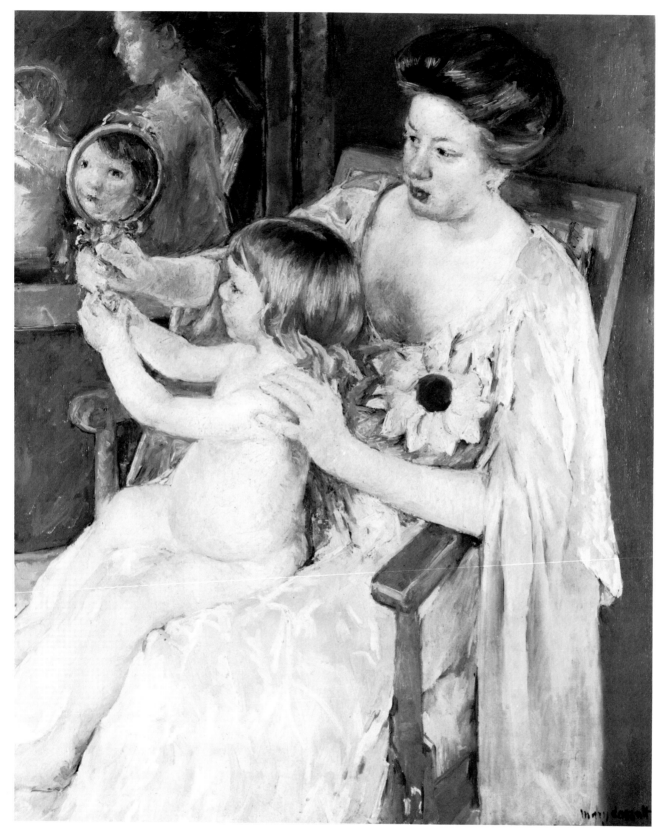

Mary Cassatt *1845–1926*
Mother and Child *c. 1905*
Canvas, 36¼″ x 29″
Chester Dale Collection

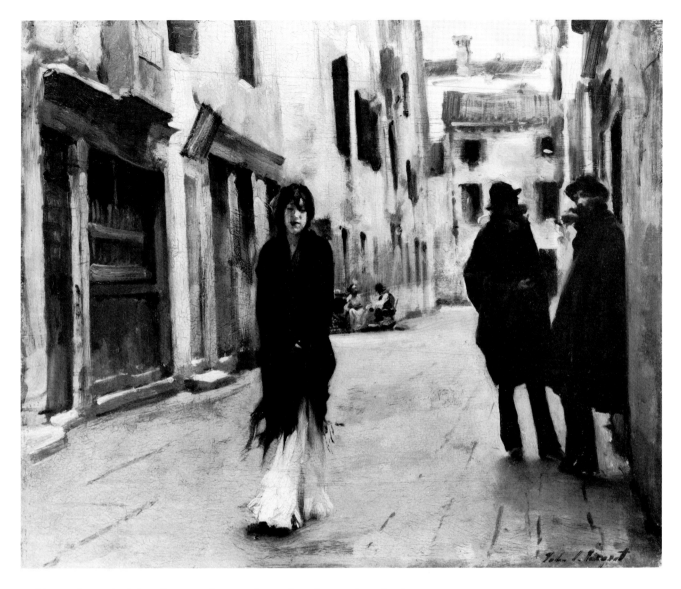

and beret, the mother's leg-of-mutton sleeves and straw hat, the boat's gunwale and sail are the major soft, puffy shapes in a picture filled with minor curvilinear accents. All elements of the design draw attention to the restlessness of the squirming baby, Cassatt's central point. The rower's arm, his oar, the sides of the craft, and the sail all converge emphatically upon the child.

The sailcloth, especially, forms an arrow pointing directly to the baby. Yet why is the oarsman rowing against the wind? Or, one might ask, where could a mast possibly be attached to such a boat? The sail is superfluous, antinatural, imaginary. Cassatt incorporated the sail as a design element. Its pale form balances the rower's dark mass, and its curved lower edge creates a series of crescents against the water and gunwales. The sheer impossibility of that sail bothers very few of the visitors to the National Gallery. Thus, it defends brilliantly the concept of artistic or poetic license. In the context of Mary Cassatt's composition, and only in that context,

the sail makes perfect sense.

This refreshing scene of a mother and child on an outdoor excursion was painted during a holiday at Antibes, on the French Riviera, in the winter of 1893–1894. Two decades later, Mary Cassatt wrote to her dealer, "As for my picture, *The Boating Party,* I do not wish to sell it; I have already promised it to my family. It was painted at Antibes twenty years ago, the year my niece came into the world; the year and fact make it a souvenir. I have so few things to leave to my nieces and nephews." But she did sell it later—not for money but out of cantankerousness. Mary Cassatt quarreled with her few surviving relatives in her old age. Her irascible personality is easily understood when one compounds the prejudice against avant-garde art with nineteenth-century attitudes toward women in the professions. She had exhibited all over the world, and was even commissioned to do a mural for the Woman's Building of the World's Columbian Exposition in Chicago in 1893. Yet

John Singer Sargent *1856–1925*
Street in Venice *1882*
Wood, 17¾ " x 21¼ "
Gift of the Avalon Foundation

John Singer Sargent *1856–1925*
Mrs. Adrian Iselin *1888*
Canvas, 60½ " x 36⅝ "
Gift of Ernest Iselin

in 1899 when she visited Philadelphia for the first time in a quarter of a century, a local newspaper could only note in its social column, "Mary Cassatt, sister of Mr. Cassatt, president of the Pennsylvania Railroad, returned from Europe yesterday. She has been studying painting in France, and owns the smallest Pekingese dog in the world."

Ignoring such ignorance, Cassatt kept painting as long as time allowed. *Mother and Child*, of about 1905, shows a final sharpening of her powers. The bright yellow sunflower on the woman's bodice keys a color scheme of intense greens and yellow-oranges, accentuating the pearly skin tones. The arms of both mother and daughter gracefully intertwine in a continuous curve that completes itself in a circular hand mirror. This painting is notable for its sophisticated Post-Impressionist comment on reality. The mother is seen mirrored while looking at the reflection of the girl, who sees the viewer in the hand mirror as the viewer sees the child a third time in the wall mirror.

In 1912, Mary Cassatt suffered a nervous breakdown following the death of a brother, her last intimate relative. In the same year, she underwent her first operation for cataracts in both eyes. Two years later, the Pennsylvania Academy of the Fine Arts presented her with its Gold Medal of Honor for lifetime work. She was already blind. Although she was, like Whistler, a Knight of the Legion of Honor in France, her medals could have been of little comfort during her exile on the Riviera during World War I. In 1926, Claude Monet, the founder of French Impressionism, and Mary Cassatt, one of the most brilliant Post-Impressionists, died; she, at the age of eighty-two at her chateau outside Paris. Both had outlived their contemporaries and survived beyond their era.

JOHN SINGER SARGENT

1856–1925

A perceptive art patron of the late nineteenth century would have no small choice of society portraitists to do his likeness. Europe in the Gilded Age was awash with fashionable painters willing to flatter fashionable sitters. But choosing among the really best would present a problem. Degas and Cassatt, with independent means, portrayed only their relatives and friends; although James Whistler painted members of society, he could try the patience of a saint with his endless reworkings. But there was one major artist willing to accept portrait commissions and to execute them in a reasonable period of time. To charge a reasonable fee, however, seldom occurred to John Singer Sargent. He kept escalating his prices to drive away clients, but the more he charged, the more desirable his portraits became as a sign of social status. In desperation, Sargent called his portraiture "a pimp's profession."

Born in Italy of American parents who had retired early from their mercantile career to enjoy the good life, Sargent was educated in Florence, Rome, and Nice. His phenomenal talent for drawing emerged before he was in his teens. In 1874, at the age of eighteen,

he commenced five years of study under Paris' most successful portraitist and muralist; within a short time, the student excelled the master.

Whereas Whistler and Cassatt struggled for years for mastery and acceptance, Sargent made a sensational debut at age twenty-six. Whistler, especially, must have been galled when he and Sargent both received the Legion of Honor in 1889; Sargent was twenty-two years younger than his compatriot! But Sargent's facility became his curse in posterity. Succeeding generations have increasing appreciation for the depth of Whistler and Cassatt, while even Sargent's contemporaries were somewhat uncomfortable about the lack of profundity in his superficial verve.

Henry James, the American expatriate novelist and Sargent's close friend, summed up the misgivings about "the slightly 'uncanny' spectacle of a talent which on the very threshold of its career has nothing more to learn. . . . he knows so much about the art of painting that he perhaps does not fear energies quite enough." James was wrong in one respect: Sargent could learn and learn well. But James was correct in assuming that Sargent would not develop. There is no stylistic evolution to Sargent's art; he grew not by maturation but by osmosis. After briefly visiting with Claude Monet in 1887, for example, Sargent acquired the ability to accept or reject a French Impressionist manner whenever it suited his fancy.

Street in Venice, painted during visits to the Adriatic in 1880–1882, proves Sargent's brio. The slick brushstrokes and thick highlights owe much to his study of the seventeenth-century masters Diego Velázquez and Frans Hals, but Sargent transformed their techniques for capturing light and shade into a personal projection of mood. An eerie note prevails during the three hours of siesta that leave the Calle Larga dei Proverbi, like the rest of Venice, deserted. In a still, quiet alleyway, the fringe of a passing black shawl catches the attention of two men conversing in a doorway. The rigidly confining buildings heighten the mystery of the languid, swaying figures. One wonders what Epes Sargent, that steadfast Yankee whose portrait John Singleton Copley had painted 120 years earlier, would think of this provocative, sensual scene by his distant descendant.

John Singer Sargent, having descended from the likes of Copley's sitter, felt secure in the upper strata of American or European society. The young painter, for instance, wasn't the least bit intimidated by the forceful personality of Mrs. Adrian Iselin, a prominent banker's wife. In her portrait, painted in New York in 1888, Mrs. Iselin bends forward slightly at the waist, as though anxious to see the canvas upon which Sargent was characterizing her. She had every right to be anxious. The brash artist does nothing to conceal her attitude of contempt or to flatter her elephantine ear. "I do not judge," Sargent once explained, "I only chronicle." When Mrs. Iselin appeared for her sitting, Sargent dismayed her by insisting on portraying her in the street clothes she was wearing instead of selecting one of the sumptuous gowns carried by her maid. His choice was right; the austere black dress, glinting with beads of jet, becomes a pillar of uprightness in his hands. Thirty years after painting *Mrs. Adrian Iselin*, Sargent recalled, "I cannot forget that dominating little finger."

A better rapport between artist and sitter is apparent in *Mrs. William Crowninshield Endicott* (see page 157). To complement the reserved dignity of this Boston Brahmin, Sargent chose the most delicate of the antique furnishings in his studio. (The crimson curtain makes conscious reference also to the Grand Manner court portraits of the eighteenth century.) Subduing his normally flashy technique, Sargent took great care in rendering the translucency of Mrs. Endicott's lace shawl and the silken gleam of her snowy hair. The pale tints of cream and ivory imbue the design with gentility, while the smoldering red background and the bright reflection of a red bookbinding on the polished table add warmth. The sitter, née Ellen Peabody, came from a wealthy mercantile family in Massa-

John Singer Sargent *1856–1925*
Peter A. B. Widener *1902*
Canvas, 58⅝" x 38¾"
Widener Collection

John Singer Sargent *1856–1925*
Mrs. Joseph Chamberlain *1902*
Canvas, 59¼" x 33"
Gift of the sitter, Mary Endicott Chamberlain Carnegie

145

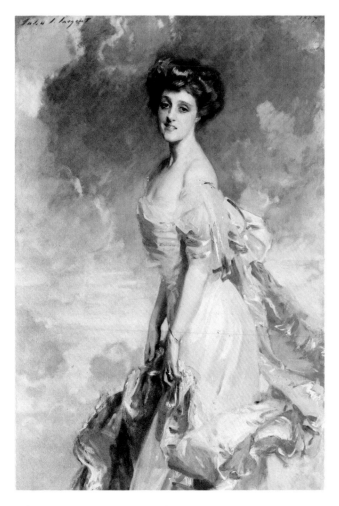

John Singer Sargent *1856–1925*
Mathilde Townsend *1907*
Canvas, 60⅜″ x 40¼″
Gift of the sitter, Mrs. Sumner Welles

chusetts. Her husband had been a justice on the state's Supreme Court and was the Secretary of War during Grover Cleveland's first administration. Widowed in 1900, she was visiting her daughter in England when Sargent accepted this commission.

In 1902, the year after painting Mrs. Endicott, Sargent executed a portrait of her daughter, Mrs. Joseph Chamberlain, the American wife of a British diplomat. The aristocratic features share a family resemblance, but Sargent saw the daughter as a modish figure. *Mrs. Joseph Chamberlain* breathes the social self-confidence that comes of youth. Sargent undoubtedly selected the ball gown she wears; he always refused portrait commissions unless he could dictate the sitters' clothing. The paint textures melt like butter across her white satin dress and whip like cream over the puffed blue sleeves. Mrs. Chamberlain must have mellowed with age to match her mother's rectitude, because after the death of her first husband in 1914, she married William Hartley Carnegie, dean of Westminster and chaplain of the House of Commons.

If Sargent could adapt his style to suit best each female sitter, he was equally adept at recording men at the peaks of their political, financial, or military careers. *Peter A. B. Widener* portrays a Philadelphia coal magnate and trolley-car manufacturer whose son, Joseph Widener, became a Founding Benefactor of the National Gallery of Art in Washington, D.C. With relatively thin paint and dark tones, Sargent captured the elder Widener's sobriety. His sagacity is artfully brought out by the light that emphasizes his impressively scaled head. Softening the upright stance and geometric wall paneling, highlights glint from his starched white collar and gold watch chain. Sargent's incredible facility at choosing the appropriate technique with which to convey his sitter's personality is deceptive. He stated, "I don't dig beneath the surface for things that don't appear before my eyes." But his eyes were so keen in picking out the superficial elements unique to differing individuals that their characters remain fixed in his portraits.

When confronted with ravishing beauty, Sargent threw artistic caution to the wind. In *Mathilde Townsend,* that wind was capable of blowing oil paint into cake frosting. As thick as confectioner's sugar, the paint has been troweled on with the blade of the painter's spatula. The subject's spritely, dancing pose and the color scheme of baby blue and pink add to the festive air. Miss Townsend, said to be the richest woman in Washington, D.C., had two prominent husbands: the first was Senator Gerry of Rhode Island; the second, Undersecretary of State for Franklin D. Roosevelt, Sumner Welles. In 1907, when he painted this patroness of animal humane societies, Sargent resolved never to do portraits again. Portraits had become to him "a painting with a little something wrong about the mouth." To one sitter who'd complained about his portrayal of her mouth, he threatened, "Well, Madame, perhaps we had better leave it out altogether."

By the time he abandoned portraiture in 1907, Sargent was possibly the most bemedaled artist in the Western world. So, he decided to devote the rest of his life to work which interested him: vast decorative murals for public buildings and small canvases of quiet domestic scenes. *Repose,* probably painted while on vacation in Switzerland in the autumn of 1911, is precisely the type of pic-

ture Sargent had always used to clear his frustrations when in the midst of posing sessions for society portraits. In a hushed interior aglow with the amber light of the late afternoon, a recumbent woman daydreams. The softness of her form is surrounded by the sharp, straight lines of the furnishings. The dominance of the amber color and the insistence on a severely architectonic setting are clearly dictated by the artist's sensibility, rather than by a given scene, revealing this as an example of "art for art's sake." Sargent enlivened his study in reverie with his usual dashing brushwork. The detail which serves as this chapter's frontispiece shows that Sargent virtually attacked the canvas as though he were a fencing master, determined to outmaneuver an opponent. With all of its vivacity, though, the stroke varies to render the crinkle of a satin skirt, the smoothness of a cashmere shawl, or the lightness of tousled hair. And, using only a few more touches of paint than

there are fingers on a hand, Sargent adroitly caught both the correct anatomy and the easy grace of her intertwined fingers.

In fact, Sargent nicknamed this model "Intertwingle," for her expressive gestures and fluid exchange of poses. She was his niece, Rose-Marie Ormond Michel, daughter of his sister. A favorite relative and traveling companion, Rose-Marie posed for many of her uncle's genre pictures. Six and a half years later, Madame Michel attended Good Friday services on March 29, 1918, at the church of St. Gervais in Paris. Just as the priest pronounced the words "Father, into thy hands I commend my spirit," a German shell from the cannon Big Bertha hit the church, killing seventy worshipers, including Rose-Marie. Her husband had fallen in action in 1914, at the beginning of the war. And World War I destroyed more than this lovely young woman; it destroyed, forever, that pleasant dream that had been the Gilded Age.

John Singer Sargent *1856–1925*
Repose 1911
Canvas, 25⅛" x 30"
Gift of Curt H. Reisinger

147

9

VICTORIAN REALISTS

As a reference to a specific monarch, the term "Victorian" may not, of course, be applied to American government of the late nineteenth century, but its application is valid to American culture. We shared with the British Empire an optimistic, expansionist policy and an exuberant, eclectic architecture that borrowed motifs whenever necessary. The homes of the wealthy could and would look like Italian villas, French chateaux, German castles, or English hunting lodges. Churches must have medieval spires; museums, classical porticos. But, just as there were architects who insisted on the engineering purity of steel and concrete without the disguise of ornamentation, so there were painters who strove to record the facts of actual existence.

Photography, invented in 1839, had given us a new, objective way of seeing; the camera lenses did not flatter. Social attitudes, especially after the 1848 revolutions that swept several European nations, saw the common man in a more dignified role. And, aesthetically, the emphasis began to shift away from grand, moralizing pictures toward straightforward renderings of visual appearance. Some American portraits, thus, sought candid truth, and still lifes and genres, or scenes of daily activities, often depicted the mundane reality of life.

EASTMAN JOHNSON

1824–1906

Being appreciably older than Winslow Homer or Thomas Eakins, Eastman Johnson led them in the rising American preference for scrupulous exactitude in depicting everyday themes. Johnson, raised in the ebullient optimism prior to the Civil War, imbued his works with a serene confidence unlike the probing profundity in the later art of Homer and Eakins. The theatrical staging

of much of Johnson's composition and his preference for hard-edged, linear form combine to give his pictures the effect of Victorian pantomime shows with the actors momentarily frozen into tableau groupings.

The son of a prosperous Maine politician, Johnson apprenticed at a lithographic firm in Boston and, by his late teens, traveled the East Coast making a success of crayon and charcoal portraits. Partially because of his father's political influence, Johnson found a ready market for his flattering likenesses in Washington, D.C. In 1849, he'd saved enough to sail for Düsseldorf, Germany. The Royal Academy at Düsseldorf, an international art center which attracted many young Americans around the mid-century, stressed meticulous drawing from plaster casts and living models. This rigorous discipline in tight contours and balanced design would characterize the underlying structure of Johnson's mature paintings. But he found German art colorless. With brief visits to Paris, Johnson spent the years 1851–1855 in The Hague, Holland, absorbing the strong hues of the seventeenth-century Dutch "Little Masters" of genre and still life and studying the free brushwork and rich tones of Frans Hals or Rembrandt. Upon his return to the United States, he worked in Wisconsin, Cincinnati, and Washington, before settling permanently in New York City in 1859. He achieved instant celebrity with genre scenes of Southern slavery that were so politely ambiguous as to appeal to Confederates and Yankees alike.

In Holland, Johnson's capacity for dark-brown color and low-keyed light had earned him the nickname "the American Rembrandt." To capitalize on that image, he attended society costume balls dressed as a seventeenth-century Dutch burgher. *The Early Scholar* of about 1865 demonstrates Johnson's superb blending of soft illumination culled from the Dutch Old Masters and sharp outlining learned from contemporary German art professors. And the anecdotal interest was bound to appeal to American taste because almost every viewer would have experienced the childhood assignment of warming the schoolhouse before his teacher and classmates arrived. The boy has just lit a fire in the cast-iron stove

148

with some of the split logs of silvery birch piled on the floor. His books, tied with a cord, lie on a bench behind him, while his lunch bucket sits on the floor under the seat. Now that his task is done and the fire has started, he sits in the teacher's rocking chair to warm his hands. The charcoal grays, earth browns, sandy beiges, and mossy greens communicate the dull light of a chilly, overcast dawn. The child's white collar and ruddy cheeks gleam against these recessive shades, calling attention to his face. The sketchy handling of the boy's slacks and sweater implies that the fabrics rustle as he bends forward, and his countenance, being blurred, assumes an idealized, even angelic innocence. The amber highlights on the rocker pick up the warmth of the red and yellow flames bursting through the chink of the stove's cracked-open door. The carefully balanced design pits the simple, dark rectangles of the schoolmaster's lectern, blackboard, and stovepipe at left against the more complex, but paler forms of the student's stepped desks at

right. The bare suggestion of the desks and benches required calligraphic outlines for definition. These geometric shapes on either side bracket the central group of boy, rocker, and stove, which is much more highly modeled.

There were other facets to Johnson's talent besides quietly toned genre scenes. *The Brown Family* (see page 156), dated 1869, demonstrates his genius at manipulating bright hues and at producing insightful portraits. John Brown, a banker and shipping magnate, commissioned Johnson to create this group portrait of his parents and son as a Christmas gift for relatives in England. Brown wrote to his nephew that a branch of the family firm in Liverpool would soon receive "a box from New York containing as a Christmas gift to yourself and your good wife from your grandparents, a picture the history of which is curious. . . . it is Eastman Johnson's handiwork, and considered as a specimen of his workmanship very good. It is in reality a copy of a portion of the picture

Eastman Johnson *1824–1906*
The Early Scholar *c. 1865*
Academy board on canvas, 17" x 21⅛"
Gift of Chester Dale

he painted for me." The National Gallery's work, painted on paper glued to canvas, is thus Johnson's replica of the lower half of a canvas which showed the Brown's parlor right up to the ceiling and chandelier. When that larger picture, now belonging to the M. H. de Young Memorial Museum in San Francisco, was exhibited at the National Academy of Design in 1869, a New York reviewer exclaimed that it "attracts great attention for its admirable qualities of drawing, composition, and color. The figures of the elder persons are somewhat constrained, but nothing could be more natural than the action of the little child, laying its hand on grandpapa's arm, to attract his attention from the newspaper. The accessories are painted with realistic fidelity and scrupulous devotion to truth of detail." Another columnist observed accurately, "His 'Portraits' are portraits of mirrors, curtains, carpet, mantelpiece, and upholstery in general, with, incidentally, an old gentleman, a lady, and a tiny child, the last being on tip toe and in blue velvet, and busily whispering in the old gentleman's ear. . . . Decidedly refreshing is it to meet with a novelty, and a novelty full of promise, contributed by the bearer of an honored name."

The much-appreciated novelty was a group portrait that utilized the setting to express the sitters' personalities. The comfortable parlor of this mansion in French Renaissance style was important to the senior Browns; it was the house where they'd reared their children. Like his son, who'd commissioned the two pictures, James Brown was a wealthy banker. Since he and his wife, Eliza, were about to move to a newly fashionable Park Avenue address, they perhaps requested the inclusion of the furnishings as mementoes of their former happy home. Typical of early Victorian décor, a riot of color erupts in the room. Mrs. Eliza Brown, dressed in black, easily holds her own against the vivid accessories, especially in the play of sparkling light on her jet beads contrasted to the shimmer of her satins. Mr. James Brown stands out by the abrupt tonal collision of his black coat and tie with his snow-white shirt and newspaper. But because William, the small grandson, must balance the visual competition of the ornate mantel garniture, he needed more than his intense turquoise velvet; so Johnson positioned him before the grand scarlet drapery.

The Brown Family is a consummation of the "conversation piece" format of group portraits. Earlier examples used only a hint of genre activity to relate the several figures in a common activity. Johnson carried that idea further, putting as much emphasis on the environment as on the sitters. In brief, he combined aspects of architectural interior renderings with genre scenes of daily life in order to create a scene wherein the portrait likenesses are of only minor interest. In composing this particularly ambitious image, the artist apparently relied on a family photograph taken around 1856 by Mathew Brady. Brady's daguerreotype showed the same corner of the parlor, an earlier arrangement of many of the same furnishings, and the Browns, posed differently but wearing the same clothes. Mr. Brown's glasses, though, are perched on the end of his nose in the photograph, while Mrs. Brown is looking up from her knitting, as she does in Johnson's painting. A popular lithograph published by Currier and Ives in 1868, the year before Johnson created this oil, similarly depicted an elderly middle-class couple — she knit-

ting and he reading a newspaper — interrupted by a grandchild. *The Brown Family*, however, goes far beyond a factual photograph or a sentimental print. The marvelous play of light across various textures demonstrates Johnson's acute perception of natural phenomena, and the superb compositional balance reveals his thorough academic background in Germany and Holland.

Johnson painted several other group portraits of prominent families in luxurious interiors, and he maintained his position as America's principal genre artist. His pictures of corn husking or collecting maple sugar continued to command attention, but eventually his dryly detailed style passed from favor. The meticulous, enameled surface of his Düsseldorf manner appeared old-fashioned compared to the free, loose paint application being taught to younger American artists in Munich. By the 1880s, Eastman Johnson retired from genre painting and settled into a lucrative practice of creating minutely exact portraits.

THOMAS EAKINS

1844–1916

Conscientious to a fault, Thomas Eakins painted as he wished to paint, regardless of the demands of potential clients. "Get the character of things," he would remind his students. "If a man's fat, make him fat; if a man's thin, make him thin. Don't copy. Feel the forms. Respectability in art is appalling." The honest lack of phony respectability made Eakins' art appear uncouth to his Victorian contemporaries; only a few perceptive critics and fellow painters understood his work. Although Eakins lived all his life in his native Philadelphia as a teacher and then director of the Pennsylvania Academy of the Fine Arts, he was virtually unknown in his home town. When a Philadelphia hostess asked the society portraitist John Singer Sargent whom he would like her to ask to dinner, Sargent replied, "There's Eakins, for instance." "Who's Eakins?" the lady asked. Her ignorance is understandable. Eakins held only a single one-man show in his entire career; that is, if his pictures sharing a gallery with hand-decorated china by a gifted local lady could be called a one-man show.

Eakins' independent, domineering nature reflects the self-confidence he gained as a youth, being a constant companion to his father. The elder Eakins, a writing master, instilled a devotion to fine penmanship into his son. Thomas Eakins' scholarship, too, must be attributed to his father's home instruction; the artist had a gift for languages, being totally fluent in French and Latin, and read mathematical treatises to relax. Father and son also engaged in friendly rivalries at swimming, skating, sailing, hunting, and other outdoor sports. Eakins studied at the Pennsylvania Academy and augmented his work there with courses in anatomy at the Jefferson Medical College. Because of his father's scrimping, he was able to attend the Ecole des Beaux Arts in Paris, working under the best French academicians from 1866 to 1868. He then traveled in

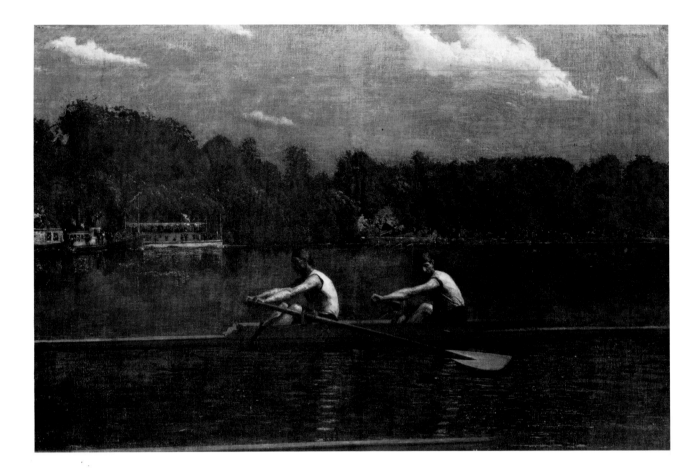

Germany and Italy, wintering in Spain, before returning to Phila-
delphia in 1870. His observations abroad taught him moderation.
"There are men in Paris in the schools who paint day after day from
the model. They never try to paint anything else. . . . They are now
old men. They cannot paint as well as they could twenty years ago."
He realized that all the study in the world wouldn't do any good if it
weren't applied to the practical problem of composing a finished
picture. He also noted that the "best artists never make . . . flashy
studies." This confirmed his own distrust of spontaneity. He devel-
oped his pictures most methodically. "The big artist does not sit
down monkey-like and copy a coal shuttle or an ugly old woman . . .
but he keeps a sharp eye on Nature and steals her tools. He learns
what she does with light, the big tool, and then color, then form."

The Biglin Brothers Racing masterfully conveys Eakins' intellec-
tual control. The shoreline divides the design in two. The rowers
and the entering prow of a competing craft fill the lower half with
their immediate, large-scale presence; the upper half consists of a
distant view of other rowers, spectators on following steamboats,
and the landscape of the Schuylkill River in Philadelphia. The
activity of the sport comes across in Eakins' conflicting placement
of highlights. As soon as the viewer's eyes fall on one bright area,
another brilliant form demands attention. No rest is to be found
between the sunlight on the oar, the white reflections from the

Biglin brothers' shirts, the fleecy clouds, or the scarlet and white
accents of boats, banners, and onlookers in the background.

An amateur oarsman himself, Eakins was a close friend of John
and Barney Biglin, New Yorkers who were the acknowledged
champions of rowing, one of the most avidly pursued sports in the
later nineteenth century. The artist's personal knowledge of ath-
letics explains the believability of the scene. The craft, recently
developed just for competition, is a pair-oared shell. Barney Biglin,
ready to pull as soon as he sees his brother's oar bite the water, is a
split-second ahead in his stroke. John, almost at the end of his
return motion, has his blade still feathered. The bow and stern of
the Biglins' shell project beyond the canvas' edge, generating an
immediacy furthered by the prow suddenly cutting across our field
of vision in the foreground. Shifting diagonal lines animate the
composition, lending urgency to the race, but the overall division
of the picture into horizontal bands of water, woods, and sky stabi-
lizes the motion. Eakins simultaneously captured, through this
complex design, both the spectators' excitement and the rowers'
intense, silent concentration.

Eakins made innumerable preliminary drawings for paintings
such as this, and he consulted his "trigonometric tables" to refine
the mathematical positioning of the elements. In speaking to his
art classes about rendering a boat, he instructed, "Now the way to

Thomas Eakins *1844–1916*
The Biglin Brothers Racing *c. 1873*
Canvas, 24⅛ " x 36⅛ "
Gift of Mr. and Mrs. Cornelius Vanderbilt Whitney

A Late-Nineteenth-Century Color Portfolio

James McNeill Whistler *1834–1903*
Chelsea Wharf: Grey and Silver *c.1875*
Canvas, 24¼" x 18⅛"
Widener Collection

James McNeill Whistler *1834–1903*
L'Andalouse, Mother-of-Pearl and Silver *c. 1894*
Canvas, 75 3/8" x 35 3/8"
Harris Whittemore Collection

Mary Cassatt *1845–1926*
Girl Arranging Her Hair *1886*
Canvas, 29 1/2" x 24 1/2"
Chester Dale Collection

154

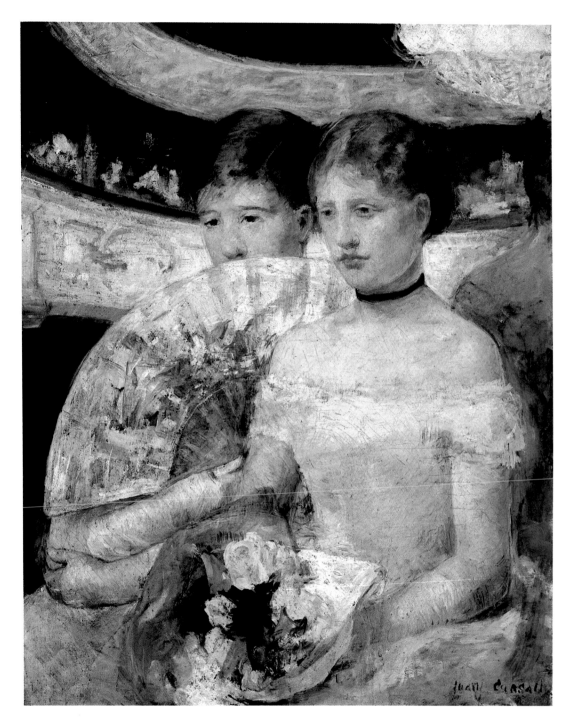

Mary Cassatt *1845–1926*
The Loge *1882*
Canvas, 31½" x 25⅛"
Chester Dale Collection

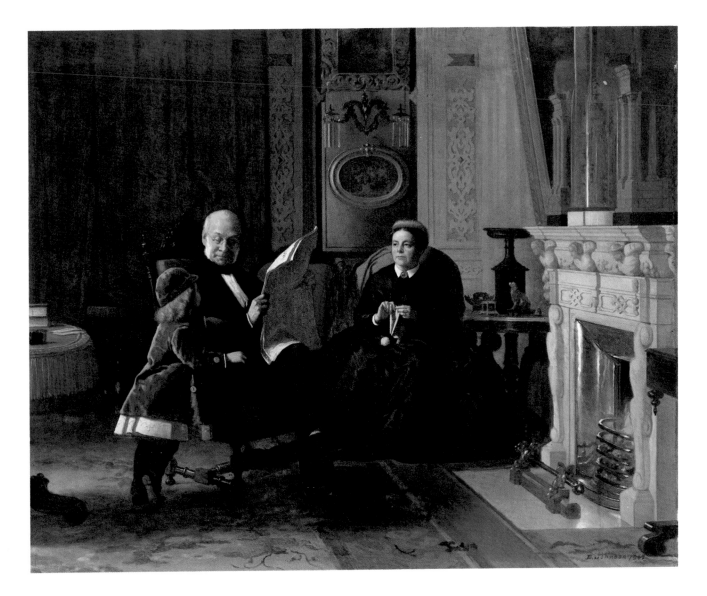

Eastman Johnson *1824–1906*
The Brown Family *1869*
Paper mounted on canvas, 23 ⅝" x 28½"
Gift of David Edward Finley and Margaret Eustis Finley

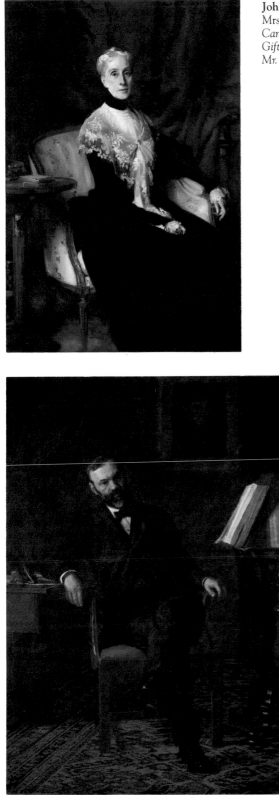

John Singer Sargent *1856–1925*
Mrs. William Crowninshield Endicott *1901*
Canvas, 64¼ " x 45⅛ "
Gift of Louise Thoron Endicott in memory of
Mr. and Mrs. William Crowninshield Endicott

Thomas Eakins *1844–1916*
Dr. John H. Brinton *1876*
Canvas, 78⅜ " x 57⅛ "
Lent by the Medical Museum of the
Armed Forces Institute of Pathology

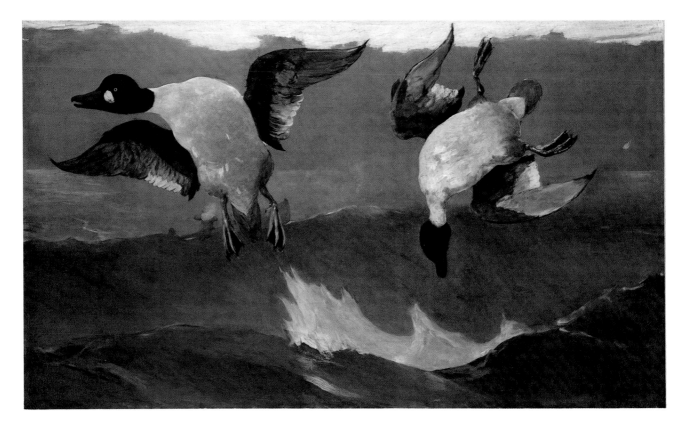

Winslow Homer *1836–1910*
Right and Left 1909
Canvas, 28¼" x 48⅜"
Gift of the Avalon Foundation

Albert Pinkham Ryder *1847–1917*
Siegfried and the Rhine Maidens 1888/1891
Canvas, 19⅞" x 20½"
Andrew W. Mellon Collection

John Frederick Peto *1854–1907*
The Old Violin *c. 1890*
Canvas, 30⅜″ x 22⅞″
Gift of the Avalon Foundation

159

John La Farge *1835–1910*
Afterglow, Tautira River, Tahiti c. 1891
Canvas, 53½ " x 60"
Adolph Caspar Miller Fund

Henry O. Tanner *1859–1937*
The Seine *1902*
Canvas, 9" x 13"
Gift of the Avalon Foundation

William Merritt Chase *1849–1916*
A Friendly Call *1895*
Canvas, 30⅛ " x 48¼ "
Gift of Chester Dale

162

Thomas Wilmer Dewing *1851–1938*
Lady with a Lute *1886*
Wood, 20" x 15"
Gift of Dr. and Mrs. Walter Timme

163

John H. Twachtman *1853–1902*
Winter Harmony *c. 1900*
Canvas, 25¾" x 32"
Gift of the Avalon Foundation

George Bellows *1882–1925*
Blue Morning *1909*
Canvas, 31⅝″ x 43⅜″
Gift of Chester Dale

166

Robert Henri *1865–1929*
Snow in New York *1902*
Canvas, 32" x 25 ¾"
Gift of Chester Dale

167

William Glackens *1870–1938*
Family Group 1910–1911
Canvas, 72" x 84"
Gift of Mr. and Mrs. Ira Glackens

168

draw her is to enclose her in a simple brick-shaped form, to give in mechanical drawing the proper tilts, one at a time, to the brick form, and finally to put the tilted brick into perspective and lop off the superabounding parts." Even more remarkable than the underlying perspectival geometry, however, is the precise observation of John and Barney Biglin's muscles. Eakins' early fascination for anatomy increased during his years in Paris and, upon his return to Philadelphia's Jefferson Medical College, he participated in more dissections in 1872–1874. When he became a faculty member of the Pennsylvania Academy of the Fine Arts in 1876, he introduced dissection to the curriculum. At that time, life study of the nude model was still considered revolutionary in America. Dissection of cadavers amounted to heresy. But, Eakins explained to his students, "This whole matter of dissection is not art at all any more than grammar is poetry. It is work, and hard work, disagreeable work." A pupil recalled, "The cadaver is used in preference to manikins, since it is the original material."

Dr. John H. Brinton (see page 157) represents the painter's close friend, a forty-four-year-old lecturer on surgery at the Jefferson Medical College. Dr. Brinton bridges the two types of individuals who would agree to sit for Eakins' forthright likenesses: friends and physicians. Possibly because they are trained to face harsh reality, doctors number high among Eakins' sitters. Shown with a granite strength in his unflattered face, Dr. Brinton had been a surgeon for the Union Army during the Civil War and had founded the Army Medical Museum. As Eakins said, "You can copy a thing to a certain limit. Then you must use intellect." He therefore blocked out his portraits with the same mechanical drafting he used for his genre scenes. That is evident here in the dramatic foreshortening of the doctor's crossed legs, which propels his right shoe directly into the spectator's space. The doctor's position, locked in a straight line between his desk and his reading stand, expresses the essential sobriety of a man lost in thought. The arrangement links the face and hands together and emphasizes the scholarly attribute of the book on the reading stand. An implied line of sight runs between the doctor's proper right hand and his face; another angled course may be imagined from the face to the left hand. Finally, the book rises as a white streak from the left hand. Thus a zig-zag of diagonals between the light, bright areas accentuates the sitter's main features. And, not coincidentally, these angled tracings across space mirror the diagonal leg projecting toward the viewer.

The importance of tone in this portrait is apt to cause an underestimation of the amount of color. All the basic hues in the spectrum are present, but as tiny highlights or muted shades. Reds are most obvious in the Oriental carpet, while a rose-tinged shield on the wall holds mounted war trophies. The three-piece suit, black at first glance, is actually a dark navy blue. And yellow ranges from the vest's pure gold watch chain to its role as the presiding color of the complexion. These understated hues add vivacity to what might otherwise be too somber an image.

Unlike the active spotlighting and full range of color of the doctor's likeness, *Archbishop Diomede Falconio* utilizes an even illumination over the sitter's entire figure and restricts the hues to variations on mauve, red-brown, and gray. The mood differs also because of the pose. The feet are planted side by side; the passive fingers rest open in the lap; and, a rectangular enframement of wall paneling reiterates the simple lines of the quiet posture. The dais elevates the archbishop, forming a physical barrier to our sight as well as a psychological barrier to emotional communication. The Franciscan priest is alone with his meditations, and the viewer is made to feel that any disturbance would be sacrilegious. Thus, this portrait expresses not so much Archbishop Falconio's individual personality as his dedication to his faith. His public office accounts for his coat of arms hanging on the wall. The fifty-three-year-old Italian had been appointed apostolic delegate to the United States in 1902, and Thomas Eakins painted this portrait on a trip to Washington, D.C., three years later. The reason for the painting remains a mystery; it was found unfinished in the artist's estate. The habit, for instance, progressed beyond the point of basic blockage but never received its finishing touches of blending, covering oils. Whatever occasioned the picture in the first place, we can be sure the pious father and the learned painter chatted amiably away in Latin during the posing sessions.

Although he earned the esteem of scholars and students, Eakins finally went too far. To demonstrate the attachment of a muscle, he removed the loin cloth from a male model in a women's drawing class. The conflict between scientific accuracy and social propriety exploded, and the director of the Pennsylvania Academy of the Fine Arts was fired in 1886. A Philadelphia newspaper politely noted, "Mr. Eakins has for a long time entertained and strongly inculcated the most 'advanced' views . . . he holds that, both as to the living model in the drawing room and the dead subject in the anatomical lecture and dissecting room, Art knows no sex." Most of Eakins' pupils followed him when he set up the independent Art Students League, at which he taught without pay.

To pursue his interest in anatomical and perspectival correctness, Eakins experimented with photography. In 1884-1885, he helped develop a system for triggering several cameras in rapid succession so that the resulting images would be "stop-action" shots of sequential movement. It is no wonder that a French photographer who'd settled in Philadelphia, Louis Husson, was one of Eakins' best friends. Eakins' *Louis Husson* of 1899 betrays both the artist's anatomical and photographic interests in its precise delineation of muscle and tissue around the temples, eye sockets, and nostrils. It is also a superb design, communicating the man's intensity through its sharply triangular emphasis of the collar opening, pointed beard, and sharp nose. *Mrs. Louis Husson,* created several years later as a pendant to her husband's portrait, uses a paler setting and outfit to make the sitter appear less withdrawn. Also, because she is closer to the spectator, Mrs. Anna Husson fills the picture and becomes more imposing, more direct than her spouse. Eakins remarked on one occasion, "How beautiful an old lady's skin is. All those wrinkles!" With a sympathy borne of mutual admiration, Mrs. Husson allowed her friend to show the true personality in her face. But society at large would have none of this dispassionate frankness. As one gentleman apologized, Thomas Eakins "would bring out all the traits of my character that I had been trying to hide from the public for years."

Thomas Eakins *1844–1916*
Archbishop Diomede Falconio *1905*
Canvas, 72⅛″ x 54¼″
Gift of Stephen C. Clark

Thomas Eakins *1844–1916*
Louis Husson *1899*
Canvas, 24" x 20"
Gift of Katharine Husson Horstick

Thomas Eakins *1844–1916*
Mrs. Louis Husson *c. 1905*
Canvas, 24" x 20"
Gift of Katharine Husson Horstick

The poet Walt Whitman stated, "I never knew but one artist, and that's Tom Eakins, who could resist the temptation to see what they think ought to be rather than what is." Whitman, a disarmingly honest man, summed it up this way, "Eakins is not a painter, he is a force." Recognition from more conventional quarters came late. In 1904, the Pennsylvania Academy, which had earlier discharged him, presented Eakins with a gold medal. He purposely appeared in bicycling togs, charged the academicians with "a heap of impudence" to give him a medal, and pedaled off to the Mint to cash in the gold. This, of course, finally made him a true celebrity. When newspaper reporters asked him whom he considered the greatest American painter, Eakins replied, "Winslow Homer."

WINSLOW HOMER

1836–1910

Winslow Homer, like Thomas Eakins, was an outdoor sportsman and straightforward realist; unlike Eakins, Homer was finan-

cially successful. A principal reason for the difference between these two dominant painters of American genre is that both had another field of endeavor. When not portraying scenes of daily life, Homer painted landscapes, which had earned a niche of respectability in the United States. Eakins, with his obsession for anatomy, tried to be a portraitist as well as a genre artist, but few potential sitters had the courage to allow Eakins to subject them to his scathingly honest brush. Besides their divergent subject matters, the two geniuses had opposed working methods. Eakins used elaborate preliminary studies to focus on the particular. Homer improvised directly on the canvas from the natural motif and sought the general, overall effect.

From a Massachusetts family, Winslow Homer showed a precocious talent for drawing. His mother, an amateur watercolorist of flower pieces, encouraged him. At eighteen, Homer apprenticed at the same lithographic firm in Boston that had earlier trained Eastman Johnson. In 1857, aged twenty-one, he quit the printing firm and set up as a free-lance illustrator, selling his drawings to magazines such as *Harper's Weekly*. He went to the front for *Harper's* during the Civil War, becoming one of America's most popular illustrative reporters. During respites from the front lines, he became a member of New York's National Academy of Design and

Winslow Homer *1836–1910*
Sunset *c. 1875*
Canvas, 15½ " x 22½ "
Gift of John W. Beatty

commenced painting in oils. Although his training in oil techniques was severely limited, his years of work as an illustrator had taught him to capture the essentials of a scene. He spent ten months in Paris in 1866–1867, but remained aloof from French art circles.

Homer wisely continued to produce magazine illustrations, both comic and reportage, until he was well established as a painter. He used his income to travel widely, summering in the White Mountains or Canada, wintering in Florida or the Caribbean. The exact site of *Sunset*, done around 1875, is not known, but the small canvas is patently a quick sketch done out-of-doors before the motif. Even in a reproduction, one can see that there's no detail in the fisherman's shadowed face or hands and that the marsh grasses are licks of paint revealing the shape of Homer's brush tip. Homer preferred a picture "composed and painted out-doors," saying, "The thing is done without your knowing it." For this study in tone, five streaks interact across the picture: two dark areas

sandwiched between three bright ones of sky, distant bay, and foreground tidal pool. "Out-doors you have the sky overhead giving one light; then the reflected light from whatever reflects; then the direct light of the sun; so that, in blending and suffusing of these several luminations, there is no such thing as a line to be seen anywhere." True to his own word, Homer painted only a darkened silhouette, no outlines, to show the boy straining to pull his dory ashore for the night.

Breezing Up, when exhibited at the National Academy in 1876, was "settled upon by the artists as the author's greatest hit" since his early Civil War paintings. The bold juxtaposition of the craft and its sail against the open space over the right-hand ocean was quite an adventurous compositional balance. As the catboat *Glouster* turns toward port in the late afternoon, we sense the immediacy of Homer's statement: "When I have selected the thing carefully, I paint it exactly as it appears." This doesn't mean he painted it at that instant. He'd summered on Ten Pound Island in Gloucester Harbor, Massachusetts, in 1873 and produced a vivid watercolor of this scene. The oil was created much later, as Homer told a prospective buyer, "As it stands now it must bring me the price in the catalogue to have it pay me for three years' work." Notwithstanding his three years' thought about the composition, it

172

does preserve the freshness of an observed scene. The heavy-soled shoes worn by the boy sprawled across the bow prove he is a landlubber; the fish in the cockpit tell us why he is so inappropriately attired. The bearded fisherman in his red shirt and yellow sou'wester has taken the town boys out for a day's excursion. A sudden evening breeze heels the boat over until its lee rail is awash, so the boys throw their weight to the windward side of the craft. The vivacious strokes of pure white paint over the blue-green and blue-violet water express the exhilaration of salt spray.

Homer's gift for putting down his spontaneous reaction recalls his assertion, "I try to paint truthfully what I see, and make no calculations." The large schooner in the distance, however, was calculated. Its original position close to the stern of the catboat and much nearer to the foreground is easily visible through the overlying layers of later paint. Homer had changed his mind and moved the schooner farther away so that it wouldn't interfere with the churning wake kicked up by the catboat's rudder and so that it could anchor the decided lean of the smaller craft. Notice that the catboat's mast was also altered by the painter; it didn't always tilt down as sharply. The contradictions between what Homer said and what he did are not all that serious. No one ever produced a masterpiece in a few minutes. And Winslow Homer was a cantankerous, close-mouthed Yankee who disliked arty conversation. Possibly the most revealing of his few comments about aesthetics was, "You must not paint everything you see. You must wait, and wait patiently until the exceptional, the wonderful effect or aspect comes."

Homer changed his mind again when working on a genre inspired by an 1891 summer vacation in the upstate New York Adirondacks. The watercolor Sketch for *Hound and Hunter* was done on the spot and differs slightly from the finished oil on canvas, completed in October 1892. The watercolor possesses the immediacy of a nature study; the clean white paper left showing for highlights is far brighter than any opaque white pigment could be. But the black-and-white spaniel is nearly lost in the conflicting light reflections over the pond. In the final oil, the rippling water has been controlled to silhouette the dog and deer. And, with the deer's eye and antlers farther underwater, we understand more clearly that the hunter is drowning his quarry. Whether one prefers the evocative watercolor or the greater detail in the oil is a matter of personal taste. Winslow Homer, even if he'd never painted in oils, would be considered one of America's foremost artists on the basis of his bravura watercolor techniques. But, to him, *Hound and Hunter* was a challenge pure and simple: "Did you notice the boy's hands — all sunburnt; the wrists somewhat sunburnt, but not as brown as his hands; and the bit of forearm where the sleeve is pulled back not sunburnt at all? That was hard to paint. I spent more than a week painting those hands."

In 1883, at the age of forty-seven, Homer had settled in Prouts Neck, Maine. Always a taciturn man, he became a reclusive bachelor in his last years. He devoted more and more time to refining his pictures, completing only two or three oils a year. In December 1908, he wrote his brother, "I am painting when it is light enough — on a most surprising picture but the days are short and sometimes very dark." The surprising picture was to be the last work he ever exhibited, and it summarizes his lifelong interest in the struggle for survival and in strong compositional design. *Right and Left* (see page 158) portrays the death throes of two golden-eye ducks, shot by a hunter in a boat. When the untitled work was first shown in 1909, a sportsman exclaimed, "Right and Left!" — the term for bringing down a bird with each muzzle of a double-barreled shotgun. That exclamation became the painting's title. The grays require virtually every adjective capable of describing a range from white to black: ice, silver, pearl, charcoal. Although Homer had said, "Why, do you know, a black and white, if properly balanced, suggests color," there are several strong hues present in addition to the neutrals. Blues, greens, and violets course through the water, and the shotgun blast, rising sun, morning clouds, and birds' feet and eyes supply warm reds and yellows. Even so, there is a bleakness about the picture that goes beyond the austerity of a winter dawn along the Maine coast. The diagonal bands of sea and clouds, the stark silhouettes of the ducks, the play of angular points in wings, feet, and waves have an explosive, jagged energy. These severe shapes and their harmonic interaction owe a debt to the bold patterns in Japanese woodblock prints. Another source might be the "stop-action" photography similar to the experiments carried out by Thomas Eakins and his friends. Certainly no naked eye could perceive the exact configuration of the ducks' rapidly moving wings and feet.

Legends abound concerning *Right and Left*. One says that Homer went out in a boat to watch a friend fire his shotgun; another claims that Homer stood on a cliff while blank cartridges were fired in his direction; still others say that Homer purchased the ducks for Thanksgiving dinner but decided to paint their glorious plumage instead of eating them, or that a neighbor hung the ducks on Homer's door as a gift. There is probably some truth to all these tales because Homer did insist upon working from direct experience. However, as a naturalist and outdoorsman, Homer must have been aware of John James Audubon's famous *Birds of America*. In particular, the 1836 Audubon Print of *Golden-eye Duck*, illustrated on page 78, was in the back of Homer's mind. It shows the same species, the same splayed postures, and the rippling indication of a cloud which Homer converted into an interlocking design of sky and sea. Homer may have claimed, "If a man wants to be an artist he should never look at pictures," but he had studied them carefully. Audubon's accurate scientific illustration inspired Winslow Homer to create a metaphor of life and death.

WILLIAM M. HARNETT

1848–1892

America's most emulated still-life painter, William M. Harnett, was born in County Cork, Ireland, but reared in Philadelphia. Harnett perfected a degree of illusionism in still life that exactly corresponded to the tastes of Victorian patrons. In the late

nineteenth century, beauty tended to be confused with the possession of physical objects. Harnett's extremely convincing depictions of expensive objets d'art, fine musical instruments, and succulent foodstuffs achieved such popularity that they gave rise to scores of imitators. Even though not unique to America, these meticulous still lifes enjoyed such a vogue here that the United States led the world in their production and appreciation.

The ultimate expression of this visual trickery has the French name *trompe l'oeil,* literally translating "trump the eye." The objects in this peculiarly American form of art must be depicted approximately to the size of life, or the viewer, by noticing that the scale is wrong, will see through the deception. Much more important, though, is the type of object represented: three-dimensional solids do not lend themselves to *trompe l'oeil* because our eyes automatically perceive the world with binocular vision. A spherical ball painted on a flat panel or canvas wouldn't fool anyone. The deception only works with two-dimensional items which, being flat in the first place, do not offer any clues as to whether they are the real things or clever imitations. Dollar bills, calling cards, coins, stationery, newspaper clippings, horseshoes, postage stamps, and similarly thin items can, in the hands of a master craftsman, be counterfeited so well that they pass for the genuine article. Forgery is the word for it.

The sheet music in Harnett's *My Gems* qualifies as *trompe*

l'oeil. The paper is flat; it hangs perpendicular to the viewer's line of sight; and its detail is unbelievably complete. Harnett simulated the sharp-edged letters made by engraver's ink and even the pressure mark of the printer's copper plate. One can actually tell that this score was once bound in a book that was carried in the rain! The left border of the paper is creased from bindery stitching, and water stains invade the sheet only from the sides.

Since *My Gems* is a smaller than life-sized painting and the other elements portrayed are three-dimensional, the whole picture cannot be called *trompe l'oeil.* But it is a breathtaking example of Harnett's unmatched technical genius at normal still life. The title, invented by an art dealer, refers to the painter's most treasured possessions. The antique Roman lamp, the Dutch blue-and-white tankard, the piccolo, and the meerschaum pipe appear over and over again in Harnett's precise paintings. The enlargement of the painting at the beginning of this chapter reveals Harnett's phenomenal subtlety. The paint does not have a slick, enamellike uniformity. Textures vary to best convey the substance of each item depicted. Razor-sharp edges define the pipe's metallic band, but its lustrous meerschaum bowl has soft, fuzzy contours. The spilled ashes show a pricking and dabbing application of pigment. As a foil to these precise imitations of the object's surfaces, the setting is an abstracted, mottled vacuum, neither wall nor sky.

Arranged in a pyramidal format, the composition entails a

Winslow Homer *1836–1910*
Breezing Up *1876*
Canvas, *24⅛" x 38⅛"*
Gift of the W. L. and May T. Mellon Foundation

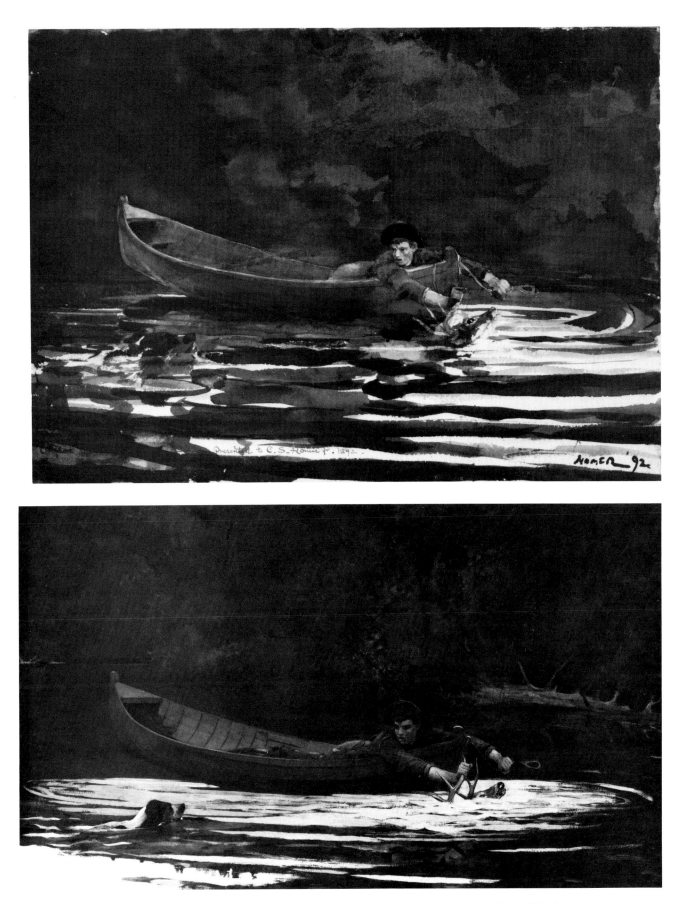

Top: **Winslow Homer** *1836–1910*
Sketch for Hound and Hunter *1892*
Watercolor on paper, 14¹/₁₆ " x 19⁷/₈ "
Gift of Ruth K. Henschel in memory of her husband, Charles R. Henschel

Above: **Winslow Homer** *1836–1910*
Hound and Hunter *1892*
Canvas, 28¼ " x 48⅛ "
Gift of Stephen C. Clark

complicated system of checks and balances among innumerable diagonal movements. The piccolo, for instance, leans at a slant exactly opposite the line of the pipe's stem. The apparent clutter of these abandoned objects conceals a symbolic meaning. The books' partially hidden titles include the somber poetry of Dante and Tasso, as well as a volume of Shakespeare's tragedies *Troilus and Cressida* and *Hamlet, Prince of Denmark.* The music cover below the pipe reads *Rigoletto,* Verdi's famous opera about murderous vengeance. The sheet music itself clearly bears the name *Hélas Quelle Douleur,* "Alas What Sadness." And, with the lamp burned out, the allegory of death is complete. Harnett may have introduced a note of humor for sophisticated audiences because the music is scored for a flute, but the only instrument in the picture is a piccolo. He was, incidentally, an amateur flutist.

In an interview with a newspaper reporter, the artist maintained that he did not merely copy his models. "In painting from still life I do not closely imitate nature. Many points I leave out and many I add. Some models are only suggestions. Take the flute in one of the accompanying illustrations. The flute that served as a model is not exactly like the one in the picture. The ivory was not on the flute at all, and the silver effects for the keys and bands I got from a bright silver dollar. The gold band on the pipe was painted from a new gold coin. The whole effect in still life painting comes from its tone, and the nearer one attains perfection, the more realistic the effect will be."

Harnett's precision can be traced to his apprenticeship as an engraver and modeler of silverware. His mind and habits were as tidy as his pictures. After he began painting, his eighteen-year career divided evenly into three phases of six years apiece. From 1874 to 1880, he worked in New York and Philadelphia; in Philadelphia, he befriended John Frederick Peto who later adopted Harnett's style. Harnett lived from 1880 to 1886 in Europe, where he acquired many of the objets d'art pictured here. From 1886 until his death in 1892, he lived exclusively in New York, where he painted *My Gems.* It probably won't surprise anyone to learn that the police, misunderstanding Harnett's reason for exhibiting a picture of a five-dollar bill, once arrested him for counterfeiting.

JOHN FREDERICK PETO

1854–1907

John Frederick Peto's *The Old Violin* (see page 159) is pure *trompe l'oeil* still life, in the tradition of William Harnett. Indeed, it is so much in Harnett's tradition that experts believe Peto borrowed the motif from a print after one of the older artist's paintings of 1886. Violins are thin enough to fool the viewer into accepting the illusion of two-dimensional reality. Anything thicker would have had an actual projection into space which cannot be simulated on a flat picture surface. Peto plays a dangerous game with our willing-

Winslow Homer *1836–1910*
Right and Left *1909*
Canvas, 28¼" x 48⅜"
Gift of the Avalon Foundation

William M. Harnett *1848–1892*
My Gems *1888*
Wood, 18″ x 14″
Gift of the Avalon Foundation

ness to accept this visual trickery. And he wins the game. Rusty nails cast strong shadows across the weather-beaten door. A fiddling bow lifts the violin clear away from the cupboard door, and a broken string pops farther forward still. With all of Peto's teasing, it is still difficult to believe that this life-sized musical instrument is not real.

The attention to detail is what makes this picture so convincing. A stain on the lower body of the violin, where the player's chin would hold the instrument, proves that the owner was right-handed. Traces of rosin cling to the wood beneath the strings. The visible portions of the sheet music are so accurate in staff and notation that they can be performed, suggesting that Peto painstakingly copied the score for a polka as yet unidentified. *Trompe l'oeil* artists often demonstrate a wry wit — after all, their pictures amount to visual puns — and Peto was no exception. He signed this work twice. His regular signature appears in the lower left corner; but he also placed his initials "JFP" above the violin as though a penknife had carved them into the wooden door.

In addition to the sure balance of shapes, the serenity of this canvas comes from its carefully integrated color scheme. The hues all relate to the yellow range established by the brass key and hinges. The door's green paint is of course made by mixing blue with yellow, while the violin's orange wood is merely red and yellow. This elegance, including the depiction of a fine old musical instrument, falls outside Peto's customary work. He normally depicted commonplace things like straw hats, clay pipes, and pottery mugs, which is why he failed to make much of an impression on the art market when Harnett couldn't supply pictures fast enough to suit his patrons. The Victorians appreciated Harnett's renderings of costly objects but did not care for Peto's rustic, homespun subject matter. If Peto had painted more pictures like *The Old Violin,* he would have had as many clients as Harnett did. But he chose to communicate the pathos of the old, tattered, and discarded.

After working with Harnett in the late 1870s, Peto tried unsuccessfully to win acceptance from Philadelphia's art community. He ended up supporting himself by playing cornet for religious camp meetings at Island Heights, New Jersey. In 1889, he and his wife moved there and took in summer boarders. Peto kept on painting dark, almost tragic still lifes for his own satisfaction and to sell as souvenirs to the vacationers.

Emil Carlsen *1853–1932*
Still Life with Fish *1882*
Canvas, 29⅝" x 39¾"
Gift of Chester Dale

EMIL CARLSEN

1853–1932

A native of Copenhagen, Emil Carlsen briefly studied architectural design at Denmark's Royal Academy. He arrived in the United States in 1872, aged nineteen, and soon took up painting in Boston. Carlsen's depictions of inanimate objects had such tactile believability that he quickly became New England's most celebrated still-life specialist. *Still Life with Fish* typifies his best work and admirably demonstrates the reason for his success. The dead fish and common kitchen utensils gain a monumental dignity far beyond their mundane existence. Perhaps Carlsen's early interest in architectural massing explains his ability to counteract the weight of the large cauldron and white fish with the carefully positioned clusters of smaller fish and shells. The wet scales of the fish, the glint off a glass bottle, the sheen of copper and brass vessels, the luster of oyster shells — all appear so convincing that the viewer needs reassurance that the scene is, in fact, a picture.

The sensuous beauty of these homely items recalls that Carlsen greatly admired the still lifes of Chardin, an eighteenth-century French master of subtle lighting effects. But Carlsen's heavily laden brush also shows an acquaintance with trends toward richly textured canvases current among Munich and Paris Realists. While conveying the surface textures of the forms it describes, Carlsen's thick paint retains its own identity as an artist's creation. The copper urn, for example, may be read as a simulation of the marks from a metalsmith's hammer or as the reality of strokes from a painter's brush.

FRANK DUVENECK

1848–1919

Through his repeated trips to Germany, Italy, and France, Frank Duveneck became a vital link between young American artists and the trend current in Europe toward a warm, loose style. Juicy paint handling is but one of the charcteristic Duveneck traits; he also preferred rugged form, focused spotlighting, and a rapport with unpretentious models such as peasants or convival friends. *William Gedney Bunce*, probably done in Munich around 1878 or a little later in Venice or Florence, portrays such a friend. Though only around forty, the sitter was affectionately called "Old Bunce" by the circle of artists around Duveneck. Bunce's ample body and massive head were observed by Duveneck with unflattering candor; yet a nonchalant fondness obviously existed between artist and sitter. Bunce sits so close to the spectator that one can almost hear him breathing, and the cigar jutting from his stubby fingers adds to the intimacy.

Bunce, a painter who specialized in views of Venetian canals and gondolas, once joked about his own success with watery subject matter, "Now if I were really to try to draw that anchor, it would immediately begin to wiggle, and before I knew it would be off in a seasick whirl!" Duveneck's depiction communicates much of his follower's poker-faced humor. Bunce was one of the many pupils who willingly traipsed around Europe in Duveneck's footsteps. Known as "Duveneck's Boys," they exerted a strong impact on American painting of the late 1870s and 1880s. Their spontaneous brush strokes and suggestions of weighty mass came as a welcome relief to Americans used to the dry, polished surfaces popular in the mid-century. Taste in the United States was shifting from the Düsseldorf tightness of Eastman Johnson to the Munich bravura of Frank Duveneck.

Duveneck's own early works, church decorations and portraits in Kentucky, Ohio, and Quebec, had been in the detailed, linear manner of Düsseldorf academicism. But on his first trip to Europe in 1870 to 1873, he quickly adopted the bold, blocked-out style being taught in Munich. His popularity as a painter matched his amiability as a teacher. "Duveneck's Boys" included Bunce, the future Impressionist John Twachtman, and William Merritt Chase, with whom Duveneck shared a studio in Munich. Directly through his own teachings back in Cincinnati and indirectly through his followers, Duveneck fostered an appreciation for robust paint and brash honesty which would eventually evolve into the Ash Can school.

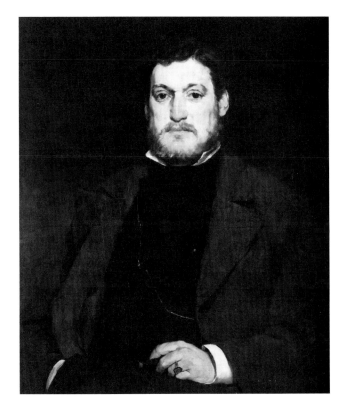

Frank Duveneck *1848–1919*
William Gedney Bunce *c. 1878*
Canvas, 30½" x 26"
Andrew W. Mellon Collection

179

10

VICTORIAN ROMANTICS

When Elisha Otis installed the world's first passenger safety elevators in 1857, few realized what was in store for civilization. Since prehistory, population densities had been limited to the maximum of five or six stories that healthy people could climb. In 1876, Alexander Graham Bell invented the telephone, providing instant personal communication between businessmen or lovers. Thomas Alva Edison's 1879 patent on the incandescent lamp removed all dawn-to-dusk strictures on work or play. And Edison's 1877 phonograph and 1891 motion picture meant that the sound and sight of living history could be recorded forever. Such technological changes, coupled with the massive immigrations from Europe to the "land of golden opportunity," made a decisive change in the pace of American life.

The population explosion and economic expansion of the last quarter of the nineteenth century were disorienting to most, unfortunate for many, and profitable for a few. A strain of emotionalism pervaded the arts as painters created visions of spiritual worlds or glossed over the deficiencies of the physical world. No coherent stylistic movement binds these artists together; they simply represent the varied temperamental reactions to what Mark Twain labeled "the Gilded Age." Some, like Albert Pinkham Ryder, escaped into inner mysticism; others, like William Merritt Chase, reveled in outward opulence.

GARI MELCHERS

1860–1932

Born in Detroit, Gari Melchers went to his family's native Germany to study art at the age of seventeen. He didn't return permanently to the United States until the outbreak of World War

I. From 1884 to 1900, Melchers lived in the small Dutch town of Egmond-ann-Zee, where he produced *The Sisters*. The motif of lonely peasants, which occupied a prominent position in nineteenth-century art, formed a social statement about the plight of the poor. The strong contours and firm modeling reveal Melcher's disciplined training at Düsseldorf. But the high vantage point that flattens space and the subdued tones of grayish browns and greens show that Melchers was aware of current trends in Paris. To evoke the viewer's sympathy for these downtrodden children, Melchers placed them in an isolated meadow, far from their tiny hamlet. The grazing goats have no more energy than do the girls, who stand listlessly holding hands. And, Melchers squeezed every tear duct he could with the older sister's maternal attitude, the younger child's poignant expression, and her wistful gesture of clutching a limp rag doll.

ALBERT PINKHAM RYDER

1847–1917

Albert Pinkham Ryder is now recognized as nineteenth-century America's most imaginative romantic painter, but his contemporaries largely misunderstood or ignored this odd, hermitlike man. Living alone in a filthy, squalid garret, Ryder worked laboriously and feverishly on his canvases; yet, because he continually repainted his works, often over decades, his entire life's output may amount to no more than 165 or so pictures. From a Massachusetts whaling family, Ryder received a little art instruction in New York City. An independent man, he disdained both the old and modern art he saw on four trips to Europe, claiming to have made the voyages for the experience of the open sea and sky alone. Only to one

Albert Pinkham Ryder *1847–1917*
Detail of Siegfried and the Rhine Maidens *1888/1891*
Andrew W. Mellon Collection

of his closest friends, the painter Julian Alden Weir, did Ryder confide that he'd enjoyed seeing "the great art treasures." His style does reveal familiarity with the paintings of the English romantic artist-poet William Blake as well as with those of the American folklore painter John Quidor. Like Blake and Quidor, Ryder created bold forms, luminescent glows, and haunting moods.

An infection brought on by a faulty vaccine damaged Ryder's eyes when he was a boy. Throughout his life, he couldn't bear to look at bright light, and reading so strained his vision that his education was cut short. His father purchased a paint kit to amuse the child. "In my desire to be accurate I became lost in a maze of detail," Ryder later wrote. "I threw my brushes aside; they were too small for the work in hand. I squeezed out big chunks of pure, moist color. . . . As I worked, I saw that it was good and clean and strong."

Mending the Harness, painted after his New York studies, reveals his extraordinary way of merely suggesting rather than detailing main forms. In Ryder's twilight vision, the black harness stands out as a strong linear pattern against the white horse, but the wagon master nearly disappears before the similarly toned haywain. The dim, evocative shapes recall the unconventional imagery of Ryder's poetry:

> *The wind, the wind, the wind,*
> *The breath of balmy, balmy evening,*
> *That am I, that am I!*
> *My unseen wanderings*
> *Who can pursue, who comprehend?*

Ryder's early work often dealt with rustic farm scenes such as this; in fact, the horse here appears in other paintings, apparently worked up over years from the same sketch drawings.

In his mature work, Ryder turned more and more to the sea for motifs and to literary or biblical themes. *Siegfried and the Rhine Maidens* (see page 158), for example, was inspired by a New York performance of *The Twilight of the Gods,* the fourth and last opera in Richard Wagner's cycle, *The Ring of the Nibelungs.* Ryder depicted the moment when the Rhine maidens, recoiling in surprise, realize that Siegfried has possession of their magic ring. When the enchantresses demand back their stolen ring, the Norse hero refuses to part with its unlimited wealth and power; the maidens predict that he will die violently, as have all the ring's previous owners.

Ryder claimed, "I had been to hear the opera and went home about twelve o'clock and began this picture. I worked for forty-eight hours without sleep or food." Nevertheless, when he exhibited the canvas in 1891, he had been revising it for three or four years. Ryder's eccentric techniques, including mixtures of oils and varnishes, as well as adding fresh paint on top of earlier layers that had not dried, had disastrous results. The detail at the front of this chapter shows the peeling, cracking surface which today characterizes most of his work. But that same detail also reveals the power of his creativity. The rocks and trees writhe at the knight's advance as if struck by a tornado. His bolting steed is as alarmed by the Rhine maidens as they are by the sudden intrusion of the strange horseman. Every element of the design contributes to its weird melancholy. The tortured shapes, crusty textures, and unearthly colors

Gari Melchers *1860–1932*
The Sisters *1884/1900*
Canvas, 59¼" x 39⅝"
Gift of Curt H. Reisinger

182

all hint at Siegfried's impending doom. The sickly green pallor, although somewhat darkened by decay, was calculated to be bizarre. Ryder, aware of his faulty technique, emphasized the creative experience itself: "When a thing has the elements of beauty from the beginning, it cannot be destroyed."

RALPH ALBERT BLAKELOCK

1847–1919

The Artist's Garden, painted at the peak of Ralph Albert Blakelock's career, portrays his tidy backyard in East Orange, New Jersey. The neatly tended rows of vegetables, the trees, fences, and neighboring buildings glow with pinpoint highlights of late evening reflections. But, strangely, the sky is ablaze with full midday sunlight on the clouds. This eerie contradiction between night and day in the same picture is only part of Blakelock's magic. The true mystery lies in his technical ability to make the viewer accept, and therefore believe in, such impossible light effects. Blakelock, virtually self-taught, experimented with personal methods of applying silvery or pastel paint layers, scraping them partially away, and then laying richer colors on top, only to wipe selectively at them, too. Final details, applied in thick pigment, describe the shapes half-hidden in these complex tonal layers. Unfortunately for Ralph Blakelock, his contemporaries did not appreciate his mystic vision until after he had become hopelessly insane.

A precocious New York City youngster, Blakelock was equally adept at music and painting. "The color," he once wrote, "should be used until it seems to flow upon the senses as if it were some melody." As a late Hudson River school landscapist, Blakelock traveled in the Far West and Central America from 1869 to 1872,

becoming enamored of Indian encampments by moonlight. Back home, however, he had to peddle his pictures door-to-door like a traveling salesman. Trying to support his wife and nine children on a nonexistent income proved too much. When he realized that a buyer had cheated him in 1899, Blakelock tore the money to shreds, was declared insane, seized, and confined to a New York state asylum. Meanwhile, his work began to be appreciated to such an extent that forgers made fortunes copying his style. In 1916, the National Academy of Design elected him a member, not that it did him much good in the hospital. His sanity returned and he was released — but only one month before his death. Today, the twentieth-century Surrealists hail Blakelock's compelling landscapes as forerunners of their probings into the inner mind.

THOMAS MORAN

1837–1926

The Moran family, which produced a large number of painters and photographers, did not emigrate to the United States until Thomas was seven. Yet despite his English birth, Thomas Moran will always be remembered as the "father of the national parks." Through Moran's gigantic panoramas of the Grand Canyon, Yosemite's waterfalls, the Petrified Forest, and Yellowstone's hot springs, the United States Congress became aware of its natural heritage, setting aside such sites as public wildernesses. In 1873, the artist-explorer was honored by having the most massive peak in the Grand Tetons, Mount Moran, named after him. And he was as famous for his romantic scenes of Venice and Britain as he was for his Western vistas.

In 1884, being comfortably established, Moran built a vacation home at East Hampton, a resort on Long Island. *The Much Resounding Sea,* dating from the first year he summered there, must have been painted at the beginning of the stormy autumn season. Five feet wide and thus somewhat small by Moran's normally colossal standards, this canvas belongs to a series of horizontal formats devoted to breakers crashing on the beach. All the other variants, however, have narrative themes, such as ships floundering on the wind-swept waves as horrified spectators watch helplessly from shore. The simplicity of *The Much Resounding Sea* sets it apart from those melodramatic anecdotes; the only reminder of human activity is a lobster trap, thrown up on the sand by the pounding surf. This shattered lobster trap might be symbolic of time's relentless destruction, but the picture's visual interest far outweighs any moralizing content. The shell-strewn beach and splashing breaker on the left cleverly balance the sunlight filtering through the clouds to irradiate a distant swell to the right.

Admired by critics for his illusionism, Moran worked energetically, backing far away from canvases to analyze the effect and then dashing forward to paint only one or two strokes at a time. Building layers of transparent blue, green, and brown oil glazes for the sea

Albert Pinkham Ryder *1847–1917*
Mending the Harness *c. 1875*
Canvas, 19" x 22½"
Gift of Sam A. Lewisohn

183

and sky, he here achieved a liquid depth of tone. Over these clear colors, Moran scumbled masses of opaque pigments. The grays and whites of the foam and mist betray a bewildering variety of manipulations, including the use of cloths, palette knives, sponges, several different brushes, and the artist's favorite tool—his thumb.

JOHN LA FARGE

1835–1910

John La Farge, born to a prosperous French émigré family in New York, gave up law school to study art under the most respected academic painters in America and France. His social graces and his ability to devise grand decorative schemes made him the leading muralist and stained-glass window designer in the United States. His brilliantly hued, strongly patterned embellishments graced fashionable churches, civic institutions, and the homes of the wealthy. An ardent collector and ambitious traveler, La Farge adapted the flat color areas of primitive and Oriental art to the two-dimensional, architectural surfaces of his own wall and window schemes. He communicated his fascination for Oriental woodblock prints to his friend Realist Winslow Homer following a trip to Japan in 1886 with Henry Adams, a foremost American man of letters.

La Farge and Adams journeyed together again in 1890–1891, this time to the South Seas. These exotic isles had already lured the Scottish novelist Robert Louis Stevenson, whom they visited in his temporary home at Tahiti. The South Pacific captivated La Farge. "No one had told me of a rustic Greece still alive somewhere, and still to be looked at." (This connection of a glorious ancient past with an idyllic modern paradise had also occurred to Benjamin West in colonial times, when he compared a Roman statue to a Mohawk warrior.) While Henry Adams took photographs, La Farge made numerous watercolors of Tahiti and its natives. Soon after his return to the United States in August 1891, La Farge began the largest of his South Pacific oils, *Afterglow, Tautira River, Tahiti* (see page 160), relying on memory, his own watercolor sketches, and possibly on Henry Adams' Kodaks.

To convey the softening light of evening, La Farge painted very thinly, allowing the pale tan underpaint to show through the overlying layers of oil colors. The extraordinarily rich hues of purple, violet, and lavender form a sonorous background to accents in hot pink, red-orange, and vivid chartreuse. The nearly perfect

Ralph Albert Blakelock *1847–1919*
The Artist's Garden *c. 1880*
Canvas, 16″ x 24″
Gift of Chester Dale

cones of the mountains, rendered as flat shapes silhouetted before the blazing twilight, march across the canvas as a series of interlocking triangles. This dark, jagged band is locked into the middle of the design by the light in the sea below and the sky above. *Afterglow* may appear Romantic in mood and Abstract in composition, but its evocative poetry is due in large part to its strange setting. In Tahiti, mountain slopes really are conical and sunsets do last a half hour. La Farge meditated every evening on these fabulous twilights. "One seemed to see everything accentuated and as in a dark mirror. The reflections were those of the land; the natives crossed the water in boats for bathing to places known by them; the red skins of the bare bodies of the men, the flaming red of women's dresses or their white gowns made spots like feathers of tropical birds in the glassy reflections." Similar observations of delight were to be made by the famous French Post-Impressionist Paul Gauguin, who arrived in Tahiti to live only one month after La Farge and Adams had left in May 1891.

HENRY OSSAWA TANNER

1859–1937

Not only was Henry Ossawa Tanner the first American black artist to achieve international praise, but he is also one of the very few Americans whose pictures were acquired for the French national museums. Tanner worked under Thomas Eakins in 1880–1882 at the Pennsylvania Academy of the Fine Arts; his early paintings show Eakins' influence in their dark tonality, straightforward realism, and choice of everyday subjects. Tanner's race frustrated his artistic career in the United States, so he left for Paris in 1891, never to return home. In France, he could be treated as a painter, not as a Negro. But Tanner, as a preacher's sensitive

son, didn't fit into Paris' sophisticated milieu any better than, as the only black art student in Philadelphia, he could blend into the crowd there. His faith prevented him from drinking wine or working on Sunday; he must have been the only teetotaling fundamentalist in France's Bohemian art circles. His fame and honors rested on his profoundly moving Old and New Testament themes. To ensure the accuracy of his biblical and Oriental tableaux, Tanner made several trips to the Holy Land and to North Africa.

Around the turn of the century, Tanner abandoned the somber color schemes he learned from Thomas Eakins and experimented with a lighter, brighter palette. *The Seine* (see page 161), a tiny oil sketch dated 1902, is among the earliest indications that Tanner had observed the pictures of the French Impressionists. The asymmetrical naturalness of the design places the visual weight to the right. The quay, boats, and tall buildings there are contrasted to the glaring reflection of sunset on the river to the left. Backlit by the setting sun, the city loses all local color to become a stark silhouette of violet seen against the pinks and yellows of sky and water. Even though the off-center composition and the rendition of light may be Impressionistic, the detail and the mood belong to Tanner's Realist background. His exact position on the Seine's Right Bank can be determined as he looked west-southwest toward the twin towers of the Trocadéro Palace, an ornate convention center built for the 1878 Exposition in Paris. The shadowy figure on the dock, moreover, recalls the mystical aura that pervaded his traditional religious themes.

WILLIAM MERRITT CHASE

1849–1916

William Merritt Chase once bragged, "I believe I am the father of more art children than any other teacher." His boast wasn't

Thomas Moran *1837–1926*
The Much Resounding Sea *1884*
Canvas, 25" x 62"
Gift of the Avalon Foundation

185

far wrong. Like Benjamin West, the "father of American painting," William Merritt Chase accepted and influenced a vast number of pupils and was as important for his teaching as for his painting. When he tired of working for colleges or academies, he intermittently ran his own private enterprise, aptly named The Chase School, from 1896 to 1915 in New York. Chase's personality was as gregarious, and his lifestyle was as outrageously extravagant, as his teaching methods were radical. "If you can paint a pot you can paint an angel," he exhorted his students. Or, "Paint the commonplace so that it will be distinguished." To force his pupils to reach his own level of rapid facility, he'd make them do a portrait head in one hour flat, wipe it off with turpentine, and do another in even less time. His generosity and far-sightedness in letting each follower pursue his or her own course allowed Chase to train many of the leading artists of the twentieth century.

Chase, born the son of an Indiana shoe salesman, received some training in Indianapolis and New York before departing for Munich, Germany, where he studied from 1872 to 1878. The Munich curriculum stressed heavy paint application and dramatic spotlighting against a dark background, methods derived from Frans Hals, Rembrandt, Velázquez, and other seventeenth-century masters. *Chrysanthemums*, dating from the end of his German years, demonstrates Chase's thorough mastery of this quick, energetic style. The impastoed, or pasty textured, pigment still looks as fresh as the day Chase's brush laid it on the canvas. The sheer physical presence of the paint lends the blossoms and leaves a vitality which a meticulously detailed still life would lack. In speaking of an age-old legend about illusionism, Chase once asked his students, "You have all heard of the picture of the fruit which was so natural that the birds flew down to peck at it? I do not need to see *that* canvas to know that it was a terrible, T-errible thing." A degree of symbolism about life's transience may be implied by the wilting stalks and fallen petals (if so, it would be consistent with the Munich school), but the brilliant light on the flowers indicates a growing awareness of French Impressionism.

Chase and his Munich classmate, the American Realist Frank Duveneck, made a trip to Venice in 1877 with the American Impressionist John Twachtman. Duveneck remained true to the contrasting light and shadow of the German style, but nine months of Adriatic sunlight began to lighten the palettes of Twachtman and Chase. With his continual travels in Europe, Chase quickly absorbed the Impressionists' shimmering color effects, but he never lost track of the contour-clinging, form-modeling brush strokes of his earlier Realist training.

A Friendly Call (see page 162) superbly combines all that Chase had learned of the Old Masters' brushwork, of Oriental clarity, Munich solidity, French Impressionist color, and of the "art for art's sake" composition of his friend James McNeill Whistler. In a sparsely rectangular setting, the soft curves of two elegant ladies accentuate the straight lines of the framed pictures, built-in banquette, straw floor matting, bamboo chair legs, gilt mirror, and square-cornered cushions. The juxtaposition of the contrasting hues of soft red and green enhances a shimmering atmosphere of pale yellow and pure white. Chase defied logic by dividing the composition right through the middle with an alignment of geometric shapes formed of pictures on the wall, a pink pillow on the banquette, and a green cushion on the floor. But Chase kept the two halves of the painting from separating; he repeated identical tones on both sides of this median line and he stressed the intent communication between the ladies who sit, leaning toward each other, on either side of center.

A Friendly Call depicts the studio in Chase's rambling summer home near Southampton, New York. From 1891 to 1902, he taught classes there, emphasizing painting out-of-doors on the spot. His own abilities show in the tour de force of the large mirror on the wall; it reflects a variety of illumination, ranging from the pure sunlight glaring off a distant hallway door to the iridescent glow through red curtains. The Oriental flavor of the furnishings indicates Chase's own high fashion, as do the expensive objets d'art and bric-a-brac acquired on his numerous travels. The model for the hostess in pale gold was Alice Gerson Chase, the painter's wife. That the woman with hat, parasol, and gloves was a visitor would have been immediately apparent to Chase's contemporaries, because current etiquette books insisted, "A lady should never lay aside her bonnet during a formal call even though urged to do so. If the call be a friendly and unceremonious one, she may do so if she thinks proper, though never without an invitation." We can only

Irving R. Wiles *1861–1948*
Miss Julia Marlowe *1901*
Canvas, 74¼" x 55⅜"
Gift of Julia Marlowe Sothern

assume that Mrs. Chase hasn't yet asked her guest to relax.

The international sophistication apparent in Chase's home recalls his youthful aspiration: "My God, I'd rather go to Europe than go to heaven." Chase, who'd won top awards at nearly all significant exhibitions in Europe and the United States, still had twenty years of teaching and honors ahead of him. For example, when his friend John Twachtman died in 1902, Chase was elected to fill his place in The Ten American Painters, the most exclusive American group of avant-garde artists at that time.

IRVING WILES

1861–1948

Possibly no figure better personifies America's Gilded Age than the actress Julia Marlowe, portrayed in 1901 by Irving Wiles. A Broadway critic termed her "all that is most wholesome and winsome in American womanhood." Her already considerable fame increased after her marriage in 1911 to her leading man, E. H. Sothern. The husband-and-wife team capitalized on their own romance by portraying Shakespearean lovers, being especially popular in the title roles of *Romeo and Juliet. Wiles'* portrait of *Miss Julia*

William Merritt Chase *1849–1916*
Chrysanthemums *c. 1878*
Canvas, 26⅞ " x 44¾ "
Gift of Chester Dale

Marlowe exudes the aplomb and loveliness which allowed a thirty-five-year-old actress to portray juvenile heroines. She leans forward intently from her chaise, as though to spellbind an audience. The luxurious fabrics of the carpet, upholstery, pillows, and curtain are heavy and richly colored to act as foils for her cream-white silk gown, which flows in soft rivulets to the floor.

Irving Wiles specialized in such elegantly flattering society portraits. The son of a leading landscape painter, Wiles studied with his father, at Parisian academies, and with William Merritt Chase in New York. The only one of Chase's innumerable pupils to visit the master when he lay dying, Wiles was entrusted to complete Chase's unfinished portrait commissions. As Chase's chosen successor, Wiles represents the last of those artists who could portray an untroubled, self-assured age. "The War to End All Wars" was ravaging Europe when Chase passed away.

187

11

SENTIMENTAL IMPRESSIONISTS

Impressionism originated in France during the early 1870s when Claude Monet, Auguste Renoir, Camille Pissarro, and others began painting familiar outdoor scenes and recording the effects of natural sunlight. They used high-keyed colors to imitate the sensation of brilliant illumination and employed dabbed brush strokes to simulate the flickering qualities of sunshine. Their ability to observe such effects out-of-doors depended on a British patent granted in 1841 to John Rand, an American artist. Rand had invented collapsible tin tubes to hold premixed oil paints, an idea soon widely applied to the packaging of other spoilables. Prior to the paint tube, artists desiring to work outdoors in oils either moved their studios into cumbersome caravan wagons or relied on leaky, unwieldy bladders. Now, with their equipment in portable cases, painters came face-to-face with natural daylight. The visual results differed radically from the spotlit illumination and meticulous detail of studio-concocted pictures. To deal with the variety of hues they saw before them, the Impressionists turned to *The Principles of Harmony and Contrast of Colors and their Application to the Arts*, published in Paris in 1839. Its author was Michel Eugène Chevreul, a French chemist who experimented with dyes while director of the Gobelins tapestry works. Chevreul's book presented systematic "color-wheel" diagrams explaining which hues clash, which blend, and why. The complex color brilliances, apparently spontaneous designs, and mundane subject matter made Impressionism difficult for Europeans to comprehend. But new concepts in art, education, medicine, or any other aspect of human endeavor have to overcome conservative resistance, and most of the French Impressionists eventually gained respect and wealth.

As early as the mid-1880s, exhibitions in Boston and New York introduced this modern French art to a receptive American public. Impressionism swiftly won widespread acceptance in the United States. Decorative, pastel-tinted canvases were in strong evidence among the art entries at the Chicago World's Columbian Exposition in 1893, and by 1915 they totally dominated the Panama-Pacific Exposition in San Francisco. The reason that American Impressionists were greeted so eagerly here is that their art differed significantly in two ways from its French source.

First, the American painters were too imbued with their national tradition of Realism to succumb completely to the French

vision, in which figures and objects were dissolved under strong light. American Impressionists, in short, retained the comforting security of both an organized compositional structure and a sense of solid, three-dimensional modeling. Second, unlike the extreme objectivity of the French, the American artists chose subjects with decided poetic and sentimental overtones. While the United States emerged as a world power and gained industrial wealth after the Civil War, Americans sought elegance and sophistication, favoring depictions of well-dressed, well-mannered high society. Conversely, the French Impressionists focused candidly on middle-class life. Even in pure landscapes, the Americans most often selected views with picturesque undercurrents, such as pools in woodland glens or gardens at moonrise.

The earliest American artist of the movement was Mary Cassatt who, as an expatriate living in Paris, exhibited with the Impressionists there. For a change of pace from their studio work, John Singer Sargent and William Merritt Chase occasionally painted outdoor scenes in the Impressionist manner. Many major Impressionists in the United States belonged to a select group of ten artists called The Ten American Painters, formed in 1897. The Ten, which held annual shows in New York from 1898 to 1906, had been established to defy the conservative Society of American Artists. George Inness, John La Farge, Thomas Moran, and Albert Ryder were members of that society, which itself had come into being as an avant-garde reaction to the conservatism of the National Academy of Design. So goes the world.

THOMAS WILMER DEWING

1851–1938

A critic, remembering a trip to Thomas Wilmer Dewing's studio, recalls that he was charmed by a harp which hung on the door and which "gave forth delicate music as the door opened and shut. That is what characterizes his art, an exquisite music." Dewing's *Lady with a Lute* (see page 163) symbolizes the analogy between

Edmund Charles Tarbell *1862–1938*
Detail of Mother and Mary *1922*
Gift of the Belcher Collection, Stoughton, Massachusetts

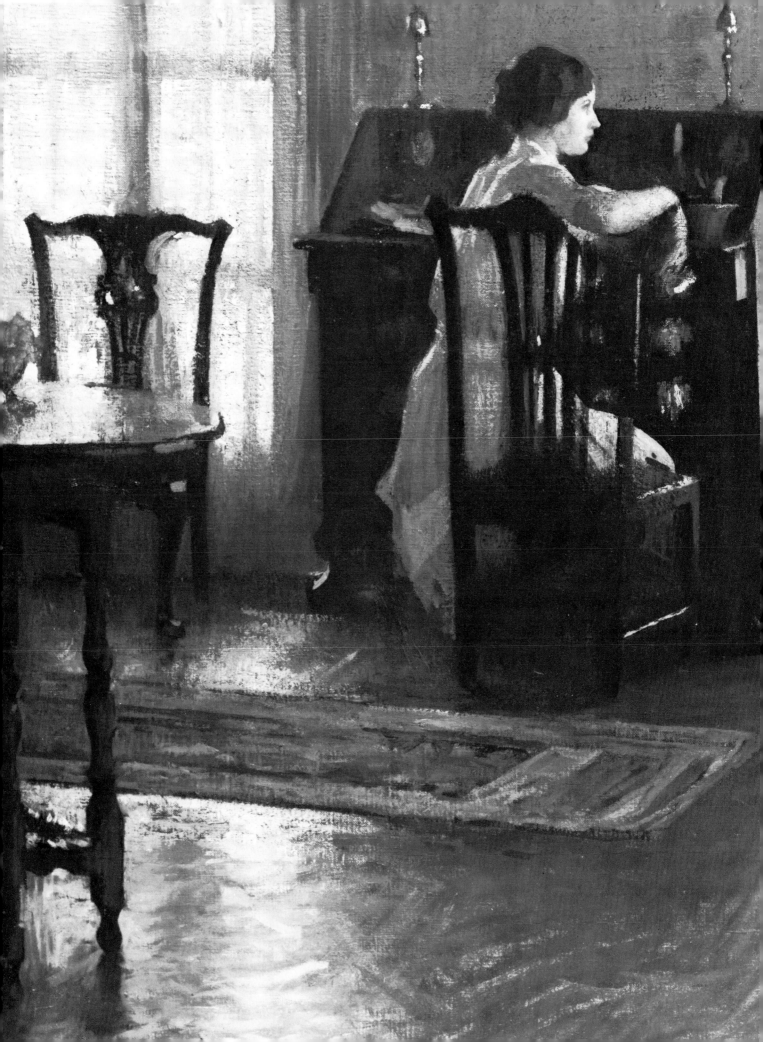

musical and pictorial composition so fashionable in late-nineteenth-century cultural circles. His earliest known profile figure, this painting foretells the hazy mists typical of Dewing's mature depictions of wistful yet austere women lost in reverie. The skirt, for example, shimmers in the dim half-light, being rendered as random scumbles of layered paint. As an artist so concerned with nuances of tone, Dewing quite often chose to paint on wooden panels rather than on canvas. The fabric weave of canvas would absorb light, whereas the smoothed, varnished surface of wood reflects it, adding luster to Dewing's enamellike oils. A selective finish pulls the eyes to the more detailed areas of the face, bosom, hands, and instrument. Against the loosely defined space and gown, the sharp contours of the aristocratic nose and slender neck echo the delicate positioning of the fingers. These areas are united by color as well as by their high degree of detailing. The deep brown setting and olive-green costume form a neutral foil to the warm ivory, almost golden, flesh. And the auburn highlights in the hair match the reddish woods in the lute.

Dewing's reserved, distant women, for which he became world famous, lived more in his imagination than in flesh and blood. Emotionless, these haughty beauties exist for themselves alone. This lady occupies a timeless environment of nostalgia; her gown is a Renaissance costume, and her lute is an antique. Since her bench has no visible means of support, she seems to float in the air as a dream. The creator of these effete, fragile works was a big, brash man. Dewing rejected the idea that he was a subtle interpreter of femininity, sneering, "Not at all. All I ever did was to insist that my model have *brains!*"

FRANK WESTON BENSON

1862–1951

The model in Frank Weston Benson's *Portrait in White* sits patiently with her hands folded in her lap. Since her face registers complete repose, the viewer is allowed to read any mood whatever into that placid countenance. The work is an exercise, à la Whistler, in an "art for art's sake" treatment of tone. The miraculous translucency of the striped sleeves and overskirt reveal the powdery complexion of the arms and the satin sheen of the underskirt. Against a dark gray-green setting, the yellow-white lawn chair increases, by contrast, the purity of the blue-white gown. To ensure comparison of the two types of white, Benson placed the bright gold button on the model's bodice to align with the brass knobs atop the chair's back. These hard spheres of yellow catch the eye and force one to look back and forth across the diversity of whites.

Frank Benson, at twenty-six, married Ellen Perry Peirson in 1888. Painted the year after their wedding, *Portrait in White* depicts the artist's new bride. Although an early work with traditional light and shadow modeling, the canvas already hints at Benson's future development of Impressionism. Soft blue and yellow reflections

catch in the pure snow white of the dress, and there are even suggestions of the palest jade green.

A tall, handsome man with a sociable personality, Benson gained his fame from the most startlingly bright pictures conceived by any American Impressionist. His mature paintings, often of lovely young women or enchanting children picnicking at the beach, consist of electric-blue skies, emerald-green grass, lemon-yellow daisies, and glaring white pinafores. In comparing Benson's festive subjects to the intimate scenes depicted by his closest friend, a sarcastic critic noted that Benson "pictures the same people that Mr. Tarbell has painted, but as it were, on holiday."

WILLARD LEROY METCALF

1858–1925

Most painters who weren't from artistic families met strong parental resistance to the idea of their becoming professional artists. Not so with Willard Leroy Metcalf. His parents, believers in the supernatural, received the message at a seance that their son would become an important painter, so they actively encouraged him. Metcalf grew up as an occultist with a mystic view of nature. A six-foot-four near-alcoholic, he couldn't cope with life very well. His first wife, an aspiring actress, ran off with another man, and when Metcalf remarried a decade later, it was to a woman thirty years younger than himself.

One would expect a certain flamboyance in such a man's paintings. It isn't there. Metcalf was the most straightforward of the American Impressionists. Art is, after all, a matter of discipline and not dissipation. What shows in Metcalf's work is the keenly penetrating eye and sure sense of balance acquired from twenty years of being a magazine illustrator before turning full-time to oil painting.

Midsummer Twilight, done in France, demonstrates Metcalf's careful approach to composition. The man-made buildings relate to their natural setting through repetition of the roofs' straight-sided lozenges in the geometric pattern of cultivation over the distant fields. Similarly, Metcalf employed the rounded boulders of the rock wall to pick up the soft ovals in the foreground bushes and the background woods. And the angled eave of the central roof establishes a sightline that passes beyond its chimney to point directly at the moon, rising in the east just above the horizon. The amber tone of the setting sun gleams from the terra-cotta roofs and stucco walls, while blue-violet shadows collect in the lower courtyards. The brushwork is beautifully varied to convey the visual effects both of different surfaces and of specific distances. Parallel strokes serve as the terra-cotta tiles, while cross-hatching captures the character of stuccoed plaster. For the bushes, the paint is briskly dabbed and flecked to give the impression of leaves waving in the breeze. The long grasses are represented by whipping lines, and Metcalf rapidly swirled his brush through the distant clouds to lend them an airy, rolling motion. As the objective recording of natural appearance in *Midsummer Twilight* proves, Willard Metcalf came very close to the visual optics of pure French Impressionism.

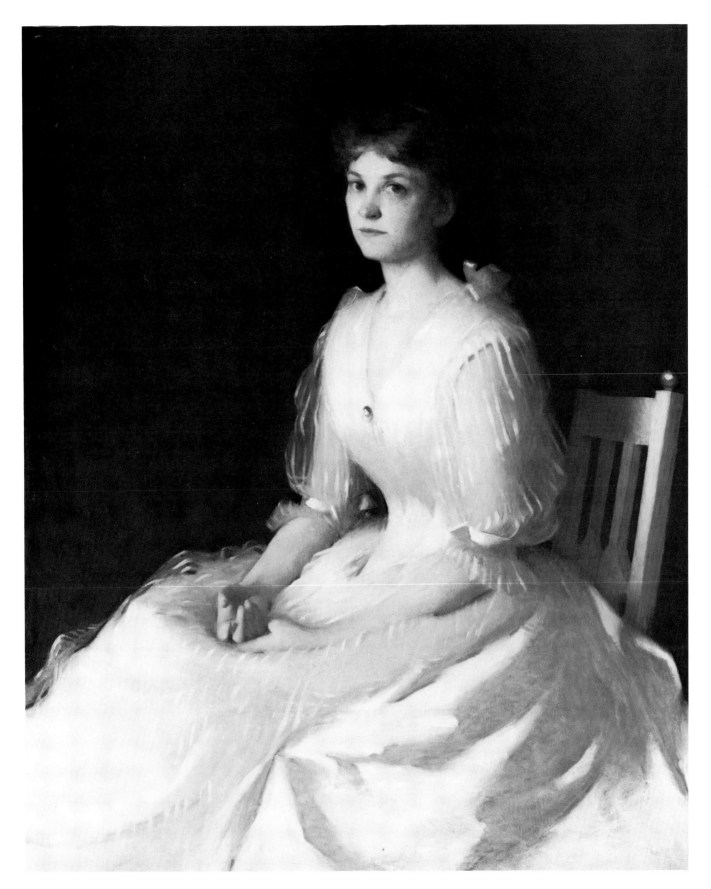

Frank Weston Benson *1862–1951*
Portrait in White *1889*
Canvas, 48⅛″ x 38¼″
Gift of Sylvia Benson Lawson

Willard Leroy Metcalf *1858–1925*
Midsummer Twilight *c. 1885 / 1887*
Canvas, 32¼ " x 35⅝ "
Gift of Admiral Neill Phillips in memory of
Grace Hendricks Phillips

CHILDE HASSAM

1859–1935

Childe Hassam was among the first "foreigners" to embrace French Impressionism. On his second trip to Europe, in 1887, he quickly absorbed the new style's fundamentals. Hassam tempered Impressionism's surrender to sensation with a New Englander's worship of order. "I have to de-bunk the idea that I use dots of color, so called, or what is known as Impressionism." Hassam rigorously subjected his brushwork and composition to a consistent geometric orientation. The compositional arrangement of *Oyster Sloop*, for instance, is much too calculated to have much connection with the natural, snapshotlike composition of the French. The uprights of the mast and fisherman lie equidistant on either side of the painting's vertical center line. Three long shadows cross the water, but only the right-hand two can be explained as reflections from the tall mast or standing man. The left-hand reflection does not coincide with any object on the ship or shore behind it. It does, however, continue the line running through the corner of the house and the flagpole, thus further helping to unify the composition. This view of Cos Cob, Connecticut, comprises rectangular shapes of buildings, sea, and land that fit as tightly together as bricks in a wall. What is Impressionistic is the heightened color freshness of a mustard-yellow house, rusty-orange boat shed, and turquoise-blue sloop.

Nude Seated imposes the same strict method onto a figure

study. The model's anatomy and coiffure have been simplified into graceful ovals. Although her body possesses natural substance and weight, the artist removed any harsh, bony protrusions which should honestly show through such a slender woman's hips, elbows, or shoulders. Her hair and chignon form two interlocking ellipses. These sleek, svelte curves of the model play against straight lines of the drapery's ribboned stripes and pleated folds. Haloed by back-light, the nude acquires an opalescent complexion partaking of every color in the rainbow, albeit the colors are pearly, pastel hues.

On May 9 and 11, 1917, the British and French war commissioners paraded down Fifth Avenue, temporarily proclaimed "the Avenue of the Allies," to celebrate the United States' entry into World War I. The slogan "Show your colors" brought an immediate flurry of Union Jacks, Tricolors, and Stars and Stripes. Hassam's *Allies Day, May 1917* (see page 6) sings of that patriotic gusto. With his easel on an upper balcony of a building at the corner of Fifth Avenue and 52nd Street, Hassam looked northward past Saint Thomas Episcopal Church, the University Club, and the Gotham Hotel to the yellow-green spring foilage in Central Park. The bold designs of the flags and the strong lines in the architecture exactly complement each other. So that the sky could compete with these vigorous shapes and assertive colors, Hassam applied vivid aqua blue in vertical streaks that march across the air. Impressionism alone could not account for such dramatic patterns and startling hues. Henri Matisse and a group of other French artists had already been nicknamed *les fauves*, "the wild beasts," for their expressive use of color. Hassam had had two opportunities to see this radical new style: on his last trip to Paris in 1910, and at New York's famous Armory Show in 1913. But he waited until the festive flags of *Allies Day, May 1917* gave him an excuse to venture into such modernity.

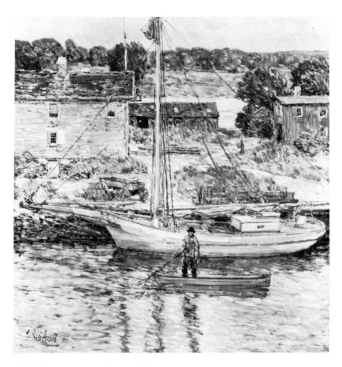

Childe Hassam *1859–1935*
Oyster Sloop *1902*
Canvas, 24⅜ " x 22⅜ "
Ailsa Mellon Bruce Collection

JOHN H. TWACHTMAN

1853–1902

Born to a poor German family in Cincinnati, John H. Twachtman worked his way through a local university's art curriculum by painting decorations on bric-a-brac at night. The successful Realist Frank Duveneck, though only five years Twachtman's senior, recognized his talent and asked the young Ohioan to return with him to Munich, Germany, for further study. Twachtman learned solid modeling in Munich, sophisticated color nuances in Paris, and the effects of atmosphere while on a famous trip to Venice in 1877 with Duveneck and William Merritt Chase. Twachtman did not become an Impressionist until around 1890 when he was back in New York. Since he loved working with pastel chalks, it has been assumed that the light, pure tones of pastel had some significance in Twachtman's late conversion to a brighter oil palette.

In 1893, Julian Alden Weir and Twachtman showed their works in New York, along with paintings borrowed from the French Impressionist Claude Monet. The Monets sold well in the United States, but not a single canvas by Weir or Twachtman was purchased. Twachtman's increasing anger at the American press and public caused him in 1897 to be instrumental in forming The Ten American Painters—with the emphasis on American—to foster avant-garde art. With the exception of Childe Hassam, John Twachtman created the finest, most personal Impressionist canvases in America. But Twachtman never lived to fulfill his prom-

ise. He died of a brief illness just after his fiftieth birthday, leaving a widow and five children. His friend William Merritt Chase was unanimously elected to fill his position in The Ten.

In December 1891, Twachtman had bought a thirteen-acre farm near Greenwich, Connecticut, within commuting distance of his teaching job in Manhattan. Shortly after the mortgage was signed, he wrote Weir, "We must have snow and lots of it. Never is nature more lovely than when it is snowing. Everything is so quiet and the whole earth seems wrapped in a mantle. . . . All nature is hushed to silence." *Winter Harmony* (see pages 164–165) is one of Twachtman's many serene studies of a pool on his property. The silver-gray tones and subdued blues and mauves suggest the evanescent transitions of light on an overcast day. The feathery touches of Twachtman's brush are especially evident in the shimmering evergreens and the patches of golden-brown leaves still clinging to the branches. Unlike a French Impressionist, who built up his picture with separate touches of color side-by-side, Twachtman preserved the Old Master technique of painting in layers. Using opaque oils, he quickly scumbled nearly dry paint over each successive tone. He worked so loosely that the underlying colors show through between the irregular, incomplete network of covering strokes. This novel method gains the vibrant surface of Impressionism while retaining the depth of tone associated with traditional modeling. The evasive form and misty atmosphere it creates work particularly well in Twachtman's snow scenes.

JULIAN ALDEN WEIR

1852–1919

Julian Alden Weir, the youngest of sixteen children, was born at West Point while his father was art instructor to cadet James McNeill Whistler. Ironically, Whistler's refined style was to have more impact on Julian Alden Weir than the boy's father had on Whistler. But in 1877, with his conservative artistic background, Weir was shocked when he saw the third Impressionist exhibition in Paris, writing his father, "They do not observe drawing nor form but give you an impression of what they call nature. It was worse than the Chamber of Horrors." Later, however, Weir's eyes opened to "a big truth," although he never adopted the more extreme notions of Impressionism.

Moonlight has the regular order of tiny brush strokes which Weir employed to systematize Impressionism. The cocoa-brown trees stand mysteriously as a dark screen against the blue-gray sky. The moon and its beams appear bright in comparison, but are actually no higher in tone than beige. Furthering the vague, recessive effect, a muted earth-red mixes with the dry browns of the foliage, bark, and picket fence. A reviewer in 1911 perfectly summed up this lyric poetry: "Mr. Weir's paintings are invariably reticent and personal, they never clamor for attention, but . . . his pictures have both beauty and charm. In them values are finely related, complete mastery of medium is shown, and intangible things, the things of the spirit, are interpreted with subtlety."

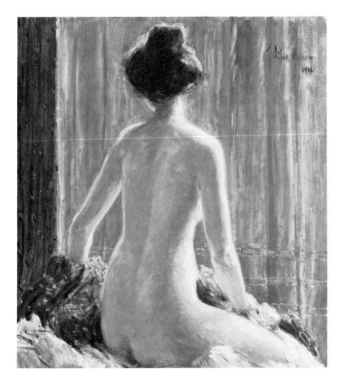

Childe Hassam *1859–1935*
Nude Seated *1912*
Canvas, 24⅛" x 22"
Gift of Chester Dale

Julian Alden Weir *1852–1919*
Moonlight c. 1905
Canvas, 24" x 20"
Gift of Chester Dale

EDMUND CHARLES TARBELL

1862–1938

From looking at *Mother and Mary*, one would never guess that the artist was a feisty, aggressive man whose strong character made him one of the most respected and feared art instructors in America. At the Boston Museum School, Edmund Charles Tarbell had such control over a gang of followers that critics termed the group "Tarbellites." Tarbell continued to have an impact in Washington, D.C., when in 1918 he was appointed principal of the Corcoran School of Art. A master designer, Tarbell grasped the importance of draftsmanship through his teenaged apprenticeship to a lithographic company and his academic studies in Boston and Paris.

As shown in this chapter's frontispiece detail, Tarbell did not allow his touches of broken color to interfere with his representation of solid, three-dimensional form. Dabbed spots of paint render the trees seen through the French windows; then, thin streaks convey the light-catching folds in the sheer curtains. Criss-crossed over the polished floor, long strokes not only imitate the luster of reflected sunlight but also reveal the marks of hand buffing on freshly waxed wood. The diffused light within the room contrasts with the stark clarity of the sunlight on the lawn and trees outside. In fact, the exterior light is so bright that one's eyes can isolate the views through the two French windows as pictures within a picture. The rectangular shapes of the windows, picture frames, and wall moldings are played off against the curving lines of the Chippendale chairs, oval gate-leg table, and tranquil figures of the artist's youngest daughter, Mary, and his wife, Emeline, who sits mending. Tarbell, who liked the challenge of painting interior and exterior light in the same composition, often depicted the tall French windows in his living room at New Castle, New Hampshire.

FREDERICK CARL FRIESEKE

1874–1939

The only artist in this chapter who was not a member of The Ten American Painters, Frieseke nonetheless was a prominent Impressionist. In fact, a leading art magazine claimed in 1932 that "Frieseke, internationally, is perhaps America's best known contemporary painter." That he is virtually unknown today is due to his sentimentality. The very sweetness of subject matter which made him popular eventually became cloyingly saccharine compared to the sour realities of the years following World War I.

Memories, of 1915, represents Frieseke at his peak. The hesitant quietude of a lavender pallor touches every color in the painting from the off-pink wallpaper to the ice-blue dress. A delicate, powdery texture also covers every inch of the canvas, unifying the

Edmund Charles Tarbell *1862–1938*
Mother and Mary *1922*
Canvas, 44⅛" x 50¼"
Gift of the Belcher Collection, Stoughton, Massachusetts

varied objects. This gossamer touch appears as insubstantial as the young woman's momentary reverie. Her knitting needles held list-lessly in her lowered hand, she pauses in thought. Her downward gaze fails to connect with the flowers or the lace tablecloth; she focuses on nothing in particular. The whole painting is a consum-mate expression of the mood which the artist wished to evoke. That some of his contemporaries viewed such pictures as "tea cakes" and "confections" simply says that their personalities dif-fered from Frieseke's. For, as he said, he painted "what I see that is interesting and which appeals to me at the moment."

What appealed to Frederick Carl Frieseke was the delightful home and pleasant garden he purchased in 1906 at Giverny, France, where *Memories* was created. At Giverny, Frieseke's next-door neighbor was Claude Monet, the aging initiator of French Impressionism. An expatriate from Michigan, Frieseke had gone to France in 1898 when he was twenty-four; he didn't return to the United States. After brief study under Whistler and an acquaint-ance with the Impressionists, Frieseke developed his style, noted for its prettiness. Frieseke's decorative and sentimental pictures ele-vated Impressionism to the status of official art back in the United States. Just as Impressionism had begun as a reaction to conserva-tive taste, now it had itself become the bulwark of entrenched aca-demic art, ready to be assaulted by the upcoming generation.

Frederick Carl Frieseke *1874–1939*
Memories *1915*
Canvas, 51¾" x 51¼"
Gift of Frances Frieseke Kilmer

12

ASH CAN REPORTERS

One of the main training grounds for young artists in the late nineteenth century was newspaper and magazine illustration, just as engraving had been a principal source of employment in the earlier 1800s. At the turn of the twentieth century, there seemed no end to the demand for black-and-white drawings to be mechanically translated into printed images. The illustrators, therefore, got a solid foundation in making quick, accurate sketches of newsworthy images. But in 1893 in Philadelphia, a commercially viable method of printing photographs was developed, and by World War I, the need for artist-reporters had vanished.

In the heyday of illustration, it was Realist depictions of city life that preoccupied the artists and readers of the papers. Thirty-eight large cities dominated the United States in 1900, whereas only six communities of more than a hundred thousand people had existed in 1850. With 40 percent of the population living in urban environments, the cityscape came to replace the landscape in American consciousness.

Robert Henri, a leading Realist and influential teacher, stated, "Draw your material from the life around you, from all of it. There is beauty in everything if it looks beautiful to your eyes. You can find it anywhere, everywhere." This ostensibly simple statement is a complete reversal from previous generations' search for idealism. Conservative institutions such as the National Academy of Design in New York still upheld the grandiose, establishment standards. In 1906, the National Academy refused to exhibit Realist paintings by some of Henri's friends, including William Glackens and George Luks. John Sloan, another painter who felt the pinch, grumbled that "a young man with 'fossilized' ideas had no trouble getting in."

In 1908, eight of these Realist rebels banded together to stage an independent exhibition. As "The Eight," they thumbed their noses at the National Academy's stuffiness. Actually, they weren't all Realists; Arthur Davies, for instance, concocted dream worlds.

And George Bellows, in many ways the earthiest of them all, didn't join the group. Most art critics received the show well, feeling that its fresh approach to everyday scenes was "a new and distinctive movement toward Americanism." But hostile reactions branded The Eight as "The Black Gang" and "The Ash Can" school. One critic sharply observed, "Any young painter recently returned from Paris or Munich . . . would call the exhibition of The Eight painters very interesting but far from revolutionary." The Ash Can school went on to present other independent exhibitions, most importantly the Armory Show of 1913, which brought quantities of modern European art to America for the first time.

In defending his own attitude, Henri wrote, "There is a new movement. There has always been the new movement and there will always be the new movement. It is strange that a thing that comes as regularly as clockwork should always be a surprise." But it came as a shocking surprise to these American Realists when foreign Abstraction, which they had helped introduce, won the day.

ROBERT HENRI

1865–1929

"Be a man first; be an artist later," Robert Henri would admonish his students. A self-reliant individual, Henri owned much of his character to his father, a riverboat gambler turned respectable businessman. Henri's secretive nature may also be due to his father, John Cozad, who had achieved his life ambition when he established his own town: Cozad, Nebraska. Robert, while still a teenager, had joined his father in running the town, but in 1882, Cozad

196

George Bellows *1882–1925*
Detail of Both Members of This Club 1909
Gift of Chester Dale

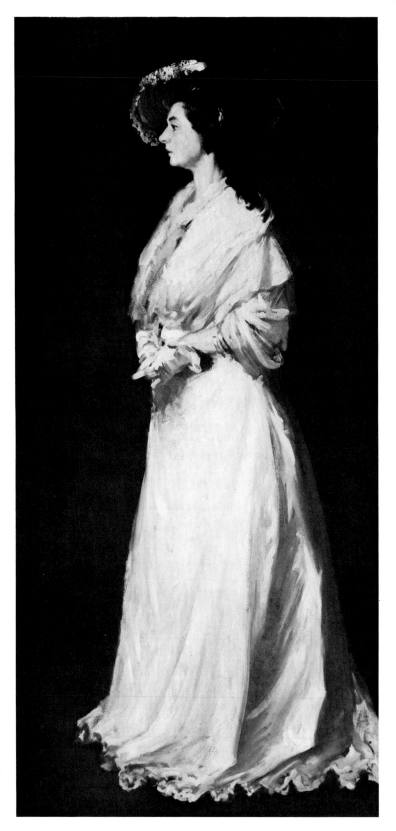

Robert Henri *1865–1929*
Young Woman in White *1904*
Canvas, 78¼" x 38⅛"
Gift of Violet Organ

198

shot a man in a fight and fled from a lynching mob. His family soon followed, all of them changing their names to avoid the stigma of being related to a murderer (who, one must point out, was eventually cleared). Robert Henry Cozad dropped the family name and turned his middle name into his last name. In the process, he altered the spelling and pronunciation from "Henry" to "Henri," rhyming with buckeye. Chagrined by his family's dishonor, Robert Henri was an extrovert when teaching an entire class but remained an introvert when confronted with personal situations.

Robert Henri enrolled in the Pennsylvania Academy of the Fine Arts in 1886, just missing working under Thomas Eakins, who'd been fired from the faculty earlier the same year. Although Henri wasn't Eakins' student, however, he became Eakins' principal heir: "It was an excitement to hear his pupils talk of him. They believed in him as a great master, and there were stories of his power, his will in the pursuit of study, his unwavering adherence to

his ideals, his great willingness to give, to help, and the pleasure he had in seeing the original and the worthy crop out in a student's work." Henri's own abilities as a teacher paralleled those of Eakins. Henri delighted in helping pupils come to grips with their own attitudes: "What a mistake we have made in life in seeking for the finished product. A thing that is finished is dead. That is why the student interests me so. He is in the process of growth. He is experimenting. . . . A finished technique without relation to life is a piece of mechanics, it is not a work of art." From 1888 to 1891, Henri worked in Paris; he was to return to Europe several times. As he wrote in his diary, "Who would not be an art student in Paris?" Success came quickly. Henri held his first one-man show in Philadelphia while still in his early thirties. In 1900, he moved permanently to New York, later convincing his Philadelphia friends, such as William Glackens, to join him there.

Snow in New York (see page 167), dated March 5, 1902, bears

Robert Henri *1865–1929*
Volendam Street Scene *1910*
Canvas, 20⅛" x 24"
Gift of Mr. and Mrs. Gerard C. Smith

199

Robert Henri *1865–1929*
Catharine *1913*
Canvas, 24" x 20⅛"
Given in memory of Mr. and Mrs. William J. Johnson

out Henri's dictum, "The various details in a landscape painting mean nothing to us if they do not express some mood of nature as felt by the artist." Suggestive rather than descriptive, the scene conveys the stillness of sounds hushed by falling snow. The distant gray sky begins an orchestration of tone that grows deeper and richer as its approaches the brownstone townhouses of the foreground. A few spots of pure white, like the light in the lamp post or the untrodden snow in the street, punctuate the umbers, siennas, and ochers. The red of a woman's shawl or the yellow mud on a horsecart's wheel play up the browns and grays. The simple masses of the buildings and the receding lines of the street lend solidity to the design, while the slashing strokes of Henri's brush animate the gloomy day. The gentle emotion recalls Henri's comment about "the romance of snow-filled atmosphere and the grimness of a house."

Henri's concern for mood, tonal relationships, and virtuoso brushwork achieved monumental proportions in his life-sized *Young Woman in White.* He executed a number of evocative character studies posed for by professional models or willing amateurs.

George Bellows *1882–1925*
The Lone Tenement *1909*
Canvas, 36⅛" x 48⅛"
Gift of Chester Dale

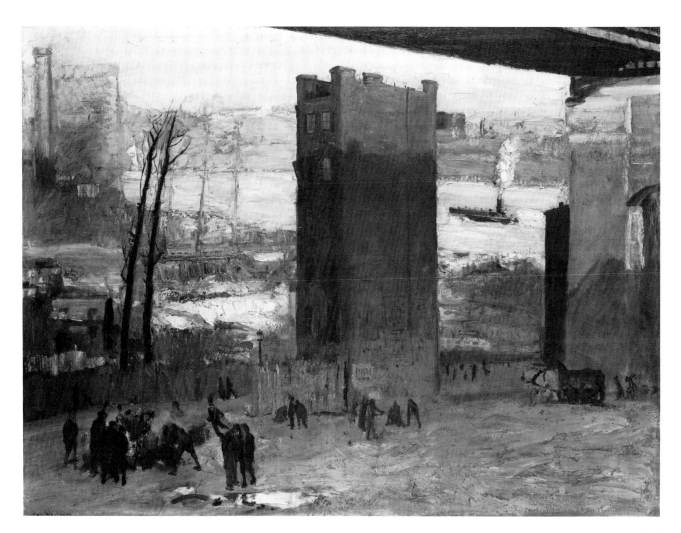

Eugenie Stein, a popular model known as Zenka of Bohemia, has here been transformed into an "art for art's sake" composition. The dazzling display of paint textures on her gown indicates Henri's awareness of the tactile qualities in the work of William Merritt Chase, John Singer Sargent, and Frank Duveneck. The stark patterns of light and dark owe something to the compositions of James McNeill Whistler. The jet-black plume on her hat, for instance, creates a perfect foil to her blinding-white dress and gloves. An exercise in black and white, the figure study gains warmth from the golden bracelets and yellow scarf. But despite his interest in the formal concerns of "art for art's sake," Henri's inherent Realism dominates the design; and Zenka of Bohemia looks exactly like herself, not like a Sargent socialite or a Whistler will-o'-the-wisp.

Henri felt a joy in life, and he often produced sparklingly gay sketches. *Volendam Street Scene,* done during a summer in Holland in 1910, gives the appearance of having been whipped out in a few moments before the busy marketplace activity faded. Single strokes of the brush capture the ships' masts, and rapid scumbles of paint indicate the villagers. Against an earth-brown background, mere dots and scratches of bright red, blue, yellow, and green are enough to make us sense the baggy trousers, aprons, starched caps, shawls, and market baskets.

Henri's interest in humanity found no better theme than childhood. In America and Europe, he incessantly portrayed the changeable expressions on young faces. "If one has love of children as human beings, and realizes the greatness that is in them, no better subjects for painting can be found," he said. *Catharine* communicates both the innocence and seriousness of the young. The dull, neutral tones of the dress and background swirl in a vortex of thick impastoed paint around her quiet face. Her large eyes gain both liquid depth and psychological meaning from sharp pinpricks of white highlights. The model was the daughter of an Irish fisherman; on this 1913 trip to County Mayo, Ireland, as always on his travels, Henri searched for mobile faces to perpetuate with his brush. Perhaps the best way to understand this brilliant artist and influential teacher is to ponder his concept of individuality: "Don't follow the critics too much. Art appreciation, like love, cannot be done by proxy. It is a very personal affair."

GEORGE BELLOWS

1882–1925

If any painter summed up the aspirations of the Ash Can school, that painter was George Bellows. His bravura brushwork, solidly constructed designs, and subjects of the docks, saloons, and tenements characterize the group's Realist intentions. Yet Bellows was not a member of The Eight. Because he had not joined them in their independent defiance of the National Academy of Design in 1908, he escaped the savage criticism leveled at most of the others.

It is a harsh indictment of art critics and society patrons that they accepted Bellows and even raised him to the heights of one of America's most popular painters—simply because he had no official affiliation with a band of artists who had been stamped unacceptable. While ridiculing The Eight, these shallow minds failed to note that Bellows—in temperament, style, theme, and personal friendship—was an integral, though not "card-carrying," member of that radical group. Unfortunately, at the peak of his career, Bellows died suddenly of appendicitis when only forty-two.

Bellows' father was a building contracter in Columbus, Ohio, where the youth was raised. While attending Ohio State University, George Bellows was a "big man on campus," playing varsity basketball and baseball while being sports illustrator and cartoonist for college publications. When his classmates assumed he was going to become a professional shortstop, he always answered, "No, I'm going to be a painter." Saving his summer income from playing semiprofessional baseball, he moved to New York in 1904, got a room at the YMCA, and enrolled in the New York School of Art. Although his first teacher was the fashionable William Merritt Chase, Bellows fell under the spell of a younger instructor within only a few days. Bellows wrote, "Arrived in New York I found myself in my first art school under Robert Henri having never heard of him before . . . My life begins at this point."

Under Henri's guidance Bellows advanced rapidly from a slick commercial illustrator to a hardy artist. He also joined Henri's weekly open houses, the "Tuesday Evenings," where his outgoing personality won him the close friendship of George Luks, John Sloan, and the other young Henri followers. With his background in college high-jinks, he soon led their revelries. However, his common sense prevailed when the others bolted from the National Academy of Design in 1908; one year earlier, he'd had a work accepted by that hallowed institution and didn't wish to endanger his standing. His strategy worked. While the Henri band reeled under the jeers that greeted them as the Ash Can school, Bellows was elected an associate member of the National Academy in 1909.

Like many people who first see Manhattan as adults, Bellows entered into a love affair with the metropolis. Painted in March 1909, *Blue Morning* (see page 166) documents the bustling change of the big city. A great iron girder and beam enframe a view of the excavation for the Pennsylvania Railroad Station. From the foreground fence, through the tilted crane at right, to the buildings and scaffolding in the background, a sturdy geometric design locks the canvas into rational proportions. The workmen's activity, adding life to the scene, possibly reminded Bellows of his father's job as a contractor back in Columbus. Although clearly a cityscape with a precisely described location and a genre scene of construction workers, it was neither the landscape nor the daily life that drew Bellows' interest. *Blue Morning,* the title he used in his careful record books, indicates his artistic preoccupation with the color range. The azure and violet shadows achieve remarkable clarity, contrasted to the warm amber sunlight on bricks, steam, and frost.

The Lone Tenement, done in December of the same year, shows the continuing intrigue that construction and demolition held for Bellows. Almost an allegory of life and death, the picture centers on the last remaining building below the approaches to the

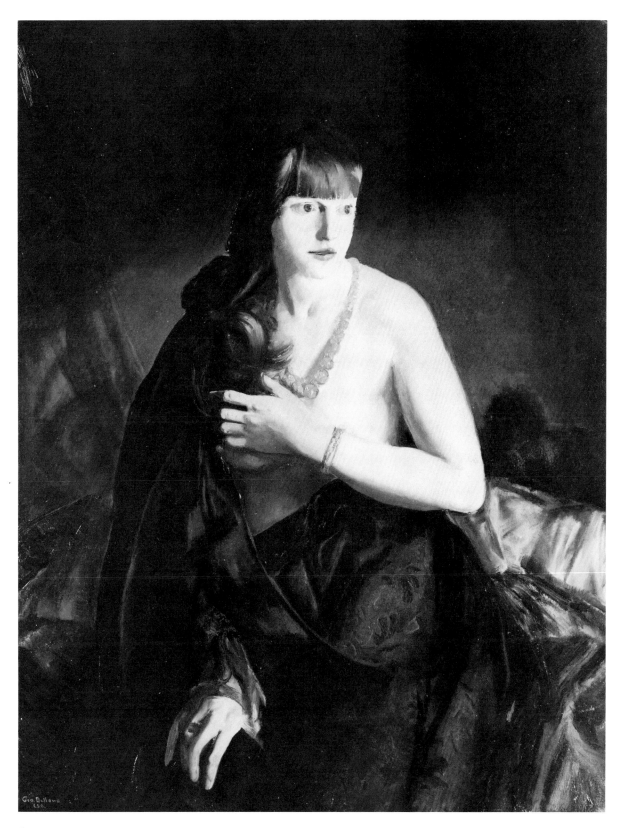

George Bellows *1882–1925*
Nude with Red Hair *1920*
Canvas, 44⅛" x 34⅛."
Gift of Chester Dale

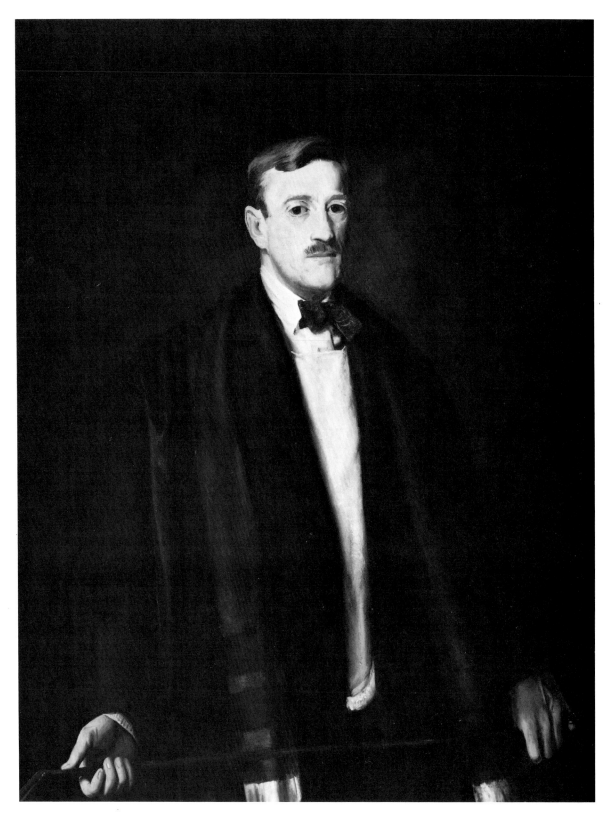

George Bellows *1882–1925*
Chester Dale *1922*
Canvas, 44 ¾ " x 34 ¾ "
Gift of Chester Dale

Queensboro Bridge, everything else in the neighborhood having long since been razed. Two dead trees add to the nostalgia. The bridge, begun in June 1901, had opened to traffic on March 30, 1909, nine months before Bellows painted this scene. The oppressive roadway, crushing in from the top of the design, and the span's dark shadow against the red brick tenement seem to foretell the apartment's doom. The whole design directs attention to the bridge's mass. Pointed up toward the black roadway from below, a system of verticals marches left to right. A factory smokestack, the tree trunks, the masts of a moored ship, the tenement itself, and smoke from a ship on the East River all lead across the canvas to the bridge's heavy pier. This powerful composition and the superb handling of earthy umbers, ochers, and siennas make it difficult to believe that Bellows began his painting career only five years earlier.

Bellows' athletic ability, including playing ball for the Brooklyn Howards to put himself through art school, explains his fascination for the type of sporting picture with which his name has become synonymous—boxing matches. In all, he depicted fights in six paintings, sixteen lithographic prints, and innumerable drawings. *Both Members of This Club* (see page 220) is the most violent of these scenes. The odd title requires explanation. From 1900 to 1910, public boxing was illegal in New York State because of corruption, cheating, and gambling. The law was easily circumvented, however, by staging matches at private clubs, where the spectators held memberships. The boxers weren't considered good enough to belong to the associations, so they were granted memberships only for the night of the fight. Bellows' title sarcastically refers to the privilege that the two boxers held only so long as they were entertaining the blood-thirsty, self-satisfied spectators. Although Bellows was obviously caricaturizing the audience here, he had great respect for the fighters. The matches allowed him to study anatomy in action in a way impossible in painters' studios. He explained, "A fight, particularly under the night light, is of all sports the most classically picturesque. It is the only instance in everyday life where the nude figure is displayed."

The location must be Tom Sharkey's Athletic Club, but the specific fight has not been identified. The black contestant, one of the greatest boxers in history, is Joe Gans. For eight years, Gans held the lightweight championship—that is, boxers weighing less than 135 pounds. His opponent is unknown, and there is reason to believe that *Both Members of This Club*, painted in October 1909, conjures up an imaginary confrontation. Gans' famous "right punch after blocking a lead," may have led Bellows to record that famous manuever for its own sake. Gans' body lunges across the picture in a sharp diagonal, accented by the glistening sweat on his legs, ribs, and arms. His white opponent buckles under the thrust into a flaccid S-curve, falling toward the canvas with all the strength of limp spaghetti. It's interesting to note that the boxers' faces are half hidden behind their arms or buried in shadow. Bellows wasn't doing a dual portrait; he was creating an action picture in which personalities not only don't count but might interfere with the brute passions. Turning on a critic who questioned the likenesses in his boxing pictures, Bellows once remarked, "Who

cares what a prizefighter looks like? It's his muscles that count."

Generating a sense of immediacy, Bellows presented the viewer with a kind of "you are there" effect. Three rows of spectators in front of us cut off part of our view of the smoke-filled arena, and the ringside ropes loom overhead of our low vantage point. The lurid spotlights pit shadow against glare, just as the fighters are pitted one against the other. Indeed, the boxers' complexions deliberately throw the design off balance, increasing the dynamism. Gans's dark skin, though occupying the center of interest, blends into the gloomy arena. The loser, reflecting the blinding lights, is far to one side of the composition. In this struggle of clashing light and dark, color is restricted almost entirely to blood-red streaks defining the loser's ribs and gaping jaws. And Bellows painted as rapidly as the fighters danced around the ring. The enlarged detail at the front of the chapter shows his quick flicks of the brush, used to lacerate the spectators. A collection of grotesque caricatures, they roar approval of the bloodshed.

These lunatic expressions recall the nineteenth-century parodies of the Spaniard Francisco de Goya and the Frenchman Honoré Daumier. Bellows, who never went to Europe, must have become acquainted with the imaginative prints and paintings of Goya and Daumier in American museums. *Both Members of This Club*, regardless of whether or not it depicts an actual fight, conveys excitement and gore as well as any Expressionistic canvas could. The artist even denied his vast knowledge of the sport to proclaim, "I don't know anything about boxing. I am just painting two men trying to kill each other." And critics agreed. "As for Mr. Bellows he is in a class by himself . . . his boxing pictures, and call them brutal if you will, they hit you between the eyes with a vigor that few living artists known to us can command. Take any of these Parisian chaps, beginning with Henri Matisse, who make a speciality of movement—well, their work is ladylike in comparison with the red blood of Bellows."

The public took Bellows to heart. In 1910, he held his first one-man show, received the first of several important teaching positions, and, with his financial success assured, married a beautiful young painter. He was elected a full academician of the National Academy of Design in 1913; at the age of thirty-one, he was the youngest full member yet appointed. He began to experiment with formal schemes for composition and systems of color matching. *Nude with Red Hair*, painted in 1920 while he was summering at an artist's colony, has a calmer, more highly calculated effect than his spontaneous, earlier work. The model's coppery red hair and orange beads play against complementary background colors of violet draperies and wall. Similar restraint is evident in *Chester Dale*, a commissioned portrait of Bellows' good friend and major patron. Dale holds a golf club that places his hands at the lower corners of a triangular configuration topped by his head. His green scarf and yellow sweater form verticals rising to accentuate his face. Chester Dale, a New York stockbroker who gave his extensive collection of French Impressionist pictures to the National Gallery, had been an amateur boxer himself. Bellows and Dale, both interested in art and both sportsmen, had much in common, as the candor of this portrait proves.

Arthur B. Davies *1862–1928*
Sweet Tremulous Leaves 1922 / 1923
Canvas, 30⅜ " x 18¼ "
Gift of Chester Dale

206

GEORGE BENJAMIN LUKS

1866–1933

George Benjamin Luks, like his friends John Sloan and William Glackens, attended the Pennsylvania Academy of the Fine Arts and worked as a newspaper artist. But there the similarity ends. Sloan was methodical to a fault in his technique, while Luks swore, "I can paint with a shoestring dipped in lard!" Glackens portrayed domestic, polite society, whereas Luks insisted, "A child of the slums will make a better painting than a drawing-room lady gone over by a beauty shop." A brash, bellicose man, often in his cups, George Luks specialized in depicting the seamy side of life. Yet he always revealed the inner dignity of his subjects, never pitying nor caricaturing them. An extremely perceptive critic in 1903 reviewed Luks as "the painter of corner-boys and 'toughs'; street urchins, ragamuffins, and all kinds of low types employed as a subject that cannot by any possibility be called low, unless indeed we apply that term to the works of God."

Luks was better traveled than most of the other Ash Can painters, and his thickly textured pigment is indebted to both modern French artists and the seventeenth-century Old Masters Rembrandt and Frans Hals. The heavy strokes of opaque paint in *The Bersaglieri* (see page 219) perfectly convey the excitement and flair of a military parade. Italian sharpshooters, the Bersaglieri had been sent to America to stimulate interest in Liberty Bonds during World War I. Luks made the most of their olive-green uniforms, the multicolored cocks' feathers in their helmets, the band's brass instruments, and the vivid hues in the Red Cross and Allied flags as well as in Italy's green, white, and red flag. The sharp clarity of the foreground pennants and marchers fades quickly to mere suggestions of distant troops and background crowds. Reiterating the geometric designs in the flags, the buildings along Fifth Avenue create an emphatic grid of vertical and horizontal lines. If Luks seems to exaggerate the march's tempo into a frenzy, he was justified in his treatment. The Bersaglieri led the parade on Saturday, October 12, 1918, as reported in the news: "The Italians came by at a 'turkey trot' and as it was Italy Day at the Altar of Liberty as well as the anniversary of the discovery of America by Christopher Columbus, the veterans got a double-sized tribute. They were still 'turkey-trotting' when they disappeared down the avenue." Luks communicates the fervor of soldiers who must make three different presentations on the same day at far ends of Manhattan: Liberty Parade, Italy Day, and Columbus Day.

Luks' *Bersaglieri* normally hangs in the National Galley right beside Childe Hassam's *Allies Day, May 1917* (see page 6). Depicting similar events that occurred within a year and a half of each other, the two pictures visually summarize the differences in attitude between the American Impressionists and the painters of the Ash Can school. Though the colors are considerably brighter in Hassam's canvas, its overall effect is subdued compared to the brash composition by Luks. While Hassam used a regular system of small strokes, Luks employed bold patches of outlined forms. And Hassam's relatively even tonality causes his picture to shimmer in sunlight, while Luks stressed the clashing light and shadow in the narrow canyons of city streets.

Luk's subjects weren't confined to big cities. In the summer of 1925, for instance, he worked in Pottsville, a small mining town in Pennsylvania. The son of a physician, Luks had been raised in the coal belt, even claiming to have worked the mines when young. (But, then, he claimed to have done many colorful things, such as being a boxer, which are known to be tall tales.) One claim he could make truthfully is that he painted with incredible speed when the mood was upon him. In two months in Pottsville, he produced nearly thirty oils and watercolors, plus numerous drawings. The canvas that attracted the most attention in shows in the Pottsville Public Library and later in a New York sales gallery was *The Miner* (see page 221). Grimly chomping on his pipe, the anonymous miner is coated with soot after a day's labor. He sits wearily on a pile of shale, his water jug and lunch bucket dangling from one strong finger. The occasional gleam of flesh or glint of brass serve only to accentuate the cold blues, gray-greens, and blacks. The man's integrity, his pride in an honest job well done, are communicated by Luks' rugged slashes of paint and deeply sonorous tones. As the artist had earlier advised, "Surround yourself with life; fight and revel, and learn the significance of toil. There is beauty in a hovel or a grog shop." The vehemence with which Luks and other Ash Can artists advocated low-life subjects and social criticism is explained by this miner's outfit. He wears a "soft shell" hat and boots and has a carbide lamp fixed to his cap. In 1925, there were no laws to protect coal miners with "hard hats" and to prevent explosions from live flames in their lanterns.

WILLIAM GLACKENS

1870–1938

William Glackens did not share his colleagues' interest in the squalor and crowding of urban existence; his canvases record upper-middle-class pleasantries of theater-going, dining in elegant cafés, and shopping at fashionable stores. *Family Group* (see page 168) of 1910–1911, his largest and most ambitious work, typifies his delight in life. Brightly hued and boldly patterned, the scene takes place in Glackens' Fifth Avenue apartment. Seated on the sofa is Grace Morgan, a family friend who'd recently returned from France; she leans forward to tell of Parisian haute couture. Indeed, her plumed hat, boa wrap, and high-fashion gown seem to have inspired Glackens to create this dazzlingly colorful picture. The painter's wife, Edith, rests on the arm of her sister Irene's chair; the little boy is Ira Glackens, the artist's son. Edith Dimock Glackens was a painter herself, a pupil of William Merritt Chase. Irene Dimock was to marry one of the leading newspaper art critics. William Glackens cleverly stated the familial relationships by grouping his sister-in-law, wife, and three-year-old son together in

cool colors and balancing them against the brighter, hotter tones of the single figure of the visitor. Everything about the composition breathes optimism, from the interweaving curves to the vivid light. No wonder that John Sloan remarked enviously of Glackens, "He should be happy, a wife, a baby, money in the family, genius."

Glackens was the good-humored, level-headed core of The Eight. His sensible nature cooled the feisty arguments that often erupted between the others. A newspaper illustrator from Philadelphia, Glackens' powers of observation were so keen that, according to another reporter-artist, he didn't even bother to sketch when on the site of a crime or newsworthy event. "His memory was amazing; one look on an assignment was much the same to him as taking an exhaustive book of that incident from a shelf." Glackens accompanied Robert Henri to Paris in 1895–1896. He immediately adopted the rich palette of the Impressionists and renewed his understanding of their methods on repeated trips to France. Indeed, his predilection for happy moods and scintillating brush strokes has earned him the nickname of the "American Renoir."

Upon his return from Europe, Glackens shared a studio with George Luks above a milliner's shop; the street sign, provoking much laughter among the band of young Realist painters, announced, "Luks and Glackens, Furs and Feathers." After participating in the exhibition of The Eight in 1908, Glackens was appointed to chair the committee that passed on American art for the Armory Show of 1913. Comparing the avant-garde European entries to the Realist and Impressionist work of his own friends, Glackens made the prophetic remark, "I am afraid that the American section will seem very tame beside the foreign section." Exhibited at the Armory Show, *Family Group*, for all its riotous patterning and vibrant color, must have paled beside the geometric Cubism of Pablo Picasso or the garish hues of Henri Matisse's Fauvism. But Glackens had never been interested in aesthetic shock or social outcry. Even when working on the scale of life, as in the six-foot-high *Family Group*, William Glackens wove a mood of intimacy with curling lines which bind figure to figure and with unifying repetitions of rose, pink, and violet.

ARTHUR BOWEN DAVIES

1862–1928

Mystery pervaded Arthur Bowen Davies' life and art. *Sweet Tremulous Leaves*, for instance, is so effective as a literary title that one can visualize a sweet, even pastel, still life of saccharine sentimentality. The actual painting that bears this title, however, is anything but a simple still life! The nudes' eccentric poses, their pulsating outlines, and the impersonal, profile view of their faces are positively eerie. In the early 1920s, when Davies painted this work, he insisted that all great art, whether depicting plants, animals, or humans, must portray the moment of inhalation, when the lungs

are full of air. This odd notion (plants have lungs?) explains the erect postures and raised bosoms of the women. Their lithe proportions derive from Davies' appreciation for Botticelli, a Renaissance painter famed for his graceful renditions of slender figures. The rippling muscles, though, show Davies' awareness of the athletic bodies carved and painted by the Renaissance artist Michelangelo. And the flattened silhouettes, with little or no modeling in light and shadow, recall Davies' intense study of Japanese art and the Post-Impressionist canvases of Paul Gauguin.

Somehow, this potpourri of conflicting elements blends into a coherent design. Davies was a master of synthesis. He changed styles as often as he changed techniques. Davis underwent Realist, Impressionist, and Cubist phases; he painted in oils on canvas, he frescoed murals into wet plaster, he executed sculpture and prints in a variety of media, he worked with stained glass and designed tapestries. In *Sweet Tremulous Leaves*, the earth browns and tans combine with dull blues and greens to generate a quite reverie. The dry, chalky oil paint is so thinly applied that the canvas' soft weave shows through, creating a hesitant, misty effect. And the negative area of dark tree bark rising between the two women's torsos effectively mirrors the shapes of their upraised arms. He explained, "I use the method of 'continuous composition'—repetition of the same motive." As for his constant preoccupation with maidens, unicorns, pastoral animals, and twilight landscapes, Davies commented, with an imperial pronoun, "Love we consider the greatest attribute of God."

An extraordinarily successful artist, Davies understood precisely what would appeal to high-society clients at the turn of this century: images quoted from past masters and a genteel rendering of blatantly erotic subjects. Davies' prominence earned him inclusion among The Eight and the position as president of the famous Armory Show of 1913. The younger American artists appointed him mainly as a socially acceptable "front" for their radical exhibition, little knowing he would take over completely and reorient the show to include modern European art. And he was a brilliant organizer. Davies' later influence on major patrons helped formulate the ideas for the Museum of Modern Art and the historic recreation of Colonial Williamsburg.

Wealthy enough from the sales of his work to visit Europe annually from 1893, Davies led a double life—if not to say triple life. The demure model for both figures in *Sweet Tremulous Leaves*, Wreath MacIntyre, worshipped him as a father; during her fourteen years as his exclusive model, she never saw him smoke or drink nor heard him utter a profanity. This was his social image. Weekends, Davies had a private life with his two sons and wife in the country; since his wife was a doctor in a small town, she understood that his artistic career kept him in New York weekdays. What she didn't know was what he was doing with his weeknights. Davies had a mistress and daughter in Manhattan that no one knew about. In fact, his daughter didn't even know that Davies was her father. To guarantee that patrons, fellow painters, wife, mistress, or children could never cross paths, Davies kept the address of his studio a secret. Psychiatry or divorce, given the biases of his time, would have destroyed his reputation. Some authorities suspect that Davies' heart condition was aggravated, if not caused, by the con-

stant tension of maintaining this deceit for twenty-three years. On October 24, 1928, in New York, Wreath MacIntyre awoke to hear Davies' voice softly calling her name; he had suffered a fatal heart attack that night in Florence, Italy. His wife did not learn of his death until five weeks later, when a strange woman knocked on her door to announce that Davies had died in her arms in Italy. Together, the wife and mistress returned to Europe to settle his complicated estate.

JOHN SLOAN

1871–1951

Even though he spent much time away from the city, summering in Massachusetts or New Mexico, John Sloan became the painter *par excellence* of New York. His ferryboats in the fog, clothes drying on lines slung across tenement alleys, children playing in the streets, or young lovers stealing a moment's privacy on the rooftops, have entered the public's imagination as life in the metropolis at the turn of the century. In many ways, *The City from Greenwich Village* (see page 224) culminates his vision of New York by incorporating his earlier, anecdotal scenes of individual elements into a breathtaking view of the city as a whole. So strong is the overall effect of geometric masses in buildings and streets that it takes a few moments for the viewer to note the narrative details; passersby stopping at lit store windows; an elevated train whizzing past; hints of activity in distant apartments; and cars slowing to allow pedestrians to cross intersections. The shiny reflections of headlights and street lamps on the slick pavement prove this is a drizzly winter's twilight and that the umbrellas are necessary.

Not a native New Yorker, Sloan grew up in Philadelphia, attending high school in the same class as William Glackens. Sloan supported himself designing novelties, calendars, posters, and advertisements. In 1892, at nineteen, he began a long association with newspaper art departments, entered the Pennsylvania Academy of the Fine Arts, and met Robert Henri. Although Henri was only six years older and never his actual teacher, Sloan remained forever in the more experienced artist's debt. "I don't think I would have become a painter if Henri had not kept at me to become started. When I met him, I was only interested in becoming a good illustrator. He was my father in art." Long after adopting oil paints, however, Sloan continued to support himself as a newspaper illustrator and creator of "picture puzzles" for the tabloids.

He moved to New York in 1904 and emerged as one of the leading artists who were to band together in 1908 as The Eight. Sloan's close observation of city conditions soon led him to champion the poor, downtrodden victims of an unequal system of justice. He maintained, "It was not essentially wrong to break a law, that one might commit a greater wrong by obeying a law—a bad law." By 1912, he'd joined the Socialist party and acted as art editor

for *The Masses*, a political monthly, while his wife served as the magazine's business manager. Sloan's lithographic illustrations for *The Masses* form some of the twentieth century's most pointed and poignant social outcrys. As he later wrote, "It is hard for the man living in 1950 to realize that many of the things he takes for granted were considered radical proposals back in 1910; Women's suffrage, income taxes, workmen's compensation and social security, supervision of the stock exchange and regulation of interstate commerce, the United Nations." With the outbreak of World War I, Sloan became disillusioned by the Socialist cause and resigned from *The Masses*, but he never lost his liberal inclinations. By the mid-1920s, he began experiments in a novel painting technique of crisscrossed webs of modeling lines. This purely formal approach was to reduce the force of social commentary in his later art.

The City from Greenwich Village, first exhibited in the spring of 1922, balances his later fascination for complex technique with his earlier interest in everyday life. What appears to be a snapshot view taken from a roof is actually the result of calculated study. The thick strokes of pigment in the sky and over the streets reveal his knowledge of the French Post-Impressionists, such as Paul Cézanne, and the beginning of his own development of linear networks. A deliberate manipulation of thinned glazes of translucent oil paints creates the shimmering glow of the lights against the dark brown, blue, and purple nighttime. Moreover, this apparently realistic landscape is an imaginary composite of different views; from no single vantage point could all these structures be seen at the same time.

Sloan's work on this composition required more preparatory studies than any of his other pictures; all five surviving drawings belong to the National Gallery. The pencil sketch illustrated here has scribbled notes for the artist's reference. It shows the elevated train tracks at the slight angle they would create from a sixth-story rooftop; in the final oil painting, the tracks are pushed down at a steeper perspective, opening the whole foreground into a vaster space. The drawing is folded across its top, cutting off the cornice of the tall triangular building; in the painting, the building's physical presence becomes almost threatening as it pushes beyond the canvas' edge. The soaring Woolworth Building dominates the pink and yellow skyscrapers. Actually, that golden vision of a heavenly paradise would not be visible from this low a level; the skyline, therefore, derives from other studies done at higher elevations.

Sloan described this painting as, "Looking south over lower Sixth Avenue from the roof of my Washington Place studio, on a winter evening. The distant lights of the great office buildings downtown are seen in the gathering darkness. The triangular loft building on the right had contained my studio for three years before. Although painted from memory it seems thoroughly convincing in its handling of light and space." By incorporating the views from two of his favorite studios, the painting is partly autobiographical. It partakes of the city's mystery in its glimpses down narrow alleys and side streets, and yet it imparts the metropolis' awesome grandeur with its sweeping vista into depth. Sloan's lively wit also contributes to the mood. He had little love for the Prohibition era and humorously spotlit a sign in the lower left corner reading "Moonshine." Certainly no speakeasy would have dared advertise itself in 1922.

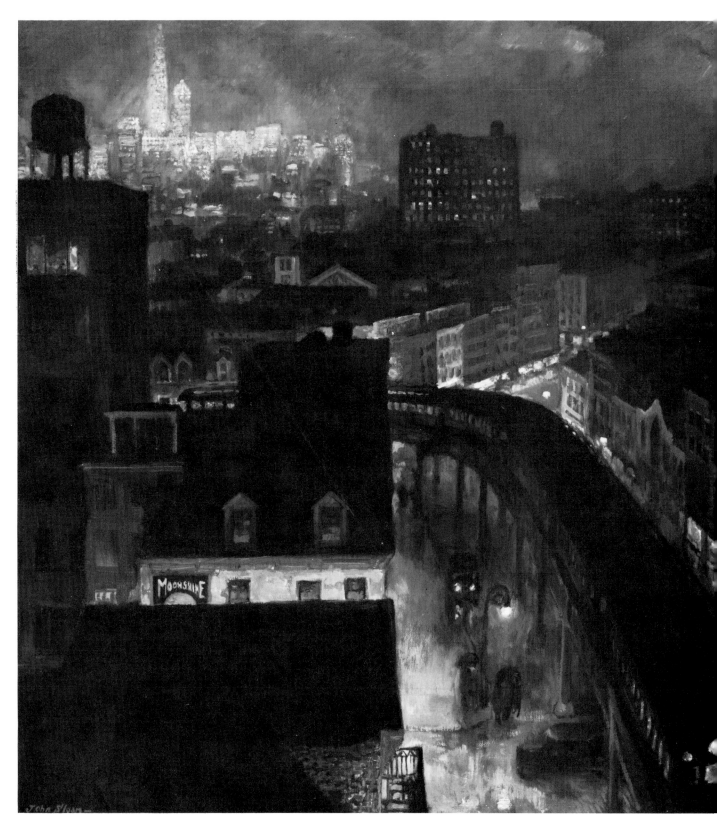

John Sloan *1871–1951*
Study for The City from Greenwich Village *c. 1922*
Black pencil on paper, 9 ½ " x 9 ⅞ "
Gift of Helen Farr Sloan

John Sloan *1871–1951*
The City from Greenwich Village *1922*
Canvas, 26" x 33 ¾ "
Gift of Helen Farr Sloan

13

MODERNISTS VERSUS TRADITIONALISTS

The year 1900 doesn't just mark the turn of the century; it stands in the exact center of a decade that forever altered the human race. In 1895, Wilhelm Roentgen discovered X-rays, proving that matter was not solid. Marie and Pierre Curie processed radium in 1898, proving that matter was not stable. The final blow came in 1905 when Albert Einstein published his theory of relativity, proving that this unsolid, unstable matter actually changes dimensions depending upon its speed through time! Everything that had appeared comfortable and predictable since the dawn of recorded history lay shattered in scientific rubble. As if this destruction of our confidence in physical nature weren't enough, Sigmund Freud released *The Interpretation of Dreams* in 1900, reappraising our understanding of human nature.

These culture shocks profoundly affected the arts. External appearance lost all meaning. Painters explored the inner reaches of the universe and of their own psyches. This is not to say that the French Cubists were x-ray technicians or that the German Expressionists were expert psychoanalysts. But the intellectual ferment bubbled over into all aspects of human endeavor. Unlike the Europeans who'd had a generation to adjust, Americans received a virtual death blow to their artistic traditions in 1913.

Late in 1911, a group of painters gathered to discuss the difficulties of exhibiting their new work in the United States. A huge, independent exhibit was proposed, and officers elected: Arthur B. Davies as president, Walt Kuhn as secretary. Although the original plans called for only recent American painting, Davies and Kuhn got the idea of asking Europeans to join. Soon, about 300 artists had contributed around 1,300 paintings, statues, prints, and drawings. No gallery in the United States was large enough, so the International Exhibition of Modern Art had to be held in the Armory Building of the Sixty-ninth Regiment in New York. The "Armory Show," as it came to be known, opened in New York on February 17, 1913, and, in reduced form, traveled to Chicago and Boston that spring. The American organizers, proud of their own national achievements in avant-garde art, included the works of Mary Cas-

satt, James Whistler, Albert Ryder, and most of the Impressionists and Realists discussed previously. But the most radical art being produced by Americans looked bland compared to the European entries. Since the Post-Impressionists Paul Cézanne, Vincent Van Gogh, and Paul Gauguin appalled or amused the public and critics, one can easily imagine the apoplexy caused by Pablo Picasso, Henri Matisse, and Wassily Kandinsky. From this date forward, it would be impossible to ignore Abstraction.

GUY PÈNE DU BOIS

1884–1958

A sophisticate equally at home in Manhattan or Paris, Guy Pène du Bois wrote as well as painted polite social satire. A major cultural columnist, music and art critic, and magazine editor, du Bois deflated the pomposity of America's social climbers by shrewdly noting, "In a country whose art lovers whisper in picture galleries it is inevitable that the men who put art above life will be considered the greater artists. . . . It does not matter that affectation takes the place of sincerity or, the moment that a painter talks like a layman it will be suspected that he is not an artist." His early works, like *The Politicians*, have the rapidly brushed, thick textures he learned from studying under Robert Henri and William Merritt Chase. The caricatures of the self-satisfied, corpulent listener and skinny, toadying speaker are clear indications of du Bois' youthful career as a newspaper illustrator and cartoonist. Throughout his life, he preferred a neutral tonality of browns and grays reminiscent of newspaper photographs.

About 1918, however, du Bois accepted the machined, streamlined style that, in architecture, the decorative arts, and commercial design, is usually termed Art Deco or Art Moderne.

Max Weber *1880–1961*
Detail of Rush Hour, New York *1915*
Gift of the Avalon Foundation

His mature pictures abandon the active paint texture in favor of sleek surface and a volumetric modeling. *Hallway, Italian Restaurant* depicts geometric Art Deco patterns on the wall behind a conversing couple, who are rendered smoothly in elegant, simplified forms. As a bon vivant, du Bois never stooped to coarse parody or revolutionary outrage. The two works here convey the quiet recording of upper-class habits characteristic of his painting and writing. As he wrote of himself, "His pictures are inclined to be mincing. His language is. He has inherited carefulness and economy."

MAX WEBER

1880–1961

Max Weber's meditative, even reclusive character seems at odds with the radical nature of his art. Born in Russia of Jewish parents who emigrated to Brooklyn when he was ten, Weber became a teacher of drawing and manual crafts. From 1905 through 1908, he studied in Paris, having convinced the great French colorist Henri Matisse to give him lessons. It is not Matisse's bright hues that imbue Weber's *Rush Hour, New York* (see page 224), however; it is Pablo Picasso's Cubist fragmentation of space. Recognizable objects such as skyscrapers, as seen in the chapter's frontispiece detail, have been analyzed for their structural geometry, reorganized to accentuate their salient features, and assembled into a design communicating the frenetic movement in a metropolis. Repetitive angular patterns speed by the viewer like the blur of wheels on buses, cars, and elevated trains. Banks of windows and soaring spires converge on our sight as though we were a pedestrian reeling around trying to find some glimpse of a sky blotted out by the buildings. Transparent planes of color change the tone of these mechanical shapes, just as a vehicle whirring by temporarily leaves a tint in our vision.

The Cubists in France, notably Picasso, pursued their analysis of form in 1909–1910; shortly thereafter, the Futurists in Italy began to employ fragmented, overlapping shapes to express rapid motion. Similar to the Cubists and Futurists, Weber noted, "I discovered the geometry in the work of God." The mystery is how Weber did it, because he left Europe before these developments occurred! Weber must have extracted what he could from examining the very few Cubist or Futurist compositions that reached America and from reading the theoretical books of these Europeans. In 1915, when he finished *Rush Hour*, a critic noted that "Weber was ridiculed, laughed at, starved, excommunicated, censured, refused and annoyed as no man in art has ever been before. But he stood by the new spirit he had brought till it caught fire like a song in a revolution." By the late teens, Weber suddenly abandoned his Cubistic abstractions and took up the still lifes, nudes, landscapes, and scenes of Jewish community life that constitute the majority of his work. Long after returning to Naturalism, Weber wrote on "Distortion in Modern Art." In that 1930 essay, he stated,

"Art has a higher purpose than mere imitation of nature. It transcends the earthly and measurable." *Rush Hour, New York*, by deliberately avoiding imitation of nature, expresses the chaotic confusion of a city's countless inhabitants and machines.

LYONEL FEININGER

1871–1956

Lyonel Feininger spent most of his adult life in Germany. New York-born, he was a child prodigy at music, being a concert violinist at twelve. In 1887, when sixteen years old, he moved to Hamburg to study music but soon turned to the visual arts. He didn't come back to America until 1937, when the Nazis had branded his paintings and prints as "degenerate art." Lyonel Feininger's introduction to Cubism, which was one of many styles that the Nazis refused to countenance, had occurred in 1911 on a trip to Paris. Feininger's particular adaptation of Cubism consisted of breaking his subject down with "lines of force" (a term borrowed from Futurism) into transparent planes of space.

Zirchow VII (see page 218), representing a small hamlet in northern Germany, was painted in 1918 in a suburb of Berlin. The

Guy Pène du Bois *1884–1958*
The Politicians *c. 1912*
Canvas board, 16⅛" x 12⅛"
Gift of Chester Dale

Guy Pène du Bois *1884–1958*
Hallway, Italian Restaurant *1922*
Canvas, 25⅛" x 20⅛"
Gift of Chester Dale

distant airiness to the horizon. Lyonel Feininger's pristine, quiet landscapes express their lyric restfulness precisely because of the artist's supreme simplification of nature.

MARSDEN HARTLEY

1877–1943

Marsden Hartley began as an American Impressionist, studying at the Cleveland Institute of Art, the National Academy of Design in New York, and under William Merritt Chase at The Chase School. Hartley's serene style changed abruptly, though, on his first exposure to modern painting while on a trip to Paris and Berlin in 1912–1913. *The Aero* (see page 217) of 1914 is as radically abstract as anything being done by European avant-garde artists at that time. To stress that this is a painting—a man-made object in and of itself—and not a picture of something else, Hartley continued the design right across the frame. Instead of looking through the frame the way one looks through a window at a view, the audience is confronted with the physical fact of the colors and forms arranged on the canvas and overlapping its edges. The shifting, dislocated shapes owe something to special offshoots of French Cubism, but the strident colors and clashing patterns derive from German Expressionism. The visual effect is as strident as the sound of a German military brass band.

When exhibiting his Berlin works soon after they were finished, Hartley wrote, "The forms are only those which I have observed casually from day to day. There is no hidden symbolism whatsoever in them. . . . They are merely consultations of the eye . . . my notion of the purely pictorial." He was lying. An inward, private man, Marsden Hartley felt vulnerable all his life, never revealing the personal meanings or artistic sources of his work lest others discover too much about him. And, he was betrayed. A young German officer with whom he had fallen in love was to later explain the significance of the numerals, letters, flags, insignia, and medals in similar compositions. The longer one looks at *The Aero*, the more it begins to make sense, too. Propellers, wind socks, checquered pennants, levers and dials, warning flags, and a host of items associated with airfields emerge from the design. Hartley was possibly memorializing the crash of the *Zeppelin L 2* in 1913, which tragically killed twenty-seven passengers, including several noted scientists. Kaiser Wilhelm, himself an amateur artist, produced a popular commemorative picture of the disaster: "a naval airship lighthouse off on a rocky coast and a shining cross in the sky." Is that blazing red circle in the middle of Hartley's abstraction meant to signify a dirigible in flames? And does the red cross at the lower right refer to a grave?

peaceful picture gives little evidence of the horrors of World War I or the fact that, as an "enemy alien," Feininger underwent constant police surveillance. The artist's son explained, "Travel was forbidden. Hunger was severely felt by everyone. . . . The vision of unity and reconciliation which is in this and other paintings of Lyonel Feininger is to be seen against this background, like the rainbow against the thunder cloud. The theme, the church of Zirchow, a Thuringian village, was sketched by my father in the happy times he had spent in Weimar in the years 1905, 1913, and 1914." As an evocation of those happier days, *Zirchow VII* employs brilliantly clear color and exquisite crystalline form. Rising behind an abstracted green wood, the Gothic church steeple shimmers in the air. The Roman numeral seven simply refers to Feininger's delight in the challenge of creating varied designs on the same subject, just as a musician invents and plays variations on a theme. Feininger's son added, "In this particular painting, a depth of structural unity, of interpenetration of light and substance, presented in deeply glowing color, is achieved. . . . He therefore rightly considered this to be one of his very major works."

Done the year after Feininger's return to the United States, *Storm Brewing* retains reminiscences of the Germanic North Sea. His late paintings are much sparser and more stylized than his earlier works. Even so, the viewer can easily discern isolated figures on the beach, shapes inspired by ships' sails and smokestacks, and dark, menacing clouds lowering onto the sea from above. The pale wedge extending through the middle of the composition lends a

Max Weber *1880–1961*
Rush Hour, New York *1915*
Canvas, 36¼" x 30¼"
Gift of the Avalon Foundation

Although modern critics hailed Hartley as an international celebrity, he dropped his symbolic, abstract manner in 1917, just as suddenly as he'd adopted it six years earlier. He spent the summers of 1918 and 1919 in New Mexico, painting representational landscapes. But, being vain about his fame, he spurned the local artists' colony and said that Taos ought to spelled "chaos." Back in Berlin in 1923, he commenced his "New Mexico Recollections." *Landscape No. 5* is part of this series depicting the desert canyons from memory. The heavy black outlines generate a brute force, and the whole organization of undulating horizontal stripes expressed what Hartley called the "nature wave rhythms" of the bleak Southwest.

The older Hartley became, the more his painting mellowed. *Mount Katahdin, Maine* utilizes the simplest color scheme of purples in the lake, rocks, and clouds to convey the mountain's brooding majesty. Against these cold tones, the fall forest on the shore shrieks in garish crimson. Subtitled *Autumn Rain* in Hartley's estate inventory, *Mount Katahdin* expresses the grandeur of the New England wilderness and the hesitant quality in the air before a fall storm. This mountain had been a favorite motif of the Hudson River landscapists a century earlier, and Maine was the state of Hartley's birth and childhood. But, right up to the end, Hartley insisted, "I have no interest in the subject matter of a picture not the slightest. A picture has but one meaning—it is well done, or it isn't."

WALT KUHN

1877–1949

A big, boisterous, raw-boned man, Walt Kuhn lived life to the hilt. Instead of being cooped up as a fine artist, he employed his talents practically, spending at least half of each year in advising railroads on the decoration of Streamliner club cars, designing uniforms for stewardesses (even deciding the colors of their nylons), and creating the sets and costumes for Broadway musical comedies. He actually devised and directed the dance numbers for several shows like *Hitchy-Koo Revue.* "You see, I've got to be a showman. It's no disgrace to be a showman," he bellowed.

Kuhn attributed his volatile character to being the Brooklyn-born son of a Bavarian father and a Spanish mother. From 1901 to 1904, he enrolled at severely disciplined art academies in Paris and Munich. His lackadaisical habits infuriated a German instructor. When Kuhn explained that he'd painted only one canvas in an entire summer because there was plenty of time left for him to learn, the professor shouted, "Time? With your puny talent do you know what time it is? It's a quarter to twelve!" Kuhn later delighted in telling the story to his own students, and, after he nearly died of a stomach ulcer at the age of forty-eight, he devoted more and more energy to refining his craft, while muttering, "It's a quarter to twelve."

The first acknowledgment of Kuhn's amazing organizational ability came when his fellow artists elected him executive secretary

A Twentieth-Century Color Portfolio

Marsden Hartley *1877–1943*
The Aero *1914*
Canvas, without frame, 39½ " x 32"; with frame,
42" x 34½ "
Andrew W. Mellon Fund

Lyonel Feininger *1871–1956*
Zirchow VII *1918*
Canvas, 31¾" x 39⅝"
Gift of Julia Feininger

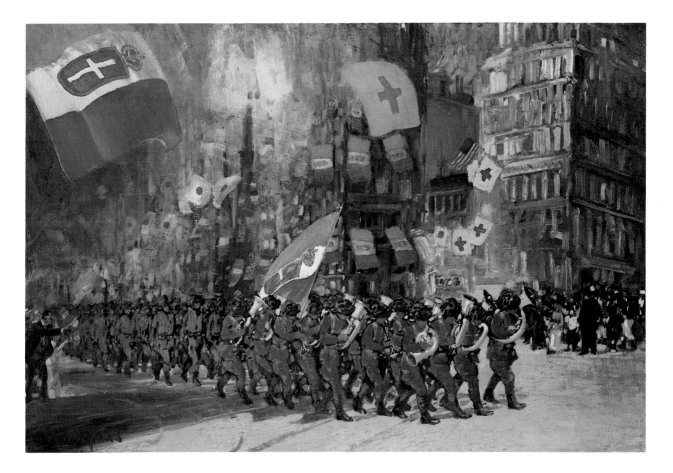

George Benjamin Luks *1866–1933*
The Bersaglieri *1918*
Canvas, 40⅛" x 59⅝"
Gift of the Avalon Foundation

Walt Kuhn *1877–1949*
Pumpkins *1941*
Canvas, 40" x 50¼"
Gift of the Avalon Foundation

219

George Bellows *1882–1925*
Both Members of This Club *1909*
Canvas, 45¼″ x 63⅛″
Gift of Chester Dale

Ivan Albright *1897–*
There Were No Flowers Tonight *1929*
Canvas, 48½″ x 30⅜″
Gift of Robert H. and Clarice Smith

220

George Benjamin Luks *1866–1933*
The Miner *1925*
Canvas, 60¼" x 50⅜"
Gift of Chester Dale

Jackson Pollock *1912–1956*
Number 1, 1950 (Lavender Mist) *1950*
Oil, enamel, and aluminum on canvas, 87" x 118"
Ailsa Mellon Bruce Fund

Arshile Gorky *1904–1948*
One Year the Milkweed *1944*
Canvas, 37 x 47"
Ailsa Mellon Bruce Fund

Andrew N. Wyeth *1917–*
Snow Flurries 1953
Tempera on panel, 37¼ " x 48"
Gift of Dr. Margaret I. Handy

Max Weber *1880–1961*
Rush Hour, New York *1915*
Canvas, 36¼ " x 30¼ "
Gift of the Avalon Foundation

John Sloan *1871–1951*
The City from Greenwich Village *1922*
Canvas, 26" x 33¾ "
Gift of Helen Farr Sloan

for the Armory Show; his trip abroad to select pictures in 1912 was largely responsible for the tremendous quantity of modern European art included in that epoch-making exhibition. Kuhn, who called himself a "Yankee-doodle boy," selected the pine-tree flag of the American Revolution as the Armory Show's emblem and bragged about the exhibition's success to his museum friends— "the artists did it all themselves."

Kuhn painted as wildly as he lived. Broad strokes of the brush create forms that appear chiseled from granite. These vigorous textures convey an illusion of three-dimensionality while simultaneously asserting the flatness of the two-dimensional canvas. Kuhn's handling of paint is obviously indebted to Paul Cézanne, the late-nineteenth-century French Post-Impressionist. Typical thick planes of pigment appear in *Hare and Hunting Boots*. The rough paint forcefully asserts the presence of these simple objects. In commenting on "this quiet, masculine still life," Kuhn wrote, "No theatrics—just a limp rabbit and muddy boots thrown in the corner. But the painting of the soft fur is whipped into convincing simulation of the actual subject. The picture has that strange loneliness of men without women."

In 1929, Kuhn hailed *The White Clown* as one of his greatest works; his severest critics had to agree with him. The massive forms seem ready to burst from the canvas. Kuhn's impassioned explanation was as follows: "Peak performance in bulk, weight, and substance. Like an animal crouched for the kill, he might instantly charge into his routine. Action strains at the bit. With the simplest colors—virtually black and white—the figure is modeled into a throbbing arabesque, fitted exactly to the canvas. Monumentality in a 30″ x 40″ area."

When he produced a "lemon," "punk," or "poop," Kuhn would scrape the canvas down, leaving traces of the failed image to work up again. He enjoyed the give-and-take of fighting an existent problem. And, although he often sketched for months before beginning an oil, he always painted directly from the actual model. *Wisconsin* gives evidence of having been painted over an earlier, unsuccessful picture. The final result superbly captures that no-nonsense determination and skepticism which turned the Midwest into the world's bread basket.

Pumpkins (see page 219) is far more colorful than was usual with Kuhn. A few cool greens heighten, by contrast, their complementary hot reds and oranges. "All art is metaphor," Kuhn explained in his distinctive way. "You don't get anywhere telling a girl she has a neck like a neck. You tell her she has a neck like a swan. You still may not get anywhere, but you've tried." This splendid autumn harvest is a metaphor of the fruitfulness of the earth.

Lyonel Feininger *1871–1956*
Storm Brewing *1939*
Canvas, 19⅛″ x 30⅝″
Gift of Julia Feininger

Marsden Hartley *1877–1943*
Landscape No. 5 *1922/1923*
Canvas, 23″ x 35½″
Alfred Stieglitz Collection

Marsden Hartley *1877–1943*
Mount Katahdin, Maine *1942*
Masonite, 30″ x 40⅛″
Gift of Mrs. Mellon Byers

Kuhn's eccentricity eventually got the better of him. Toward the end of his life, he argued with anyone who failed to see things his way. After threatening a critic with a gun, Kuhn had a nervous breakdown. He spent his last six months in a mental asylum.

JOHN STEUART CURRY

1897–1946

John Steuart Curry of Kansas cannot be mentioned alone. Along with Thomas Hart Benton of Missouri and Grant Wood of Iowa, Curry led American Regionalism or American Scene Painting of the 1930s. "Thousands of us are now painting what is called 'the American scene.' We are glorifying landscapes, elevated stations, subways, butcher shops, 14th Street, Mid-Western farmers, and we are one and all painting out of the fullness of our life and experiences." There may have been thousands of mindless followers, but the three leaders were serious artists who knew why they produced nostalgic views of rural farms and exuberant pictures of bustling factories. "The use of life as an excuse for clever arrangements of color or other pictorial elements ends where it begins," Curry stated. "The feeling inherent in the life of the world cannot be ignored or trifled with for the sake of a theory." Curry, Benton, and Wood had all received first-rate academic training, traveled in Europe, experimented with abstract styles, but returned to naturalistic portrayals of familiar experiences. Educated at the Art Institute of Chicago, Curry had noted the strong patterning and viva-

cious brush strokes of modern French art on a trip to Paris in 1926.

In the spring of 1932, Curry accompanied the Ringling Brothers, Barnum and Bailey Circus on its tour through New England. *Circus Elephants* is American Regionalist in its documenting of the excitement of a traveling tent show, but its sophisticated composition betrays Curry's knowledge of modern simplification. Hay, beasts, and awning make three vivid bands stretching across the picture. The curving arc of elephants rises toward the viewer with an energy reiterated by the angled tent poles. The nearest animal, however, halts the movement by turning against its direction, and the striped head of a zebra in the lower left corner also acts as a stabilizing anchor.

Curry explained how he achieved such a clarity of design in an interview on a children's radio program. "Elephants look easy to draw but they really are not. It is hard to get the feeling of balance and movement as well as their bulk. If you will notice, elephants are always moving and swaying back and forth on their feet. . . . How should you go about drawing an elephant? Begin with the large circular shapes first. . . . Draw them loosely so you can get the action of the animal at once. You then can make a more careful outline of the body over these forms." Making allowances for the tender years of his listeners, it is apparent that Curry started with the overall distribution of abstract form and was only secondarily interested in the realistic subject.

IVAN ALBRIGHT

1897–

The infinitesimal detailing that Ivan Albright employs to flay and disembowel his living subject matter has made him the object of an absolute cult of followers who breathlessly await each new work. His audience had best not hold its breath though, for Albright normally works at an excruciatingly slow pace in order to embalm every molecule before him. *There Were No Flowers Tonight* (see page 220), executed in 1928–1929, is one of his earliest works to go beyond the mere sadness of the human condition to probe deeply into the very meaning of existence itself. The artist's subtitle of *Midnight* makes even clearer what is all too apparent in the painting. The ballerina, exhausted after the night's performance, no longer has the energy or beauty for her task. Her admirers have abandoned her for younger stars, and she remembers better years by gazing at a dusty old bouquet on the floor while she wearily unties her slipper. The satin ribbon in her arthritic hand does not stir; there is no air, no movement, no passing of time. This aging woman does not evoke pity so much as embody pathos.

Her lumpy flesh, greasy hair, and stained, disheveled costume are the visible attributes of her condition, but Albright's artistry is what creates her compelling, almost macabre fascination. The geometric positioning of her torso and limbs cancels out any potential motion and stabilizes the pose. The cadaverous purple and pinks deepen into grayed crimson and then black. The harsh light

Walt Kuhn *1877–1949*
Hare and Hunting Boots *1926*
Canvas, 29" x 27"
Gift of the W. Averell Harriman Foundation
in memory of Marie N. Harriman

227

source from below and one side rakes sharply across the skin, forming subtle shadows which heighten the bumps and hollows of her aged skin. Finally, the microscopic delineation of every pore and each thread of lace generates the feeling that she is frozen in space for the viewer's continual examination.

Albright's preoccupation with human flesh may be explained by his early study of the medical texts belonging to his physician grandfather. Albright studied art under his father, a painter who had been in charge of the cadavers for Thomas Eakins' anatomy lectures. During service in World War I, Albright did medical drawings at a base hospital in France and, upon his return home to Chicago, continued to do illustrations of brain surgery for a doctor. His precise draftsmanship continued with his architectural studies at the University of Illinois College of Engineering, but he finally decided upon painting as a career and entered the School of the Art Institute of Chicago when twenty-three. Although Albright is world famous for his morose depictions of decay and degradation, his actual character is that of a kindly philosopher with a dry wit.

Albright's style, in many ways, combines the attitudes of two late-nineteenth-century geniuses: the realism of Thomas Eakins and the mysticism of Albert Pinkham Ryder. "In this eternal smogland of ours, if the real truth appeared, it would blind us, it would incinerate us as the sun would blind and incinerate us on close approach. We are shadows of the real but not the real; we live by

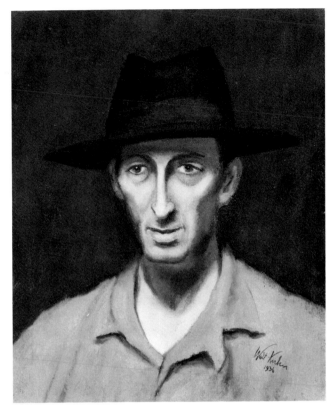

Walt Kuhn *1877–1949*
Wisconsin *1936*
Canvas, 20″ x 16″
Gift of Brenda Kuhn

half truths and half facts," the philosopher-artist wrote in 1964. "In a room if I move, all things move with me. If I stir, they stir. If I stand arrested, all things become motionless. But on canvas—a single plane—I cannot paint motion, so all things around me are deadly still, so still they hurt the eye. . . . Our world of sight is built around a world of very slow motion. If everything whirled around a room, you would see nothing, just as a fly-wheel becomes a mass of light, formless and light." Albright, being of independent financial means, could afford the time to meticulously focus on each particle of each picture; his total life output is, therefore, relatively small. Even when commissioned by MGM to create the climax for a major motion picture, Albright required seven months in 1943–1944 just to do a single, full-length, life-sized portrait. Of course, the movie was *The Picture of Dorian Gray,* and Albright's realization of that disgusting, coagulated soul precisely caught the horror in Oscar Wilde's novel.

Walt Kuhn *1877–1949*
The White Clown *1929*
Canvas, 40¼″ x 30¼″
*Gift of the W. Averell Harriman Foundation
in memory of Marie N. Harriman*

228

RICO LEBRUN

1900–1964

Executed in the midst of World War II, *The Ragged One* summarizes Rico Lebrun's feelings about man's inhumanity to man. Though not literary, in the sense that the pictures would illustrate any specific person or episode, the tragic subject becomes a universal statement about suffering and hopelessness. The huddled woman, barely covered except for the kerchief hiding her lowered face, fills the entire canvas. The gigantic size of her form gives her a monumental scale appropriate to her symbolic role. Treated as a range of dull earth browns, the color scheme retreats into darkness; even the highlights barely manage to rise to the level of mid-gray. Lebrun superimposed black outlines on top of these somber tones to define the tortured, jagged contours of the shapes.

A master draftsman, Rico Lebrun easily switched back and forth from Old Master Naturalism to Cubist Abstraction. The sharp lines of Pablo Picasso's classically inspired, figurative pictures of the 1920s are a major influence in *The Ragged One*. Lebrun was twenty-four before he arrived in the United States from his native Italy. A stained-glass window designer in Naples, he was sent by his company to work for its branch in Illinois. Although a successful painter of canvases and murals in New York and California, he often traveled to Italy to study fresco techniques. Peopling his works with "creatures of darkness," Rico Lebrun was a profoundly religious man and employed his Expressionist art to convey his dream for a betterment of the human race.

DAVID ALFARO SIQUEIROS

1896–1974

One of the twentieth century's foremost frescoists, David Alfaro Siqueiros covered literal acres of wall in the United States, Chile, Cuba, and his native Mexico. Along with Diego Rivera and José Orozco, Siqueiros formed a triumvirate of Mexican painters dedicated to political criticism. "In mural painting, the artist must paint as he would speak before the public. Clarity must be sought in

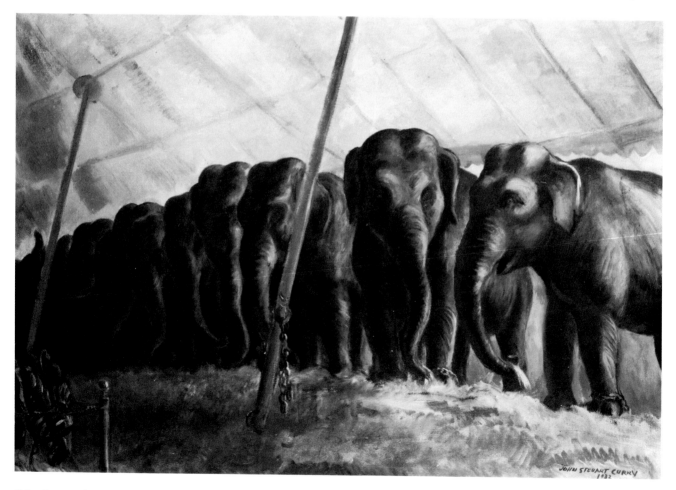

John Steuart Curry *1897–1946*
Circus Elephants 1932
Canvas, 25¼" x 36"
Gift of Admiral Neill Phillips in memory
of Grace Hendricks Phillips

229

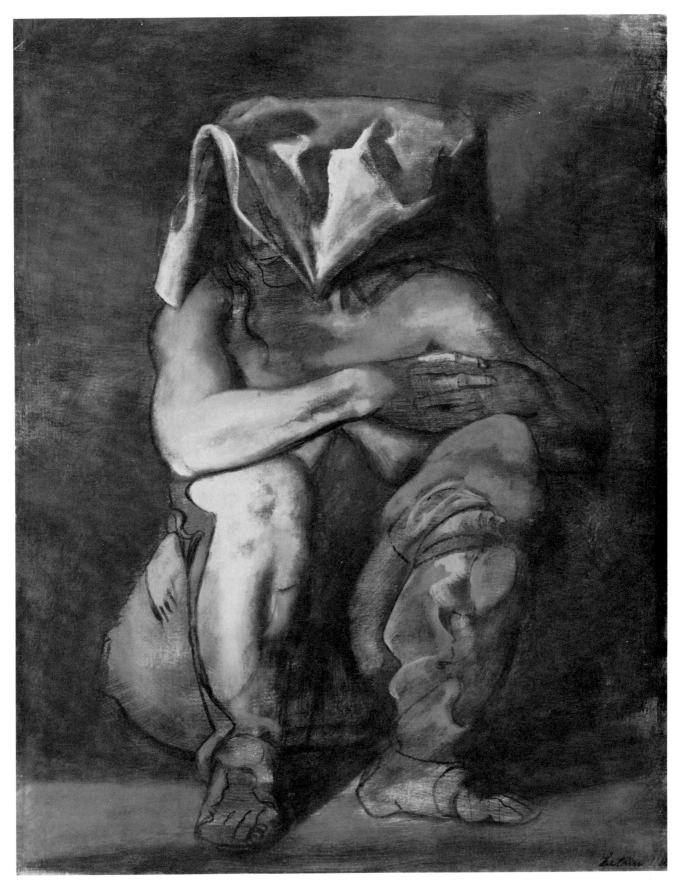

Rico Lebrun *1900–1964*
The Ragged One *1944*
Canvas, 46⅛″ x 36⅛″
Gift of Michael Straight

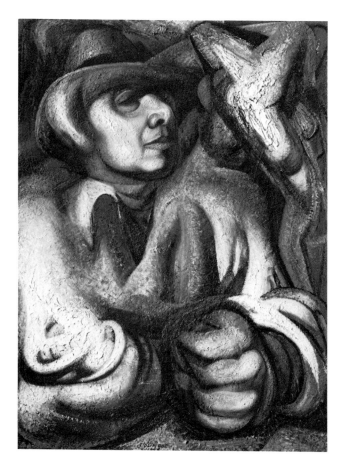

David Alfaro Siqueiros *1896–1974*
Self-Portrait 1948
Pyroxylin on masonite, 47½" x 35¾"
Andrew W. Mellon Fund

modern social art," he once wrote, continuing, "Present day European art is a blind alley, making a man and a bottle identical." A Stalinist Communist, Siqueiros spent much of his life in prison or in exile for his radical beliefs. In 1940, for example, he was implicated as a ringleader in an attempted assassination of Leon Trotsky.

Self-Portrait shows a heroic, self-confident figure assessing a strange object that could be a soldier's weapon, a peasant's tool, or a priest's crucifix. To create the most effective frescoes he could, Siqueiros was a noted innovator in technique and composition, and his experimentation shows in this panel picture. As early as 1933, he'd been among the first artists to employ pyroxylin, a synthetic plastic paint that can be built up to an incredible thickness impossible with oils. Originally used to create bold surfaces easily seen at great distances in public buildings, pyroxylin here establishes a vigorous, forceful strength of texture on a masonite panel. Siqueiros also devised "active compositions," such as optical distortions which allowed a mural in a narrow corridor to be appreciated at a steep angle as the viewer walked toward it. In his *Self-Portrait*, Siqueiros employed a similar foreshortening of his clenched fist, crashing forward out of the picture.

14

ABSTRACTIONISTS ON THE ASCENDANT

The two generations since World War I have suffered global change at an ever-increasing rate. Witness this statement by Jackson Pollock, the innovator of the once-scandalous dripped pictures, "It seems to me that the modern painter cannot express this age—the airplane, the atom bomb, the radio—in the old form of the Renaissance or of any other past culture. Each age finds its own technique." Pollock's comment, while true as a rationale for his style, has become hopelessly outmoded since he said it in 1950. Only three decades later, you'd have to change his examples to read "the space shuttle, the ICBM neutron bomb, the world-wide satellite-relay color television." In short, those who expect contemporary art to reflect a serene, controlled society either will not or cannot accept the realities of the present.

In mirroring the scientific, political, and cultural facts of twentieth-century existence, many artists have abandoned representational images as being insignificant. Such painters are properly termed "Nonobjectivists," since no objects in the physical world inspired their work. Nonobjective art relies on pure color, shape, and texture to communicate the painter's ideals. However, the word "Abstractionist" is in common use, even among the painters, although it is technically meaningless because all art is abstracted or distilled from a natural source or mental idea. These total Abstractionists generally fall between two extremes: those who express a cosmic order through geometric, balanced formality, and those who express human individuality through free, spontaneous improvisation.

America's earliest forum for viewing Nonobjective art was a New York sales gallery opened by the photographer Alfred Stieglitz in 1906. The Little Gallery of the Photo-Secession, housed in the attic of a brownstone at 291 Fifth Avenue, came to be known affectionately as "291." Although the gallery changed names and addresses until Stieglitz's death in 1946, it remained a vital link among avant-garde artists, patrons, and critics. The United States' first one-man shows for major European artists such as Auguste Rodin or Henri Matisse were held there in 1908. And, among the many American painters who made their debuts at 291 were Max Weber, Marsden Hartley, and Arthur Dove. The first American museum devoted exclusively to the acquisition and display of recent art was a private family enterprise; The Phillips Collection in Washington, D.C., opened in 1918. Founded in 1929, the Museum of Modern Art in New York was the United States' initial public institution that focused on living painters. A significant indication of the growing acceptance of modern painting was the Federal Art Projects, a group of government programs employing artists during the Depression. From 1933 to 1943, painters not only decorated post offices with patriotic murals and documented American antiques in precise renderings, but also were allowed to develop novel industrial designs and to experiment in avant-garde techniques. Without these far-sighted Federal Art Projects, the United States might have emerged from the Depression into World War II with absolutely no trained talent, not even in vital commercial and engineering crafts.

Prior to the outset of World War II in 1939, and continuing until the conflict's end in 1945, major European artists of all nationalities fled to the United States as refugees. The Dutch genius Piet Mondrian, famous for his rectilinear grids in primary colors, was foremost among the Nonobjectivists. Max Ernst and Marc Chagall were prominent amidst the numerous Surrealists, or artists who explored the suggestive possibilities of dream imagery and the subconscious mind. The presence of these exiles gave American painters an unprecedented opportunity to acquaint themselves with the current standards in European taste.

The annihilation of Hiroshima and Nagasaki in 1945 proved that humanity had acquired the ability to destroy every form of life on the planet Earth. Art could never be the same. The war's disruption of European society, coupled with America's dynamism, suddenly shifted the world's cultural center to New York City. And the hectic vitality of that metropolis soon gave rise to a volatile new art movement of international consequence: Action Painting or Abstract Expressionism. Artists like Franz Kline, Mark Rothko,

Jackson Pollock *1912–1956*
Detail of Number 1, 1950 (Lavender Mist) *1950*
Ailsa Mellon Bruce Fund

and Jackson Pollock employed a diversity of techniques to release and record their basic instincts. Their methods ranged from meditation to frenzy; the moods encompassed quietude and chaos. The one element common to all was a preference for canvases so huge that the artist became engulfed by the sheer physical presence of his work. As Rothko explained, "I paint very large pictures. I realize that historically the function of painting large pictures is painting something very grandiose and pompous. The reason I paint them, however—I think it applies to other painters I know—is precisely because I want to be very intimate and human. To paint a small picture is to place yourself outside your experience, to look upon an experience as a stereopticon view or with a reducing glass. However you paint the larger picture, you are in it. It isn't something you command."

American painting has gone far beyond Abstract Expressionism, which was replaced by newer idioms a quarter-century ago. The year 1960, however, has been established as the cut-off date for this book. When the National Gallery of Art first opened, it had an unwritten rule not to acquire works by artists who hadn't been dead

Arthur G. Dove *1880–1946*
Moth Dance 1929
Canvas, 20" x 26⅛"
Alfred Stieglitz Collection

234

I. Rice Pereira *1905–1971*
Transfluent Lines *1946*
Mixed media on corrugated glass and cardboard, 24" x 18"
Gift of Mr. and Mrs. Burton G. Tremaine

236

I. Rice Pereira *1905–1971*
Zenith *1953*
Canvas, 49¾″ x 30⅛″
Gift of Leslie Bokor and Leslie Dame

for at least twenty years. Although that policy was ignored for special circumstances and has been abandoned recently, a variation on it terminates this text with paintings that aren't at least two decades old.

ARTHUR G. DOVE

1880–1946

Arthur Garfield Dove was named after Chester A. Arthur and James A. Garfield, the two Republican candidates running for the presidential nomination the year of his birth, 1880. It is apparent that his conservative parents had no intention that their son should grow up to become the first totally Abstract painter in America and, just possibly, the first true Abstractionist in world history. At age nine, Dove received painting lessons from a farmer in the Finger Lakes region of New York. That eccentric neighbor was an amateur philosopher, naturalist, and artist. As Dove's counselor, the man's interest in wildlife was vital to the child's development. Dove studied law at Cornell, at his father's insistence, but he preferred art classes. By 1904, Dove had married his childhood sweetheart, moved to New York, and taken up popular illustration as a career. Even though he worked among the Ash Can painters, their narrative pictures didn't appeal to him. And he later came to despise the very idea of illustration. Dove and his wife spent eighteen months in France in 1907–1909, but they didn't live in the artistic center of Paris. A country boy at heart, he spent his time in a small artists' colony near the Mediterranean coast.

In 1910, Dove met the New York photographer and art dealer Alfred Stieglitz. One of Dove's paintings hung in an exhibition at Stieglitz's 291 gallery that year, and in 1912 Dove had his first one-man show there. This was a critical period for Dove's experimentation: in 1910 he produced a series of small canvases that consisted of nothing except lines, shapes, colors, and textures. They had absolutely no recognizable visual source. "I don't like titles for these pictures, because they should tell their own story," he stated. In explaining these nonrepresentational works to a patron, he wrote of their relationship to the simplicity in nature. "A few forms and a few colors sufficed for the creation of an object. Consequently I gave up my more disorderly methods (Impressionism). In other words I gave up trying to express an idea by stating innumerable little facts, the statement of facts having no more to do with the art of painting than statistics with literature." What Arthur Dove could not know was that Wassily Kandinsky, a Russian working in Germany, painted his first Nonobjective compositions in the same year. Art historians love to argue about who arrived at pure Abstraction how many weeks ahead of the other in 1910. Whether it was the American or the Russian will not alter the fact that, within a few years, hoards of painters all over the Western world were generating abstract canvases without direct influence from either of them. The cultural milieu allowed artists working independently to come up with the same idea simultaneously.

Dove had purchased a small farm in 1910, hoping to feed his family by the sweat of his own brow. When farming failed, he bought a racing yawl in 1920 and lived on the water, moving freely about in his mobile, but cramped, studio-home. *Moth Dance* was painted in 1929 on Long Island, where Dove had docked in order to be caretaker for a yacht club ashore. Although its title suggests a subject that is immediately identifiable, the composition has the same large color areas and startling contrasts of light against dark which characterize his pure Abstractions. A reorganized natural form, the sandy-hued moth sways its arms or antennae while fluttering its iridescent blue-green wings. A blue-violet oval glows with spots of white light, possibly referring to the moth's cocoon or inspired by fireflies in the Long Island night. For an exhibition catalog of a show held at Stieglitz's new sales gallery the year *Moth Dance* was done, Dove wrote about the analogy of Abstraction and music: "If the extract be clear enough its value will exist. It is nearer to music, not the music of the ears, just the music of the eyes. It should necessitate no effort to understand. Just to look, and if looking gives vision, enjoyment should occur as the eyes look."

The moth's catlike, slit eyes and tense, spiraling body assume an eerie overtone. Heightened by the abrupt conflicts of tone, the slightly menacing air might suggest a subliminal meaning. Dove's art quite often has Freudian implications, and it's easy enough to understand the moth as a phallic symbol seen against an egg or cocoon like a vaginal oval. Whether *Moth Dance* does or doesn't entail a masculine versus feminine battle, Alfred Stieglitz did acquire the work for his own collection.

Dove explained the meaning of his lighter, wittier pieces, but his attitude toward serious art is best brought out by lines from one of his poems:

> *I'd rather have truth than beauty*
> *I'd rather have a soul than a shape . . .*
> *I'd rather have today than yesterday*
> *I'd rather have tomorrow than today. . .*
> *I'd rather have the impossible than the possible*
> *I'd rather have the abstract than the real.*

The last years of Arthur Dove's life were excruciatingly painful. He contracted Bright's disease of the kidneys in 1938, resulting in the paralysis of one side of his body. But, although a semiinvalid, Dove kept on painting to the end.

I. RICE PEREIRA

1905–1971

I. Rice Pereira (Irene Rice)'s initial interest was literature, not visual art. As a schoolgirl in Boston and Brooklyn, she avidly read fiction, philosophy, and biography, often by or about great women.

237

Her personality's combination of cool logic and passionate romanticism manifested itself early. When playing near the family home in the Berkshires, the seven-year-old watched the sunlight refracting through dewdrops to create tiny rainbows above flower petals. It suddenly occurred to her, almost as a religious revelation, that the sun was God and the lights in the rainbow were his children. "I threw myself on the ground and cried for hours." Although it would be many years before she could clarify this idea in words, when she did so, she said it eloquently: "Light exists in the depth of man's psyche. . . . The sun is the reconciling symbol of all life." Her paintings were to express vividly, through personal symbols and extraordinary techniques, her preoccupation with light.

Her father died when she was fifteen, and Irene Rice found herself having to support her two sisters, brother, and ailing mother. She transferred to her high school's business curriculum, completed three years of classes in just under seven months, and crammed a stenographic course into three weeks. Working as a secretary during the day, she took evening courses at the Art Students League for three years, beginning in 1927. At twenty-one, she wed Humberto Pereira, a commercial artist. This was the first of three marriages—the second to an engineer, the third to a poet—all of which ended in divorce after about a decade each. By 1931, she'd somehow saved enough money for her first trip abroad. Since her husband declined to go at the last moment, she sailed alone and became enamored of the ship's machine forms. Her study of traditional art in Paris, Switzerland, and Italy did not affect her as much as a side excursion to North Africa did. The vastness of the Sahara totally overwhelmed her. The desert's empty space, reducing human experience to puny insignificance, joined her childhood appreciation of light as a major element in her painting. "I learned that there were intense areas of feelings that could not be interpreted through objects . . . the impact of these mysterious forces left me stunned, shattered for many months."

Her fascination with ships and machines revealed itself at her first one-woman show in 1933. Her strongly outlined, though naturalistic pictures seemed so masculine by the standards of the time that one critic reviewed the exhibition as being by a Mr. Pereira. His mistake is understandable since, throughout her career, she signed her works "I. Rice Pereira," never spelling out her first name. She integrated motifs of humanity with fragments of machines to produce Expressionist patterns of hands and cogwheels. Eventually realizing that the scope of such semirepresentational works was too limited, she sought a deeper philosophy. "I was burying the machine system in classical Greece, its ancient home of pure logic." During the Depression, the Federal Art Projects employed her as a faculty member at several schools. Teaching industrial design and composition helped mature her attitude toward materials and techniques. From 1937 to 1939, she taught without pay at a governmental arts laboratory, where work was to be "purely experimental and unhampered." Her canvases became totally abstract, utilizing only geometric shapes, and, in 1939, she produced the first of those works which gained her the reputation for innovative use of materials: multimedia paintings on overlapping layers of glass.

Transfluent Lines of 1946, though consisting of only two sheets of glass in front of an opaque cardboard panel, generates an effect of infinite depth and radiant light. The rich, shimmering luminosity appears to recede into space far behind the white plane of the unusual frame, made assertive by its fabric netting texture. Physically, however, the painting lies on top of the frame, projecting out toward the spectator. The glass panes, being corrugated, act as magnifying lenses along their vertical ribs, increasing the flux and discontinuity of the patterns covering their inner and outer surfaces. The designs themselves, though geometric, are never flat rectangles. Parallelograms, trapezoids, and rhomboids present an irresistible illusion of receding or advancing into space. In addition to these angled shapes, thin black or white lines are anchored to horizontal forms floating at varied depths. As these networks converge or diverge, they too heighten the effect of movement backward and forward in space.

Not all these elements are painted. Some are sandblasted into the clear glass, making translucent areas that allow color and form from lower depths to be seen as though through clouds. The only colors employed are red, yellow, and blue, the three basic hues in the spectrum. But, since they are sometimes opaque, sometimes translucent, these three simple colors interact through the glass to make mixtures of greens, purples, and oranges. Real light, penetrating into the glass shadow box, picks up color on its way in and, then reflecting off the plastered backing, absorbs more color on its way out. And the whole configuration fluctuates as the spectator moves in front of the piece, changing his viewing position down into its layers. At a symposium in 1940, Irene Rice Pereira explained that her "pure scientific or geometric system of esthetics" was a search for visual "equivalents for the revolutionary discoveries in mathematics, physics, biochemistry, and radioactivity." And indeed *Transfluent Lines* evokes just such a feeling; it places rational form in an ordered sequence like a diagram of interacting cosmic forces.

Pereira continued experimenting with glass, plastic, aluminum, synthetic chemicals, and gold foil, and she once put an actual light bulb inside one of her layered, mixed-media constructions. The harshness of the electric light displeased her because it lacked the iridescent variation in natural light. Her development of new methods for generating the effect of light emanating from within her compositions bore results.

By the late 1940s, Pereira returned to painting on flat surfaces. Done as a traditional oil on canvas in 1953, *Zenith* is anything but traditional in appearance. It glows from within, not because of any actual depths of transparent glass, but because of the artist's total control of her techniques. Beginning with a snow-white background, she added increasing planes of translucent or opaque colors, in elaborate varieties of texture. The paint has been scratched with toothed instruments, troweled with palette knives, dabbed with cloths, and flicked off stiff brushes to land on the canvas as gently stippled droplets. Dense black lines of diverse widths form rectilinear spirals winding back and forth between the solid or vaporous color bands. No longer does she rely on the optical illusion of perspective shapes to render depth. The lines and

bands, all perfectly horizontal or vertical, are so well adjusted in thickness and translucency as to convey the radiance of light pouring around them and to make it emerge into the viewer's space. Of her recurring straight lines, she said, "Geometric symbols are essences of mathematical structure. Geometric symbols are unknown qualities and quantities of the phenomena of nature." I. Rice Pereira also wrote extensively about her abstract inquiry into the infinite. "My philosophy is the reality of light and space; an ever flowing—never-ceasing—continuity, unfettered by man made machinery, weight and external likenesses."

MARK TOBEY

1890–1976

In 1958, Mark Tobey won first prize for painting at the XXIX Biennale in Venice, possibly the most important continuing series of international art exhibitions in our time. It had been sixty-three years since an American had won that prestigious award—Whistler in 1895—yet Tobey's honor was virtually ignored by the American art establishment. Major professional journals, for instance, failed to mention Tobey's participation in the biennial show, much less his winning achievement. A British critic has hailed him as "the foremost living American artist," and even the jealous French have admitted that "Tobey is perhaps the most important painter of our epoch." Why, if he is so highly regarded abroad, is he so little known at home?

For one thing, Tobey was born in Wisconsin and grew up in the Midwest, attending Saturday classes as a teenager at Chicago's Art Institute. But he is most often associated with Seattle, where he spent much of his adult life. Tobey did work for long periods in New York, but his art lacks the vigor and gusto of big-city living. His small, not to say petite, paintings seem at odds with the colossal scale customary for the contemporary New York Abstract Expressionists. Rather than their outbursts of creative energy, Tobey exercised cerebral control like an Oriental calligrapher. His intimate, quiet paintings and drawings require concerted reverie on the part of the viewer, which is precisely why they appeal to Europeans, who often dislike the huge, bright murals by his New York contemporaries. In all, though, there is something to be said for being in the right place at the right time. Tobey, as a world traveler whose most consistent residence was on the West Coast, was out of the sight of the established art circles in the United States. The principal dealers, critics, and collectors are based in New York City, and, with the reverse provincialism of the sophisticated, they tended to ignore the meditative man from Seattle. American artists, however, admire his work, and Tobey's webs of intricate lines are known to have inspired Jackson Pollock, while his gentle moods are echoed by Mark Rothko.

Tobey's restlessness is evident from his extended residences in England, France, and Switzerland, and in his constant travels; it is difficult to think of a country he didn't visit. From 1911 to 1917, he moved back and forth between Chicago and New York, working as a fashion artist, interior decorator, and portraitist. At the end of this period, he converted to the Baha'i World Faith, an optimistic sect seeking universal brotherhood. Tobey devoted himself to the reconciliation of Oriental and Occidental cultures in his art. While teaching in Seattle in 1922–1924, he met a Chinese student who first introduced him to the elegant brush writing of the Orient. Among his innumerable trips, the most significant was in 1934: a one-month stay at a Zen Buddhist monastery in Kyoto, Japan. "Baha'i sought me, but I sought Zen." He practiced meditation, wrote poetry, and studied Japanese calligraphy under the finest traditional masters. Within a year or so, Tobey commenced his famous "white writing"—a pale linear network on a dark background, combining the discipline of Oriental brushwork with the freedom of Occidental improvisation.

New York of 1944 is Tobey's most famous example of "white writing," having been in over thirty exhibitions at home and abroad, not counting an American art show organized by the United States Information Agency to tour Europe and Asia. Considered by many to be his masterpiece, it calms the hectic pace and impersonal anonymity of Manhattan into a comprehensible entity. Tobey said New York presents "a type of modern beauty I find only in the delicate structures of airplane beacons and electrical transformers and all that wonderful slender architecture connected with a current so potent and mysterious." His singling out the ethereal forms of wires, beams, and skyscrapers is significant because he really didn't care for the general urban environment. Of his earlier, semirealistic cityscapes, he has said, "No doubt I did them because I am an American painter. I cannot be indifferent to the swarming crowds, multitudes, neon signs, movie theaters, to the noises I hate of modern cities."

To Tobey, the pulsating lines represented light coursing through space and time, unifying the cosmos. The intervals between the linear elements are exactly calculated to open, revealing further webs below the surface and yet further skeins below that, ad infinitum. "I want vibration in it so that's why it takes so long to build this up; because I want to have air pockets." Explaining his solid or plastic qualities, Tobey remarked, "I cover my surface completely and I put my plastic elements into motion up to the four corners. Everything stirs, everything moves, everything becomes animated." The infinite sense of depth generated by these interweaving, overlapping lines makes the viewer aware of the very air through which they dart, like sparks burning an afterimage in the night sky. "Scientists say that . . . there is no such thing as empty space. It's loaded with life." Even the deliberate omission of a central focus has a philosophic basis; it requires the spectator to become an active participant in the work of art. "I take no fixed position," Tobey explained. "My paintings belong to the type that do not allow the viewer to rest on anything. He is bounced off it or he has to keep moving with it."

The cliché that great art "sings" would have to be rephrased to apply to Tobey's designs; they "hum." Tobey played the piano to relax, finding that its vibrations clarified his understanding of higher states of consciousness. Citing an old Chinese proverb, Tobey stated, "It is better to feel a painting than to look at it."

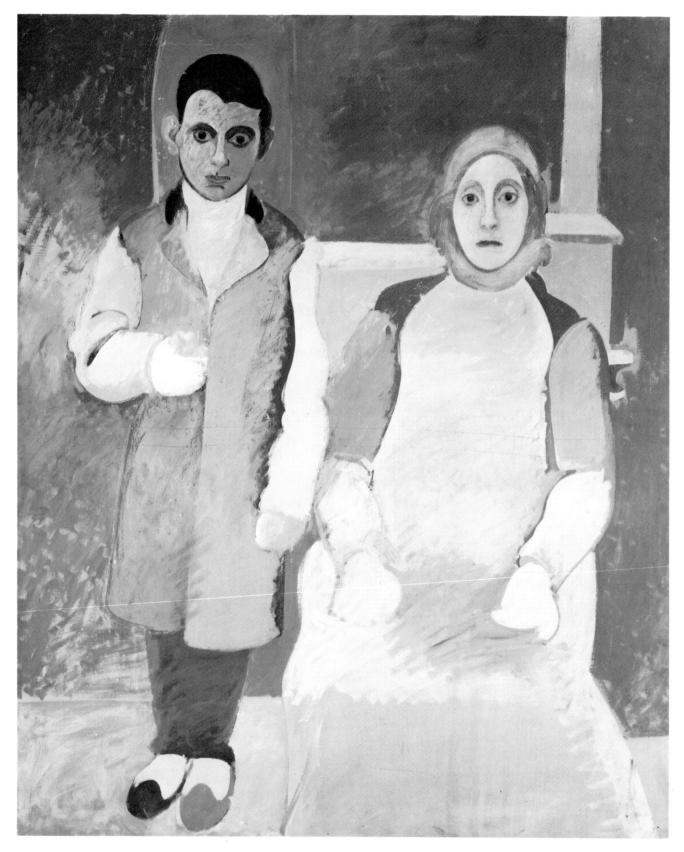

Arshile Gorky *1904–1948*
The Artist and His Mother *c. 1929–c. 1936*
Canvas, 60″ x 50″
Ailsa Mellon Bruce Fund

Although we may not comprehend his personal interpretation of "white writing," it does create a tingling exhilaration when we allow our eyes to follow the paths of this light—this life-blood of the universe—as it ceaselessly flows. Tobey really didn't expect anyone else to share his Baha'i optimism and Zen placidity: "I can't understand doctors or lawyers, so why the hell should anyone understand me?" Perhaps his beliefs have not affected many others, but his art has had international repercussions. Modern Japanese painters have learned as much or more from his assimilation of Oriental and Occidental styles as have American artists. And many Europeans have adopted strains of his gossamer texturings. Mark Tobey helped introduce Asian Existentialism to the United States, although he never succeeded in his desire for a universal culture. "If the West Coast had been open to aesthetic influence from Asia, as the East Coast was to Europe, what a rich nation we would be!"

Arshile Gorky *1904–1948*
Organization *c. 1936*
Canvas, 49¾" x 60"
Ailsa Mellon Bruce Fund

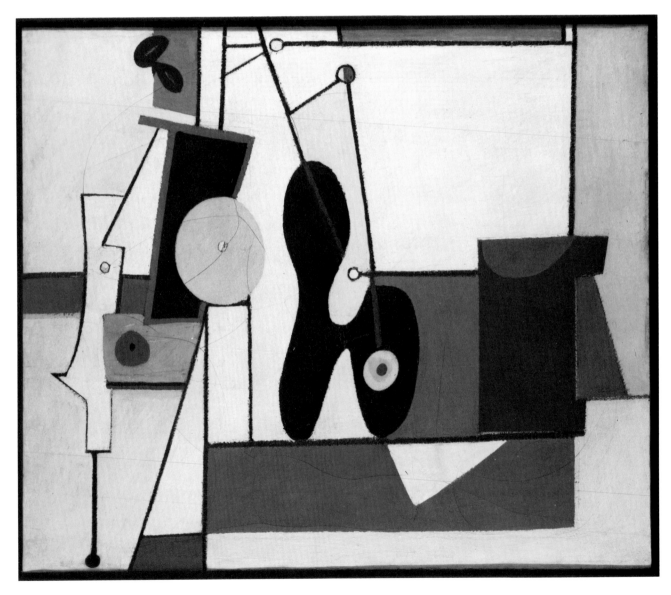

ARSHILE GORKY

1904–1948

Arshile Gorky was an exile haunted by a happy childhood and beautiful homeland destroyed by war. His birthplace on the shores of Lake Van, the center of the ancient Armenian nation, held fertile wheatfields in its valleys and lush orchards in its hills. Gorky grew up in an atmosphere rich in Armenian folk culture: art, music, dance, and tales. He attended elementary school at the American Mission near Van and began to draw at the age of six. When he was ten, his idyllic life was shattered. The czarist Russians, eager to control this farmland, invaded northeastern Turkey in 1914. His father and older sisters fled, eventually reaching America. But Arshile, his mother, and youngest sister became refugees in Russia. Although he worked at odd jobs such as carpentry to earn enough for food, it was no use. In 1919, Arshile's mother died of starvation while he held her in his arms. He and his sister finally rejoined the rest of the family in Providence, Rhode Island, in 1920. Arshile, having already enjoyed and suffered so much, was only in his mid-teens. He maintained an intensive correspondence with his family and friends, often including lines such as, "Beloved ones, write me and tell me of mountains and valleys. Sing of Van. Sing of apricots and wheatfields, of plows. Sing of songs." His grim experiences might have crushed a lesser man, but Gorky remained buoyant, sustained by his pleasant memories.

Gorky enrolled at art schools in Boston and, by 1925, in New York; both institutes also made him a teacher. He loved museums and developed into an extremely articulate observer of Old Master and modern painting. *The Artist and His Mother*, begun around 1929 and still being worked on seven years later, distills his reminiscence of a loving childhood. The motif was based on a treasured relic—an old family photograph taken in 1912 when he was eight.

The photograph showed his mother wearing an ornately embroidered apron, but the adult Gorky eliminated those frivolous patterns from his painting. Likewise, the many buttons on his double-breasted coat are missing here; they would have made rows of dots too busy for Gorky's intention. Heavily textured brush strokes lend a stony solidity to the schoolboy and his mother. The loose patches of paint inside the forms are contained by severe, occasionally outlined contours. The sculptural quality even extends to the strong arches of his dark brown eyebrows and the rolling curves of his black hairline. The colors are dulled and grayed like a vague recollection. The woman's chalky skin complements her son's pale tan complexion. The pinks and violets of her dress and apron correspond to the warm browns and cool blues of his suit. The overall effect is of earthen orange—the color of the apricots Gorky had once picked for his grandfather. Even without knowing the tragedy associated with the artist's early life, anyone can feel the stability and love generated by this sturdy compositional design. Of his ability to impart a visionary mood, Gorky said, "What man has not stopped at twilight and on observing the distorted shape of his elongated shadow conjured up strange and moving and often fantastic fancies from it? Certainly we all dream and in this common denominator of every one's experiences I have been able to find a language for all to understand."

Gorky changed his style of painting several times in his brief career. *Organization,* done around 1936, is an homage to the Spaniard Pablo Picasso. Its straight black lines and loud primary colors against a white background were inspired by a Picasso oil that had recently been acquired by the Museum of Modern Art. The Picasso depicted, in abstracted terms, a painter in his studio. If you examine Gorky's composition carefully enough, you'll find a standing figure to the left, holding an artist's oval palette. The rough paint surfaces, however, are not due to Picasso's impact but to that of Paul Cézanne, the French Post-Impressionist noted for modeling with patches of pigment. Gorky thus pits himself against the two modern masters he most admired. And he did a superb job of distributing soft, curving shapes over the rectilinear gridwork of lines. This geometric manner did not hold his interest too long, though. In writing of the "soulless technology" in the United States, Gorky stated, "I am an Armenian and a man must be himself. For that reason urban cubism hinders my self-expression for its technological direction is couched in an unfeeling tongue that grates against my ears which are accustomed to different songs. Its lines are straight, but I am a curved line."

Gorky preferred the organic shapes of life and the mysteries of folklore: "In trying to probe beyond the ordinary and the known, I create an inner infinity. I probe within the confines of the finite to create an infinity. Liver. Bones. Living rocks and living plants and animals. Living dreams . . . to this I owe my debt to our Armenian art. Its hybrids, its many opposites. The inventions of our folk imagination. These I attempt to capture directly, I mean the folklore and physical beauty of our homeland, in my works." He was so fixated on nature and his motherland that in 1943, two years after his marriage, when he first visited his in-laws' farm, Gorky found that Virginia reminded him of Armenia. *One Year the Milkweed* (see page 222), possibly inspired by his vacations in Virginia, assumes the infinite complexity of natural forms. A sculptor recalled Gorky's playing the game of finding pictures in the clouds: "We had terrible arguments about it because I said, 'That's just a cloud.' He said, 'Oh no, don't you see that old peasant woman up there?'" By employing every conceivable hue and thinning his oils with turpentine until they ran together in blurring mazes, Gorky here created a fertile microcosm from which beings and objects fleetingly emerge. Shapes appear from the dense, overlapping imagery only to recede into the imagination again. Milkweed pods, insects, raindrops, leaves, or human faces may or may not suggest themselves. In speaking of his mature works, Gorky noted, "I might add that though the various forms all had specific meanings to me, it is the spectator's privilege to find his own meaning here. I feel that they will relate to or parallel mine."

Dated 1944, *One Year the Milkweed* derives its hallucinatory power from European Surrealism. The Surrealists goaded, teased, and tantalized the imagination's capacity to invent very realistic fantasies when given the slightest provocation. Gorky utilized the

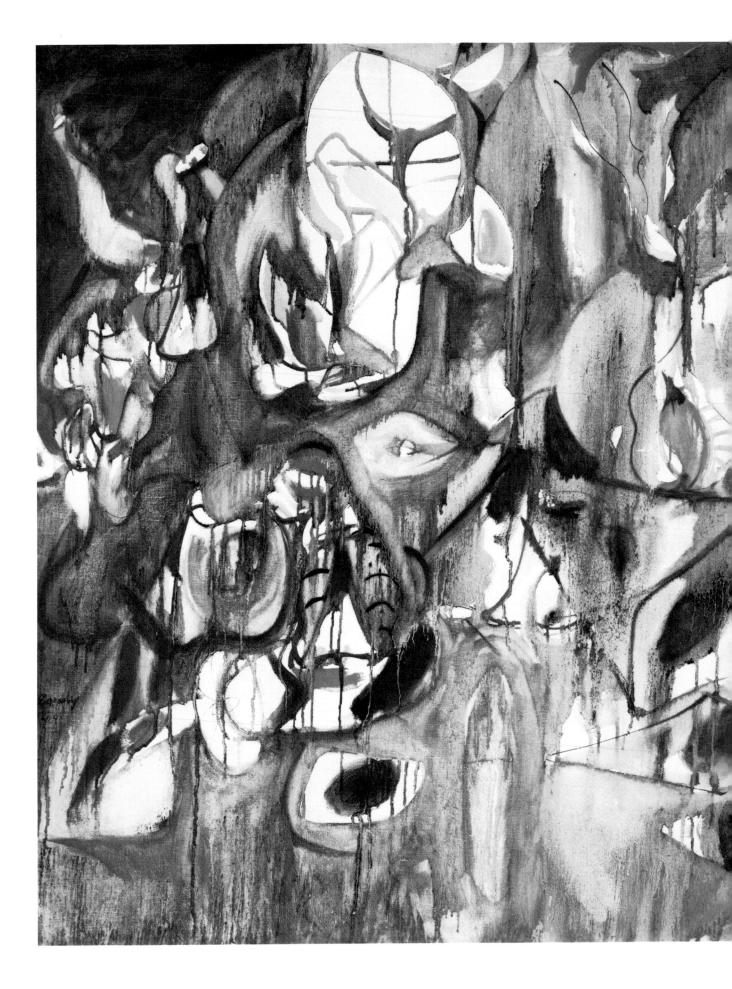

accidents he knew would happen when he allowed areas of wet paint to bleed together. This forceful technique looks forward to the active methods employed later by the American Abstract Expressionists. In short, Arshile Gorky's art is a bridge between an older European tradition of calculated dream imagery and a newer American form of spontaneous creativity.

Had Gorky lived longer, he might have totally dominated the American Abstract Expressionists. We shall never know. The misfortunes which visited him as a boy returned, if possible, in still more grisly fashion. In January 1946, fire destroyed his Connecticut studio and an appreciable portion of his life's work. One month later, he underwent a cancer operation. Although he recovered and spent the summer drawing at his relatives' Virginia farm, an automobile accident in June 1948 broke his neck and paralyzed his painting arm. His wife deserted him within a few weeks, taking their two children. Gorky's zest for life faded; on July 21, 1948, the forty-three-year-old genius hung himself. Years before his suicide, a hopeful, striving Arshile Gorky had written his sister, "I shall resurrect Armenia with my brush for all the world to see, and when we return to clay as we all must, then perchance they might say, 'as a son of the Armenian mountains he offered his modest share to the accumulation of our world's great culture.'"

FRANZ KLINE

1910–1962

That Franz Kline literally attacked his canvases with vehement swipes of brushes as much as eight inches wide is apparent to all. That he controlled the direction and texture of the paint requires careful scrutiny. His compositions are such brutal collisions of jet black and stark white, however, they almost defy close inspection. Their very scale (for gigantic dimensions typify his mature work) seems threatening. But slowly, the awesome power of these works will draw the viewer nearer. As you approach, you'll notice that the initial impact of straight black lines and sharply defined white slabs will vanish. The contours fluctuate and curve erratically; the edges are loose and blurred. The whole configuration appears to shift and reform itself. The striations of thin pigment, the splatters of one tone atop the other, the globs of impasto or pasty textured paint—all imply that Kline is still at work. The spectator soon feels that he is watching the process of creation. Kline communicated his excitement in the very act of painting by leaving erasures and corrections everywhere. His love of paint amounted to a passion for its changing moods, compliant one minute, obstinant the next. "Paint never seems to behave the same. Even the same paint doesn't, you know. It doesn't dry the same. It doesn't stay and look at you the same way." The concept of the paint looking at you instead of you looking at the paint proves that Kline thought of the work of art as a living entity.

Kline's paintings inevitably suggest letters from some strange, huge alphabet or the structural framework of some impossible machine or building. He denied these associations with any subject matter, insisting he was "painting experiences . . . I'm not painting

Arshile Gorky 1904–1948
One Year the Milkweed 1944
Canvas, 37" x 47"
Ailsa Mellon Bruce Fund

Franz Kline *1910–1962*
Four Square 1956
Canvas, 78⅜" x 50¾"
Gift of Mr. and Mrs. Burton G. Tremaine

bridge constructions, skyscrapers." Nevertheless, he acknowledged that human beings do subliminally read familiar meanings into unfamiliar contexts.

"If someone says, 'That looks like a bridge,' it doesn't bother me really. A lot of them do. . . . I think that if you use long lines, they become—what could they be? The only thing they could be is either highways or bridges." He also rejected the notion that Oriental pictograms inspired his work. "People sometimes think I take a white canvas and paint a black sign on it, but this is not true. I paint the white as well as the black, and the white is just as important." In other words, the white is not simply raw canvas or a blank background for a black design.

Four Square, created at the peak of Kline's artistic maturity in 1956, demonstrates these qualities. The black can be read as a positive form atop the white, or the white can be seen as the positive field on top of the black. Seen either way, an illusion of tremendous spatial depth occurs. To discover the visual similarities to the real world which Kline admitted, try imagining various configurations. If you take the white to be negative space, then the black will project forward like architectural girders or tree branches. But if you assume the blacks to be negative, the white areas will recall an aerial view of ice flows on a river or of snow with muddy footpaths beaten down through it. The constant reversal of positive versus negative eventually will cancel out all sensation of depth. You will be confronted with Kline's ultimate goal—a man-made object consisting of flat areas of paint applied to the flat surface of a canvas. What Kline communicates most forcefully is his thrill in controlling the creation of this object. One can sense him thrusting out to place the two narrow lines to the left in order to counterbalance the thick border at the right. The fact that *Four Square* is six and a half feet high shows that he did have to thrust actively. The explosive energy of his working methods expresses the dynamism of a modern urban and industrial world.

Kline was born in Wilkes-Barre, Pennsylvania, at the center of the coal-mining industry. The overwhelming magnitude of that mechanical environment is often cited as a source for his bold compositions. He trained in art at Boston University from 1931 to 1935 and continued his academic study for two years in London. A master draftsman, he taught drawing at Black Mountain College, a major art center, and painted scenes of city and farm life often tinged with social commentary. Kline's conversion to nonrepresentational art was quite dramatic. In 1949, he was examining some of his drawings with the aid of an opaque enlarger, the kind of projector that teachers use to throw images from books or postcards onto the wall for the whole class to see. Kline suddenly realized the abstract beauty of individual lines. When isolated from their realistic images and blown up several times the size of life, the strokes of his pen and brush on small paper sketches achieved new grandeur. He immediately set to work creating his monumental black-and-white Abstractions. About a decade later, after employing only neutral tones, Kline began to introduce bright hues to his paintings, but he passed away before doing much more than merely experimenting with color. His violent wielding of the brush had made him the foremost action or gesture painter among the Abstract Expressionists.

MARK ROTHKO

1903–1970

Mark Rothko was among the most verbally articulate of the Abstract Expressionists. This is strange because he was afraid that explaining too much would result in the public developing "paralysis of the mind and imagination." Also, his mature works are so understated as virtually to deny any explanation. Rothko's characteristic paintings comprise two or three softly textured rectangles stacked vertically against a plain background, all rendered in closely matching colors. *Orange and Tan* (see page 8), being dated 1954, is from his classic phase; against a warm beige field, a red-orange rectangle hovers above a lower shape of yellow slightly tinged with green. A few strokes of pale violet and one spot of thick, opaque paint touch the lower right edge of the upper, orangish area. The rectangles shimmer in thin paint applied so loosely that underlying coats of similar hue and even the beige background emerge. On a canvas nearly seven feet high, that's all that exists. "There are some artists who want to tell all, but I feel that it is more shrewd to tell little. My paintings are sometimes described as facades, and indeed, they are facades."

The bleak, geometric configuration unites with the radiant hues and pulsating textures to create a mood of unutterable calm. Rothko said of his work, "Silence is so accurate." When one of the other Expressionists remarked that Rothko was the most abstract artist of them all, he snapped back, "What do you mean? I'm straight out of Rembrandt," calling attention to his subtle technique of modulated layers of translucent paint and to the light which emanates from his canvases. And, when someone else asked if growing up in the spaciousness of Oregon had prompted him to make simplified landscapes, Rothko barked, "Absolutely not; there is no landscape in my work." Since he denied being either a total Nonobjectivist or a painter of generalized nature, what was Rothko? His most famous answer came in an interview:

"You're a master of color harmonies and relationships on a monumental scale. Do you deny that?"

"I do. I'm not interested in relationships of color or form or anything else."

"Then what is it you're expressing?"

"I'm interested only in expressing basic human emotions—tragedy, ecstasy, doom, and so on—and the fact that lots of people break down and cry when confronted with my pictures shows that I *communicate* these basic human emotions . . . the people who weep before my pictures are having the same religious experience I had when I painted them, and if you, as you say, are moved only by their color relationships, then you miss the point."

Thus, it was expression that mattered most to him. The effect of bricks or ashlar masonry in his compositions has often been compared to a wall or door into a spirit world because, although one is confronted by an apparently sturdy barrier, the textures and colors are so ephemeral one feels capable of walking right through it. In hot tones like those of *Orange and Tan,* it is almost impossible not to be reminded of a bed of glowing embers or a sheet of flames. Rothko's cool blue or green canvases, similarly, recall ice or water. But, surely, he meant more than to evoke the experience of watching a fireplace or of looking down into a pool. Moreover, the contemplative nature of his pictures contradicts his assertion that he was the most violent artist in America.

To understand Rothko's message, a little biography is necessary. He was born in czarist Russia, the youngest son of a middle-class Jewish pharmacist. When Mark's older brothers approached draft age, their father decided it would be best if the family emigrated to America. They arrived separately, Mark at age ten in 1913 with his mother and sister, and moved to Oregon. Mark Rothko didn't show any unusual interest in art until he enrolled at Yale University in 1921. By 1925, he was studying under Max Weber at the Art Students League in New York. Rothko was employed by the Federal Art Projects in 1936–1937, producing cityscapes. He then turned to expressionistically distorted scenes from Greek mythology. In 1943, Rothko and a friend wrote a manifesto to a New York newspaper critic: "It is a widely accepted notion among painters that it does not matter what one paints as long as it is well painted. This is the essence of academicism. There is no such thing as good painting about nothing. We assert that the subject is crucial and only that subject matter is valid which is tragic and timeless. That is why we profess spiritual kinship with primitive and archaic art. Consequently, if our work embodies these beliefs it must insult anyone who is spiritually attuned to interior decoration . . . pictures for over the mantel . . . prize-winning potboilers . . . the Corn Belt Academy. . . trite tripe, and so forth." By the late 1940s, the inevitable happened. Strong abstract elements—rectangular forms— began to invade Mark Rothko's representational art.

Rothko defined his shapes as "organisms with volition and a passion for self-assertion." And his motionless rectangles do dominate and control his colors. No matter how loud or subdued, hot or cold the hues Rothko selected, all his mature canvases breathe an atmosphere of quiet reverie. When listing the "ingredients" of his paintings, Rothko included, "A clear preoccupation with death. All art deals with intimations of mortality." During the 1950s, Rothko told something to a close friend, who related it to another mutual friend. "It was a childhood memory of his family and relatives talking about a Czarist pogrom. The Cossacks took the Jews from the village to the woods and made them dig a large grave. Rothko said he pictured that square grave in the woods so vividly that he wasn't sure that the massacre hadn't happened in his lifetime. He said he's always been haunted by the image of that grave, and that in some profound way it was locked into his painting. Though I knew Rothko for years, I felt that this was too personal a subject to ever broach to him myself. The point is that our response to his painting, on some subliminal level, involves our sensing his feeling about that rectangle."

In 1968, Rothko suffered a heart attack. The color evaporated from his late works, and the space became a vacuum as brown and gray rectangles reached to the very edge of the paintings. Soon, his studio filled with black canvases. Mark Rothko, in 1970, slashed his wrists in front of his easel. The final work on that easel was

247

scarlet. Although Rothko was a profound man, he was never morbid. If one chooses to believe that those rectangles were inspired by a grave, one must remember that for most of Rothko's career, they pulsed with the vivid light of a brilliant life.

JACKSON POLLOCK

1912–1956

A legend has developed that Jackson Pollock's birthplace, Cody, Wyoming, affected his later art, giving his gigantic canvases the wide sweep of the Western plains. It's a nice idea except that Cody lies in a mountain basin and Pollock left Wyoming when only eleven months old, never to return. If the spaciousness of his paintings is attributable to early influence from the environment, then one must look to his childhood and teenage residences in Arizona and California. He was a vigorous youth, to say the least, often getting into trouble at school. His somewhat quixotic personality explains those unproductive periods in his adult career, when he couldn't paint because he was undergoing treatment for alcohol abuse.

At the age of eighteen, Jackson Pollock joined an older brother who was studying at the Art Students League in New York. There, he worked for two years under the Missouri Regionalist Thomas Hart Benton. Pollock later recalled, "He gave me the only formal instruction I ever had... I'm damn grateful to Tom. He drove his kind of realism at me so hard I bounced right into nonobjective painting." He also studied briefly under John Sloan at the League and, in 1936, he joined the New York workshop run by the Mexican artist David Alfaro Siqueiros. Pollock's innovative use of media may be indebted to Siqueiros' experiments in technique. From 1935 to 1943, Pollock worked for the Federal Art Projects. Lee Krasner, a noted Abstractionist in her own right, married Pollock in 1945, and they purchased a small farm at Springs, Long Island, converting its barn into a studio.

Pollock's early works were thickly textured, Expressionistically distorted renderings of motifs derived from Western folklore and American Indian mythology. But in 1947, Jackson Pollock dropped recognizable imagery. He began to place his paintings flat on the floor and, standing over the canvases, he poured and dripped his paints. This revolutionary method eliminated mixing colors on the palette, picking them up with a brush, transferring the paint from brush to canvas, and all the other mechanical acts that slow down and interfere with spontaneous thought. In Pollock's own words, "I need the resistance of a hard surface. On the floor I am more at ease. I feel nearer, more a part of the painting, since this way I can walk around it, work from the four sides and literally be *in* the painting. This is akin to the method of the Indian sand painters of the West. I continue to get further away from the usual painter's tools such as easel, palette, brushes, etc. I prefer sticks, trowels, knives, and dripping fluid paint or a heavy impasto with sand, broken glass and other foreign matter added.

When I am *in* my painting, I'm not aware of what I'm doing. It is only after a sort of 'get acquainted' period that I see what I have been about. I have no fears about making changes, destroying the image, etc., because the painting has a life of its own. I try to let it come through. It is only when I lose contact with the painting that the result is a mess. Otherwise there is pure harmony, an easy give and take, and the painting comes out well."

While not the largest of Pollock's drip paintings, *Number 1, 1950 (Lavender Mist)* (see page 222) is nevertheless the most complex work he ever executed. Its ten-foot width possesses more intricately interwoven skeins of pigment than any of the other canvases in this technique. The colossal scale of the painting fills the spectator's field of vision, just as it engulfed Pollock who, while executing it, was never more than standing-height above it. Since there is no focal point, no compositional arrangement as such, the viewer's gaze wanders easily and constantly over the fluid surface, following the webs of paint in all directions. Soon, an almost hypnotic state will occur as one literally gets lost in this maze of fine lines. As with the works of the other Abstract Expressionists, it is vital not to resist the sensual attraction. Thinking about the lack of a formal design or demanding an explanation of subject matter will only destroy the mood. "Abstract painting is abstract. It confronts you. There was a reviewer a while back who wrote that my pictures didn't have any beginning or any end. He didn't mean it as a compliment, but it was. It was a fine compliment." The totality of the image will develop as one contemplates the surface. Pollock created an entirely consistent texture of gossamer fragility. His control of the pouring and dripping generated a perfect aesthetic harmony: all the linear interplay, down to the last splatter, partakes of the same pulsating vibrancy. The overall effect of *Lavender Mist* is a muted, lyric poetry. Unlike other drip paintings, with coarser lines or stronger colors, this work seems recessive, beckoning.

The infinite layers of paint generate a definite sense of space. And actual depth is produced by the lumps and blobs of impastoed pigment. The crisscrossing lines, darting below and jumping over each other, force one another outward or inward. In innumerable places, the raw canvas remains exposed, adding further depth and texture to the painting. This soft, vaporous surface which reaches out and sinks in is responsible for part of the work's subtitle, "mist." The "lavender" is an optical illusion because of the many industrial, commercial, and artists' pigments employed, none is a pale violet. Flesh-pink, robin's-egg blue, charcoal-gray, snow-and-cream white, silvery aluminum paint, a few drops of orange, and beige are the only colors here, along with yellow-gray of the visible fabric. Since these hues are primarily pastel tints and occur in slender networks, they blend together in the viewer's eyes, creating the sensation of lavender. The evocative name *Lavender Mist* was devised by a critic; Pollock liked it and retained it. Normally, his drip paintings bear merely numbers and dates since they have no subject matter to be described by a title. *Number 1, 1950* simply states that it was the first of a series of particularly ambitious paintings Pollock began in the summer of 1950.

Lee Krasner, Pollock's wife, pointed out the chief problem he had in painting a work on the floor from all four sides and without a

traditional center of interest: the drip paintings had no orientation for hanging them on the wall. "Sometimes he'd ask, 'Should I cut it here? Should this be the bottom?' He'd have long sessions of cutting and editing. . . . These were difficult sessions. His signing the canvases was even worse. . . . He hated signatures. There's something so final about a signature." Pollock's printed signature in the lower left corner proves his ultimate decision as to the top and bottom of *Number 1, 1950.* But, his name spelled out was not innately his; we are taught to write in memorized codes called alphabets. As a culturally acquired message, these letters weren't unique to Pollock. His personal signature—the expression of himself as a living entity—is the series of handprints in an aluminum paint along the upper edge of the left side. These handprints may be scrutinized better in the chapter's frontispiece, which also presents a clearer view of the coherent similarity of the drips and splatters. When Lee Krasner introduced her husband to a respected Abstractionist, the older man said, "after looking at his work, 'You do not work from Nature.' Pollock's answer was, 'I am nature.'"

By 1951, Pollock returned to figurative pictures with totemic, Indian themes. The drip paintings which made him so famous or infamous occupied but a brief period of his career, from 1947 to 1952. But, as another Abstract Expressionist said, Pollock's classic phase "broke the ice," preparing the way for innovations by others at home and abroad. Pollock himself never went abroad, although he had more impact on European painting than any American artist since Benjamin West and James Whistler. We have little notion what direction Pollock would have taken in later work. While his wife was on a European trip, the forty-four-year-old Jackson Pollock was killed instantly when his car accidentally ran off the road not far from his Long Island home.

ANDREW N. WYETH

1917–

Son of N. C. Wyeth, a noted illustrator of decorative books at the turn of this century, Andrew N. Wyeth developed into one of the most popular painters in American history. His depictions of the farmland around his native Chadd's Ford in southeastern Pennsylvania, or of rural Maine, where he summers, have endeared his art to a generation of Americans nostalgic for a quiet, serene escape from industrialized, urban lives. Wyeth's subject matter derives from his father's renditions of American history, from the celebrations of country life painted by the American Regionalists of the 1930s, and ultimately from the nineteenth-century Realists Winslow Homer and Thomas Eakins. A frail child, Wyeth received tutelage at home rather than going to school. His father also taught him art with the traditional methods of drawing from plaster casts of sculpture, painting still lifes in fixed tonal ranges, and the like. Regarding his own early spontaneity, Andrew Wyeth recalls family friends asking his father, "'Well, aren't you scared that all this academic, stiff training that you're putting your son through is going to kill this marvelous freedom?' He would say, 'If it kills it, it ought to

be killed.' I think that's a very good statement. If it isn't strong enough to take the gaff of real training, then it's not worth very much." Wyeth's first works were quite painterly, with fluid handling of the brush; the tight, precise technique for which he is so famous did not develop until the mid-1940s.

Snow Flurries (see page 223), like most of Wyeth's mature work, evolved from careful preparatory drawings and meticulous treatment of tempera paints, an Old Master technique that utilizes the natural glue in eggs to bind the pigments in a delicate, dry surface. We know that Wyeth was very familiar with the motif, as he is with much that he chooses to paint, because the landscape shows a neighboring farm where he played as a child. "This was a *very* difficult picture to paint. It really was because there is not much in it. It's just a hill where I walked a great deal." Wyeth's sketches included a number of actual and imaginary motifs on the horizon and at the foot of the hill, forming visual centers of interest to bracket the ground between distant and near motifs. He omitted all these anecdotal elements from the final tempera painting. Only two fence posts and a rutted country road are present to lend a sense of scale and to help define the successive ridges over the sloping land. "By taking out the fence posts I think I would have gone too far. I think you can over-do it in simplification. You can be too Homeric, too life-eternal."

Interviewed more than twenty years after completing this severe landscape in 1952, Wyeth stated, "Well, actually, this picture is to me a whole lifetime. It summarizes an awful lot. . . . You keep boiling it down until you have the essence of purity. . . . When I did the studies for *Snow Flurries,* they were really only slices of the whole. One showed a tree and an old abandoned house at the bottom foreground of the drawing. And another had some crows in it but I eliminated the crows. . . . You would be shocked at the stages *Snow Flurries* went through. . . . I kept building over it so that I could get that tilting-in quality of the grass. . . . The red is the underpaint up on the right of the field, which was red, red because it was new-plowed earth in January or February. . . . That sky was painted from my studio window. . . . God, I worked and worked and worked to get it right. I would paint that sky and then I would take a really fine brush and massage it and merge those colors to get it down to that gray which is not an obviously overdramatic gray, but just enough toned down so that a snowflake will count." The results form one of the sparsest pictures Andrew Wyeth ever painted. The brooding silence covers even the slight traces of man's activity. The composition becomes an essay in subtle whites and grays mingling with the blacks, dark greens, browns, and earth reds of the soil and dead grass.

The stark simplicity of this landscape lends importance to its formal elements not unrelated to the majestic compositions of the Abstract Expressionists. While Wyeth's realistic subject and methodical execution are at opposite poles from the total Nonobjectivity and violent frenzies of creativity typical of his New York contemporaries, the elimination of detail, the juxtaposition of a few massive shapes, the interest in strongly contrasting tone, and the flat, textured surface all belong to the development of bold Abstraction in mid-twentieth-century America.

WHAT'S AMERICAN ABOUT AMERICAN ART?

The easiest response to the proverbial question about the Americanism of our art is to ask in return, "What's French about French art?" Or, for that matter, what distinguishes Germanic or Japanese culture? Such challenges avoid the issue without answering it. There must be certain geographic qualities—just as there are chronological and class distinctions—or "style" as such would not be recognizable. The whole history of human life, in fact, consists of the interactions between recognizable styles in art, science, politics, and society.

A critical, but often overlooked, factor virtually prohibits any single definition of an American style per se. Fewer than three-fifths of the paintings reproduced in this book were created either within the present United States or by artists born within the fifty states. In short, over two-fifths of these so-called "American" pictures were painted on foreign soil or by immigrants!

Regardless of our melting-pot civilization, summaries of American taste often mention qualities such as those apparent in the naïve or folk rendering of George Washington riding his favorite steed, Jack. The bold silhouette indicates that the unknown creator was a craftsman, most likely schooled in sign lettering, rather than a professionally trained artist. In spite of its shortcomings in anatomy and perspective, *General Washington on a White Charger* possesses a consummate design, including the horse's muscles forming rhythmic curves to echo the curled mane and tricorn hat. The factual attention to detail, evident in the bridle and saddle trappings, has been termed part of American practicality. The tangible imitation of surface textures, as in the hooves' sheen and tail's striations, has been cited as an American concern for believability. The shading does a creditable job of conveying three-dimensional mass, and even though the scene lacks atmosphere, its pale blue background gives a sense of limitless depth. Solid form existing in airy space is another American preference.

The vastness of our land might account for our love of mass and atmosphere. Our well-known national traits of practicality and materialism could explain the desire for realistic details and textures. Furthermore, the absence of patronage by court or church would remove those excesses of frothiness or profundity sometimes felt in other nations' arts. Even among our Abstract painters, a certain simplicity and assertiveness exists. American art, like the American character, then, may be said to be straightforward.

250

Unknown American Artist
General Washington on a White Charger *First Half 19th Century*
Wood, 38⅛" x 29⅜"
Gift of Edgar William and Bernice Chrysler Garbisch

SOURCES

The quotations derive from these books as well as periodical articles, public educational texts previously released by the National Gallery, and unrestricted materials in the Gallery's curatorial archives. Omissions within quotations are indicated in customary manners, but ellipses points are not used before or after quoted passages.

General Works

Baigell, Matthew. *Dictionary of American Art.* New York: Harper & Row, 1979.

Bouton, Margaret. *American Painting in the National Gallery of Art.* Washington, D.C.: National Gallery of Art, 1959.

Cooke, Hereward Lester. *Painting Techniques of the Masters.* New York: Watson-Guptill, 1972.

Eliot, Alexander. *Three Hundred Years of American Painting.* New York: Time, 1957.

Honour, Hugh. *The European Vision of America.* Cleveland: The Cleveland Museum of Art for the National Gallery of Art, 1976.

Larkin, Oliver W. *Art and Life in America.* New York: Holt, Rinehart and Winston, 1960.

McCoubrey, John W. *American Art, 1700–1960: Sources and Documents.* Englewood Cliffs, N.J.: Prentice-Hall, 1965.

National Gallery of Art. *American Paintings: An Illustrated Catalogue.* Washington, D.C.: National Gallery of Art, 1980.

Randel, William Peirce. *The Evolution of American Taste.* New York: Crown Publishers, A Rutledge Book, 1978.

Smith, Bradley. *The USA, A History in Art.* Garden City, N.Y.: Doubleday & Co., 1975.

Walker, John. *National Gallery of Art, Washington.* New York: Harry N. Abrams, 1974.

Walker, John. *National Gallery of Art, Washington, D.C.* New York: Harry N. Abrams, 1963.

Wilmerding, John. *American Art.* New York: Penguin Books, The Pelican History of Art, 1976.

Wilmerding, John. *American Masterpieces from the National Gallery of Art.* New York: Hudson Hills Press, 1980.

The Eighteenth Century

Adams, William Howard, ed. *The Eye of Thomas Jefferson.* Washington, D.C.: National Gallery of Art, 1976.

Alberts, Robert C. *Benjamin West, A Biography.* Boston: Houghton Mifflin Company, 1978.

Dickason, David Howard. *William Williams, Novelist and Painter of Colonial America, 1727–1791.* Bloomington, Ind.: Indiana University Press, 1970.

Evans, Dorinda. *Benjamin West and His American Students.* Washington, D.C.: Smithsonian Institution, 1980.

Flexner, James Thomas. *John Singleton Copley.* Boston: Houghton Mifflin Company, 1948.

Goodrich, Laurence B. *Ralph Earl, Recorder for an Era.* N.p.: The State University of New York, 1967.

Jaffe, Irma B. *John Trumbull, Patriot-Artist of the American Revolution.* Boston: New York Graphic Society, 1975.

Mount, Charles Merrill. *Gilbert Stuart, A Biography.* New York: W. W. Norton, 1964.

National Gallery of Art. *Gilbert Stuart, Portraitist of the Young Re-*

public. Providence, R.I.: Rhode Island School of Design, 1967.

Prown, Jules David. *John Singleton Copley.* 2 Vols. Cambridge, Mass.: Harvard University Press for the National Gallery of Art, 1966.

Reynolds, Sir Joshua. *Discourses on Art* (1797). Introduction by Robert R. Wark. New York: Collier Books, 1966.

Sellers, Charles Coleman. *Charles Willson Peale.* New York: Charles Scribner's Sons, 1969.

Stewart, Robert G. *Henry Benbridge, 1743–1812, American Portrait Painter.* Washington, D.C.: Smithsonian Institution, 1971.

Steward, Robert G. *Robert Edge Pine, A British Portrait Painter in America, 1784–1788.* Washington, D.C.: Smithsonian Institution, 1979.

The Nineteenth Century

Breeskin, Adelyn D., et al. *Mary Cassatt, 1844–1926.* Washington, D.C.: National Gallery of Art, 1970.

Domit, Moussa M. *American Impressionist Painting.* Washington, D.C.: National Gallery of Art, 1973.

Ewers, John C. *George Catlin, Painter of Indians and the West.* Washington, D.C.: Smithsonian Institution, 1956.

Flexner, James Thomas. *That Wilder Image, The Painting of America's Native School from Thomas Cole to Winslow Homer.* Boston: Little, Brown and Company, 1962.

Frankenstein, Alfred. *The Reality of Appearance, The Trompe l'Oeil Tradition in American Painting.* Greenwich, Conn.: New York Graphic Society, 1970.

Gould, Jean. *Winslow Homer, A Portrait.* New York: Dodd, Mead, 1962.

Haberly, Lloyd. *Pursuit of the Horizon, A Life of George Catlin.* New York: The Macmillan Company, 1948.

Halpin, Margorie. *Catlin's Indian Gallery.* Washington, D.C.: Smithsonian Institution, 1965.

Hills, Patricia. *The Genre Painting of Eastman Johnson.* New York: Garland, 1977.

Inness, George, Jr. *Life, Art, and Letters of George Inness* (1917). Introduction by Elliott Daingerfield. New York: Kennedy Galleries, Inc., Library of American Art, 1969.

McCracken, Harold. *George Catlin and the Old Frontier.* New York: The Dial Press, 1959.

McMullen, Roy. *Victorian Outsider, A Biography of J. A. M. Whistler.* New York: E. P. Dutton & Co., 1973.

Mount, Charles Merrill. *John Singer Sargent, A Biography.* New York: W. W. Norton, 1955.

Pierce, Patricia Jobe. *The Ten.* Concord, N.H.: Rumford Press, 1976.

Porter, Fairfield. *Thomas Eakins.* New York: George Braziller, 1959.

Sully, Thomas. *Hints to Young Painters* (1873). Introduction by Faber Birren. New York: Reinhold Publishing Corporation, 1965.

Talbot, William S. *Jasper F. Cropsey.* Washington, D.C.: Smithsonian Institution, 1970.

Weintraub, Stanley. *Whistler, A Biography.* New York: Weybright and Talley, 1974.

Whistler, James Abbott McNeill. *The Gentle Art of Making Enemies* (1892). Introduction by Alfred Werner. New York: Dover Publications, 1967.

Wilmerding, John, et al. *American Light, The Luminist Movement, 1850–1875.* Washington, D.C.: National Gallery of Art, 1980.

Wilmerding, John. *Fitz Hugh Lane*. New York: Praeger Publishers, 1971.

The Twentieth Century

Andrew Crispo Gallery. *I. Rice Pereira*. New York: Andrew Crispo Gallery, Inc., 1976.

Baur, John I. H. *Loren MacIver and I. Rice Pereira*. New York: Whitney Museum of American Art, 1953.

Carmean, E. A., Jr.; Rathbone, Eliza E.; and Hess, Thomas B. *American Art at Mid-Century: The Subjects of the Artists*. Washington, D.C.: National Gallery of Art, 1978.

Chapellier Galleries. *Robert Henri, 1865–1929*. New York: The Chapellier Galleries, Inc., 1976.

Cincinnati Art Museum. *Walt Kuhn*. Cincinnati: Cincinnati Art Museum, 1960.

Czestochowski, Joseph S. *John Steuart Curry and Grant Wood*. Columbia, Mo.: University of Missouri Press, 1981.

Everitt, Anthony. *Abstract Expressionism*. Woodbury, N.Y.: Barron's, 1978.

Glackens, Ira. *William Glackens and the Ashcan School*. New York: Crown Publishers, 1957.

Haskell, Barbara. *Marsden Harley*. New York: New York University Press, 1980.

Kennedy Galleries. *Walt Kuhn*. New York: Kennedy Galleries, Inc., 1967.

Kuhn, Walt. *Fifty Paintings*. New York: Studio Publications, 1940.

McBride, Henry, et al. *George Bellows, A Retrospective Exhibition*. Washington, D.C.: National Gallery of Art, 1957.

Metropolitan Museum of Art. *Two Worlds of Andrew Wyeth*. New York: The Metropolitan Museum of Art Bulletin (XXXIV, 2), 1976.

Morgan, Charles H. *George Bellows, Painter of America*. New York: Reynal & Company, 1965.

Munson-Williams-Proctor Institute. *George Luks*. Introduction by Ira Glackens. Utica, N.Y.: Museum of Art, 1973.

Rose, Barbara. *American Art Since 1900, A Critical History*. New York: Frederick A. Praeger, 1967.

Schmeckebier, Laurence E. *John Steuart Curry's Pageant of America*. New York: American Artists Group, 1943.

Schmied, Wieland. *Tobey*. New York: Harry N. Abrams, 1966.

Scott, David. *John Sloan*. New York: Watson-Guptill, 1975.

Seitz, William C. *Mark Tobey*. New York: Doubleday & Co., 1962.

Sweet, Frederick A., et al. *Ivan Albright, A Retrospective Exhibition*. Introduction by Ivan Albright. Chicago: The Art Institute of Chicago, 1964.

Werner, Alfred. *Max Weber*. New York: Harry N. Abrams, 1975.

Wright, Brooks. *The Artist and The Unicorn, The Lives of Arthur B. Davies*. New York: The Historical Society of Rockland County, 1978.

Young, Mahonri Sharp. *The Eight*. New York: Watson-Guptill, 1973.

INDEX

*Artists with individual texts are listed in **bold-face**; incidental references to these painters follow their main entries. Illustrations are indicated by italic numerals; textual references to those paintings follow. Portraits are listed by the sitter's last name; initial articles have been omitted from all titles.*

ACKNOWLEDGMENTS

At the National Gallery, I wish to thank Frances Smyth and Theodore Amussen, who introduced me to The Rutledge Press, as well as Charles Parkhurst, Elizabeth Croog, John Wilmerding, Linda Ayres, and Ira Bartfield for their invaluable counsel and assistance. Margaret Bouton, Curator in Charge of Education, liberally granted my use of leave time, while Rita Cacas deserves credit for compiling the captions and typing much of the manuscript. Among other friends, both within and outside the Gallery, to whom appreciation is offered for their patience are Lynn Russell, Georgiana Dunham, Mary Ellen Wilson, Patricia Schrepel, Donna Mann, Nichols Clark, Sylvia Goldman, Rodney Burbach, and my devoted companions, Ma'at and Nefret.

Due to a series of unforeseen circumstances, the manuscript arrived not only sporadically but also months late. That the final book appears as originally scheduled is due entirely to the miraculous efforts of Fred Sammis, chairman of The Rutledge Press, and his excellent staff: Cynthia Parzych, publisher; Deborah Weiss, editor; Allan Mogel, designer; and Lucy Adelman, copyeditor. Hugh Johnson and Warren Cox of Hammond Incorporated oversaw the project with understanding. To all these people and more, I owe a debt of personal gratitude as well as a public exoneration from any errors within the text.